JEWISH-MUSLIM INTERACTIONS

Performing Cultures
between North Africa and France

FRANCOPHONE POSTCOLONIAL STUDIES

The annual publication of the Society for Francophone Postcolonial Studies

New Series, Vol. 11

Francophone Postcolonial Studies

The annual publication of the Society for Francophone Postcolonial Studies

The Society for Francophone Postcolonial Studies (SFPS) is an international association which exists in order to promote, facilitate and otherwise support the work of all scholars and researchers working on colonial/postcolonial studies in the French-speaking world. SFPS was created in 2002 with the aim of continuing and developing the pioneering work of its predecessor organization, the Association for the Study of Caribbean and African Literature in French (ASCALF). SFPS does not seek to impose a monolithic understanding of the 'postcolonial' and it consciously aims to appeal to as diverse a range of members as possible, in order to engage in wide-ranging debate on the nature and legacy of colonialism in and beyond the French-speaking world. SFPS encourages work of a transcultural, transhistorical, comparative and interdisciplinary nature. It implicitly seeks to decolonize the term Francophone, emphasizing that it should refer to all cultures where French is spoken (including, of course, France itself), and it encourages a critical reflection on the nature of the cognate disciplines of French Studies, on the one hand, and Anglophone Postcolonial Studies, on the other.

Our vision for this publication with Liverpool University Press is that each volume will constitute a sort of *état présent* on a significant topic embracing various expressions of Francophone Postcolonial Cultures (e.g. literature, film, music, history), in relation to pertinent geographical areas (e.g. France/Belgium, the Caribbean, Africa, the Indian Ocean, Asia, Polynesia) and different periods (slavery, colonialism, the post-colonial era, etc.): above all, we are looking to publish research that will help to set new research agendas across our field. The editorial board of *Francophone Postcolonial Studies* invites proposals for edited volumes touching on any of the areas listed above: proposals should be sent to Julia Waters (j.waters@reading.ac.uk). For further details, visit: http://sfps.org.uk/.

General Editor: Julia Waters (University of Reading, UK)

Editorial Board
Charlotte Baker (Lancaster University)
Leslie Barnes (The Australian National University)
Lia Brozgal (UCLA)
Patrick Crowley (University College Cork)
Nicki Hitchcott (University of St Andrews)
Kate Hodgson (University College Cork)
Maeve McCusker (Queen's University Belfast)
H Adlai Murdoch (Tufts University)
Srilata Ravi (University of Alberta)
Ieme van der Poel (University of Amsterdam)
John Walsh (University of Pittsburgh)

JEWISH-MUSLIM INTERACTIONS

Performing Cultures between North Africa and France

Edited by
Samuel Sami Everett and Rebekah Vince

Liverpool University Press

First published 2020 by
Liverpool University Press
4 Cambridge Street
Liverpool
L69 7ZU

Copyright © 2020 Liverpool University Press and the Society for Francophone Postcolonial Studies

The right of Samuel Sami Everett and Rebekah Vince to be identified as the editors of this book has been asserted by them in accordance with the Copyright, Designs and Patents Act 1988.

All rights reserved. No part of this book may be reproduced, stored in a retrieval system, or transmitted, in any form or by any means, electronic, mechanical, photocopying, recording, or otherwise, without the prior written permission of the publisher.

British Library Cataloguing-in-Publication data
A British Library CIP record is available

ISBN 978-1-78962-133-4 cased

Typeset by Carnegie Book Production, Lancaster

Contents

Illustrations	vii
Acknowledgements	ix
Introduction	1
Samuel Sami Everett and Rebekah Vince	

I. Accents, Affiliations, and Exchange

Albert Samama, a Tunisian Filmmaker in the Ottoman Empire at War (1911–1913)	23
Morgan Corriou	
Translated by David Motzafi-Haller	
More than Friends? On Muslim-Jewish Musical Intimacy in Algeria and Beyond	43
Jonathan Glasser	
Nationalist Records: Jews, Muslims, and Music in Interwar North Africa	61
Christopher Silver	
Marie Soussan: A Singular Trajectory	81
Hadj Miliani and Samuel Sami Everett	
Retelling the Jewish Past in Tunisia through Narratives of Popular Song	101
Ruth F. Davis	

vi　　　　　　　　　*Jewish-Muslim Interactions*

'Free, but United'? Artistic and Political Issues of Intercommunal
Solidarity in Tunisia and Algeria, 1940–1960　　　　　　　121
　　　Fanny Gillet
　　　Translated by David Motzafi-Haller

II. Absence, Influence, and Elision

Neglected Legacies: Omissions of Jewish Heritage and Muslim-Jewish
Relations in Algerian *Bandes Dessinées*, 1967 through the 1980s　　141
　　　Elizabeth Perego

Forgotten Encounters: Sounds of Coexistence in Moroccan Rap Music　161
　　　Cristina Moreno Almeida

Unmuted Sounds: Jewish Musical Echoes in Twenty-first Century
Moroccan and Israeli Soundscapes　　　　　　　　　181
　　　Aomar Boum

Connecting the Disconnect: Music and its Agency in Moroccan
Cinema's Jewish-Muslim Interactions　　　　　　　　201
　　　Vanessa Paloma Elbaz

Jerusalem Blues: On the Uses of Affect and Silence in Kamal
Hachkar's *Tinghir-Jérusalem: Les échos du Mellah* (2012)　　　223
　　　Jamal Bahmad

A Newfound Voice from across the Mediterranean: Kamal Hachkar's
Dans tes yeux, je vois mon pays (2019)　　　　　　　235
　　　Miléna Kartowski-Aïach
　　　Translated by David Motzafi-Haller

Creative Coexistence or Creative Co-resistance? Transcultural
Complexity in the Work of Street Artist 'Combo'　　　　253
　　　Nadia Kiwan

Shalom alikoum! Challenging the Conflictual Model of
Jewish-Muslim Relations in France through Stand-up Comedy　　273
　　　Adi Saleem Bharat

Post-face　　　　　　　　　　　　　　　293
　　　Valérie Zenatti

Afterword　　　　　　　　　　　　　　301
　　　Translated by Samuel Sami Everett

About the Contributors　　　　　　　　　　309
Index　　　　　　　　　　　　　　　315

Illustrations

Figure 1: Postcard depicting a family party with musicians in Setif, circa 1930. © Jean Laloum and Jean-Luc Allouche. 49

Figure 2: Marie Soussan and Rachid Ksentini performing one of their many sketches for the Union Sportive Musulmane in Blida, 1933. *L'Afrique du Nord illustrée*, 28 January 1933. 91

Figure 3: 'Gala organisé par la « la Rachida »'. *L'Écho de Bougie*, 15 June 1930. 94

Figure 4: '"El Mossila" au Théâtre Muncipal'. *La Revue musicale nord-africaine*, 3 March 1934. 95

Figure 5: 'Le Samedi soir dans une famille juive de Tunis'. Engraving by Horace Castelli (1825–1889). © Collection Bernard Allali. 102

Figure 6: 'Judische Familie in Tunis'. *Die Heimat*, 1881. Wood engraving designed by D. Maillars after a photographic negative produced in 1865 by M. Catalanotti. © Collection Bernard Allali. 103

Figure 7: Artists from l'École de Tunis meet on the terrace of the Café de Paris in Tunis, 1953. 123

Figure 8: Slim marks the Casbah as a uniquely Muslim space (2011). 151

vii

viii *Jewish-Muslim Interactions*

Plates

Plate 1: 'Musiciens chaâbi à travers les générations' ['Chaâbi Musicians across the Generations']. © Imis Kill.

Plate 2: 'Soussan et Ksentini' ['Soussan and Ksentini']. © Imis Kill.

Plate 3: Cover picture. Mohamed Boudhina. *Aghānī min al-turāth.* Hammamet–Tunis, 1997. © Jamīʿ al-Huqūq Mahfūza Manshūrāt Muhammad Būdhīna Shārīʿ Faysal Bin ʿAbdulʾazīz – al-Hammāmāt 8050 – al-Jumhūriyyah at-Tūnisiyyah.

Plate 4: 'Film et exil' ['Film and Exile']. © Imis Kill.

Plate 5: CoeXisT 1 ('Mohamed'/CoeXisT). © ADAGP, Paris, and DACS, London 2020.

Plate 6: CoeXisT 2 ('Mohamed' and 'Moshe'/CoeXisT). © ADAGP, Paris, and DACS, London 2020.

Plate 7: 'Mohamed' and 'Moshe' (Tel Aviv). © ADAGP, Paris, and DACS, London 2020.

Plate 8: 'Loin des yeux, loin du cœur' (Tel Aviv). © ADAGP, Paris, and DACS, London 2020.

Plate 9: 'La plume ou le danger?' ['The Pen or the Sword?']. © Imis Kill 2018.

Acknowledgements

In line with the historical breadth of this volume and its focus on interaction and intergeneration, we would like to dedicate this volume to both ends of era and new beginnings. A lot can and did happen in the time that it took to bring this book into being. We would like to recognize the generosity of spirit and keen attention to detail of the late Kate Marsh, who encouraged us in the early stages of this project. At the other end of the life cycle we would like to welcome Fanny Gillet's baby Arthur into the world of books, languages, and words. He was born hours after Fanny finished her chapter. Special thanks also go to graphic artist Iris Miské who drew the tailormade images that punctuate the volume, to Emily Harding for designing the book cover, and to Logan Williams for taking care of the index. For competitive funding, we would like to acknowledge the generous support of the European Association for Jewish Studies, the Centre for Research in the Arts, Social Sciences and Humanities (CRASSH) and the Faculty of History at the University of Cambridge, The Institute of Modern Languages Research, and finally the Paris Sciences et Lettres Research University (PSL)-University of Cambridge fund, thanks to which we were able to hold two conferences on Maghribi Jewish-Muslim interactions in the performative realm – at CRASSH and the Camargo Foundation, Cassis, respectively (particular thanks go to Karima Dirèche, Nilüfer Göle, and Simon Goldhill for supporting our bids). We are grateful to all those who so willingly participated in these conferences and to those who contributed to

this volume, for their valuable insights, openness, and collegiality, including those who were not able to contribute or for whom the primary mode of expression is not written (long may our interactions continue): Seth Ansizka, Arthur Asseraf, Naomi Davidson, Mathias Dreyfus, Neta Elkayam, Amit Hai Cohen, Warda Hadjab, Khalid Lyamlahy, Chana Morgenstern, Jonas Sibony, Naima Yahi, and Mourad Yelles. We would particularly like to thank David Motzafi Haller for his perceptive translations, and Chloe Johnson for her editorial discernment, as well as, of course, Charles Forsdick and Charlotte Baker, who served as coordinators with the Society for Francophone Postcolonial Studies.

Introduction

Samuel Sami Everett and Rebekah Vince

The now household name Jamel Debbouze, a French comedian of Moroccan descent, famously told the French public in an interview that 'on voulait faire un truc pour nous', before launching the Jamel Comedy Club.[1] The 'nous' of Debbouze's soundbite meant 'les Noirs et les Arabes' ['Blacks and Arabs'], a self-referential vernacular used to describe being a descendant of Northern or Western Africa and therefore inheritors of a French postcolonial situation.[2] Debbouze's 'pour' ['for'] was about recognition and a sentiment that there is a lack of space for diversity and plurality in the multiple institutions that represent *la culture française* ['French culture'], that is, space to express simultaneously not being entirely (or at least only) French but yet still being from France, without neatly fitting the othering labels of *le Banlieusard, le Maghrébin,* or *le Musulman.*

Jamel Debbouze made it his mission to create such a space in mainstream French culture. But where do young French Jewish people of North African descent fit with his 'pour nous' ['for us'], since they are presumably neither entirely Arab nor Black by his definition? Debbouze's response has been consistent on this point throughout his on-stage career, during and since his rise to fame. For him, Moroccan Jews are brothers (*des frères*), as can

[1] 'We wanted to do something for us'. All translations our own, unless otherwise stated.

[2] See Kleppinger and Reeck (2018: 1–2).

2 *Jewish-Muslim Interactions*

be seen in his career-long on- and off-stage friendship with Gad Elmaleh, another French household name and comedian of Moroccan descent from a Casablanca-based Jewish family of performers.[3] It was through the 'Jam et Gad' sketches developed on Canal+ in the late 1990s, such as their parody of famous raï[4] singers Cheb Mami and Faudel, that the inspiration came for Elmaleh's later and more well-known characters Chouchou (2003), the North African transvestite from *la place de Clichy*, and Coco (2009), the Sephardi media tycoon. For Debbouze and Elmaleh, Jewish and Muslim cultural histories from the Maghrib are intimately tied together, and comedic play with their ethnicization in France made the pair's performances particularly stimulating and dynamic as a site of transgressing ethnic boundaries.

Whether or not this was intentional, it is above all the cultural and historical referents of music and humour in a theatrical mode that Jam et Gad brought together. Their sketches reflect a continuation of a Maghribi genealogy of anarchic popular theatre from the embryonic musical theatre of Algiers in the interwar years to the gritty urban beginnings and scandalous lyrics of raï luminaries such as Cheikha Rimiti whose stage name 'Rimiti' came from the fusion of the French word *remettre* as in 'remets moi un verre' ['pour me another glass'] and the Arabic language ending *-ti* to denote the second-person singular, in the past mode.[5] The everyday is a source of infinite inspiration for artists such as Cheikha Rimiti, and more recently Jam et Gad, who draw on a legacy of Maghribi popular musical and theatric culture. Hadj Miliani and Samuel Sami Everett (this volume) chart the singular trajectory of another female protagonist, Marie Soussan, whose sketches alongside her partner Rachid Ksentini drew on a repertoire of the warring couple as a humorous trope. Indeed, if we are to seek an origin for the form of Maghribi stage culture that Jam et Gad perform, this might be traced back

[3] Jamal Debbouze, Twitter post. 4 March 2018, 3:31 pm: 'qu'est que je suis fier de toi mon frère' ['unbelievably proud of my brother']. Available at: https://twitter.com/debbouzejamel/status/970316324982480897?lang=en-gb (consulted on 5 August 2019). The concept of brotherhood is explored by Glasser and Moreno Almeida (this volume).

[4] From the Algerian Arabic *rây* (to see, or have an opinion), raï or rai is an alternative popular form of music that has its roots in the Algerian *nahda* (renaissance) period from the 1920s and subverts the established order of traditionalist Maghribi society.

[5] The definition of *cheikha* (feminine form of the much more common *cheikh*, literally meaning tribal leader) can be anywhere on a scale from virtuoso music composers to simple *musicien* (see Davis, this volume). The epitaph cheikha is subversive in that it feminizes a label given to the great musical leaders of the Andalusi repertoire who would have scores of pupils.

Introduction 3

to Soussan and Ksentini. The duo were deeply influential in establishing Algerian popular musical theatric production during the interwar years. Meanwhile, in Tunisia, Jewish superstar Habiba Messika brought Jews and Muslims together through her music and her untimely death, forming a shared cultural memory of mourning and leaving behind a musical legacy that contributed to nationalist movements across the Maghrib, as did Lili Labassi and Salim Halili in 1930s Algeria (see Silver, this volume). Decades later, at the height of the Algerian War of Independence, the death of Andalusi[6] singer Cheikh Raymond in Constantine was also grieved by Jews and Muslims alike (see Boum, this volume). Yet his assassination was taken by many Algerian Jews as a cue to leave their native country.[7] Unlike most Moroccan and Tunisian Jews who did not necessarily have French nationality, many Algerian Jews ended up in France despite antisemitism and sometimes discriminatory assimilationist policies that persist to this day, as evidenced in the sketches of Jam et Gad, and the up-and-coming comedy duo Younes et Bambi (see Bharat, this volume).

Jam et Gad performed together frequently until the end of the 1990s, a period when people of North African heritage were commonly defined as *des arabes* ['Arabs'] or *beurs* in verlan (back slang), which differs significantly from their vernacular, monolithic ethno-religious ascription today as *des musulmans* ['Muslims']. While he may not have been seen as entirely Arab at the time, Elmaleh's North African credentials were not in question. However, since that period, partly in reaction to 9/11, a discursive shift has sharpened religious differences. Slowly, and no doubt also as a consequence of their professional trajectories, the two performers seem to have gone their own ways. The unhinged energy and excitement of their early material has dissipated in more recent on-stage performances together, for example at

6 According to Nadir Marouf (2002: 11), the musical tradition known today as Andalusi sits at the crossroads of oriental/Eastern and occidental/Western musical traditions, arriving via the settlement of the Umayyad Caliphate (from Baghdad) in North Africa and the Iberian Peninsula, and the musical culture it brought with it.

7 Benjamin Stora describes the assassination of Cheikh Raymond as 'le grand tournant, le moment où ce qui restait de la communauté juive de Constantine en 1961 a choisi de parti vers la France' ['the turning point, the moment when what was left of the Jewish community of Constantine in 1961 chose to leave for France'] (2015: 99; cf. Valensi, 2016: 146). Although this event took place in a specific location – Stora speaks of 'le choc' for Constantine's Jewish community in particular (2015: 96) – shockwaves spread throughout Algeria. Valensi describes how the fear it provoked had a ripple effect ('des échos') among Jewish communities across the nation (2016: 180).

the *Marrakech du Rire*, Jamel's French spectacle for the wealthy *chichi* urban upper classes of Morocco's coastal and imperial cities. This ongoing process of gentrification (Elmaleh has moved to New York to make a career for himself there while Debbouze has taken a break from comedy) has unfortunately coincided with their implication in the polarizing language of conspiracy theories (Obadia, 2013). Such conspiracy discourse has further type-cast North Africans as exclusively and politically Muslim while Jews have become Zionist apparatchik, recalling the fall-out of Jam et Gad's comedic *grand frères*, Elie Semoun and Dieudonné Mbala Mbala, exemplars of the first non-white generation to break into the mainstream comedy market in France (Quemener, 2014). This comedic and political context is analysed in depth in this volume, specifically in relation to satirical engagement with religious discrimination against Jews and Muslims through the artwork of 'Combo Culture Kidnapper' (Kiwan, this volume) and the comedy of Debbouze's protégés Younes et Bambi (Bharat, this volume).

The trajectory of Jam et Gad thus speaks to both popular and state representations of plurality in North African history and their ongoing and complex relationship to the geopolitically constructed discursive doxa that has shifted over the last two decades. It is within this context that historical and ongoing interactions among Jews and Muslims from the Maghrib have taken on such forceful significance. Nowhere are these interactions more dynamic than in cultures of performance past and present.

Maghribi Jewish-Muslim Interactions

For the purposes of this volume, our focus is on creative interactions between Jews and Muslims – container words that we do not take for granted but that we acknowledge in their etymological and experiential complexity – in and from those Maghribi countries that were most directly affected by French colonialism, namely Algeria (department from 1830 to 1962), Tunisia (protectorate from 1881 to 1956), and Morocco (protectorate from 1912 to 1956) within the context of the wider Muslim Maghrib (Ahmida, 2000: 6). Under the French colonial-settler model, this area was known as Tam-Tam (*Tunisie, Algérie, Maroc*), reduced to the cliché of an African drum (*le tamtam de l'Afrique*). Conscious of the deep colonial heritage that permeates bringing these countries together again, rather than describing interactions as 'Francophone', we see them as existing within multilingual and transcultural *spheres* (Vince, 2019a) encompassing interreligious *ambiances* (Everett, 2020). Spheres and ambiances evoke influence and affect, contingent publics and atmospheres, all of which are in contact with one another, and thus undergird our exploration of the transcultural,

Introduction 5

the interactive, and the dynamic. We consider Maghribi Jewish-Muslim interactions in performance culture broadly defined as encompassing creative practice, stimulus, and collaboration between Jewish and Muslim artists and performers for whom often these words meant very little, across the often-overlapping spheres of performance through music, theatre, film, art, and stand-up. The multilingualism and heteroglossia of these performative spheres and the ambiances of those who produce them encompass oral and written engagement not only with the former colonial language (including through a kind of hybrid *français-arabe* that would emerge from such extensive contact in the colony and later in the post-colony), but also with Amazigh languages, Darija (local North African Arabic), Judeo-Arabic (in this case, a form of Darija), Ladino or Judeo-Spanish, and even the liturgical (read but not spoken) languages of Hebrew and classical Arabic (Kosansky, 2016: 5). This volume is thus inherently transnational, multilingual, and interdisciplinary.

As well as shifting from the term 'Francophone' as a colonial hangover to multilingual as a more fitting description of past and current reality in North Africa, the choice of 'Maghrib' (instead of 'Maghreb') to designate this region is an intentional one. Indeed, much like the monolithic term 'Mizrahi' (literally: Oriental) was invented in Israel to put Jews from countries across North Africa and the Middle East into one category (Shohat, 1999) while 'Sephardi' has come to designate Jews of North Africa regardless of whether they have origins in Sepharad (Attias and Benbassa 2002 [2001]: 15, 93–94, 120), 'Maghrébin' ['Maghrebian'] is a homogenizing neologism with colonial undertones, often synonymous with 'Arabe' ['Arab'] or 'musulman' ['Muslim'] (see Harrison, 2018). Rather than seeing North Africa as 'a European periphery' (Seddon, 2000: 198), we take the Maghrib as our starting point, focusing on the indigenous populations, including Amazigh, Jewish, Muslim, and Arab, acknowledging the overlaps between these internally diverse groups, while also taking into account Maghribi Jewish-Muslim interactions in France, particularly following decolonization and mass migration.

An autochthonous Jewish presence in northern Africa pre-dates Roman times (Stillman, 1979; Tedghi, 2015) but also maps on to later patterns of commercial trade across the southern Maghrib brought by Islamized Arab populations in the eleventh century (Hirschberg, 1963). Along with the Morisco (Muslims of Andalusia), a significant number of Jews found refuge in North Africa following expulsion from Spain and Portugal in 1492 and 1497, respectively. As Abdelmajid Hannoum (2001) has noted, historiography is often bound to national mythologies, and the history of the Maghrib is composed of distinctive and intertwining stories about Arab, Amazigh

6 *Jewish-Muslim Interactions*

('Berber'), and Jewish origins all of which contain semi-truths.[8] What is perhaps more certain is that later these communities and groups would become subject to French assimilationist colonial rule wherein Jews were known as *israélites* (Lorcin, 2012: 904) and Muslims as *indigènes*; moreover, many Jews across the Maghrib and beyond would be recipients of a French education through the institution of the Alliance Israélite Universelle in 1860, which sought to bring 'Oriental' Jews into 'modernity'.[9] However, while Algeria is often seen as the exception in terms of its colonial political structure (an integral part of France as opposed to a protectorate, and without the sultanate system of neighbouring Morocco), *israélites* across Algeria, Morocco, and Tunisia were also seen as indigenous by the French administration. In the anthropological writings of the late nineteenth century (then closely aligned to French military bureaucracy; see Silverstein, 2004), Jews were depicted as descendants of tribes from first-century Palestine (see Cazès, 1888: 167–79), and as such they were seen as religiously distinct from Muslims, similarly uncivilized though somehow more amenable to assimilation. Significantly in this regard, under the Third Republic, Jewish-Muslim indigeneity was ruptured by the 'ethnocultural' Crémieux Decree of October 1870 (Savarèse, 2002: 79), which imposed French citizenship upon Jews across northern Algeria without taking account of their choice in the matter (Schreier, 2010: 49; Everett, 2017: 66). This is clear from the fact that, five years prior to the Crémieux Decree, voluntary indigenous naturalization (of Jews and Muslims) via the Napoleon III Senatus-Consultus of July 1865 saw less than 5 per cent take-up by town-dwelling Jewish populations (Nadjari, 2007: 83; Weil, 2003: 10). While the Crémieux Decree was not applied throughout the Maghrib, the colonial logic of associating indigeneity with abasement, and differentiating through religion, was prevalent in Tunisia and Morocco.

Samir Ben-Layashi and Bruce Maddy-Weitzman write that Moroccan Jewish engagement with 'the French, whom they had received with open arms in 1912 and whose culture they had quickly embraced', soon led to disillusionment as

> [the French] turned out to be virulently antisemitic. Ironically, it was their *dhimma* status, which they despised, which turned out to be a crucial

[8] Bruce Maddy-Weiztman (2011: 2) writes, 'Today, the term [Berber] is viewed by many Berbers as pejorative and, as their modern ethnonational consciousness deepens, is increasingly being supplanted by "Amazigh" [...] lit. "free man"'. See also Aïtel (2014: 9–15).

[9] See Valensi (2016: 106–10), Kenbib (2016: 56–58), and Allagui (2016: 61–62).

Introduction

factor in their survival. Indeed, the protection of the Sultan and other Muslim notables was solicited by some Moroccan Jews, a reversion to pre-colonial behavior. (Ben-Layashi and Maddy-Weitzman, 2010: 97)[10]

This situation was not so dissimilar to the Vichy period of 1942–1945, which saw the introduction of the Peyrouton laws (in which the Crémieux Decree was revoked) during which time, in mixed Jewish-Muslim neighbourhoods across Algeria, Muslim families aided Jewish ones to make ends meet (Stora, 2006), while in Morocco the Jews' *dhimma* status as Moroccan subjects under the monarchy granted them protection from Nazi persecution. The independences of 1956 and 1962, and the parallel bellicose history of the emergence of Israel means that today Jewish presence in Maghribi countries is marked by absence, and the memory of departure following decolonization has led to narratives of nostalgia on the one hand and trauma on the other. However, as we know, historical narratives cling to particular pasts and as such their traumatic vicissitudes and nostalgic reinventions redefine the historiography of the cultural dynamism that Jewish-Muslim interactions brought to bear. In the post-independence period, France came to have the largest Jewish and Muslim populations in Europe, most of whom are of North African heritage, suggesting a potential for meaningful exchange and differentiated solidarity (Moses and Rothberg, 2014) in the face of rising antisemitism and Islamophobia. Yet Jewish-Muslim 'relations' are often reduced to tensions surrounding the Israeli-Palestinian conflict as transposed and played out on French soil (Mandel, 2014), hence our emphasis on Jewish-Muslim *interactions* in an attempt to chart an alternative trajectory centred on performing cultures in North Africa and France.

Performing Cultures and Multilingualism

In this volume, we have deliberately chosen to focus on creative interactions between Maghribi Jews and Muslims on both sides of the Mediterranean, highlighting their interconnectedness across time. Drawing attention to interactions moves away from narratives of conflict, trauma, and nostalgia, which pit Jews and Muslims against each other or depict past experiences of relatively peaceful coexistence in irremediable terms. Interactions too are a way of distancing often empty notions of *vivre ensemble* (see Kiwan and Bharat, this volume), which can restrict relations to institutionalized interfaith dialogue limited to religious, political, and diplomatic contexts.

[10] *Dhimma* 'refers to the status of non-Muslim subjects in an Islamic polity, protected but restricted' (Zia-Ebrahimi, 2018: 321).

8 *Jewish-Muslim Interactions*

Similarly, token coexistence can involve official processes of forgetting as well as remembering, whereby 'non-dominant groups become absorbed into the Arab-Muslim male identity and get forgotten within the lexicon of unity and brotherhood' (Moreno Almeida, this volume; see also Perego, this volume). These processes are often based on one-dimensional golden age narratives and folklorization that emphasize conviviality. However, they simultaneously cover up moments of rupture in an attempt to keep the status quo free from criticism, and to maintain national unity. Here again, music, through its repetitive nature, plays a key role in reinforcing collective memory and in this case 'narratives of tolerance, religious moderation, and coexistence' (Moreno Almeida, this volume), but can also be a point of encounter or 'competitive exchange' (Glasser, this volume), challenging essentialist notions, binary oppositions, and official patriotic discourse. Similarly, street art can act as 'co-resistance' (Kiwan, this volume) and comedy as *rire-ensemble* (Bharat, this volume), de-essentializing creative models that satirically challenge the official language of peaceful coexistence and *vivre-ensemble* as well as conflictual models, with the potential to facilitate alternative discourses. Yet, as Nadia Kiwan (this volume) warns us, in their double 'representation', these artists must actively be on their guard against reductionism, political neutralization, and co-option into hegemonic institutional discourse, as they advocate transcultural complexity and multi-faith coexistence.

Moving away from narratives of conflict or harmony, the 'idiom of affinity', which recognizes historical 'non-hierarchical forms of difference' between Maghribi Jews and Muslims, questions the emphasis on assimilationist models, for example the aforementioned imposition of French citizenship on Algerian Jews under colonial rule, and their later recasting as *pieds-noirs* following decolonization (see Glasser, this volume).[11] The re-configuration reflected in this volume displaces a Franco-centric approach, by establishing

[11] The term *pied-noir* refers to former European *colons* or settlers and their black boots, and has come to represent a community of French citizens who lived in colonial Algeria, and left for France *en masse* during and following decolonization. Their conflation with Algerian Jews is thus a politically charged and highly problematic one. As Gil Anidjar writes, '[i]t is one of the ironies of history that Algerian Jews are often considered to be descendants of French *colons*, indeed *pieds-noirs*, rather than as what they historically were in their majority, namely, indigenous Jews of Algeria' (2003: 165, n. 5). Similarly rejecting the '*pied-noir* Jew' designation as an anomaly, Robert Watson positions Jews in Algeria 'in between Algerian Muslims and *pieds-noirs*, forever attached to both, but reducible to neither' (2011: 1). See also Mandel (2014: 43, 56) and Moumen (2010: 61, 65–66).

Introduction

9

a wider historical and geographical context of influence, engagement (or borrowing), and shared tradition between Muslims and Jews across the Maghrib, from before the Ottoman era to post-colonialism, with an ongoing legacy on both sides of the Mediterranean. As Jonathan Glasser notes, 'music [...] is one way in which Jews have remained present even in their physical absence', a present absence explored by French-Moroccan filmmaker Kamal Hachkar (see Bahmad and Kartowski-Aïech, this volume). Marianne Hirsch's concept of 'affiliative memory' (2008: 114) – here interpreted as a connection to the history of Jewish-Muslim interactions in the Maghrib through proxy (or approximation) as opposed to direct experience – complements the notion of affinity, with an emphasis on differentiation and rehabilitation.

Scholars and artists alike, represented within this volume, are actively involved in re-pluralizing the histories of North Africa, including the history of music (see Davis, this volume), the history of art (see Gillet, this volume), and the history of comedy (see Perego, this volume), as well as creative works such as film where music plays a prominent role (see Paloma Elbaz, this volume). Rather than a cameo, music is a 'medium of relatedness' (Glasser, this volume) in past experience and (affiliative) memories of Jewish-Muslim interactions in the Maghrib. Yet forgetting persists, and often in the form of omission, as is evident in patriotic Moroccan rap and post-independence Algerian comics (see Moreno Almeida and Perego, this volume), in favour of golden age narratives or unifying nationalistic rhetoric. At the same time, silence can be just as powerful a presence as music, notably in film, particularly when addressing the absence of Jewish communities, as is the case with Hachkar's *Tinghir-Jérusalem: Les échos du Mellah* ['Tinghir-Jerusalem: Echoes from the Mellah'] released in 2011 (see Bahmad, this volume). Art, meanwhile, expresses cultural phenomena without words, providing an alternative site of abstraction and emancipation for both Jews and Muslims, albeit often constrained by colonial authorities and dominated by a Western elite (see Gillet, this volume) or more recent institutionalized narratives of *vivre-ensemble* (see Kiwan, this volume).

In a similar way to how the interactional allows us to circumvent the institutionalization of interfaith relations in political and religious spheres by exploring the dynamics of what is produced in the crucible of the Jewish-Muslim *rencontre* in performance culture, this volume also resists 'disciplinary thinking' (Rothberg, 2018: 115), acknowledging the overlap between postcolonial studies and Jewish studies in particular (Cheyette, 2017). Thus, we have consciously included contributions by scholars working across and beyond disciplines. In what follows, this can be read in those creative tensions that emerge between not only postcolonial and Jewish studies but also history, ethnography, memory studies, cultural studies, and

transnational French studies. Moreover, many of these scholars are themselves engaged in activism, mediation, and artistic output in the realm of Jewish-Muslim interactions 'in a bid to engage with the world beyond disciplines' (Cheyette, 2009: 2). As Karen Till writes: 'Rather than uncovering hidden histories, artist-scholars challenge dominant regimes of memory by creating spaces that revisit historical social relations and imagine new possibilities' (2008: 104). This is a volume that, although written predominately in English, has a multilingual thread running throughout, including original quotes in French, Amazigh, Hebrew, and various Arabics, with translations into English. We have therefore had to make choices, in particular regarding the use of different ways of transcribing Arabic and which script (Latinate or Arabic) to use. In order that the reader, whether an Arabic-reader or not, be confronted by another script, through its varying aesthetics, different movement (right to left) and structure (root) – leading to a kind of cultural–linguistic *dépaysement* to borrow the Meddebian phrase (1987) – we have maintained Arabic script where possible. However, because many of us work with different Arabics – spoken, Darija, sung, Judeo-Arabic and so on – it is not always possible (or even desirable, in remaining faithful to the source text) to 'maintain' the Arabic script. Songs that are not available in Arabic script online or on record are transcribed, and the way that we are trained to do this (at least in places like SOAS, London, and INALCO, Paris) is by transcribing into something approaching phonetic script. Christopher Silver and Cristina Moreno Almeida (this volume), who deal with songs sung but not necessarily written down, transcribe these using an interna-tionally recognized (IJMES standard) transliteration of either Fusha or Darija, although, even then, for record titles in Silver's contribution, we decided to keep the way in which the Arabic appears in Latin script on many of the covers. Moreover, the songs themselves, for example those of Messika, were in local Arabic (for Messika, this was the Arabic of Tunis) but, as Silver points out, Mizrahi's Arabic was a mix of Levantine and others. Meanwhile, Moreno Almeida transcribes urban Darija or *Casaoui* (from Casablanca) rap songs. All of this points to the fact that, in the Maghrib, the oral repertoire is still an important source of cultural production, notwithstanding the politics that surrounds language use and its appearance in the public domain, whether French, Modern Standard Arabic, or Darija. Miliani and Everett (this volume) touch on this in their passage about Marie Soussan's inability to read Arabic; members of the French intelligentsia visiting Algiers in the 1930s expected the 'only Jewish actress in Arabic theatre' to be an Arabic virtuoso, but, as Miliani and Everett point out, many actors who could not read learnt by rote. Such was the force of the colonial situation.

The Question of the Arab-Jew

Perhaps it is no coincidence, given the synergies in our research that crosses the socio-literary divide in its engagement with the concept and lived reality of 'Arab Jews', that we as co-editors met at an Ella Shohat event on 'the invention of Judeo-Arabic' (2017b) at SOAS, London. Shohat has been influential not only in probing the limits of the post-colonial, including in the French-speaking world (1992; see also Shohat and Stam, 2012a; 2012b), but also in conceptualizing the hyphenated identity of 'Arab-Jew' as an alternative to the term 'Mizrahi' (2017a). In the North African context, anti-colonial Tunisian Jewish writer Albert Memmi asserted in the 1980s, 'J'ai contribué à lancer il y a quelques années la formule: « Je suis un juif-arabe », qui a surpris et irrité; elle ne voulait rien dire de plus: nous sommes d'une même souche et nous partagerons dorénavant un destin' (1985: 43).[12] Emily Gottreich (2007; 2008) has historicized the Arab Jew against the geopolitical backdrop of North Africa, while Gil Anidjar (2003; 2008) has discussed the semantics of the Jew and the Arab – and the Jew and the Muslim – together, particularly in relation to Europe and colonialism. Meanwhile, Esther Benbassa has identified a 'jeu de miroirs' ['play of mirrors'] surrounding Arab Jewish suffering (2007: 192 [2010: 137]), a leitmotif within the current 'refugee' movement for Arab Jewish reparations resulting in the 2010 Knesset law.[13]

However, in this refocus on Arab-Jews, it is important to also remember Jewish-Amazigh connections, which have been temporarily lost not only in the 'collective imaginary' of North African countries – due in part to post-independence Arabization and Arabo-Islamic cultural campaigns (see Moreno Almeida, this volume) – but also in the emphasis on Arab-Jews in recent scholarship. Rehabilitating Jewish-Amazigh identity alongside Arab-Jewish identity complicates notions of hybridity to reveal plurality, and goes further back than al-Andalus, which is often treated

[12] 'A few years ago, I contributed to debate around the self-declaration, "I am an Arab-Jew", which surprised some and irritated others; I meant nothing by it but this: we are have the same origins and we share the same destiny'. See Vince (2018: 107–8).

[13] 'In February 2010 the issue did gain recognition in Israel, with the legislation of the "Law for Preservation of the Rights to Compensation of Jewish Refugees from Arab countries and Iran", passed by the Knesset'. Israel Ministry of Foreign Affairs. 3 April 2012. Available at: https://mfa.gov.il/MFA/ForeignPolicy/Peace/Guide/Pages/Jewish_refugees_from_Arab_and_Muslim_countries-Apr_2012.aspx (consulted on 2 June 2019).

as a mythological (European) foundation or starting point displaced from the African continent. At the same time, seemingly paradoxical 'Jewish-Muslim' identities, such as that embodied by adopted Turkish-Moroccan rapper Hoofer, and 'Christian-Muslim' identities, such as that embodied by French Lebanese-Moroccan street artist Combo, are perhaps even more marginalized and must therefore also be grappled with (see Moreno Almeida and Kiwan, this volume). Moreover, we must not forget the role that a significant minority of Jews played in promoting Arab nationalism, and individual Maghribi nationalisms, contrary to narratives of apathy or opposition (although these also have their place), a role that comes to the fore in the history of music. As Silver (this volume) notes, 'the Jewish-Muslim relationship, as expressed through music, was sometimes at its most dynamic when it intersected and engaged with nationalism' across potential religious and class divides. While French colonial and protectorate officials attempted to silence anti-colonial nationalist movements across the Maghrib, Jewish singers raised their voices in patriotic solidarity, particularly in the interwar years, when Jews and Muslims collaborated to facilitate the spread of nationalist records by Jewish cheikhs in spite of sanctioned censorship. Asserting loyalty to the nation is important for Jewish musicians who chose to remain in the Maghribi countries of their birth, particularly for Jewish Moroccan musicians, while music remains a 'tool for cultural diversity' (Paloma Elbaz, this volume; see also Moreno Almeida, this volume).

Over the last half decade, there has been a growing cultural expression of Arab-Jewish and Jewish-Amazigh identity, particularly in the Middle East and North Africa. The Israeli musical duo Amit Hai Cohen and Neta Elkayam, who have reappropriated the North African Andalusi and chaâbi (popular) repertoires of various Jewish musicians from the 1930s onwards and play to pan-Mediterranean audiences (from Morocco to Israel), are one illustration of this. Hachkar's aforementioned film *Tinghir-Jérusalem: Les échos du Mellah*, which features Elkayam's grandmother, and its sequel *Dans tes yeux, je voix mon pays* ['In Your Eyes, I See my Country'] (2019), which traces Elkayam's rise to stardom and return to Morocco, further confirm this trend at a transnational level (Bahmad and Kartowski-Aïach, this volume). Simultaneously, however, the *Charlie Hebdo* and kosher supermarket killings in January 2015 have acted for many as a further reinforcement of a separation between Jews and Muslims. Moreover, although 'l'arabe' ['the Arab'] and 'le juif' ['the Jew'] are depicted as separate categories in the stage name of contemporary French stand-up duo Younes et Bambi, 'they often play with the audience's perception of who is the Jew and who is the Arab', suggesting interconnectedness, if not interchangeability (Bharat, this volume).

Introduction 13

This cultural expression keys into a recent resurgence of interest in the history of Jews and Muslims in North Africa and the Middle East, particularly in France, with the launch of the *Histoire partagée* ['Shared History'] series as part of *Projet Aladin: Le pont de la Connaissance entre Juifs et Musulmans* ['Project Aladdin: The Bridge of Understanding between Jews and Muslims']. Following in the footsteps of Abdelwahab Meddeb and Benjamin Stora, who co-edited *Histoire des relations entre juifs et musulmans des origines à nos jours* (2013), the series has recently published *Juifs et musulmans au Maroc* (2016), *Juifs et musulmans en Tunisie* (2016), *Juifs et Musulmans en Algérie* (2018), and *Juifs et musulmans en Palestine et Israël* (2016).[14] The present volume approaches this history from an alternative angle, mapping a mnemonic chronology of creative encounters between Jews and Muslims through artistic influence, collaboration, and performance. The time period, from the early twentieth century to the present day, encompasses France's attempts to emancipate and assimilate Maghribi Jews and Muslims in different ways under colonial rule, followed by decolonization that saw mass departures from North Africa, ongoing conflict in the Middle East, and rising antisemitism and Islamophobia across the Western world, yet these conflicts are in the background; performance takes centre stage.

Accents, Affiliations, and Exchange

This volume is split into two sections, which are in communication with each other. The first section, 'Accents, Affiliations, and Exchange', explores the concepts of affinity and familiarity, relation and relationality, cultural entrepreneurship and changing social roles, noting points of emphasis and connection between Jews and Muslims navigating the commercial landscape of film, theatre, and music across the Maghrib and France. A 'continuum of Judeo-Arab Muslim affiliation', apparent in Moroccan Jewish novelist Edmond El Maleh's *Mille ans, un jour* ['A Thousand Years, One Day'] (Siegel, 2017: 17), can be traced in Tunisian Jewish filmmaker Albert Samama's documentaries that deal with conflict, modernity, and finding a place in the world. The notion of belonging comes to the fore in Morgan Corriou's examination of Samama and 'his ability to play with different registers of belonging': 'He is employed as

[14] The guided tours at the Institut du monde arabe ['Arab World Institute'] (in partnership with the Musée d'Art et d'Histoire du Judaïsme ['Museum of the Art and History of Judaism']) was also called 'Juifs et musulmans, une histoire partagée' ['Jews and Muslims: A Shared History']. See https://www.imarabe.org/fr/visites-ateliers/juifs-et-musulmans-une-histoire-partagee (consulted on 12 September 2019).

14 *Jewish-Muslim Interactions*

a Tunisian by French film companies, mistaken for an Italian spy by Tunisians who fail to attack him, and presents himself as a "Frenchman in Tunis" in front of the Tripolitan fighters'. This malleability of identity runs throughout the volume, with Jews often being mistaken for Muslims or vice versa, and French assimilationist policies complicating what it means to have a national identity under colonial rule.

As mentioned above, Glasser suggests affinity as a way of framing Jewish-Muslim interactions and 'closeness' through musical influence, collaboration, and 'competitive exchange'. In highlighting 'commonality' and 'musical intimacy' alongside non-hierarchal forms of difference and relationality, this provides an alternative to polemics on the one hand and ambivalence on the other. Cleaving, with its double meaning of holding together and splitting apart, might be an appropriate concept to think through these creative tensions further, particularly as we consider what it might mean to 'connect the disconnect' in Vanessa Paloma Elbaz's chapter, which features in the following section. As Glasser writes, 'linkage and separation are [...] indissociable', a kind of coalescence whereby cosmopolitanism and nationalism, the global and the local, are also 'mutually constitutive', to adopt Silver's phrasing. Indeed, in his analysis of Tunisian Jewish superstar Habiba Messika's legacy, Silver examines how the fact that Jewish and Muslim communities 'were coalescing around the increasingly nationalist tenor of her music' was perceived as a threat to the French authorities in the interwar years, during which 'Jews and Muslims crafted, recorded, performed, passed around, and consumed *nationalist* music together'. Focusing in on high-profile Jewish musicians like Habiba Messika, alongside Lili Labassi and Salim Halali, he also draws attention to the on-the-ground 'Jewish-Muslim network of merchants and peddlers' as well as the cross-confessional, cross-class audiences who bought records and attended concerts across the Maghrib.

Similarly, Miliani and Everett speak of a 'cultural convergence' between Jewish and Muslim artists during the interwar years of colonial Algeria; drawing attention to Algerian Jewish actress Marie Soussan, they highlight her performative affiliation and romantic liaison with Muslim actor Rachid Ksentini. Meanwhile, through tracing the development of folksong within mixed Muslim-Jewish communities and exploring the 'absent presence' of Jews in its historiography, Ruth Davis reveals how both Jewish and Muslim musicians formed Tunisian cultural identity through popular music, and how the Rashidiyya Institute in particular brought them together. Indeed, along with Glasser and Silver, Davis reminds us of music's ability to form connections, specifically between Jews and Muslims across the Maghrib, a theme picked up on by Paloma Elbaz in relation to film soundtracks. By way of contrast, Fanny Gillet highlights the issues surrounding intercommunal

Introduction

solidarity in the art world across Algeria and Tunisia from 1940 to 1960, revealing a 'complex hierarchical relationship' related to the 'triangulation between colonial authorities, Muslim minorities, and Jewish elites'.

Absence, Influence, and Elision

Speaking of Maghribi Jews, with a particular focus on Morocco, Lawrence Rosen writes evocatively, 'They have become a phantom memory, the felt presence of an absent limb' (2002: 103). This spectral presence of absence – or 'absent presence' (Davis, this volume) – in the wake of Jewish departure from North Africa is explored in the second section, which focuses on taboos, (unacknowledged) influences, and elision in both senses of the term: omission and merging. Rosen's focus on Morocco is not incidental; this country and its (former) Jewish population is very much present in the imaginary of contemporary scholars of North Africa across the disciplinary spectrum. This is because Morocco, which has the largest Jewish population in North Africa, albeit very small, is a country that partially relies on the financial streams that tourism provides. Since the 1960s, Morocco has been extremely open to research and diasporic tourism, including Jewish pilgrimage to the tombs of a number of saints. This has resulted in something of a Moroccan prevalence in research on anything Jewish and Maghribi. Such a situation is reinforced by the active role that André Azoulay, senior advisor to the King, has taken in trying to shape the regional history and continuation of relations between Jews and Muslims. This material reality, of which we as editors are fully aware, goes some way in explaining the Moroccan hue in the second part of our volume. Nevertheless, from outside of such a Moroccan purview, Elizabeth Perego highlights neglected legacies in her analysis of *bandes dessinées* in post-independence Algeria, which leave out any reference to intercommunal Muslim-Jewish comedic traditions in their depiction of a homogenous, exclusively Muslim, national community. Similarly, Moreno Almeida interrogates patriotic discourse, although conversely focusing on narratives of religious co-existence in Morocco as propagated in patriotic rap. Paloma Elbaz continues the exploration of music, although with a variation on the theme, as she reveals its central role in Moroccan films that portray relationships between Jews and Muslims, including romantic ones, as almost possible, in spite of the former's supposed 'foreignness'. Indeed, music in various forms (traditional Andalusi, popular chaâbi, contemporary rock) reinforces their shared *marocanité* and joins the two together, allowing 'Jewish and Muslim men and women to connect across established communal divides'.

16 *Jewish-Muslim Interactions*

By contrast, Jamal Bahmad focuses on the effective (and affective) use of silence in Hachkar's debut documentary film, *Tinghir-Jérusalem: Les échos du Mellah* ['Tinghir-Jerusalem: Echoes of the Mellah'], which features interviews with Muslim residents of Tinghir who affectionately remember their former Jewish friends and neighbours. Drawing from Gilles Deleuze and Félix Guattari, Bahmad demonstrates how silence plays a key role in the film as it highlights the felt absence of the lost Jewish communities of Morocco and the emotional response of those who remember them. In her analysis of the sequel to *Tinghir-Jérusalem, Dans tes yeux, je vois mon pays* ['In Your Eyes, I See my Country'], Miléna Kartowski-Aïach explores the notion of forbidden memory and the potential of political song to form a bridge between Morocco and Israel. In this way, music becomes a territory of return and an opportunity for homemaking if not homecoming (Boym, 2007) – an architecture of memory, or 'maison de mémoire' (Bahloul, 1992; 1996).

Conversely, in his murals, French street artist 'Combo Culture Kidnapper', himself of mixed Lebanese-Moroccan heritage, suggests that *aliyah* need not be permanent, and provocatively advocates return migration (*verida*) to France.[15] Kiwan interrogates the portrayal of 'interfaith communities of friendship' in Combo's aesthetics that, while offering a subversive 'critique of categorization and othering', risks falling into reductionist stereotypes even as it aims to turn these on their head. Yet his street art nevertheless poses a challenge to 'ambient discourse around the polarization of French Jews and Muslims', while at the same time acknowledging tensions between them through the use of irony. Similarly, Adi Bharat demonstrates how stand-up comedy duo Younes et Bambi challenge the conflictual model of Jewish-Muslim relations in France, but tread a fine line between essentializing and satirizing, reusing stereotypes (Rosello, 1998: 9) and highlighting their constructed nature, while being careful not to reinforce them in their sharp critique of antisemitism and racism from within the skewed logic of this discourse. These two forms of co-resistance and counter-discourse are encapsulated in the subversive greeting 'Shalom Alikoum' ['Peace be with you'].[16]

In a moving afterword – both emotionally and in the sense of oscillating between past, present, and future, as well as between French and English (interspersed with references to Arabic and Hebrew) – novelist Valérie Zenatti

[15] Aliyah comes from the Hebrew עליה or עליות, meaning 'ascent' and is used to describe Jewish immigration to Israel.

[16] This phrase, which mixes Hebrew and Arabic, appears both in Combo's artwork and Younes et Bambi's comedy sets. See https://www.combo-streetart.com/gallery/coexist-1/ (consulted on 11 September 2019).

Introduction 17

maps the affective cartography of France-born Jewish Maghribiness against the stages of growing up, while advocating a dialogic approach to memory, reinforced by Everett's translation.[17] In an unexpected twist, it is an artistic gesture of dialogue between Gaza and Jerusalem that allows Zenatti to visit her parents' native Constantine for the first time, as she traces a memorial landscape: 'On peut regarder en arrière puisque l'on est allé voir ailleurs'.[18] As Aleida Assmann writes, 'in order to move forward, we have to make a detour via the past' and, when it comes to Maghribi Jewish-Muslim interactions in the realm of performance, this is a past full to the brim with creative exchanges across communal, linguistic, and cultural spheres, '[toute une] matière vivante' ['living material'] (Zenatti; Everett, this volume) that spills over into the present moment of movement.

Works Cited

Ahmida, Ali Abdullatif. 2000. 'Introduction'. In Ali Abdullatif Ahmida (ed.), *Beyond Colonialism and Nationalism in the Maghrib*. New York: Palgrave Macmillan: 1–13.

Aïtel, Fazia. 2014. *We Are Imazighen: The Development of Algerian Berber Identity in Twentieth-Century Literature and Culture*. Florida: University of Florida Press.

Allagui, Abdelkrim. 2016. *Juifs et musulmans en Tunisie: Des origines à nos jours*. Paris: Tallandier.

Allouache, Merzak (dir.). 2003. *Chouchou*.

Anidjar, Gil. 2003. *The Jew, the Arab: A History of the Enemy*. Stanford: Stanford University Press.

——. 2008. *Semites: Race, Religion, Literature*. Stanford: Stanford University Press.

Assmann, Aleida. 2014. 'Dialogic Memory'. In Paul Mendes-Flohr (ed.), *Dialogue as a Trans-disciplinary Concept: Martin Buber's Philosophy of Dialogue and its Contemporary Reception*. Berlin: De Gruyter: 199–214.

Attias, Jean-Christophe, and Esther Benbassa. 2002 [2001]. *Les Juifs ont-ils un avenir?* Paris: Hachette Littérature.

Bahloul, Joëlle. 1992. *La Maison de mémoire. Ethnologie d'une demeure judéo-arabe en Algerie (1937–1961)*. Paris: Métailé.

——. 1996. *The Architecture of Memory: A Jewish-Muslim Household in Colonial Algeria, 1937–1962*. Trans. by Catherine Du Peloux Ménagé. Cambridge: Cambridge University Press.

17 See Assmann (2014).
18 'We can look back because we have looked elsewhere'. See Vince (2019b).

Benbassa, Esther. 2007. *La Souffrance comme identité*. Paris: Fayard.

——. 2011. *Suffering as Identity: The Jewish Paradigm*. Trans. by G. M. Goshgarian. London and New York: Verso.

Ben-Layashi, Samir, and Bruce Maddy-Weitzman. 2010. 'Myth, History and Realpolitik: Morocco and its Jewish Community'. *Journal of Modern Jewish Studies* 9.1: 89–106.

Boym, Svetlana. 2007. 'Nostalgia and its Discontents'. *Hedgehog Review* 9.2: 7–18.

Cazès, David. 1888. *Essai sur l'histoire des israélites de Tunisie*. Paris: A. Durlacher.

Cheyette, Bryan. 2009. 'Jewish/Postcolonial Diasporas: On Being Ill-disciplined'. *Wasafiri* 24.1: 1–2.

——. 2017. 'Supersessionist Thinking: Old and New, Jews and Postcolonialism, the Ghetto and Diaspora'. *Cambridge Journal of Postcolonial Literary Inquiry* 4.3: 424–39.

Cohen, Amnon. 2016. *Juifs et musulmans en Palestine: Des origines à nos jours*. Paris: Tallandier.

Elmaleh, Gad (dir.). 2009. *Coco*.

Everett, Samuel. 2017. 'The Algerian Works of Hélène Cixous: At the Triple Intersection of European, North African and Religious Nationalisms'. *International Journal of Politics, Culture, and Society* 30.2: 63–80.

——. 2020. 'Une Ambiance Diaspora: Continuity and Change in Parisien Maghrebi Imaginaries'. *Comparative Studies in Society and History* 62.1: 1–21.

Gottreich, Emily. 2007. *The Mellah of Marrakesh: Jewish and Muslim Space in Morocco's Red City*. Bloomington: Indiana University Press.

——. 2008. 'Historicizing the Concept of "Arab Jews" in the Maghrib'. *Jewish Quarterly Review* 98.4: 433–51.

Hachkar, Kamal (dir.). 2011. *Tinghir-Jérusalem: Les échos du Mellah*.

——. (dir.). 2019. *Dans tes yeux, je vois mon pays*.

Hannoum, Abdelmajid. 2001. *Colonial Histories, Postcolonial Memories: The Legend of the Kahina, a North African Heroine*. Portsmouth: Heinemann.

Harrison, Olivia. 2018. 'Maghreb as Method'. *boundary 2*. Available at: https://www.boundary2.org/2018/12/olivia-c-harrison-thinking-the-maghreb-with-said-and-khatibi/ (consulted on 19 October 2019).

Hirsch, Marianne. 2008. 'The Generation of Postmemory'. *Poetics Today* 29.1: 103–28.

Hirschberg, Zeev. 1963. 'The Problem of the Judaized Berbers'. *The Journal of African History* 4.3: 313–39.

Kenbib, Mohammed. 2016. *Juifs et musulmans au Maroc: Des origines à nos jours*. Prefaces by Michel Abitbol and Abdou Filali-Ansary. Paris: Tallandier.

Kleppinger, Kathryn, and Laura Reeck (eds.). 2018. *Post-Migratory Cultures in Postcolonial France*. Liverpool: Liverpool University Press.

Introduction

Kosansky, Oren. 2016. 'When Jews Speak Arabic: Dialectology and Difference in Colonial Morocco'. *Comparative Studies in Society and History* 58.1: 5–39.

Lorcin, Patricia M. E. 2012. 'Manipulating Elissa: The Uses and Abuses of Elissa Rhaïs and Her Works'. *The Journal of North African Studies* 17.5: 903–22.

Maddy-Weiztman, Bruce. 2011. *Berber Identity Movement and the Challenge to North African Studies*. Texas: University of Texas Press.

El Maleh, Edmond. 1986. *Mille ans, un jour*. Grenoble: Éditions La Pensée Sauvage.

Mandel, Maud. 2014. *Muslims and Jews in France: History of a Conflict*. Princeton: Princeton University Press.

Marouf, Nadir. 2002. 'Le système musical de la San'a ou le paradigme de la norme et de la marge (Hommage à Pierre Bourdieu)'. *Horizon Maghrébins* 47: 8–24.

Meddeb, Abdelwahab. 1987. *Talismano*. Paris: Sindbad.

Meddeb, Abdelwahab, and Benjamin Stora. 2013. *Histoire des relations entre juifs et musulmans des origines à nos jours*. Paris: Albin Michel.

Memmi, Albert. 1985. *Ce que je crois*. Paris: Grasset.

Moses, A. Dirk, and Michael Rothberg. 2014. 'A Dialogue on the Ethics and Politics of Transcultural Memory'. In Lucy Bond and Jessica Rapson (eds.), *The Transcultural Turn: Interrogating Memory Between and Beyond Borders*. Berlin: De Gruyter: 29–38.

Moumen, Abderahmen. 2010. 'De L'Algerie à la France. Les conditions de départ et d'accueil des rapatriés, pieds-noirs et harkis en 1962'. *Matériaux pour l'histoire de notre temps* 3.99: 60–68.

Nadjari, David. 2007. 'L'émancipation à « marche forcée »: les Juifs d'Algérie et le décret Crémieux'. *Labyrinthe* 28: 77–89.

Obadia, Lionel. 2013. 'De l'islam au judaïsme: Brèves réflexions anthropo-historiques et hyper-virtuelles autour d'une « impensable conversion »'. *Histoire, monde et cultures religieuses* 28.4: 97–114.

Quemener, Nelly. 2013. 'Stand-up! L'humour des minorités en France'. *Terrain* 61: 129–40.

——. 2014. *Le Pouvoir de l'humour. Politique des repésentation dans les médias en France*. Paris: Armand Collin.

Rosello, Mireille. 1998. *Declining the Stereotype: Ethnicity and Representation in French Cultures*. Hanover, NH and London: University Press of New England.

Rosen, Lawrence. 2002. *The Culture of Islam*. Chicago: University of Chicago Press.

Rothberg, Michael. 2018. 'For Activist Thought: A Response to Bryan Cheyette'. *Cambridge Journal of Postcolonial Literary Inquiry* 5.1: 115–22.

Savarèse, Eric. 2002. *L'Invention des pieds-noirs*. Paris: Séguier.

Schreier, Joshua. 2010. *Arabs of the Jewish Faith: The Civilizing Mission in Colonial Algeria*. New Brunswick: Rutgers University Press.

Seddon, David. 2000. 'Dreams and Disappointments: Postcolonial Constructions of "The Maghrib"'. In Ali Abdullatif Ahmida (ed.), *Beyond Colonialism and Nationalism in the Maghrib: History, Culture, and Politics*. New York: Palgrave Macmillan: 197–232.

Shohat, Ella. 1999. 'The Invention of the Mizrahim'. *Journal of Palestine Studies* 29.1: 5–20.

——. 2017a. *On the Arab-Jew, Palestine, and Other Displacements: Selected Writings of Ella Shohat*. London: Pluto Press.

——. 2017b. 'The Invention of Judeo-Arabic'. *Interventions* 19.2: 153–200.

Shohat, Ella, and Robert Stam. 2012a. 'French Intellectuals and the Postcolonial'. *Interventions* 14.1: 83–119.

——. 2012b. 'Whence and Whither Postcolonial Theory?' *New Literary History* 43.2: 371–90.

Siegel, Irene. 2017. 'A Judeo-Arab-Muslim Continuum: Edmond El Maleh's Poetics of Fragments'. *PMLA* 132.1: 16–32.

Silverstein, Paul. 2004. *Algeria in France: Transpolitics, Race and Nation*. Bloomington: Indiana University Press.

Stillman, Norman. 1979. *The Jews of Arab Lands: A History and Sourcebook*. Nebraska: The Jewish Publication Society.

Stora, Benjamin. 2006. *Les Trois exils: Juifs d'Algérie*. Paris: Stock.

——. 2015. *Les Clés retrouvées: une enfance juive à Constantine*. Paris: Stock.

Tedghi, Joseph. 2015. 'Mzab'. *Encyclopédie berbère*. Available at: http://journals. openedition.org/encyclopedieberbere/681 (consulted on 17 July 2019).

Till, Karen. 2008. 'Artistic and Activist Memory-Work: Approaching Place-Based Practice'. *Memory Studies* 1.1: 99–113.

Valensi, Lucette. 2016. *Juifs et musulmans en Algérie: VIIe–XXe siècle*. Paris: Tallandier.

Vince, Rebekah. 2018. 'The (Im)possibility of Jewish-Palestinian Identity in Hubert Haddad's Palestine'. *Francosphères* 7.1: 103–20.

——. 2019a. 'Francosphères: Going Around in Creative Circles'. *Francosphères* 8.2: i–iv.

——. 2019b. 'Pulled in All Directions: the Shoah, Colonialism and Exile in Valérie Zenatti's *Jacob, Jacob*'. In Dirk Göttsche (ed.), *Memory and Postcolonial Studies: Synergies and New Directions*. Oxford and New York: Peter Lang: 235–53.

Watson, Robert. 2011. 'Memories (Out) of Place: Franco-Judeo-Algerian Autobiographical Writing, 1995–2010'. *The Journal of North African Studies* 17.1: 1–22.

Weil, Patrick. 2003. *Le Statut des musulmans en Algérie coloniale: une nationalité française dénaturée*. Florence: European University Institute.

Zia-Ebrahimi, Reza. 2018. 'When the Elders of Zion Relocated to Eurabia: Conspiratorial Racialization in Antisemitism and Islamophobia'. *Patterns of Prejudice* 52.4: 314–37.

I. Accents, Affiliations, and Exchange

Albert Samama, a Tunisian Filmmaker in the Ottoman Empire at War (1911–1913)

Morgan Corriou

Translated by David Motzafi-Haller

One day in 1912 in downtown Tunis, a young Qur'anic student steps into a cinema. The excited young man, led by his cousin, is about to watch a motion picture for the first time. To his astonishment, he notices that the two of them are the only Muslims in the audience. The projection starts with an Italian newsreel on the war in Ottoman Tripolitania, which he finds grossly biased. Indignant, he leaps from his seat, protesting loudly, and is soon forced out by the other spectators, angered by the interruption.[1] Many years later, the young man, Ahmed Tewfik El-Madani, would describe that day as a key moment in the development of his political awareness. Reconstructed newsreels were a common feature at the time, but the question of how a colonial conflict is represented on screen is explicitly raised here by a novice viewer. This may, of course, be an imprecise rendering (El-Madani's memoirs were written in the 1970s).

[1] 'Ce film n'était pas réaliste. Des acteurs et actrices italiens, vêtus d'habits arabes grotesques et montant des ânes et des chameaux, fuyaient, loufoques et apeurés devant les Italiens. Je ne pus me contrôler et me retrouvai debout à hurler: C'est faux! C'est de la falsification! C'est de la tromperie!' ['This film was not realistic. Italian actors and actresses, dressed in grotesque Arab garbs and riding donkeys and camels, scattered in terror before the Italians. I couldn't control myself and found myself standing up and screaming: "This is wrong! It's a lie, a sham!"'] (El-Madani, 1989: 65).

The episode nevertheless attests to the significance of the Italo-Turkish war to both the history of Arab nationalism and to the broader struggle over image in the Maghrib. The conflict constitutes, in fact, one of the earliest political claims within the realm of cinema in Tunisia under the French protectorate.

Only one contemporary image from the war would eventually etch itself into the collective memory: that of the hanged men of Tripoli (British Pathé, 2014). While contemporary media coverage of the conflict leaned heavily in favour of Italy – despite some expressions of indignation at the brutality of the Italian repression, there is a certain irony, and, no doubt, poetic justice in the fact that history has ultimately retained the least favourable image of the Italian aggressor. The scene is immortalized by film: at the time, there were no less than four filmmakers in Tripoli – another example of this informational imbalance (Zaccaria, 2003: 67–68). On the Ottoman side, however, one Tunisian Jewish filmmaker had also recorded the hostilities. Upon his return to Tunis, he witnessed the consequences of the conflict for his native country (especially during the trial that followed the riots around the Jellaz cemetery). A few months later, he packed his bags and left for the Balkans, where war was also raging. A rare indigenous filmmaker, Albert Samama, also known as Samama-Chikli, is an exceptional figure, an outlier in the history of early film in the Arab world.

Historians have often retained from his lengthy career just two fictional films he released in the early 1920s, *Zohra* and *Aïn-el-Ghezal ou La fille de Carthage*, both not without a tinge of exoticism. In reality, Samama crossed the boundaries between colonizer and colonized, personifying in many ways the phenomenon of 'métis de la colonisation' ['half-breed of colonization'] described by Albert Memmi (2002 [1957]: 19; 1991: xvi). It is through the prism of the prevalent idea of cultural intermediary, a role commonly – and all too hastily – associated with Maghribi Jews, that I wish to revisit Samama's cinematography here. Archives recently acquired by the Cineteca di Bologna afford us a broader perspective on his oeuvre. In this chapter, I have chosen to focus on his work from the period for which he is the least well-known, but that is also the richest in possibilities of his career, that is the period before the First World War. At a time when film distribution channels virtually did not exist and film production was still very limited, the dichotomy of centre and periphery held little sway. It is only with the advent of feature film and the establishment of several hegemonic centres of cinematic production and distribution that this dichotomy has emerged more acutely (Braun and Keil, 2010: 125–29). It is in this context of rapid evolution and formation of the early cinematic landscape that we will examine the place of newsreels

covering the Maghrib and the role of a filmmaker from a colonized country in the global film market.[2]

Towards a Professionalization of the Filmmaker's Work

Albert Samama was born into an upper-class Jewish Tunisian family in 1872, some ten years before the establishment of the French protectorate. He did, however, have French citizenship, acquired by his father, who was a banker. Samama had had a turbulent youth, and his inventive exploits often made their way into local newspapers. He also distinguished himself from a young age through his scientific curiosity and a passion for new technologies that would lead him to experiment with photography, X-rays, and eventually, of course, filmmaking.[3] This fascination with modern objects was not uncommon among Maghribi Jews who had chosen to align themselves with France. For them, this was a token of their commitment to assimilation with the colonizers, as is illustrated by the enthusiastic way that Tunisian Jewish merchants became involved in the most revolutionary products of the time (motorcars, radios, refrigerators, etc.).[4] We find an early reference to cinematic invention in a letter by Samama dated August 1897, in which he attempted to acquire some films in France.[5] He then organized a series of screenings across the country with his mobile cinema, the Cinemato-Chikli.[6]

[2] I would like to express my gratitude to Giuliana Cerabona (Cineteca Di Bologna) who guided me in the exploration of this hitherto unclassified fund. I also extend warm thanks to Agnès Berthola (Gaumont Pathé Archives), Antonio Bigini, Antoine Guichard, Mariann Lewinsky, and Stéphanie Salmon (Fondation Jérôme Seydoux-Pathé) who introduced me to valuable sources on Albert Samama. Finally, I would like to thank the participants of the workshop *Dynamic Maghribi Jewish-Muslim interaction across the Performing Arts (1920–2020)* (Cambridge, 5–7 December 2018) and members of the *ANR Ciné08-19* project for their informed comments on various drafts of this work. During my research at the Cineteca Di Bologna, I benefited from funding from the Programme d'aide à la recherche at the University of Paris 8 Vincennes – Saint-Denis.

[3] For Samama's biography, see Sanogo, Cenciarelli, Lewinsky, and Mejr (2015: 50–67); Corriou (2011); Guillot (2017); Mansour (2000); Véray (1995).

[4] See Sebag (1998: 413).

[5] Cineteca Di Bologna, the Albert Samama Archives, Album documenti nero 3 (provisional classification).

[6] A photograph depicts the Sfax Municipal Theatre in which the Cinemato-Chikli screened films (Mansour, 2000: 60).

26 *Jewish-Muslim Interactions*

His first films date back to 1905 at the latest.[7] Samama was above all an innovator, between inventor and enthusiast. In the early days, he oscillated between amateurism and professionalism, and appears to have had little interest in developing a business.

It was from 1906 onwards that he began professionalizing his activities. Abandoning the mantle of amateur photographer – as he often fashioned himself at the end of the nineteenth century – he began selling his films to European firms.[8] This development is obviously linked to the evolution of the film industry itself and, in particular, to the shift towards renting, which led to the inauguration of the first cinema in the protectorate (Omnia Pathé) in October 1908.[9] No longer filming only in Tunisia, Samama travelled to Germany, Austria, and France. At the end of 1908, he visited the Sicilian city of Messina, in the wake of a particularly violent earthquake.

In late 1911 and early 1912, Samama toured southern Tunisia and Ottoman Tripolitania. This trip was a watershed moment in his career, because it allowed him to film the Italo-Turkish War not as it was seen from the vantage of the Italian side, but from that of the Turkish one. The invasion of the last Ottoman provinces in Africa had engendered a seismic shift in the Muslim world. In Tunisia, the Arabic-language press issued calls for pan-Islamic solidarity (Yacoub, 1980) and a campaign was organized to extend aid to the resistance in Tripolitania, at the initiative of the Jeunes Tunisiens ['Young Tunisians'] movement. Altercations between Tunisians and Italians, who formed the largest European community in the country, were on the rise. France, which had just occupied Morocco, was not opposed to the Italian offensive, but tensions soon arose between the two European countries as Ottoman weapons and reinforcements streamed into Libya from the Tunisian border.

The Italo-Turkish War was highly publicized. A contingent of European journalists arriving in Tripolitania to cover the war was promptly placed

[7] In December 1905, he showed several films by Ferdinand Zecca but also his own work in the Tunis Municipal Casino: *L'Embarquement des pèlerins* ['The Pilgrims Embark'], *Les Courses de Tunis* ['The Tunis Races'], *La Fantasia arabe* ['Arab Fantasia'], *Les Souks* ['The Markets'] and *La Pêche du thon de Sidi Daoud* ['Tuna Fishing in Sidi Daoud'].

[8] His archives preserve correspondence with Pathé in 1906 (Album documenti nero 1–2, letter from the Pathé Company to Albert Samama, 18 July 1906), and his name appeared in Pathé's accounting journals in September 1907 (Fondation Jérôme Seydoux-Pathé, accounting journal no. 12, May 1907 to April 1908).

[9] The year 1907 was marked by the coup staged by the Pathé firm, which led to an abrupt halt in the sales of its productions. From then on, they were exclusively rented, a revolution that led to a sedenterization of film projections.

under the strict supervision of the Italian army, which escorted them, censored them, and briefed them through daily press conferences (Chérau, 2018). In his study of Gaston Chérau, the special correspondent for *Le Matin*, Pierre Schill points out strong similarities in the photographs appearing in the reports of nearly all the war correspondents. Italian filmmakers, including Luca Comerio and Bixio Alberini, who both worked for Pathé, were also present in Tripolitania (Zaccaria, 2003: 67–68). Samama, meanwhile, seemed isolated in his filming tour, and never mentioned encountering any of his colleagues in his field notes. In fact, few foreign journalists chose to cover the war from the underrepresented Ottoman perspective.[10] Photographs were nevertheless taken by men such as Pol Tristan or Georges Rémond. The latter, a correspondent for *L'Illustration*, reported numerous times on how invested Arab and Turkish fighters were in their image in the press, well aware that the audience for these images exceeded European readership and that they were circulating widely in the Muslim world.[11] Photography was also used in the Sultan's army – much to the surprise of the Italians, who discovered as much when they stumbled upon numerous negatives in abandoned Turkish military camps (Zaccaria, 2003: 85–88). Still, these photographs appear to have had either a private or a military use, as photography rarely featured in the Ottoman printed press. The issue of the moving picture, by contrast, was never brought up, due to the small number of filmmakers and studios in the Ottoman Empire at the time (Arslan, 2011: ch. 2). Samama's work was therefore groundbreaking in the media landscape in which he operated.

Samama followed the traditional smuggling route from Sfax to Zouagha via Ben Gardane, which Arab and Turkish fighters used to reinforce and supply provisions for the Tripolitan rebellion. Details of this trip are known to us thanks to a journal preserved by the archives of the Cineteca di Bologna: *Voyage Tripolitaine pendant la guerre italo-turc [sic]* ['Tripolitan Journey

[10] Notable exceptions include Ernest N. Bennett, who was present in Tripolitania in 1911, as well as Georges Rémond, who was there from January to May 1912 (Yacoub, 1980, fol. 206–11; Rémond, 2014).

[11] 'Le *kaymakam* s'est pris d'une amitié profonde pour *L'Illustration* et pour moi, mon interprète ayant eu l'idée heureuse de lui dire que le numéro, avec sa photographie, avait été affiché dans les mosquées et les cafés maures de l'Algérie, et qu'à cette vue tous les Algériens, sans le connaître, mais sachant avec quelle valeur il combattait pour l'islam, faisaient des prières pour lui' ['The *kaymakam* fostered a deep friendship with *L'Illustration* and with me, as my interpreter had the fine idea to tell him that the issue, along with his photograph, had been displayed in the mosques and Moorish cafés of Algeria, and that at the sight of this all Algerians, without knowing him, but knowing with what bravery he fought for Islam, prayed for him'] (Rémond, 2014: 53).

28 *Jewish-Muslim Interactions*

during the Italo-Turkish War']. Samama's text, laboriously handwritten in a school notebook and full of erasures and misspellings, was written *a posteriori*. The narrative, unfortunately, is incomplete and is cut off on 8 November 1912, when the author was supposedly approaching 'Aīn Zāra. Its purpose remains unclear. Did Samama intend to rework these field notes for publication? Samama was, without a doubt, an avid seeker of glory and recognition. Had he been hoping to complement his photographic and cinematographic oeuvre with a book chronicling his exploits? This is the most likely hypothesis, despite the fact that Samama was not a man of the written word. Detailed lists documenting expenditure appearing here and there in the text, alongside sections in which Samama took particular care to describe how Arab and Turkish fighters felt about France and Italy, suggest another possibility. Could it have been a report for the French authorities? The idea is not implausible if Samama's deep-seated patriotism were to be taken into account: he would go on to voluntarily enlist in the Film Unit of the French Army at the age of forty-four, in 1916.[12]

If providing intelligence was one of the objectives here, however, any contact with the French authorities could have only been made afterwards. It was Parisian film companies who were behind his expedition:

> [...] traînant à Paris au moment où éclat la guerre italo-turcs de septembre 1911. [...] Plusieurs maison de cinématographe surtout que j'étais Tunisien m'on proposer d'aller en Tripolitaine pour prendre des vues comme ont savez que j'étais Tunisien que je connais très bien les arabes et je parle leur langue ont m'a proposer de partir en Tripolitaine. J'ai décider de partir au plutôt me prometant de prendre des choses sensationel [*sic*].[13]

His Tunisian origins and his mastery of Arabic are presented as an asset in his dealings with the French film companies. In the notebook, his choice of covering the war from the Ottoman side is described as part of a commercial strategy:

> À Sfax plusieurs amis à qui je leur avait dit que j'allais à Tripoli m'on conseiller de ne pas y aller 1°) parce que le choléra battais son plein et 2° que à Tripoli il y avait déjà plusieurs photographe et opérateur

[12] See Mansour (2000: 216).

[13] 'Being in Paris at the time of the Italo-Turkish War of September 1911. [...] Especially because I was Tunisian, several film companies approached me and suggested that I go to Tripoli to film; since they knew I was Tunisian and that I knew the Arabs very well and that I speak their language, they proposed that I go to Tripoli. I decided to leave as soon as I could, promising to take sensational shots'.

Albert Samama, a Tunisian Filmmaker

de cinématographe italien que certainement je n'aurai put rien faire d'intérressant vue les limites très restrein où on pouvait circuler et les difficulté que les autorités italien faiser pour laisser photographier.

Après réflexion je me suis dit je parle arabe je connaît la vie des arabes. Aucun photographe n'a encore été du côté des arabes ; je vais tenter le coup si je pourrai aller du côté des Turcs. Je rapporterai des vues inédites et unique [*sic*].[14]

Samama sold his footage from Tripoli to Gaumont, signing a contract on 14 August 1912 'pour [d]es vues panoramiques et documentaires' ['for panoramic and documentary footage'] as well as materials for the *Revue Hebdomadaire Gaumont Actualités* ['Gaumont News Weekly Digest']. He was given instructions regarding the interval between the images in order to meet the firm's strict standards.[15] The war in Tripolitania thus provided Samama with the opportunity to establish a professional career in filmmaking.

The Maghrib in the Global Film Market

Professionalizing meant closer ties with the French film companies that dominated the international film trade at the time. Here, once again, the Italo-Turkish War represented an opportunity. Numerous competitors populated the burgeoning newsreel industry: Pathé Journal was founded in 1909, closely followed by Gaumont in 1910 and Éclair in 1912. It is difficult to assess the presence of the colonies in the news during the 1910s, but it seems clear that the routine coverage of privileged subjects (sporting events, visits by heads of state and ministers, crimes, etc.) normally excluded territories considered 'peripheral' (Baj and Lenk, 2004: 270). These were mentioned in the news only when they involved conquest, armed conflicts, or historic diplomatic visits. Samama regularly encountered difficulties in

14 'In Sfax, several friends with whom I shared my intentions to go film in Tripoli advised me against it (1°) because cholera was rife there and (2°) because there already were numerous Italian photographers and filmmakers in Tripoli, and [they said] that I certainly couldn't expect to achieve anything interesting given the restraints placed on free movement in the city and the difficulties Italian authorities caused photographers.

After reflection, I thought to myself that I speak Arabic [and] I know the life of Arabs. No photographer has yet been on the side of the Arabs; I'm going to give it a shot and see if I can go to the Turkish side. I will bring back new and unique views'.

15 Album documenti blu 1–2, contract of 14 August 1912.

30 *Jewish-Muslim Interactions*

selling his North African materials and attracting the interest of French film companies.[16] While he appeared to film more and more in Europe, the war in Tripolitania represented a real windfall in his career.

The days of the *Ciné-Journal Chikli* seemed to be over. Even though no footage of these newsreels survived, its logo, a caricature of a pink flamingo,[17] suggests that these news reports were more parody and prank, typical of Samama's initial experimentations, than actual Tunisian news.[18] From then on, his footage of the Maghrib travelled more widely and found a place in the global film economy. This is not insignificant when we consider that the main issue in Tunisian cinema at the end of the colonial period and at the beginning of independence was distribution.[19] The colonial and post-colonial situation has denied Tunisian cinema the mantel of 'universality' so self-assuredly claimed by French and American cinema, and reduced it to the local and particular.

The film market in the 1910s was slightly more open than it would be in subsequent decades. The Samama Archives suggest a much larger cinematic range than has been previously acknowledged. Only a few fragments of his work have survived the passage of time, but the impressive photographic collection kept at the Cineteca should enable scholars to eventually credit the Tunisian filmmaker with most of the footage shot in Tunisia and Libya during the 1910s: Samama was unique in taking still photos and films in parallel, a pattern he would continue when filming the front lines of the First World War (Guillot, 2017).[20] While authentication of his work is still underway, we can already mention the examples of *Gabès, Tunisie. Délégation du Croissant rouge* ['Gabès, Tunisia. Delegation from the Red Crescent'], and *La Tripolitaine. Zouagha: guerre italo-turque* ['Tripolitania.

[16] In the 1920s, for instance, Pathé criticized Samama for the dullness of his films (Album documenti nero 1–2, letter dated 28 August 1922). After the war, several of his films were repurposed for educational series.

[17] 03–Cinema Sc 1. The coat of arms of the 'principality of Chikli' (Chikli, in reality, was no more than a modest island in the Lake of Tunis, once acquired by his father) already depicted pink flamingos (CFSC–DOC–SC.1).

[18] His photomontages and humorous mises en scène abound. Some appear in Guillemette Mansour's book, such as a scene depicting a card game pitting him against two other Albert Samamas, or a self-portrait in bed alongside a skeleton that tenderly caresses his forehead (the only decent image in an entire series depicting him in intimate domestic settings with a skeleton).

[19] Tahar Cheriaa's dictum, 'Qui tient la distribution tient le cinéma' ['He who controls distribution controls cinema'] remains famous. See Cheriaa (1978).

[20] Several photographs of his stay in Tripolitania have been published in Mansour (2000: 201–6).

Zouagha: Italo-Turkish War'].[21] These films, each only a few seconds long, represent a radical break with most footage taken in North Africa at the time, most of which consisted of ethnographic scenes or records of official ceremonies featuring the army, colonial officials, or the Sultan of Morocco. *Gabès, Tunisie. Délégation du Croissant rouge* does not depict sovereigns full of pomp or fierce warriors on horseback brandishing swords, much less ethnographic 'types', but rather everyday Tunisians expressing their support for the resistance in Tripolitania. Samama's camera lingers on the motorcar transporting the delegation. This choice is unusual at a time when most films persisted in portraying the inhabitants of the Maghrib in traditional settings, as if they were untouched by modernity. In *Zouagha*, an old man – could this be the sheikh mentioned by Samama in his notebook? – makes a fervent speech in front of the camera. If the caption, enigmatic to say the least, casts doubt on the meaning of the scene, the importance of the latter lies perhaps more in this close-up of a Libyan haranguing the crowd. This shot contrasts with the almost uniform invisibility of the North African populations on screen at the turn of the century. Except for isolated individuals posing in front of the camera in ethnographic films, Arabs were by and large depicted as faceless men, often filmed from the back, from a long way off, their figures appearing as ghostly silhouettes in longshots of landscapes. The most representative example of this is also the most exaggerated one: *Colomb-Béchar*, a film more than seven minutes long depicting the Algerian city of Béchar, in which almost no face appears, the inhabitants mostly filmed from a distance.[22]

Gabès, like *Zouagha*, is marked by the low quality of the footage. In *Gabès*, the framing appears particularly clumsy (heads cut out of frame in the first shot, members of the delegation blocked out of frame by the crowd in the next). Still, what might appear as a sign of amateurism also testifies to Samama's uniqueness, namely his proximity to the subjects of his films: the cameraman in both films records from within the crowd. Samama thus differs from the position of detached spectator adopted by many European filmmakers who, by and large, kept away from indigenous crowds and preferred to film them from a safe distance. Admittedly, they usually filmed orderly processions, unlike Samama, who often filmed spontaneous gatherings. A later work like *Tunis: rues et paysages* ['Tunis: Streets and Landscapes'], which can most

[21] Gaumont Pathé Archives, *Gabès, Tunisie. Délégation du Croissant rouge, Journal Gaumont*, 1210GJ 00023; *La Tripolitaine. Zouagha: guerre italo-turque, Journal Gaumont*, 1407GJ 00004.

[22] Gaumont Pathé Archives, 1914EGHI 00874, Film Service of the General Government of Algeria, Éclair Ghilbert, first projected in 1914.

32 *Jewish-Muslim Interactions*

probably be attributed to him,[23] is characteristic in this respect: Samama, in the middle of the wedding procession, seems driven by the crowd he films frontally, departing from traditional representations of a faceless Arab mass.

The conflict, and, indeed, a stroke of good journalistic fortune, caught up with the filmmaker when he left Tripolitania. As he crossed the Mediterranean from Marseille to Tunis aboard the *Carthage* ocean-liner in January 1912, it was unexpectedly boarded and seized by the Italian navy: the liner was accused of transporting 'war contraband' destined for the Turkish forces. While the boat was detained in Cagliari, Samama found himself, with his filming gear and camera, in the midst of an unfolding play of Franco-Italian diplomatic theatre. His exclusive still photographs from this event made the front page of *L'Illustration* (27 January 1912), which did not hesitate to add a special supplement to cover the case. Meanwhile, his film footage was published by the Agence Générale Cinématographique. Once again, unforeseeable circumstances played into the filmmaker's favour, adding buoyancy to his effort to internationalize his business. However, the *Carthage* incident is also illustrative of the limitations within which the film industry in Tunisia developed. In fact, the film was never screened in the country itself: following the events of Jellaz (7–8 November 1911), all films about the Italo-Turkish war were banned.[24] This did not prevent the French member of parliament from Bouches-du-Rhône, Auguste Bouge, from denouncing the failures of the General Residence in the National Assembly, accusing cinema owners in Tunis of projecting scenes of the conflict in Tripolitania 'devant une foule de musulmans surexcités' ['in front of a crowd of agitated Muslims'].[25] Here we find not only the first expression of concern about the presence of Muslim audiences in cinemas, but also the first example of film censorship in the protectorate of Tunisia.

Although the local press had nothing but praise for their progressive fellow compatriot, Tunisian cinemas ultimately took little advantage of this proximity. Faced with a lack of infrastructure, Samama was forced to resort to French companies not only to have his films printed and edited, but also

[23] The images bear a strong resemblance to the photographs of a wedding procession published through Mansour (2000: Gaumont Pathé Archives, 1922GHIDOC 01064). This scene was certainly an inspiration for *Aïn el-Ghezal ou La fille de Carthage* (completed in the autumn of 1923 and released in Tunisian cinemas in May 1924).

[24] 'Cinéma et Parlement. Une remise au point des allégations de M. Bouge', *Ciné-Journal*, 17 February 1912, 182: 5. On the events of the Jellaz, see footnote 26, below.

[25] 'Cinéma et Parlement', *Ciné-Journal*, 3 February 1912, 180: 6–7.

Albert Samama, 'Bold Explorer'

In this context, the notebook left by Samama testifies to his ability to play with different registers of belonging. He is employed as a Tunisian by French film companies, mistaken for an Italian spy by Tunisians who almost attack him, and presents himself as a 'Français à Tunis' ['Frenchman in Tunis'] in front of the Tripolitan fighters. In Ben Gardane, he only avoids getting into trouble thanks to the intervention of a former porter of his, who identifies him as an 'enfant du pays' ['local lad']:

> Autour de l'auto très nombreux les arabes se son réunie et me regarder d'un air malveillant surtout voyant que j'étais arrivée seul et voyant débarquer tout mon matériel appareil, ciné, pédale ciné (qu'ont du prendre pour un pied de mitraleuse) arrivée à Ben Gardane a produit un très mauvais effet sur les Arabes. Et voici pourquoi [:] le matin de ce jour même un groupe du Croissant rouge avait quitter pour la Tripolitaine et voyant que j'arrivée quelques heures après seul en auto avec tous mon attirails et ayant un peu le types italiens surtout voyant que je parler cette langue : les arabes m'ont pris pour un officier italien – et dans les cafés maures entres eux ils disaits qu'il ne comprenez pas que le gouvernement français autoriser des officiers italiens venir jusqu'à la frontière pour épier les arabes et suivre à distance les membres du Croissant rouge. [...] Parmi eux se trouve un arabe qui me dit : Tu n'est pas Tunisien[,] toi [?] je te connais[.] Ce n'est pas toi qui est monté en ballon à Tunis [?] je répond que oui : il me dit moi j'étais portefait à Tunis et je t'ais fait souvent des commissions : tu ai Samama : tu habite près de l'avenue de Londre : cet arabe sans se douter a été mon sauveur. Je me met à causer avec lui et il s'est mis à me porter mes appareils : Mais tous les Arabes de Ben Gardane lui demande qui j'étais ceux que je fesait. Il leur a répondu que j'étais enfant du pays et qu'il s'était tous trompé sur mon compte [*sic*].[26]

[26] 'Many Arabs gathered around the motorcar and looked at me with a malevolent air especially seeing as I had arrived alone and unloaded all my

Only the French expression 'enfant du pays' is given in the text, but we can assume that it is a translation of the Arabic *weld el-bled* ['local lad'].

Thus, Samama symbolized, offhandedly, this 'métis de la colonisation' that Memmi wrote so poignantly about, the man who belonged neither to the colonizers nor to the colonized. The nascent film industry relied heavily on such intermediaries – Jewish Tunisians, but also Italians (Corriou, 2011). Samama seemed to mingle with relative ease in the different strata of this complexly hierarchical society. His freedom is consigned to a particular social environment, of course, but perhaps also to a specific era, the beginning of the twentieth century, where it was still possible to juggle identities to one's advantage.[27]

Should the choice of covering the Ottoman side be construed as taking a broader political stance? Samama does not hesitate to cover the trial of the Jellaz. We have already mentioned the rupture caused by the riots in November 1911. Following the decision by the municipality of Tunis to register the *ḥubūs* property of the Muslim Jellaz cemetery, intercommunal tensions arose in the already delicate atmosphere caused by the war in Tripolitania. The decision was eventually rescinded, but the distrustful protesters gathered outside the cemetery on 7 November, where they were confronted by soldiers and the police. The demonstration soon devolved into confrontations and clashes throughout the city, claiming the lives of many Tunisians, Italians, and French residents (Ayadi, 1989: 166–75). Repressive measures were directed primarily against the Tunisians, who were caught in the cogs of a colonial machine, panicked by the events.

equipment, camera, camera pod (which must have been taken for a machine gun mount); my arrival in Ben Gardane has produced a very bad effect on the Arabs. And here's why: on the morning of that very day, a group of the Red Crescent had left for Tripolitania and since I arrived a few hours later, alone by motorcar with all my paraphernalia and seeming a bit like an Italian, especially seeing that I speak this language, the Arabs took me for an Italian officer – and in the Moorish cafés they talked among themselves and said that they did not understand that the French government would allow Italian officers to come to the border to spy on the Arabs and follow the members of the Red Crescent. [...] Among them there was an Arab who said to me: "Aren't you a Tunisian, you? I know you. Isn't it you who went hot air ballooning in Tunis?" I said it was. He tells me, "I was a porter in Tunis and I often did commissions for you. You are Samama, you live near London Avenue." This Arab was undoubtedly my saviour. I got talking to him and he started carrying my equipment for me: but all the Arabs of Ben Gardane asked him who I was and what I was up to. He told them that I was a local lad and that they were all wrong about me'.

[27] See, in particular, Amara and Oualdi (2005) and Dewhurst Lewis (2013).

Samama followed the trial in June 1912 and turned 81 metres of footage that seem to have disappeared.[28] He also took photographs that could be read as a denunciation of the proceedings, like one portrait of an eight-year-old child standing accused and whose head, covered by a *chechia*, barely protrudes above the bar (Mansour, 2000: 210–11). In the autumn of 1912, he was prevented from filming the execution of two convicts by the head of security, who held him for two hours and briefly confiscated his equipment (Valensi, 1912: 22).

In Tunis, Samama also frequented and filmed Abdelkader, the grandson of the Algerian emir.[29] These connections infuriated the Italian press, which did not hesitate to accuse the filmmaker of spying for the Turks.[30] Arriving from Damascus, Abdelkader and his father Ali had crossed Cyrenaica and Tripolitania to organize the resistance of the local Arab tribes. As Ottomans, the two men had an apparently cordial but deeply ambiguous relationship with France – Emir Ali was received in Tunis by resident general Gabriel Alapetite (Bardin, 1979: 179–89). On 22 February 1913, an issue of the *Courrier cinématographique* announced Samama's return from the Balkans. Unfortunately, this is the only mention we have of this trip that left no other trace in the archives. Did he film the war between the Balkan League and the Ottoman Empire? That would be the most likely explanation for his expedition. Did he cover the Turkish side? Again, we could surmise as much, given his network of friendships in the Sultan's army.

These different choices appear to be the reverse of the positions held by the majority of the French population in Tunisia at the time. It would be imprudent, however, to exaggerate the role of Ottoman heritage in the filmmaker's work. It is possible that Samama initially saw the war as a way of uniting Tunisians and the French around a shared hostility towards Italy. What is particularly striking in his written notes, by contrast to some of his films and photographs, is first of all the way in which Samama distances himself from the Arab world, whether in his travel diary or in his photographs, captioned according to scenes and types – 'type arabe de la région de...' ['Arab type from the region of...']. Samama obviously makes use of the pre-established categories that enable him to sell his films and photographs abroad. However, in an undated letter, probably dating back to the early twentieth century, he describes himself above all as a 'hardi explorateur' ['bold explorer'], a 'digne et intéressant successeur des Stanley

[28] Album documenti nero 1–2, scribbled list.

[29] Album documenti nero 1–2, scribbled list.

[30] 'Espionnage turc en Italie. Les vicissitudes d'un Tunisien', *La Tunisie française*, 14 August 1912.

et des Livingstone' ['worthy and notable successor to the Stanleys and Livingstones'].[31] It is indeed under the gaze of an explorer or a tourist that the filmmaker subjected his country of birth. While these allusions may be surprising, they should not merely be considered as a kind of schizophrenia. The figure of the tourist equally expresses a relationship to modernity centred on the idea of speed, freedom, and worship of the body, which Catherine Bertho Lavenir aptly describes (1999: 87–95). Samama's passion for canoeing, motorcars, and especially bicycles in this regard is telling.[32] Bertho Lavenir links the advent of cycling to tourism during the Belle Époque. We also know that Samama worked extensively on a travel guide to Tunisia, which he never succeeded to publish due to a lack of investors.[33] A common thread runs through the figure of the tourist, the bicycle, the camera that always accompanies him on his wanderings, and, finally, the cinema itself. Being a tourist is first and foremost about being modern. To be modern in this sense and at that time was to have a chance to escape 'indigenous' status – symbolic for Samama, since he had French nationality – and to re-appropriate in a positive way a certain marginality in a Muslim-majority society (Memmi, 2002 [1957]: 38–41).

Conclusion

Finding a balance between the exceptional and the commonplace is the inevitable challenge of any biography. In the case of the self-proclaimed 'Prince of Chikli', the first pitfall is certainly the weight of his extraordinariness. Samama's eccentricities make him akin to a character from a novel; many have succumbed to the temptation to approach his biography from the point of view of the extraordinary – an angle that tends to obfuscate the colonial context.[34] Although certainly idiosyncratic, Albert Samama was also an ordinary man, increasingly constrained by political restrictions and his country's marginality in the global film market. He probably did not have the career and recognition he had hoped for. The outbreak of the First World War interrupted its momentum: the French film industry was turned

[31] Album documenti nero 1–2, unfinished letter.

[32] He joined the Union vélocipédique de France ['Cycling Union of France'], and, in 1893, he organized a bicycle expedition to southern Algeria.

[33] *Sur les grands chemins de la Tunisie* ['On the Great Roads of Tunisia'].

[34] Note the revealing title of the documentary dedicated to him by Mahmoud Ben Mahmoud in 1995: *Albert Samama-Chikli: ce merveilleux fou filmant avec ses drôles de machines* ['Albert Samama-Chikli: That Wonderful Filming Madman and his Odd Machines'].

upside down, and the big companies lost interest in films from the Maghrib. After the war, his attempts to capitalize on the 'cheikh film' wave failed. Racked by bankruptcy, the first Tunisian film director died in 1934. His frantic rush towards innovation constituted a demonstration of modernity that was relatively common among Maghribi Jews. He converted with great fanfare to Catholicism, was dubbed a member of the very selective Institut de Carthage ['Institute of Carthage'] and the Cercle Européen de Tunis ['European Circle of Tunis'], but the first words devoted to him by the *Livre d'or de la Cinématographie* made reference to 'sa physionomie élégante, vive et expressive d'Arabe très parisien'.[35] 'Plus ou moins mystifi[é], plus ou moins bénéficiair[e]',[36] Samama embodies Memmi's 'métis de la colonisation' (2002 [1957]: 41).

And yet it would be equally wrong to understate his exceptionality. He is a pioneer who, in Tunisia, experimented with everything: the submarine, the wireless telegraph, the hot air balloon. While there is no doubt that the history of early cinema has tended to underestimate the number of indigenous films in the colonized territories,[37] Samama's example, considering the longevity and the prominence of his career, seems an outlier nonetheless. The concept of the intermediary, so commonly used to describe Maghribi Jews that it has become somewhat of a truism, must therefore be more closely scrutinized. Admittedly, it was Samama who introduced Muḥammad al-Ḥabīb to the world of cinema. Despite their many disagreements,[38] the prince-turned-bey reciprocated a long friendship with him, lending him his palace in La Marsa for the filming of *Aïn-el-Ghezal*.[39] But, ultimately, Samama appears to have been too isolated and too unconventional for his experiences to have a real impact. There is a chronological disconnect between his own groundbreaking individual initiative and figures like Mustapha Bouchoucha, not to mention associations such as Tunis Films or Tunis Cinéma that strove at the end of the

[35] 'The elegant and lively features of a very Parisian Arab'. Unfortunately, the work cited is not dated (Mansour, 2000: 61).

[36] 'More or less fooled to the point of accepting the system, more or less profiting from it'.

[37] Even though these films have apparently been forever lost, it is safe to assume that the first indigenous ambulant exhibitors did indeed film and that their films were more numerous and produced earlier than is commonly acknowledged (see, for example, Ruppin, 2014: 13).

[38] On several occasions Samama complains about having provided Muḥammad al-Ḥabīb with filming materials without getting paid in return (Album documenti blu 1–2).

[39] 'Un film tunisien', *Mon Ciné*, 30 October 1924, n° 141.

38 *Jewish-Muslim Interactions*

1930s, with great difficulty and little success, to forge a national film industry in an increasingly repressive colonial context (Corriou, 2011: 327–33). This did not discourage a new generation of Tunisian film-lovers and filmmakers in the 1960s from dubbing him another link in the chain of national cinema going back to the beginning of the century.[40] But the mediatory role the figure of Samama played here appears to be more symbolic than concrete. What, then, remained of his works? No trace, it would seem, given that, in a 1963 report, Tahar Cheriaa copied the summary of *Aïn el-Ghezal* that appears in Maurice Bataille and Claude Veillot's book, *Caméras sous le soleil* (1956). This suggests that even the president of the Fédération Tunisienne des Ciné-Clubs ['Tunisian Federation of Film Clubs'] and director of cinema at the Ministry of Cultural Affairs had never seen the film for himself.[41]

'Il n'eut ni succès ni descendance', writes Tahar Cheriaa, accusing colonial policy for 'l'échec et la stérilité de cet avorton [*Aïn el-Ghezal*] admirable et émouvant'.[42] On balance, it is more through his subsequently forgotten films on the 1910s, which we are only now beginning to rediscover, that it becomes possible to truly approach Albert Samama as an 'homme-relais' ['relay man'].[43] Mediation does not play out here on the level of technological transmission, but in representation: one fine day in 1911, a 'local lad' left for Tripolitania in search of a scoop (consciously or unconsciously?) to film Muslims committed to resistance not as extras of a story that would unfold without them, but as political protagonists on the world stage.

[40] Nouri Zanzouri, who opens a section on the history of Tunisian cinema in the journal of the Fédération Tunisienne des Ciné-Clubs, describes *Aïn-El-Ghazal* as 'la première tentative de faire du cinéma spécifiquement tunisien' ['the first attempt to make specifically Tunisian cinema'] (1959: 1). In September 1965, Omar Khlifi devoted an article to Samama in *Maǧallaï al-masraḥ wa al-sinimā* (6–8).

[41] Tahar Cheriaa, 'Cinéma et culture en Tunisie', Paris, 11 October 1963. The United Nations Educational, Scientific and Cultural Organization (UNESCO) report to the second Beirut roundtable on Arab cinema and culture from 28 to 30 October 1963.

[42] 'He knew neither success nor progeny'; 'the failure and the stagnation of this moving and admirable stunted effort'.

[43] Bendana's expression (1992: 70) was used to designate Tunisian intellectuals, with a dual culture, who made the link between the French and Tunisian cultural circles.

Works Cited

Primary Sources

British Pathé. 2014. 'Public Hanging of 14 Turks: Italo-Turkish War War (1911)'. 13 April. Available at: https://www.youtube.com/watch?v=EprSRy_cG0A& bpctr=1566393761 (consulted on 19 August 2019).

'Cinéma et Parlement', *Ciné-Journal*, 3 February 1912.

'Cinéma et Parlement. Une remise au point des allégations de M. Bouge', *Ciné-Journal*, 17 February 1912.

Cineteca Di Bologna. The Albert Samama Archives. Album documenti blu 1–2, contract of 14 August 1912.

——. Album documenti nero 1–2, letter from the Pathé Company to Albert Samama, 18 July 1906.

——. Album documenti nero 1–2, letter dated 28 August 1922.

——. Album documenti nero 1–2, scribbled list.

——. Album documenti nero 1–2, unfinished letter.

——. Album documenti nero 3.

Fondation Jérôme Seydoux-Pathé. Accounting journal no. 12, May 1907 to April 1908.

Gaumont Pathé Archives, Film Service of the General Government of Algeria, *Colomb-Béchar*, Éclair Ghilbert, first projected in 1914, 1914EGHI 00874.

——. *Gabès, Tunisie. Délégation du Croissant rouge. Journal Gaumont*, 1210GJ 00023.

——. *La Tripolitaine. Zouagha: guerre italo-turque. Journal Gaumont*, 1407GJ 00004.

Mon Ciné, 30 October 1924.

La Tunisie française, 14 August 1912.

Valensi, André. 1912. 'Autour d'une exécution'. *Le Courrier cinématographique*, 15 November, p. 22.

Secondary Sources

Amara, Noureddine, and M'hamed Oualdi (eds.). 2005. 'La nationalité dans le monde arabe des années 1830 aux années 1860. Négocier les appartenances et le droit'. *Revue des mondes musulmans et de la Méditerranée* 137: 13–28.

Arslan, Savaş. 2011. *Cinema in Turkey: A New Critical History*. New York: Oxford University Press.

Ayadi, Taoufik. 1989. 'Insurrection et religion en Tunisie: l'exemple de Thala-Kasserine (1906) et du Jellaz (1911)'. In Fabienne Gambrelle and Michel Trebitsch (eds.), *Révolte et société*. Paris: Histoire au présent: Publications de la Sorbonne: 166–75.

Baj, Jeannine, and Sabine Lenk. 2004. '"Le premier journal vivant de l'univers!" Le *Pathé Journal*, 1909–1913'. In Michel Marie and Laurent Le Forestier (eds.), *La firme Pathé Frères: 1896–1914*. Paris: Association française de recherche sur l'histoire du cinéma: 263–72.

Bardin, Pierre. 1979. *Algériens et Tunisiens dans l'Empire ottoman de 1848 à 1914*. Paris: Éditions du CNRS.

Bataille, Maurice, and Claude Veillot. 1956. *Caméras sous le soleil*. Alger: impr. de V. Heintz.

Bendana, Kmar. 1992. 'Revues culturelles françaises à Tunis pendant la Seconde Guerre mondiale'. *La revue des revues* 12–13: 63–72.

Bertho Lavenir, Catherine. 1999. *La roue et le stylo: comment nous sommes devenus touristes*. Paris: Éditions Odile Jacob.

Braun, Marta, and Charlie Keil. 2010. 'No Centre, No Periphery?: Early Film Exhibition in Ontario, Canada'. In François Amy de la Bretèque (ed.), *Domitor 2008: les cinémas périphériques dans la période des premiers temps: actes du 10ᵉ Congrès international, Girona – Perpignan, 16 juin – 21 juin 2008*. Perpignan: Presses universitaires de Perpignan: Institut Jean Vigo; Girona: Museu del cinema: 125–29.

Chérau, Gaston. 2018. *Réveiller l'archive d'une guerre coloniale: photographies et écrits de Gaston Chérau, correspondant de guerre lors du conflit italo-turc pour la Libye, 1911– 1912*. Ivry-sur-Seine: Creaphis éditions.

Cheriaa, Tahar. 1978. *Écrans d'abondance ou cinémas de libération en Afrique? à propos de l'importation-distribution des films en Afrique et dans le monde arabe et de la nécessité de sa nationalisation*. Tunis: SATPEC; Tripoli: El Khayala.

Corriou, Morgan. 2011. *Un nouveau loisir en situation coloniale: le cinéma dans la Tunisie du protectorat*. Unpublished doctoral thesis. Université Paris Diderot-Paris 7.

Dewhurst Lewis, Mary. 2013. *Divided Rule: Sovereignty and Empire in French Tunisia, 1881–1938*. Berkeley, CA: University of California Press.

Guillot, Hélène. 2017. *Les Soldats de la mémoire: La Section photographique de l'armée, 1915–1919*. Nanterre: Presses universitaires de Paris Nanterre.

Khlifi, Omar. 1965. 'Šamāmaï Šiklī'. *Maǧallaï al-masraḥ wa al-sinimā*, September, pp. 6–8.

El-Madani, Tewfik. 1989. *Mémoires de combat*. Trans. by Malika Merabet. Alger: EnAP: OPU: ENAL.

Mansour, Guillemette. 2000. *Samama Chikly. Un Tunisien à la rencontre du XXᵉ siècle*. Tunis: Simpact éditions.

Memmi, Albert. 1991. *The Colonizer and the Colonized*. Trans. by Howard Greenfeld. Boston, MA: Beacon Press.

——. 2002 [1957]. *Portrait du colonisé; précédé de Portrait du colonisateur*. Paris: Gallimard.

Rémond, Georges. 2014. *Aux camps turco-arabes: notes de route et de guerre en Tripolitaine et en Cyrénaïque*. Levallois-Perret: Turquoise.

Ruppin, Dafna. 2014. 'From "Crocodile City" to "*Ville Lumière*": Cinema Spaces on the Urban Landscape of Colonial Surabaya'. *Sojourn* 29: 1–30.

Sanogo, Aboubakar, Cecilia Cenciarelli, Mariann Lewinsky, and Ouissal Mejr. 2015. 'Albert Samama Chikly, principe dei pioneri'. In *Il cinema ritrovato 2015*. Bologne: Edizioni Cineteca di Bologna: 50–67.

Sebag, Paul. 1998. *Tunis: histoire d'une ville*. Paris: L'Harmattan.

Véray, Laurent. 1995. *Les films d'actualité français de la Grande Guerre*. Paris: SIRPA: AFRHC.

Yacoub, Taoufik. 1980. *La Presse française et tunisienne face à la guerre italoturque: 1911–1912*. Unpublished doctoral thesis. Paris 2.

Zaccaria, Massimo. 2003. 'The Other Shots: Photography and the Turco-Italian War, 1911–1912'. In Anna Baldinetti (ed.), *Modern and Contemporary Libya: Sources and Historiography*. Rome: Istituto italiano per l'Africa e l'Oriente: 63–89.

Zanzouri, Nouri. 1959. 'Pour une histoire du cinéma tunisien'. *Nawadi Cinéma*, Vol. 1.

More than Friends?
On Muslim-Jewish Musical Intimacy
in Algeria and Beyond

Jonathan Glasser

For many people in Algeria, the wider Maghrib, and its diaspora, music is a potent medium for talking about Jewish-Muslim connection. But as anthropologists working on kinship have long known, relatedness is anything but simple. What does it mean to be close? And doesn't closeness imply a baseline separation? To take one classic distinction from this literature, to be related by 'blood' (consanguineous kinship) is not the same as being related by marriage (affinity). And even if in all societies a close degree of consanguinity bars sex and marriage, in some instances certain consanguineous kin make preferred marriage partners, and everywhere affinity in one generation leads to blood relationship in the next.

It is an open question what such matters might teach us about closeness between people who neither share 'blood' nor think of one another as legitimate marriage partners. But perhaps it is the very openness of this question that brings to mind snippets from two recent conversations I had with music aficionados in Algeria. One of these was with a friend in Tlemcen in July 2017. Recounting his close relationships with Jews during his youth in the independence era, he said to me, 'Ils étaient plus que des amis [...] Qu'est-ce que ça veut dire qu'ils étaient plus que des amis?'[1]

[1] 'They were more than friends [...] What does it mean to say they were more than friends?'

The second conversation took place in Algiers in February 2018. Speaking with a friend about someone we know in common who had been close to the great Algerian Jewish singer Sultana Daoud, known as Reinette l'Oranaise, I described him in French as having been 'son proche'. My friend's quickly passing look of surprise made me realize that I had misspoken even before he explained my linguistic error: whereas I meant to say they were close, it had come out sounding as if they were relatives.

Neither of these conversations was about music per se, although both of them were with music aficionados, and the second concerned musicians. But both conversations bear great relevance to the question of the Muslim-Jewish relationship around music in Algeria and its diaspora that is my focus in the following pages. At the most basic level, they are both about closeness between people who are neither consanguineous kin nor potential affines. In the first conversation, the idiom of friendship does not quite go far enough, while in the second, the idiom of kinship goes too far. How then, are we to make sense of closeness? Is kinship an appropriate metaphor, or a dangerous one? And if it is appropriate, what kind of kinship should we be talking about?

But at another level there is an additional form of relevance in these conversations that more specifically engages the question of music: the way in which music might be a medium of relationship between Muslims and Jews in Algeria and the wider Maghrib – one that is all the more important in the absence of ties of 'blood' and marriage. What happens when music becomes an arena or object of the Muslim-Jewish relationship, or for talking about that relationship? And can anthropological thought about kinship help us to think through the relationships and forms of representation mediated through this proxy substance?

In the following pages, I offer a cautiously affirmative answer to the latter question. In particular, I find it useful to draw on a contrast traced by the Amazonianist Eduardo Viveiros de Castro between two notions of relatedness, and recently applied by Naor Ben-Yehoyada (2017) to rhetorics of national brotherhood and transnational 'cousinage' between Sicilians and Tunisians. In the first of Viveiros de Castro's notions of relatedness, an idiom of 'brotherhood' predominates, in which '[two] partners in any relation are defined as connected in so far as they can be conceived to *have something in common*, that is, as being in the *same* relation to a third term. To relate is to assimilate, to unify, and to identify' (2004: 18). For Viveiros de Castro, this idiom of brotherhood stands in contrast to certain 'Amazonian ontologies [which] postulate difference rather than identity as the principle of relationality [...] [If] all men are brothers-in-law rather than brothers [...] then a relation can only exist between what differs and in so far as it differs' (2004: 18). In other words, contrary to agnation (consanguineous kinship

On Muslim-Jewish Musical Intimacy in Algeria and Beyond 45

traced through fathers), in affinity, 'difference is a condition of signification and not a hindrance' (Viveiros de Castro, 2004: 18).[2]

The following pages trace these two possibilities through a reading of a range of conversations about Muslim-Jewish musical relationship in Algeria and its diaspora. Whether in the form of recordings, musical instruments, or personal reminiscences, the sonic traces of Jewish musicians have circulated in Algeria continuously since Jews' mass departure following independence in 1962. But it was not until the 1980s that popular and scholarly written texts began to appear about them in Algeria (Allalou, 1982; Bouzar-Kasbadji, 1988) and France (Teboul, 1987). For many of those working on Algerian Jewish musical expressions since then (Shiloah, 2002; Swedenburg, 2005; Guedj, 2009a; 2009b; Saadallah, 2010; Bousbia, 2011; Miliani, 2011; Seroussi and Marks, 2011; Langlois, 2015; Glasser, 2012; 2016; 2017; Silver, 2017), I suspect that a good part of the attraction to this topic lies in its offer of a counter-narrative to the 'lachrymose historiography' (Baron, 1928: 526) of Jewish North Africa. The sound of Jews singing the Arabic standards straight through their post-independence exile in and just after 1962 challenges the notion that Algerian Jews' 'enjoyment' of French citizenship starting from the Crémieux Decree of 1870 resulted in an inexorable, wholesale casting-off of Maghribi culture in favour of the French. While the bulk of Algerian Jews may have become French citizens, speakers of French, and eventually inhabitants of France, where they would even be retroactively cast in the settler-turned-repatriate category of *pieds-noirs*, the longstanding Jewish engagement with Algeria's urban Arabic music traditions – and the memory of such engagement – seems to tell a different story from the one that emphasizes a France-centred process of assimilation, unification, and identification.

But what is this story? That is the lingering question in this small but growing literature, and it finds its counterpart in more popular discourse as well, including that of the organic intellectuals of urban music scenes in North Africa and France. In my ethnographic and historical work in and around Algeria, France, and Morocco, I have often been struck by the sheer variety of ways in which people have described the Muslim-Jewish musical relationship. It is not that there is no agreement that Jewish performers were part of the urban Algerian and wider Maghribi music scene before independence, or that music has continued to be important to Algerian

[2] The masculine emphasis reflects the terminological and conceptual emphases of Viveiros de Castro's and Ben-Yehoyada's respective regions of discussion, as well as the relative rarity of enatic rather than agnatic principles in the general ethnographic record.

and other Maghribi-origin Jews in France and elsewhere. But the details of this story are up for dispute. Or rather, even when there is broad agreement about the details, there is little agreement on their import. In some instances, these disagreements can be rather subtle: was there a recognizably Jewish style, and in what domains? If so, what did these distinctions mean? Were and are they evaluated positively or negatively, and by whom? In other instances, the disagreements can be quite sharp: in Algeria, recent public discussion of Jewish participation in musical life has been an important avenue for advocating a pluralist rereading of the national project, but in part because of this it has also opened the door to tropes about loyalty to the nation, normalization with Israel, and alleged plots to 'Judaize' Algerian and Arab patrimony (Saadallah, 2010: 12–13). The most prominent illustration of such a dynamic was in President Abdelaziz Bouteflika's 1999 address in Constantine, during which he briefly acknowledged and celebrated Jews' role in upholding the musical patrimony of that city in the face of French colonial rule (Bouteflika, 1999). This was swiftly followed by an unprecedented presidential invitation to the Jewish singer Enrico Macias, born and raised in Constantine, for a series of concerts in Algeria, only to be rescinded in the face of strong denunciations, including from those who viewed the invitation of someone with unabashed Zionist sympathies as a fig leaf for normalization of relations with Israel. In other words, notwithstanding the seeming counter-exemplarity of music for the historiography of Muslim-Jewish relations in the Maghrib, we find ourselves caught between polemics on the one hand, and, on the other, what is for students of such matters an all-too-familiar morass of ambiguity and ambivalence. Is this a story about conflict or harmony, or about both, or about neither?

While what follows does not definitively sidestep either the polemics or the alternative modality of ambivalence, it gestures towards an escape route by musically extending Viveiros de Castro's terms to locate some order in this welter of competing evaluations of what Jewish musicality means, including connections between evaluations that usually are thought of as contrasting. In three sections, I sketch a typology of the stories and accompanying moral lessons that scholars, memoirists, politicians, aficionados, and others have crafted about Jewish involvement in Algerian musical practices, both in North Africa and France, punctuated by three brief intertwined ethnographic vignettes. The discussion begins with narratives that treat music as an emblem of Jewish belonging in Algeria, and of Muslim-Jewish commonality rooted in the deep past – an approach that corresponds closely to Viveiros de Castro's idiom of brotherhood. I then turn to an incipient critique of this emblematic approach that, while not definitively eschewing the concept of agnation, emphasizes the embeddedness of musical practices in colonial and

On Muslim-Jewish Musical Intimacy in Algeria and Beyond 47

post-colonial institutions and politics, cultural and otherwise. This critique shifts the conversation from the idea that music was a countercurrent, or a glimpse of what was really there beneath the modern colonial veneer, to one that suggests that music was but another arena of sociality – one that might blur the distinction between Muslim and Jew, or alternatively might be a point of separation that helps reproduce many of the familiar patterns of Muslim-Jewish difference and even hierarchy. But while this critique is important to make, I end with a critique of this critique, suggesting that the institutional view of music, while valuable, is not entirely satisfying, particularly in its blindness to non-hierarchical forms of difference that the idiom of affinity is particularly helpful in recognizing, and that was prefigured in an earlier generation of anthropological work on Muslim-Jewish relationships in the Maghrib. Thus, this discussion, in addition to trying to make sense of the conversation about the Muslim-Jewish musical relationship, also seeks to recover a neglected thread in the North Africanist literature.

Music as an Emblem of a Substrate of Sameness

Let me start with my first ethnographic vignette, from June 2009, in which I am catching a ride towards downtown Algiers with an Andalusi music aficionado who has recently introduced me to Sid Ahmed Serri, the late dean of the Andalusi musical style of the capital. Serri had told us of Charles Sonigo, a blind Jewish violinist who left Algeria in the mid-1960s. Destitute, his fellow musicians had mounted a concert to help pay his ship's fare. During the benefit performance, Sonigo played several unknown pieces from the repertoire, leaving these 'lost' songs behind in Algiers with his Muslim fellow musicians. As we are wending our way down into the city centre, I ask my friend to tell me more about Sonigo, and he tells me he has a short recording of him. 'Les juifs étaient des algériens', he assures me, 'ils étaient d'ici'.[3]

In the circles of musicians and listeners that I am familiar with in Algeria, there is nothing particularly surprising about this statement. Among music-lovers, particularly those who, like my friend at the wheel, are partial to the wide range of urban song repertoires marked as patrimonial, Jewish performers are a frequent topic of conversation, and in recent years this presence has seeped into wider journalistic debates regarding the place of Jews in the Algerian nation. Indeed, on the Algerian side, music – whether through recordings, photographs, anecdotes, journalistic accounts, instruments left behind by Jewish musicians, vocal timbres, or even presidential addresses – is one way in which Jews have remained present even in their physical absence.

[3] 'Jews were Algerians; they were from here'.

The volume of popular discussions of Algerian Jews and music stands in striking contrast to the quietness of music in the old, rich, and still growing scholarly literature on Muslim-Jewish relations in the Maghrib, including the more specialized subset devoted to Algeria and its French diaspora, where music has made what we might call a cameo appearance (Boum, 2014; Katz, 2015; Stora, 2016 [2015]). When music makes its turn in the generalist scholarly literature on Muslim-Jewish relations in Algeria and the wider Maghrib, it tends to do so in forceful and consistent ways that echo the popular discourse and in many respects run against the leitmotiv of rupture that dominates the field. First and foremost, and particularly striking in the Algerian case that is my focus here, music, much like cuisine, often stands for a deep past that reaches back before the modern colonial experience but that persists right up to the end of the colonial period and into the post-colonial diaspora, albeit in fragmentary form. Yet, in contrast to cuisine, which introduces myriad elements of Muslim-Jewish differentiation (Bahloul, 1989), music is often treated as a medium of unalloyed sameness. Thus, unlike most other 'cultural' phenomena (language and dress being at the fore; see Allouche-Benayoun, 2015: 40), music is often treated as something that resisted the disentanglement of Jews from Muslims over the colonial period. The deep past that is allegedly indexed by music situates Jews as indigenous to North Africa, and also as intimately connected to Muslim North Africans. Indeed, the idea of a cameo appearance in its everyday theatrical sense might not accurately capture the potency of the musical figure in some treatments of the Algerian Jewish experience. Instead, it might be better to talk about music as standing as an *emblem* of indigeneity and intimacy, albeit located in a difficult to access substrate. In this way, music is treated as a privileged sign, an index that through some unspecified mechanism acts as a self-evident reflection of a deep past.

The semiotic and ontological qualities of music's emblematicity in this context are telling. As in much of the literature on Muslim-Jewish relations, there is a frequent slippage between the intercommunal intimacies of the late colonial past and the much deeper past that reaches back to the Ottoman era and even before. While there are some counter-tendencies that would trace Jewish participation in the public cultural sphere – including in music – to the French colonial era, the main tendency is to treat music as a vestige of a primordial indigeneity and intimacy, thereby collapsing modernist musical experimentation into much older repertoires that are conventionally traced back to al-Andalus. Such an approach conceives of music as an undifferen-tiated spirit or soul of a place; while it often treats Jews as epitomizing the musical, ultimately the musical figure points back to a fundamental, essential sameness of Maghribi Jews and Muslims that came to be disguised by the vicissitudes of the colonial era and its end.

On Muslim-Jewish Musical Intimacy in Algeria and Beyond 49

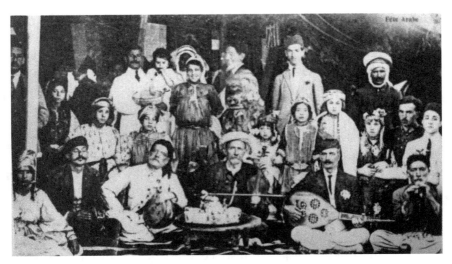

Figure 1: Postcard depicting a family party with musicians in Setif, circa 1930. © Jean Laloum and Jean-Luc Allouche.

Note, too, the way the emphasis on sameness is tied in turn to discreteness. In this reading, Muslims and Jews are clearly distinguishable as discrete categories and perhaps even discrete groups. They are brought into relatedness through something they share – in this case, music. This music, too, is discrete – a singular unit emerging from the past. In Viveiros de Castro's 'idiom of brotherhood' (2004: 18), the partners are Jewish and Muslim men and women, and the thing they have 'in common', the 'third term' to which they stand in relation and by which they stand in relation to each other, is music marked as patrimony. In other words, the ability to bridge the two groups depends upon the unity of the linking object. Take, for example, the following caption from a photograph (Figure 1) of an early twentieth-century ensemble:

> Ce sont des musiciens juifs, identifiés à tort par l'observateur français à des Arabes, la carte postale portant la mention « scène indigène. Fête arabe ». Bien davantage que dans le vêtement ou la cuisine, s'est perpétuée dans le domaine musical une fusion culturelle judéo-arabe: il n'y avait aucune distinction entre musiciens juifs et arabes (sauf peut-être une pointe d'accent différent, perceptible à l'oreille attentive). Seule comptait la qualité de l'interprétation. (Teboul, 1987: 277)[4]

[4] 'These are Jewish musicians, misidentified by the French observer as Arabs, with the postcard bearing the label "Native Scene – Arab Party". In the

A lot rides on Annie Teboul's parenthetical exception here, and I can only hint at the debates surrounding the legitimacy or lack thereof of the labels (some of them quite popular in France) of Judeo-Algerian, Judeo-Maghribi, Judeo-Andalusi, and Judeo-Arabic music, and the ways these relate to the 'misidentification' identified by Teboul. The basic point is that, in such an approach, assimilation of Muslims and Jews with each other through a common relation to the privileged, indeed exceptional third term of music is presented as being able to overcome other assimilations and separations: Jewish assimilation to Frenchness through the granting of citizenship and Jews' subsequent cultural and political 'francisation', particularly through integration into the French educational system during the colonial period, and, by the end of the War of Independence, Jews' cleaving from normative understandings of Algerian citizenship and nationhood.

There is a less celebratory coda to this logic of sameness, in that debates in the Maghrib regarding Jewish distinctiveness or lack thereof can blend into a certain reticence or even embarrassment concerning Jewish presence – in other words, the logic of sameness, pushed far enough, can in fact assimilate Jews out of existence. By this I refer to those streams of thought that acknowledge Jewish participation in Algerian musical life but that either retreat from Jews' identification as Jews (Hachelef and Hachelef, 1993), ignore musical activities associated with specifically Jewish religious practice (see discussion in Aous, 2002: 129–30), avoid Jews' identification as Algerians (Bendamèche, 2003; Meziane, 2009), seek to downplay the extent of Jewish contributions to Algerian musical life (Na'ila, 2007), or try to correct an allegedly excessive emphasis among Jews on Algerian Jewish difference from their Muslim compatriots (Saadallah, 2010).[5] Some of this can be explained by the vexed nature of Algerian citizenship and national discourses of unanimity (McDougall, 2006; Goodman, 2013a; 2013b), the complicated place of Jews in post-1962 Algerian discussions of the makeup of the nation (as well as the similarly fraught conversation in France regarding the place of Jews, Muslims, and Algeria past and present in the national imaginary), and of course the complications raised by the Palestinian-Israeli question inside various national and transnational politics. These positions require a much fuller account of their ideological implications and entanglements vis-à-vis

musical domain, much more than in dress or cuisine, a Judeo-Arabic fusion was maintained: there was no distinction between Jewish and Arab musicians (except perhaps a bit of a different accent, noticeable to an attentive ear). The only thing that counted was the quality of the performance'.

[5] This is by no means limited to Algeria, but can find counterparts throughout the Maghrib and indeed beyond.

On Muslim-Jewish Musical Intimacy in Algeria and Beyond 51

Jewish indigeneity, Muslim-Jewish intimacy, and the various lacks thereof within the Algerian political field. But for the purposes of this chapter, they point out some of the more problematic potentialities of the emphasis on sameness.

The Institutional Alternative: Integration or Hierarchy?

While emblematicity and its tensions predominate in the scholarly and popular literature that deals (however briefly) with Muslim-Jewish interactions around music, an emerging alternative approach offers a challenge. This institutional alternative dispenses with a largely stable, primordialist picture of mainly positive commonality and instead introduces a number of other factors that afford a great deal more specificity and critical edge. The decisive advantage of this approach lies in its assertion that music is not timeless but timeful, in the sense of being situated in specific (and changing) historical conditions, and therefore being embedded within larger social patterns. Even some of the oldest parts of the repertoires linked to Algerian Jews – here I am thinking mainly of certain para-liturgical repertoire in Hebrew and the melodically and modally related anonymous Arabic-language urban repertoire popularly traced to al-Andalus – underwent many changes over time, whether with regard to modes of circulation or performance practice (Bouzar-Kasbadji, 1988; Saadallah, 2010; Seroussi and Marks, 2011; Langlois, 2015; Glasser, 2016). This is not only a question of change in some autonomous field called 'music', but raises the question of the way in which musical change is tied to wider social changes, without simply saying music is a transparent reflection of its surroundings. Far from being a holdout from the pre-colonial era, these changes were themselves closely connected to colonial-era institutions, technologies, and politics that were simultaneously creating and reshaping many aspects of the Muslim-Jewish interface (Saadallah, 2010; Miliani, 2011; Glasser, 2016; Silver, 2017; Théoleyre, 2016). Furthermore, there were many musical elements of Algerian Jewish experience and Muslim-Jewish interaction in the colonial period that were tied to new, non-traditional genres, whether in Arabic, French, or other languages. Here we can think of Moroccan, Tunisian, Egyptian, French, Spanish, and pan-Mediterranean, as well as various Algerian popular novelties, among them the *franco-arabe* experiments of the 1940s and 1950s associated with such figures as Lili Boniche and Line Monty. In addition, Western European classical ensembles and genres were important parts of the Algerian and wider Maghribi soundscape in the colonial period and to a degree since.

Very quickly, then, such a track leads us to complicate the idea of music as a bulwark against the colonial, and even its very evidential value as

an unproblematic, privileged sign of some deeper truth. Instead, musical practice gets situated inside the colonial (alongside the pre-colonial, the anti-colonial, and the post-colonial), standing therefore as a sign of a near context, a sign that is itself reshaped by that context. And, of course, part of this is tied to the plurality that hides behind the singularity of such a term as 'musical practice'. So, we can find in the literature on Algerian Jewish experience (in reference to genres marked as French) evaluations of music as a vehicle of Frenchness (Lamarre, 2017). We can likewise find other genres being set up in the colonial Algerian scene as *opposed* to Frenchness – itself a form of entanglement with the colonial (Glasser, 2015). Hence, we can find the ways in which the 'pure', 'patrimonial' genres are themselves packaged and repackaged in ways that are deeply indebted to the past presents of the colonial era.

As someone whose published work fits rather well into the institutional approach, I can attest to the existence of two versions that are of relevance to the question of a Muslim-Jewish relationship but that stand in considerable tension with each other. One of these asserts that indeed there was musical intimacy involving Muslims and Jews, but that the notion of Muslim or Jewish groupness is misplaced. Instead, what we are dealing with is categories, not groups, and fluid ones at that. In other words, we ought to downplay Muslim-Jewish difference, as well as even the utility of framing things in terms of Muslim-Jewish relations; instead, we should be paying closer attention to questions of region, the urban-versus-rural, and, above all, socioeconomic class. Note that this approach allows for a far more detailed and variegated sense of the genre map, and for a deep embedding of Jews within the Algerian social fabric. In a sense, it offers an alternative notion of Viveiros de Castro's relation through identity: instead of music standing as the third term that lies in common between Muslims and Jews, Jews are here presented as already assimilated into the wider Algerian society, with music simply being one of many components of that social web. Here, it is the broad structures of society that constitute the third term through which Muslims and Jews stand in a relationship of identity.

The problem with such a move, however, is that in emphasizing Jewish embeddedness in the Maghribi social fabric, it has difficulty dealing with the question of the dilatory senses of groupness, Jewish prominence, and genre specializations – as if the very idea of Muslim-Jewish difference beyond mere nominalism is unthinkable. The second version of the institutional approach, while emphasizing a complex, diverse genre map, attempts to address this shortcoming by retaining a sense of Jewish and Muslim groupness and in turn linking this sense to generic diversity, thereby embracing questions of difference and prominence. Evidence for such musical differentiation between

On Muslim-Jewish Musical Intimacy in Algeria and Beyond 53

Jews and Muslims is not difficult to find in the historical record or in contemporary memory. At least in the nineteenth and twentieth centuries, Jews were disproportionately represented among urban professional musicians in Algeria, the Maghrib at large, and the wider Arab and Middle Eastern worlds (Seroussi, 2010). While these Jewish professional musicians (and not the cantors, amateurs, or instrumentalists specializing in Western European art music) are often the reference points when Jews, Muslims, and others speak of music as an emblem of Jewish integration in the Maghrib, they also turn out to be fulcrum points for questions of social exclusion in that, like many Muslim colleagues in the ranks of professional musicians, they were largely subaltern figures. Not unlike in Northern India and many other places (Brown, 2007), in the relations of musical production in urban Algeria in the nineteenth and twentieth centuries, the prestige associated with these musicians was largely understood by their patrons to redound to themselves through the act of patronage. And in many other cases, these urban musicians were associated with 'low' registers, with 'vulgar' vocal timbres, or with allegedly adulterated versions of the higher-prestige repertoires. At times, such linkages spilled into rivalries between majority-Muslim and majority-Jewish ensembles as well as into debates about musical reform, particularly as urban art music entered into colonial and anti-colonial cultural politics in the interwar period (Seroussi, 2010; Glasser, 2012; Théoleyre, 2016). Once again, this is not unrelated to the notion of identity and assimilation along Viveiros de Castro's model, but the form of assimilation in this variant is one of hierarchical subsumption or encompassment, in which a nested sense of groupness is emphatically maintained. As in the first version of the institutional approach, Jews and Muslims are linked through the broader social web, and not by music per se, but here the web tends towards the vertical rather than the horizontal. In this respect, the hierarchical option shares with the emblematic approach an emphasis on discrete Muslim and Jewish groupness, although on unequal terms.

This hierarchical option brings me to my second vignette featuring the same *algérois* aficionado whose comments about Charles Sonigo I recounted in the previous section. This time, however, we are in the office of one of his relatives. Without my prompting, my friend asks if I've ever heard the Israeli ensemble. He shows me a video clip on the computer, explaining that this is the 'l'école andalouse israélienne' ['the Israeli school of Andalusi music']. The clip is of a female vocalist, accompanied by an ensemble, singing 'Yā nāss mā ta'dhirūnī' ['O people, Do Not Blame Me'], from the Andalusi repertoire of Algiers. I point out some of the unidiomatic elements of the instrumental accompaniment and of the singer's vocal timbre, and he explains that yes, Jews played this music, but it was never theirs.

And so the institutional approach leaves us in a strange position. On the one hand, it is far richer than the emblematic approach with regard to musical specifics. On the other hand, we should be wary of where it is taking us. Is it saying that the idiom of 'brotherhood' does not go far enough – that in fact we should not get hung up on separate Muslimness and Jewishness or even 'fraternity' tout court, but rather should pay attention to the luxuriant diversity of musical practices on the ground? Or is it saying that that very diversity provides the building blocks (or at least the refractions) of a hierarchical relationship – neither between siblings nor between affines but, as illustrated in my friend's dismissive comment regarding the Andalusi Orchestra of Israel, between patrons and clients? In other words, it raises the question of whether we should be thinking of Jewish specialization in professional music-making as a sign of marginality rather than of integration, of outsider status rather than insider status, of dhimmi status rather than equality, of exogeneity rather than indigeneity, of hierarchy rather than intimacy, and of difference rather than sameness.

Towards a Conclusion: The Affinal Alternative

The problem with all these approaches lies in the way they limit us. In the emblematic approach, we were stuck with a simplistic view of music and of the social terrain, and only the options of sameness of relationship and assimilation. The institutional approach offered a richer, more thoroughly contextualized musical map with two paths. In one, a thoroughgoing, multilayered assimilation was triumphant, while in the other, hierarchy reigned. The valuable critique offered by the institutional approach notwithstanding, in a sense this approach puts us back to square one in the literature on the Muslim-Jewish interface. It seems to close off the possibility of non-hierarchical forms of difference; it focuses almost exclusively on Jewish participation in profane Arabic-language repertoires at the expense of liturgical and para-liturgical musical practice; and it brings to mind the old zero-sum game that pits integration against conflict (Stillman, 1977; Deshen, 1989; Bilu and Levy, 1996), leaning either in the latter direction or in the direction of that vague sense of ambivalence that seems to pervade the literature on Muslim-Jewish relations in North Africa (Gottreich and Schroeter, 2011).

In a way, even the emblematic approach already unloads us of the assumption that intimacy and difference are opposed, in that the closeness of Muslims and Jews around the third term of music assumes that we are dealing with two collective subjects in relationship. But how can we keep this insight in mind while taking into account the generic and other social subtleties associated with the institutional approach? And, moving beyond

On Muslim-Jewish Musical Intimacy in Algeria and Beyond 55

the latter, is there a way to think about difference that does not only take the form of hierarchy or simple nominalism? One helpful precedent in the North Africanist literature on Muslim-Jewish relationships is Lawrence Rosen's work on Sefrou, Morocco (1984), where he suggests that Jewish-Muslim separation in the realm of kinship and its accompanying domain of competitive exchange facilitated Jewish-Muslim friendships, even if some of these friendships took a hierarchical form through Muslim patrons' protection of Jewish subjects. In other words, difference facilitated intimacy (including hierarchical forms of intimacy) in a way that actual non-metaphorical agnation made difficult. But how might we translate Rosen's ethnographic insights into a response to the questions at hand? This is where the idea of music as a medium of relatedness becomes useful, as a kind of sonic alternative to the bonds of kinship. And it is in this medium that Viveiros de Castro's affinal alternative becomes most promising. If the emblematic approach was all about the idiom of 'brotherhood', in which '[two] partners in any relation are defined as connected in so far as they can be conceived to *have something in common*, that is, as being in the *same* relation to a third term', meaning that '[to] relate is to assimilate, to unify, and to identify' (Viveiros de Castro, 2004: 18), the institutional approach tended to emphasize relationality through hierarchy, or to dissolve the possibility of talking about Muslim-Jewish relationality at anything beyond an atomistic level altogether. But what about the possibility of a non-hierarchical form of relationality? Is there an echo of the Amazonian ontologies here, and their postulation of 'difference rather than identity as the principle of relationality', in which 'a relation can only exist between what differs and in so far as it differs' (Viveiros de Castro, 2004: 18)?

In many ways, such an approach has not yet been fully articulated in the academic literature, although the comments of Rachid Aous (2002) come close, as does the work of Maya Saidani (2006) on Constantine, particularly in her discussions of pre-1962 Jewish performers and of post-1962 women's versions of urban repertoires. However, in my experience as an ethnographer, something like affinity or what Ella Shohat has called 'differentiated commonalities' (2017: 169) is strewn throughout people's discourse and practice, even if it is not named as such. Take, for example, the ubiquitous phenomenon of contrafact, including the sharing of melodies across profane Arabic and sacred Hebrew texts. One of the things that is liberating when thinking about such sacred-profane communication is the way that it allows us to consider much more than the profane, Arabic-language repertoire, and start to consider both Jewish and Muslim sacred practice in relation to each other and in relation to that more public domain. Anecdotes of Muslims frequenting the Jewish sacred sphere, in which the synagogue

56 *Jewish-Muslim Interactions*

serves as a space of exportation, are particularly evocative. In some cases, these anecdotes deal with parody, in which auditory proximity leads to the capacity to imitate the singing of *piyyuṭim* (para-liturgical repertoire). In other anecdotes, listeners learn aspects of Jewish liturgical practice in order to adapt it to the profane sphere. In some instances, I have heard the colloquial Arabic word 'shnūgha' – generally meaning synagogue – used to refer specifically to liturgical and para-liturgical singing, as in ''andu shshnūgha dyal līhūd'.[6] But one of the most suggestive of such anecdotes, one that we can think of in terms of affectionate theft, came from the late Sid Ahmed Serri, dean of the Andalusi tradition of Algiers, who recounted to me how he used to eavesdrop with friends in a foyer adjoining the small synagogue in Bab Azzoun in the centre of Algiers, in order to listen in on what was being sung on the other side of the wall.

Much more can and should be said about contrafact, including the trope of borrowing and its ideological implications. But for the purposes of our discussion here, I would like to point out the way in which the melody's imputed unity across texts is intertwined with the difference in words and their context, not unlike the cross-cousin relationship in much of Amazonia, whose closeness lies precisely in the linkage through parents who are cross-sex siblings rather than two brothers or two sisters. Or take the question of what made and makes a Jewish voice, and why Muslim listeners would have found a Jewish voice attractive; one Algerian Muslim singer explained to me that one of the things that made Jewish singers attractive was their difference in pronunciation, so that this 'faisait partie du charme' ['was part of the charm']. In other words, the melody and text may have been more or less the same, but it was its passage through the Jew rather than the Muslim that made its performance attractive to the latter. This is not about sameness through and through; nor is it about hierarchy per se, or a narrowed frame of Jewish 'participation' in the profane, at the expense of Jewish specificities, whether liturgical, para-liturgical, or extra-liturgical. While musically there is 'something in common', it is emphatically not a question of Jews and Muslims bearing the '*same* relation to a third term' (Viveiros de Castro, 2004: 18), but rather of their bearing a somewhat different relation to that third term, and thereby producing somewhat different versions of it.[7] As opposed to the model

 6 'He has [knowledge of] the liturgy of the Jews'.

 7 This is a simplification, in that the third term ('music') is itself fluid and incomplete, and in that Jews and Muslims do not preexist the musical field but rather both make it and are in part made by it. Nevertheless, my reading here is an approximation of a widespread insider model, as well as a sketch of a possible map of a longue durée social dynamic. Note, furthermore, that relationship

On Muslim-Jewish Musical Intimacy in Algeria and Beyond 57

of unanimity sometimes ascribed (often rightfully) to the Algerian political ethos (McDougall, 2006; Goodman, 2013a; 2013b), this is a model that posits a heterophonic cultural politics, in which multiple (although collective) voices that only approximate a common theme provide the dominant aesthetic.

Musically or otherwise, such affinity is not devoid of tension – indeed, it depends on tension. And in this respect, it is useful to return one last time to my interlocutor in the car in Algiers. Later in our conversation on the way to the centre of Algiers, just after he had asserted that Jews like Charles Sonigo 'étaient des algériens, ils étaient d'ici',[8] he also said that that was 'la belle époque, les années 30, quand il y avait une concurrence entre juifs et musulmans en ce qui concerne la musique'.[9] Indeed, according to him, this rivalry moved things forward. In other words, discreteness and sharing can easily shift into agonism, into competitive exchange between equals or near equals.

This comment about rivalry also demonstrates the way in which the three approaches mapped in the preceding pages might easily blend into one another in practice, so that my friend's statement about the belle époque can coexist with his statement that Jews played this music, but it was never theirs, and even with his assertion that Jews 'étaient des algériens, ils étaient d'ici'.[10] Linkage and separation, each in their various forms, are indissociable. My friend's three assertions – that Jews were the same as Muslims, that this music was not theirs, and that a shoulder-to-shoulder rivalry between Jews and Muslims was good for music – are signs not so much of his contradictions but rather of the energies of closeness, of three potential aspects of relationality, three possible answers to the question of what it means to say people are more than friends.

Works Cited

Allalou (Selali Ali). 1982. *L'Aurore du théâtre algérien* (1926–1932). Oran: Université d'Oran.

Allouche-Benayoun, Joëlle. 2015. 'Les Juifs d'Algérie: Du *dhimmi* au citoyen français'. In J. Allouche-Benayoun and G. Dermenjian (eds.), *Les Juifs d'Algérie: une histoire de ruptures*. Aix-en-Provence: Presses Universitaires de Provence: 27–42.

through the third term of music does not negate relationship through the broader third term of society.

[8] 'Jews were Algerians, they were from here'.

[9] It was 'the belle époque, [during] the 1930s, when there was a rivalry between Jews and Muslims with regard to music'.

[10] 'were Algerians, they were from here'.

Allouche-Benayoun, Joëlle, and Geneviève Dermenjian (eds.). 2015. *Les Juifs d'Algérie: une histoire de ruptures*. Aix-en-Provence: Presses Universitaires de Provence.

Aous, Rachid. 2002. 'Le Chant et la musique judéo-arabes: contexte historique et définition'. *Horizons maghrébins: Le droit à la mémoire* 47: 126–34.

B., Nā'ila. 2007. 'Al-tahwīd..al-tahdīd al-akhar lil-turāth al-jazā'irī ba'd al-tahrīb' ['Judaization: The Other Threat to the Algerian Patrimony After Contraband']. *Ennahar Online*, 1 December. Available at: https://www.ennaharonline.com/ التهويد-التهديد-الآخر-للتراث-الجزائر (consulted on 10 September 2019).

Bahloul, Joëlle. 1989. 'From a Muslim Banquet to a Jewish Seder'. In A. Udovitch and M. Cohen (eds.), *Arabs and Jews: Contacts and Boundaries*. Princeton, NJ: Darwin Press: 85–95.

Baron, Salo. 1928. 'Ghetto and Emancipation: Shall We Revise the Traditional View?' *The Menorah Journal* 14.6: 515–26.

Bendamèche, Abdelkader. 2003. *Les grandes figures de l'art musical algérien*. Algiers: ENAG.

Ben-Yehoyada, Naor. 2017. *The Mediterranean Incarnate: Region Formation Between Sicily and Tunisia since World War II*. Chicago: University of Chicago Press.

Bilu, Yoram, and André Levy. 1996. 'Nostalgia and Ambivalence: The Reconstruction of Jewish-Muslim Relations in Oulad Mansour'. In Harvey Goldberg (ed.), *Sephardi and Middle Eastern Jewries: History and Culture in the Modern Era*. Bloomington: Indiana University Press: 288–311.

Boum, Aomar. 2014. *Memories of Absence: How Muslims Remember Jews in Morocco*. Stanford: Stanford University Press.

Bousbia, Safinez (dir.). 2011. *El Gusto*.

Bouteflika, Abdelaziz. 1999. 'Commémoration du 2500ème Anniversaire de la Fondation de la Ville de Cirta (Constantine, July 6, 1999)'. Available at: http://www.el-mouradia.dz/francais/president/recherche/Presidentrech.htm (consulted on 5 December 2018).

Bouzar-Kasbadji, Nadya. 1988. *L'Emergence artistique algérienne au XXe siècle: contribution de la musique et du théâtre algérois à la renaissance culturelle et à la prise de conscience nationaliste*. Algiers: Office des publications universitaires.

Brown, Katherine Butler [Schofield]. 2007. 'The Social Liminality of Musicians: Case Studies from Mughal India and Beyond'. *Twentieth-Century Music* 2: 13–49.

Deshen, Shlomo. 1989. *The Mellah Society: Jewish Community Life in Sherifian Morocco*. Chicago: University of Chicago Press.

Glasser, Jonathan. 2012. 'Edmond Yafil and Andalusi Musical Revival in Early 20th Century Algeria'. *International Journal of Middle East Studies* 44.4: 671–92.

―――. 2016. *The Lost Paradise: Andalusi Music in Urban North Africa*. Chicago: University of Chicago Press.

―――. 2017. 'Musical Jews: Listening for Hierarchy in Colonial Algeria and Beyond'. *Anthropological Quarterly* 90.1: 139–66.

Goodman, Jane E. 2013a. 'Acting with One Voice: Producing Unanimism in Algerian Reformist Theater'. *Comparative Studies in Society and History* 55.1: 167–97.

―――. 2013b. 'The Man Behind the Curtain: Theatrics of the State in Algeria'. *Journal of North African Studies* 18.5: 779–95.

Gottreich, Emily Benichou, and Daniel J. Schroeter (eds.). 2011. *Jewish Culture and Society in North Africa*. Bloomington: Indiana University Press.

Guedj, Jérémy. 2009a. 'La Musique judéo-arabe: patrimoine de l'exil'. In Driss El Yazami, Yvan Gastaut, and Naïma Yahi (eds.). *Générations. Un siècle d'histoire culturelle des Maghrébins en France*. Paris: Gallimard: 148–56.

―――. 2009b. 'Un symbole de l'exil des juifs d'Afrique du Nord en France: la musique judéo-arabe'. *Écarts d'identité* 114: 35–43.

―――. 2012. 'Juifs et musulmans d'Algérie en France Cinquante ans d'exil partagé, entre mémoire, échanges etdéchirements'. *Hommes et migrations: Revue française de référence sur les dynamiques migratoires* 1295: 144–54.

Hachelaf, Ahmed, and Mohamed Elhabib Hachelaf. 1993. *Anthologie de la musique arabe, 1906–1960*. Paris: Publisud.

Katz, Ethan B. 2015. *The Burdens of Brotherhood: Jews and Muslims from North Africa to France*. Cambridge, MA: Harvard University Press.

Lamarre, Annie Stora. 2015. 'Transmissions mémorielles au féminin. Constantine-Paris'. In Joëlle Allouche-Benayoun and Geneviève Dermenjian (eds.), *Les Juifs d'Algérie: une histoire de ruptures*. Aix-en-Provence: Presses Universitaires de Provence: 225–38.

Langlois, Tony. 2015. 'Jewish Musicians in the Musique Orientale of Oran, Algeria'. In Ruth F. Davis (ed.), *Musical Exodus: Al-Andalus and Its Jewish Diasporas*. New York and London: Rowman and Littlefield: 141–63.

McDougall, James. 2006. *History and the Culture of Nationalism in Algeria*. Cambridge: Cambridge University Press.

Meziane, Abdelhakim. 2009. 'Le Vieil Alger musical'. Conferences of the 6th Andaloussiate Festival, 20 May. Algiers: Complexe Culturel Laâdi Flici.

Miliani, Hadj. 2011. 'Crosscurrents: Trajectories of Algerian Jewish Artists and Men of Culture since the End of the Nineteenth Century'. In Emily Benichou Gottreich and Daniel J. Schroeter (eds.), *Jewish Culture and Society in North Africa*. Bloomington: Indiana University Press: 177–87.

Rosen, Lawrence. 1984. *Bargaining for Reality: The Construction of Social Relations in a Muslim Community*. Chicago: University of Chicago Press.

Saadallah, Fawzi. 2010. *Yahud al-Jaza'ir: Majalis al-Tarab wa-l-Ghina'*. Algiers: Dār Qurṭuba.

Saidani, Maya. 2006. *La Musique du Constantinois: Contexte, nature, transmission et définition*. Algiers: Casbah Editions.

Seroussi, Edwin. 2010. 'Music'. In Norman A. Stillman (ed.), *Encyclopedia of Jews in the Islamic World*. Leiden: Brill: 498–519.

Seroussi, Edwin, and Essica Marks. 2011. 'Ha-musīqa' ['Music']. In Haim Saadoun (ed.), *Alg'iryah [Algeria]*. Jerusalem: Ben Zvi Institute: 213–34.

Shiloah, Amnon. 2002. 'Pe'ilutam shel musikayim yehudim ba-musika ha-klasit ha-algerit ye-ba-sugot she-hist'afu mimenah'. *Pe'amim* 91: 51–64.

Shohat, Ella. 2017. 'The Invention of Judeo-Arabic'. *Interventions* 19.2: 153–200.

Silver, Christopher Benno. 2017. 'Jews, Music-Making, and the Twentieth-Century Maghrib'. Unpublished doctoral thesis. University of California Los Angeles.

Stillman, Norman. 1977. 'Muslims and Jews in Morocco'. *Jerusalem Quarterly* 5: 74–83.

Stora, Benjamin. 2016 [2015]. *Les Clés retrouvées: Une enfance juive à Constantine*. Paris: Champs histoire.

Swedenburg, Ted. 2005. 'Against Hybridity: The Case of Enrico Macias/Gaston Ghrenassia'. In Rebecca L. Stein and Ted Swedenburg (eds.), *Palestine, Israel, and the Politics of Popular Culture*. Durham, NC: Duke University Press: 231–56.

Teboul, Annie. 1987. 'Les musiciens'. In Jean Laloum et Jean-Luc Allouche (eds.), *Les Juifs d'Algérie: images et textes*. Paris: Editions du Scribe: 276–81.

Théoleyre, Malcolm. 2016. 'Musique arabe, folklore de France? Musique, politique et communautés musiciennes en contact à Alger durant la période coloniale (1862–1962)'. Unpublished doctoral dissertation. Sciences Po.

Viveiros de Castro, Eduardo. 2004. 'Perspectival Anthropology and the Method of Controlled Equivocation'. *Tipití: Journal of the Society for the Anthropology of Lowland South America* 2.1: 3–22.

Nationalist Records:
Jews, Muslims, and Music
in Interwar North Africa

Christopher Silver

Introduction

In the early hours of 20 February 1930, Eliaou Mimouni entered the apartment of Tunisian Jewish superstar Habiba Messika as she slept.[1] The septuagenarian fan-turned-assassin then lit her bedroom aflame.[2] The following day, Messika, the most popular recording artist and actor of the interwar Maghrib and all of twenty-seven years old, succumbed to her wounds. Messika's murder shocked her native Tunis. It also set the city on edge. In her death, as in her life, Messika had brought Tunisian Jews and Muslims together. That fact alone was not necessarily cause for alarm for the French Protectorate authorities then preparing for her public funeral. But the ways in which the two communities were coalescing around the increasingly nationalist tenor of her music was.

[1] 'Habiba Messika "Chikhat" réputée victime d'une vengeance, meurt après avoir été afreusement brûlée', *L'Écho d'Alger*, 22 February 1930. Available at: http://gallica.bnf.fr/ark:/12148/bpt6k75852128/f6.item.r (consulted on 10 September 2019).

[2] Mimouni was known to Messika and her neighbours. Messika herself identified him as her assailant from her hospital bed (see above article), but the exact nature of their relationship remains unclear.

On 23 February 1930, Resident General François Manceron's office sent a hurried note to the Director of Public Security in Tunisia regarding Messika's impending funeral.[3] Manceron's Plenipotentiary Minister had gleaned from the morning papers that the burial on 24 February 1930, just a few days before the end of Ramadan, would be a decidedly Jewish-Muslim affair. 'Les obsèques de la chanteuse juive Habiba Messika', he reported, 'ont été renvoyés à 14 h 30 à la demande des musulmans de Tunis, qui désirent y assister', and who had preferred fasting at home before joining the cortege in the afternoon.[4] Not mentioned in the press, however, was the more actionable piece of intelligence. Manceron's minister spelled it out in no uncertain terms: 'Habiba Messika s'était mise des dernières années au service des destouriens'.[5] Given that her most recent recordings for the Baidaphon label had celebrated Egyptian independence,[6] the Great Syrian Revolt,[7] the Iraqi king,[8] and the Tunisian Bey[9] – and that security services were already having difficulty impeding the flow of her discs, the Director of Public Security was likely aware of her political proclivities (Silver, 2018). That Messika had found common cause with the anti-colonial nationalist Destour (the Tunisian Liberal Constitutionalist Party) justified the call 'de faire observer très sérieusement ce qui se passera aux obsèques'.[10]

[3] 'Note pour M-le Dr de la Sûreté', 23 February 1930, as cited in *Watha'iq* (1994: 126).

[4] Ibid.: 'The funeral of the Jewish singer Habiba Messika has been moved to 2.30pm at the request of the Muslims of Tunis who would like to attend'. This and all subsequent quotations were translated by the author of this chapter.

[5] Ibid.: 'Habiba Messika had been in the service of the Destourians for the last few years'.

[6] Habiba Messika, 'Elnachid el mousri' ['The Egyptian National Anthem'], Baidaphon, B 086520, 1928. Baidaphon records, like most labels catering to the region, carried song titles and artist names both in Arabic and in French transliteration or translation. When referencing songs or musicians, I have chosen to provide the French rendering in order to match the spelling found in archival documents.

[7] Habiba Messika, 'Anti Souria Biladi' ['Syria, You Are My Country'], Baidaphon, B 086596, 1928.

[8] Habiba Messika, 'Hymne malik Fayçal' ['The Anthem of King Faysal'], Baidaphon, B 086530, 1928.

[9] Habiba Messika, 'Salam Bey Tunis' (the Beylical hymn and Tunisian national anthem), Baidaphon, B 086622, 1928.

[10] 'Note pour M-le Dr de la Sûreté', 23 February 1930, as cited in Watha'iq (1994: 126): 'The most serious observation of what was to take place at the funeral'.

On 24 February 1930 – the day of Messika's funeral – the Director of Public Security reported back to Manceron.[11] By midday, the funeral procession had ballooned beyond expectation – 5,000 according to one estimate (Hamrouni, 2007: 21) – 'grossissait d'instants en instants',[12] as it made its way eastward out of the capital's Jewish quarter towards the Borgel Cemetery. 'La foule', cosmopolitan in its ethno-religious and social diversity, 'était composée d'élements israélites, européens et musulmans appartenant à toutes les classes de la population'.[13] As the mass of mourners arrived at the city's principle Jewish cemetery, the Director of Public Security underlined the fact that Destourians had mingled among them but had been careful not to congregate as a group so as not to arouse suspicion. Given the cross-confessional, cross-class, and high-profile nature of the funerary ceremonies, it was with little exaggeration that the Director of Public Security concluded that 'jamais en Tunisie, des obsèques se sont déroulées au milieu d'un concours aussi important de personnes'.[14]

Within weeks of Messika's funeral, the French Residents-General in Tunisia and Morocco and the Governor General in Algeria found themselves with another problem on their hands. While Messika was gone, her voice was everywhere. Her death had contributed to a surge in the spread of her nationalist records. That swell in sales was facilitated by the commercial collaboration of North African Jews and Muslims who worked hand-in-hand to distribute her discs across the Maghrib. As a result, French patience with an industry that had once had their support wore thin. Adding to their frustration was the subsequent release of other nationalist records – or records understood to threaten French control – by Algerian Jewish veteran recording artist Lili Labassi and Algerian Jewish newcomer Salim Halali. To stop the potent sounds of Messika, Labassi, and Halali, draconian censorship policies targeting records were established in Morocco, Algeria, and Tunisia throughout the 1930s.

Scholars of North Africa have long recognized that Jews and Muslims performed and sometimes consumed music together during the interwar period (Glasser, 2016; Katz, 2015; Miliani, 2010; Carlier, 2009; Swedenburg,

[11] 'A/S des obsèques de HABIBA MESSIKA', 24 February 1930, *Watha'iq* (1994: 122–23).

[12] Ibid.: 'Growing minute by minute'.

[13] Ibid.: 'The crowd was composed of Jewish, European, and Muslim elements belonging to all classes of the population'. The Europeans in attendance may have been members of the Maltese or Sicilo-Italian communities or even Livornese Jews (known as the 'Grana' to the indigenous 'Twansa' Jewish population).

[14] Ibid.: 'Never before in Tunisia has a funeral taken place among such a vast gathering of people'.

2005; Bouzar-Kasbadji, 1988). This chapter, drawing on Jonathan Glasser (2017) and his work on rethinking the Jewish-Muslim relationship in the Maghrib through the lens of musical hierarchy (as opposed to music in a more general sense), reveals a phenomenon beyond the symbolic Jewish-Muslim sonic symbiosis already documented in the scholarship. Between the two world wars, Jews and Muslims crafted, recorded, performed, passed around, and consumed *nationalist* music together. This is all the more striking when considering that Jewish voices, almost entirely absent from the historiographic literature on interwar nationalism in North Africa, often came to best capture the anti-colonial nationalist ambitions of their Jewish and Muslim compatriots.

This chapter traces the distribution in Morocco of three interwar records made by Tunisian and Algerian Jewish artists. These discs, recorded, respectively, by Habiba Messika, Lili Labassi, and Salim Halali, were all deemed nationalist by a host of colonial and indigenous actors and were subsequently subjected to French censorship. This trio of musical episodes, I contend, reveals as much about the Jewish-Muslim relationship as it does about the practice of nationalism among ordinary – as opposed to elite – Jews and Muslims in the Maghrib. Operating between these thematic axes, this chapter makes three arguments. First, the Jewish-Muslim relationship, as expressed through music, was sometimes at its most dynamic when it intersected and engaged with nationalism. Indeed, while treatment of nationalism in North Africa has tended to render Jews, Muslims, and their relations as static, if not opposed, music and its movement make clear the frenetic energy with which Jewish and Muslim musicians, merchants, and customers actively participated in emerging nationalist forms. Second, while the study of nationalism in the Maghrib has largely focused on political parties and their elite leadership – as Susan Gilson Miller (2013: 4) has made clear with regard to Morocco – this chapter demonstrates that professional musicians of dubious social status, small-scale merchants and peddlers, and patrons of popular cafés and less savoury venues actively shaped the sounds that fed nascent nationalist movements. Third, that Jews and Muslims of diverse classes gathered around the nationalist records of someone like Habiba Messika reveals that cosmopolitanism and nationalism were not always opposed in North Africa but were in myriad ways mutually constitutive. In similar fashion, a certain cosmopolitanism can be detected in the nationalist music itself, which ranged in global, regional, and local styles and was sung in a number of dialects. To make these arguments, this chapter follows music rather than borders. In other words, the story of three censored North African records – one by the Tunisian Messika and one each by Algerians Labassi and Halali – necessitates narrating along what Julia Clancy-Smith (2006: 3) has

referred to as the Maghrib's 'horizontal axis', rather than looking northward to metropolitan France. What happened in Tunis sometimes played out in Morocco while taking inspiration from Egypt. Such was certainly the case with Habiba Messika and her recording of the Egyptian national anthem, the first of our three case studies.

Habiba Messika and 'El Nachid El Mousri' ['The Egyptian National Anthem']

On 24 February 1930, the Tunisian Muslim theatrical luminary Bechir Methenni delivered an eloquent eulogy for Habiba Messika, the Tunisian Jewish leading light of stage and song now fallen. The prominent Muslim personality did so before a diverse and overflowing Jewish and Muslim crowd in the capital's expansive Jewish cemetery. Among them were members of the Destour which, like most other nationalist movements in the Maghrib, called for increased rights for the indigenous population and reform of the colonial state but not yet full independence. For the French colonial regimes operating in Algeria since 1830, Tunisia since 1881, and Morocco since 1912, however, such challenges to their authority were regarded as menacing and often existentially so.

Like the rest of Tunis, Bechir Methenni, director of L'Avenir théâtral (al-Mustaqbal al-Masrahi), the theatre troupe in which Messika starred, was devastated by the loss of the woman who had earned the title of 'malikat al-tarab' ['the queen of musical ecstasy']. In his elegiac remarks, Methenni highlighted Messika's extraordinary contribution to Tunisian theatre and music. She was at once her own person, Methenni reminded the assembled, the embodiment of an artist 'aux yeux de la population tunisienne' ['in the eyes of the Tunisian population'], and at the same time, no less than a 'seconde SARAH BERNARDH [sic]' ['second Sarah Bernhardt'] – the turn-of-the-century French Jewish actress to whom she was frequently compared.[15] He concluded his powerful address by speaking to Messika directly:

> Hélas chère camarade, ta voix ne se fera plus entendre, mais sois sûre que son souvenir restera gravé dans notre imagination et lorsque nos enfants entendront quelques uns de tes disques, c'est les larmes aux yeux que nous leur raconterons ta vie, tes sentiments généreux en leur inculquant cette idée que personne n'égalera ton génie [...] Adieu HABIBA, dors en paix sœurette, tu l'as bien mérité.[16]

15 Untitled and undated eulogy, *Watha'iq* (1994: 124–25).

16 Ibid. 'Alas, dear friend, your voice will no longer be heard, but rest assured that

66 *Jewish-Muslim Interactions*

Methenni's words undoubtedly reverberated among the mourners. As many already knew, however, Messika's records did not have to wait a generation to be passed down and around. Within months of her death, her discs proliferated, especially in Morocco. For the French authorities there, the problem was not their volume per say but their dubious origin and content. Messika's music, recorded outside of French reach, was nationalist. As the Civil Controller of Morocco's Doukkala region cautioned in a report to his Civil Control superior in Rabat, records like '"El Nachid El Mousri" (disque no B 86.520)' – Messika's rendition of the Egyptian national anthem – were 'susceptibles de provoquer une agitation dans les milieux musulmans'.[17]

In 1928, two years before her death and a decade since the launch of her illustrious career, Habiba Messika travelled beyond French control to record with the Baidaphon label in Germany. It would be her first and last time doing so. Baidaphon, established by the Lebanese Christian Baida family in Beirut in the early years of the twentieth century and shortly thereafter headquartered in Berlin, had commenced operations in North Africa as early as 1922 but had only begun to record commercial artists there – or more accurately, from there – in 1928.[18] Rather than meeting musicians where they were, as was common practice at the time among other record labels, Baidaphon brought the musicians to them. In doing so, Baidaphon accomplished two aims. First, it guaranteed artists access to new technologies like electrical recording, which permitted a wider range of frequencies to be captured on disc than ever before. Second, the label provided cover for musicians to do things otherwise near impossible under colonial rule in French North Africa. This included recording nationalist material. Thus, when Théodore Khayat, the Casablanca-based head of Baidaphon operations in the Maghrib, brought Messika to Berlin to record in April 1928, she was very pleased with what she saw and heard.

its memory will remain engraved in our imaginations and when our children listen to some of your records, it will be with tears in our eyes that we will tell them about your life, about your generous spirit, and that we will instill in them the idea that no one will ever be the equal of your genius [...] Farewell Habiba, rest in peace, little sister, you have earned it'.

[17] Centre des Archives diplomatiques de Nantes [CADN] MA 200/193, 'Propaganda étrangère par les phonographs', 30 May 1930: 'Prone to provoke unrest in Muslim milieux'.

[18] On Baidaphon in Germany, see Lotz, 'The German 78rpm Record Label Book'. Available at: http://www.recordingpioneers.com/docs/BAIDA-TheGerman 78rpmRecordLabelBook.pdf (consulted on 10 September 2019). For Baidaphon's initial activities in the Maghrib, see CADN MA/200/193, Théodore Khayat to Yves Sicot, 5 May 1937.

In a letter penned to the executives at Baidaphon on 21 April 1928, and reproduced in the label's first Tunisian record catalogue, Messika thanked the company for 'le bon enrégistrement electrique' ['the fine electrical recording'] of her voice.[19] 'Plus d'une manière exceptionelle', she added of her discs, 'ils sont meilleurs que tous ceux que j'ai enrégistré [sic] ailleurs'.[20] Her best recordings to date included classical and popular Tunisian and Egyptian pieces, much like her past sessions with the Pathé and Gramophone labels. But, in Berlin, Messika veered headlong into the politically subversive as well.[21] For Baidaphon, the Jewish artist recorded songs extolling Tunisia and so too, Syria, Iraq, and Egypt, the latter of which served as a potent symbol of independence for Arab nationalists across the greater Middle East.[22] If it could have been concluded, however, that Messika was merely singing about Egypt, the 'malikat al-tarab' quickly laid that to rest by adding geographically specific verses to certain songs and by recording unambiguously nationalist dialogue in the midst of others. On 'Baladi ya baladi' ['My Country, O My Country'], for example, Messika sang almost entirely of Egypt, her 'baladi ba'ida' ['distant country'], save for a single but powerful couplet about Tunisia.[23] On still other Egyptian-themed records, such as 'Marche de sa Majeste Fouad I[er] Roi d'Egypte' ['His Majesty King Fuad's March'], the Tunisian Muslim pianist Mohammed Kadri yelled, 'Ta'ish al-malik Fuad, malik masr' ['Long live King Fuad, King of Egypt'], as Messika and her orchestra erupted in thunderous applause.[24] Messika's recording of the Egyptian national anthem for Baidaphon, another march, was likewise far from innocent. For fans of the Jewish artist in the Maghrib, an Egyptian anthem hailing liberty was easily imagined as theirs as well.

In early May 1930, just a few months after Messika's death, Baidaphon sent a large shipment of their records from Germany to the Jewish-owned

[19] Centre des Musiques Arabes et Méditerranéennes, Ennejma Ezzahra [CMAM], uncatalogued, 'Istwanat Baydafun', 1928. Similar letters by other artists were included in Egyptian Baidaphon catalogues (Racy, 1976: 39).

[20] Ibid.: 'More than exceptional, these are better than any I have recorded elsewhere'.

[21] This was not the first time that Messika engaged in the political (Idris, 2007: 102).

[22] In Morocco, Algeria, and Tunisia, the French authorities regularly complained about the nationalist potency of Egyptian film and music. See, for example, ANOM 15h/32, 'Contrôle des disques de gramophone de langue étrangère', 4 December 1937.

[23] Habiba Messika, 'Baladi ya Baladi' ['My Country, O My Country'], Baidaphon, B 086405, 1928.

[24] Habiba Messika, 'Marche de sa Majeste Fouad Ier Roi d'Egypte' ['His Majesty King Fuad's March'], Baidaphon, B 086473, 1928.

record store empire of Bembaron et Hazan in Morocco.[25] It was business as usual as far as the two companies were concerned. The French security services, by contrast, were still acclimating to the new nationalist reality in their midst. 'Dissimuler parmi un lot de disques de musique arabo andalouse',[26] the Civil Controller of Morocco's Oued Zem region wrote on 16 May 1930 to Civil Control headquarters in Rabat, was a disc entitled 'l'hymne national des jeunes marocains' ['the National Anthem of Moroccan Youth'], recorded by the Moroccan Muslim musician Thami Ben Aomar. Civil Control headquarters, however, were already well aware of the Ben Aomar record. Since Bembaron et Hazan had begun selling 'l'hymne national des jeunes marocains' in its ten-plus branches, reports on the nationalist hymn – penned by Baidaphon's Théodore Khayat – had been flooding the Office of Civil Control in Rabat.[27] By 16 May 1930, the stakes had been raised considerably. That same day, Resident General Lucien Saint and Sultan Mohammed Ben Youssef promulgated what became known as the 'Berber Dahir', a decree that attempted to legally segregate Moroccan Berbers from Moroccan Arabs (Wyrtzen, 2015; Miller, 2013). The 'Berber Dahir', which was seen by many Moroccans Muslims, Berbers and Arabs alike, as a violation of Islamic law, set off months of protest that fed the growing anti-colonial nationalist movement. That movement, it seemed, might now have its anthem. In his letter of 16 May 1930, the Civil Controller of Oued Zem slammed Ben Aomar's Baidaphon disc, referring to it as no less than a 'Marseillaise Marocaine' ['Moroccan Marseillaise'].[28] Given the ensuing climate, Civil Controllers across Morocco redoubled their efforts to seize copies of Ben Aomar's anthem before it could do further harm.

But even at its outset, the search quickly shifted away from Ben Aomar and towards Habiba Messika, whose 1928 recording of the Egyptian national anthem proved enduringly popular among ordinary Moroccans. In the hunt for Ben Aomar's records, security officials, intelligence officers, and police instead found the Jewish artist's records time and again. On 5 May 1930, for example, hot on the trail of Ben Aomar's 'Marseillaise Marocaine', security service agents zeroed in on a Muslim merchant by the name of Mustapha Lemcharfi in the nationalist hotbed of Fez.[29] Operating out of the medina

[25] CADN MA/200/193, 'ACTIVITE DES JEUNES MAROCAINES', 16 May 1930.

[26] Ibid.: 'Hidden in a batch of records of Arabo-Andalusi music'.

[27] CADN MA/200/193, 'A.S. hymne chanté par des élèves du Collège Musulman de Rabat', 30 May 1930.

[28] CADN MA/200/193, 'ACTIVITE DES JEUNES MAROCAINES', 16 May 1930.

[29] CADN/MA/200/193, 'Propagande anglaise', 5 May 1930.

(the Muslim quarter), Lemcharfi was found to be renting phonographs for the sum of ten to fifteen francs per day. That price included a stack of approximately twenty records, a number of which, according to the author of the unsigned intelligence report, had the effect of 'exaltant le sentiment arabe' ['stirring up Arab feelings']. An informant passed on a sample list of the records included with a rental from Lemcharfi. On it were three titles. Each was by Messika – including the Egyptian national anthem. In other words, two years since the release of her Baidaphon records and less than three months since her death, it was the Jewish Messika who was still 'exaltant le sentiment arabe' in an important urban centre in Morocco. And it was a small-scale Muslim merchant who enabled the reach of her anti-colonial message from beyond the grave.

On 30 May 1930, yet another Civil Controller sent an urgent message on the subject of 'propagande étrangère par les phonographes' ['foreign propaganda by way of the phonograph'] to Civil Control headquarters in Rabat.[30] 'Il m'a été signalé', the Civil Controller of Doukkala wrote, 'qu'une maison de Berlin expédiait au Maroc des disques de phonographe reproduisant, en langue arabe, des chansons en faveur de l'indépendance égyptienne susceptibles de provoquer une agitation dans les milieux musulmans'.[31] The Civil Controller identified the main culprit as Messika's Egyptian national anthem. But the characterization of her records as prone to wreak havoc was too little, too late. According to the same report, Messika's nationalist record was already 'un succès énorme parmi les indigènes de Mazagan',[32] a 'Muslim milieu' within the Doukkala region that held a sizeable Jewish minority. Residents of Mazagan were 'excités par une musique entraînante et par des paroles exaltant la liberté'.[33] He reported that 'ils le chantent en groupe, avec entrain, en même temps que le phonographe, s'accompagnant eux-mêmes des guitares et de mandolines'.[34] Given the scale of the Messika problem – Radio Maroc had reportedly broadcast her Egyptian national anthem on at

[30] Foreign in this case meant non-French. CADN MA/200/193, 'Propagande étrangère par les phonographs', 30 May 1930.

[31] Ibid.: 'It has been brought to my attention that a record label in Berlin has sent phonograph records to Morocco reproducing, in the Arabic language, songs in favour of Egyptian independence which are prone to provoke unrest in Muslim milieux'.

[32] Ibid.: 'a huge success among the natives of Mazagan'.

[33] Ibid.: 'excited by the rousing music and by the words hailing liberty'.

[34] CADN MA/200/193, 'Propagande étrangère par les phonographes', 30 May 1930: 'They sing it in groups, full of energy, in-sync with the phonograph, even accompanying it with guitar [likely the 'ud] and mandolin'.

70 *Jewish-Muslim Interactions*

least one occasion – the authorities concluded that Baidaphon would need reining in.[35] But the label was only part of the problem.

'S'il est en effet relativement commode de contrôler l'importation des disques fabriqués par les grandes et moyennes firmes', wrote the Director General of the Military Cabinet in Morocco to the Bureau of Native Affairs and to the Secretary General of the Protectorate on 27 February 1931, 'il est plus difficile d'empêcher la fabrication clandestine qui est dès maintenant à la portée des particuliers'.[36] Despite the considerable inroads made by Baidaphon, he was more concerned with the mushrooming of small record labels of unknown origin that had suddenly appeared on the Moroccan market. One such label, Arabic Record, which curiously carried an English-language name, was particularly vexing for the Military Cabinet. So too did it confound Lieutenant Colonel Margot, head of the Muslim Press Service and director of *Es-Saâda*, the official Arabic-language newspaper of the Protectorate, who identified a certain 'engouement' ['craze'] for their records among those he referred to paternalistically as 'nos Marocains' ['our Moroccans'].[37] Among the Arabic Record releases causing a stir were those that listed the performer on the label simply as 'malikat al-tarab'. Using Messika's sobriquet in place of her real name, Arabic Record was bootlegging her Baidaphon records.[38] Or perhaps Arabic Record was Baidaphon itself. Either way, the fact that a label of unknown origin could sell the Jewish artist's records in the years after her murder, without inscribing her actual name anywhere on the disc, signalled at once the enduring popularity of Messika and, at the same time, the scale of nationalist sentiment among Jews and Muslims in Morocco.

While regional civil controllers chased Habiba Messika records, the Resident General, head of the Military, and Bureau of Native Affairs simultaneously considered a more robust response to the nationalist record problem. On 1 May 1930, the Protectorate's Secretary General wrote to the Directors General of the Military Cabinet and the Bureau of Native Affairs on the subject of the 'introduction et vente au Maroc, de disques phonographiques'.[39] The

[35] CADN MA/200/193, letter from Civil Controller of Rabat to Director General of Native Affairs and Military Cabinet, 18 February 1931.

[36] CADN MA/200/193, 'Contrôle des enregistrements sonores', 27 May 1931: 'If it is relatively easy to control the importation of records made by the large- and medium-sized firms, it is more difficult to prevent the clandestine fabrication [of records] which is [currently] within reach of individuals'.

[37] CADN MA/200/193, 'A/S. de disques arabes', 27 February 1931.

[38] It is also possible that Baidaphon itself was behind Arabic Record.

[39] CADN MA/200/193, 'A/s introduction et vente au Maroc, de disques

Secretary General proposed that a committee be established to explore control mechanisms for records of a 'caractère séditieux' ['seditious character']. He suggested that entry points for record shipments be restricted to Casablanca and Oujda, and that French translation be appended to a file for every record arriving in Morocco. On 6 May 1930, Resident General Charles Noguès wrote back to the Secretary General.[40] He was on board.

Six months later, Resident General Noguès wrote again to the Secretary General.[41] The phonograph record problem was growing worse: 'Il m'a été signalé que plusieurs indigènes enregistraient sur des disques vierges, au cours de concerts privés, des hymnes analogues [à ceux de Habiba Messika] et parfois [plus] subversifs'.[42] He continued, 'la nécessité de l'instituion d'un contrôle des productions phonographiques s'impose donc'.[43] On 26 January 1931, following a gathering of government representatives from Morocco, Algeria, and Tunisia at the sixth annual North African Conference, the Director of General Security in Algeria wrote energetically to his Director of Native Affairs.[44] When it came to control of records, he reported, Morocco should serve as a guide.

During 1931 and 1932, a legislative committee attached to the Resident General of Morocco met three times in an attempt to decide the fate of phonograph records there. If successful, the legislation would be turned into a *dahir* (a royal decree). That Moroccan decree, originally inspired by a Tunisian Jewish artist and her recording of the Egyptian national anthem, would wait approval for several years as bureaucrats jostled over how best to handle the transnational problem. Meanwhile, other nationalist records, this time made by Algerian Jews, were again sounding the alarm.

phonographiques', 1 May 1930: 'the introduction and sale of phonograph records in Morocco'.

40 CADN MA/200/193, 'Introduction et vente au Maroc de disques phonographiques', 6 May 1930.

41 CADN/MA/200/193, 'Disques phonographiques', 6 December 1930.

42 Ibid.: 'I have been told that many natives record on blank discs, in the course of private concerts, analogous anthems [to those of Habiba Messika] and sometimes [more] subversive ones'.

43 Ibid.: 'The necessity of instituting control over phonograph record production is therefore vital'.

44 ANOM 15h/32, 'Note pour Monsieur le Directeur des Affaires Indigènes au G.G.', 26 January 1931.

Lili Labassi and 'Lellah yal ghadi lessahra' ['By God, O You Who Is Going To The Sahara']

Ya l-ghadi li-bilad al-ghazal
Idha laqit li ghazali
Qulu qulu mazal mazal
Ghayr ma yaḥla li
Lillah ya l-ghadi lil-saḥra' shuf li ghazal.[45]

Lili Labassi was born Elie Moyal in the western Algerian city of Sidi Bel Abbes in 1897. Like Messika, Moyal began publicly performing Arab music in his teens. By the interwar years, Labassi, a vocalist and violinist, could already claim veteran status on the Algerian music scene. During that period, Labassi served as a prominent member of Algeria's premier Andalusian orchestra El Moutribia, recorded extensively with Gramophone and then Columbia, and since 1930, was both the artistic director for Algerian Parlophone and its star artist. His popularity, like that of Messika, extended to both Jews and Muslims. For the French authorities in Algeria, as well as the European settler literati class, Labassi was also well known.[46] In fact, the existence of the Algerian Jewish musician was sometimes (curiously) used to demonstrate the success of the French civilizing mission. In Columbia Record's 1931 Algeria catalogue, the introduction boasted, 'l'influence occidentale apparaît nettement dans les interprétations de [...] M. LILI LAABASSI, incorporant dans ses chansons des paroles françaises'.[47] The reference was to his popular song 'Mamak',[48] a somewhat scandalous foxtrot that did indeed include a smattering of French among otherwise Algerian Arabic lyrics. The celebration of Western influence on Labassi was ironic given that he was a French citizen, as were the majority of Algerian Jews since the enactment of the 1870 Crémieux Decree. Certainly by

[45] Lili Labassi, 'Lellah yal ghadi lessahra' ['By God, O You Who Is Going To the Sahara'], Polyphon, V 46.117, 1937: 'O you who is going to the land of the gazelles / If you find my gazelle, / Tell him, tell him, he's still, he's still [alive] / No one can replace him for me. / By God, O you who is going to the Sahara, find my gazelle'. 'Ghazal' ['gazelle'] also means 'love' and serves that function in this song-text.

[46] French writer Lucienne Jean-Darrouy made regular reference to Labassi. For an example, see Jean-Darrouy (1934: 4).

[47] Centre de Recherche en Ethnomusicologie [CREM], uncatalogued, 'Columbia en Algerie', 1931: 'Western influence can clearly be detected in the interpretations of Mr. LILI LAABASSI [sic], who is incorporating French words into his songs'.

[48] Lili Laabassi, 'Mamak' ['Your Mother'], Columbia, GF 262, c. 1930.

Jews, Muslims, and Music in Interwar North Africa 73

1931, Labassi was already supposed to be Western, French-speaking, and sympathetic to the French colonial project. It was thus that much more jarring a few years later when French security services in Morocco discovered that Labassi's 'Lellah yal ghadi lessahra', recorded for the Polyphon label, seemed to make allusion to the deportation of Allal al-Fasi, the leading figure of the Moroccan nationalist movement (Silver, 2016).

On 25 October 1937, Allal al-Fasi, chairman of the Moroccan anti-colonial nationalist party al-Ḥizb al-Watani, was imprisoned by order of Resident General Charles Noguès. Days later, al-Fasi was shuttled to the edge of the Saharan desert. On 3 November 1937, al-Fasi was transferred still farther into the Sahara – along with other leading members of his nationalist circle, including Mohamed Lyazidi. From the Sahara, al-Fasi was taken by plane to Gabon in Central Africa, where he spent the next decade as a political exile. Protectorate officials were attempting to quiet, if not silence, al-Fasi and his clique. On 27 October 1938, nearly a year to the day after al-Fasi's arrest, Yves Sicot, Director of Political Affairs in Rabat, sent a confidential letter to the heads of Civil Control and to the highest ranking generals across Morocco, warning of a new musical menace – a 'disque subversif relatif à ALLAL EL FASSI' ['subversive record related to Allal al-Fasi'] – that threatened to undo the silencing of the nationalist movement by Protectorate officials.[49] In his letter, Sicot wrote, 'Il m'est rapporté qu'un chant arabe comprenant des allusions très nettes à l'exil d'ALLAL EL FASSI a été enregistré sur des disques dont un certain nombre d'exemplaires ont été distribués récemment dans les médinas'.[50] He asked political and military heads to investigate the origins of the al-Fasi-themed record and the mechanics of its distribution. Days later, the reports started pouring in.

On 2 November 1938, the Civil Controller of Rabat sent word back to Sicot that he had identified the record championing al-Fasi's cause: '"Pour Dieu, ô toi qui va au Sahara" [...] a été enrégistrée en Algérie il y a environ un an, elle est chantée par le Maalem LILI EL ABASSI [*sic*]'.[51] In that same letter, the Civil Controller outlined the path of the Labassi release on the Polyphon label as it fanned out across the Protectorate. In their eyes, it did

[49] CADN MA/200/193, 'A/S. Propagande par disques phonographiques: Disque subversif relatif à ALLAL EL FASSI', 27 October 1938.

[50] Ibid.: 'It has been reported to me that an Arabic song containing very obvious allusions to the exile of Allal al-Fasi has been recorded to disc and a certain number of such discs have recently been distributed in the medinas'.

[51] CADN MA/200/193, 'Propagande par disques phonographiques', 2 November 1938: '"By God, O You Who Is Going To The Sahara" [...] was recorded in Algeria around a year ago and is sung by Maalem [master] Lili Labassi'.

not look good. The Labassi record about an exile in the Sahara had been imported into Casablanca by Moroccan Jewish Polyphon concessionaire Jules Toledano, distributed in the hundreds to Jewish-owned record stores in the country's major cities, and then passed around by a network of Jewish and Muslim middlemen. As with Messika, Jews and Muslims were once again collaborating to facilitate the spread of a nationalist record by a Jewish artist. In many ways, its success could be measured by the fact that Labassi's 'Lellah yal ghadi lessahra' had even found its way into the hands of the wife of exiled nationalist Mohamed Lyazidi. She had apparently picked up two copies of the disc after 'trouvant dans ce chant une allusion à l'éloignement au Tafilalet de son mari'.[52] No longer just a problem of the French imagination, those Moroccan Muslims closest to the nationalist movement believed that an Algerian Jew was articulating their aspirations.[53]

In reality, Labassi's 'Lellah yal ghadi lessahra' was not intended to be nationalist. Here, Messika and Labassi differed. To begin with, the record was made in 1937 just prior to al-Fasi's exile. In addition, the recording itself was not expressly political. Labassi was merely, if not brilliantly, interpreting a much older *qasida*, a colloquial song-text belonging to the urban Algerian *ḥawzi* tradition. On 2 November 1938, a Deputy Officer in the Regional Bureau of Fez accurately described the Labassi release of a record about a Saharan exile at the same time as the exile of al-Fasi to the Sahara as 'une coïncidence' ['a coincidence'].[54] Nonetheless, the officer understood that, coincidence or not, the record 'peut d'ailleurs très bien être mise à profit par les dirigeants actuels du mouvement nationaliste'.[55] Lyazidi's wife had already done just that. If the intent was different from Messika's Egyptian national anthem, Moroccans nevertheless heard much the same nationalist message in Labassi's recording of Algerian music.

On 19 November 1938, the Brigadier General of the Meknes region laid bare the scale of the problem, alerting Sicot that 'l'on évalue à environ un millier d'exemplaires, le nombre des disques enregistrés par le maalem Lili Labassi, juif d'origine dit-on, sur l'exil d'ALLAL EL FASSI. Il parait difficile, en raison de ce nombre élevé de les retirer de la circulation'.[56] In addition to

[52] Ibid.: 'finding in the song an allusion to her husband's removal to Tafilalt [a region at the edge of the Sahara]'.

[53] CADN MA/200/193, 'Note de Renseignements', 7 November 1938.

[54] CADN MA/200/193, 'Propagande par disques phonographiques', 4 November 1938.

[55] Ibid.: 'could very well be taken advantage of by the current leaders of the nationalist movement'.

[56] CADN MA/200/193, 'Disque subversif relatif à ALLAL EL FASSI',

Meknes, security officials found the record by 'le Cheik Israélite' ['the Jewish cheikh'], as one Civil Controller accurately described Labassi, in nearly a dozen other cities.[57] No copies were found in the Sahara itself.[58] Despite the difficulty of withdrawing the record from circulation, officials attempted to do just that through pinpoint search and seizure operations. Those raids were conducted not in the homes of elite nationalists but in other places where nationalism was expressed: in urban markets and medinas.

'De nombreux indigènes de Mogador', wrote the region's Commissioner of Regional Security, 'des épiciers notamment détiennent un exemplaire de ce disque qu'ils font jouer dans leurs magasins'.[59] He continued, 'à Casablanca, ce même disque est également très répandu dans les milieux indigènes', by which he meant the city's densely populated Muslim and Jewish quarters.[60] When the hunt for Labassi's 'Lellah yal ghadi lessahra' moved to Agadir in November 1938, the record was seized mostly from Jews, among whom were again spice merchants but also tailors, bakers, and lorry drivers.[61] On 27 January 1939, the offending disc was confiscated from an unidentified merchant in Marrakesh's Djemma El Fna, a plaza known as much for its hustle as for its bustle.[62] By 13 July 1939, the Chief Commissioner for Regional Security in Oujda, on the Algerian border, discovered the nationalist record spinning at a mix of Jewish- and Muslim-owned bordellos.[63] Labassi's voice, it seemed, aroused in more ways than one.

Many of the offending Labassi records originated at a Casablanca store by the name of Art et Industrie, run by Raoul Hazan, formerly of Bembaron

19 November 1938: 'We have evaluated around one thousand records made by Maalem Lili Labassi – of Jewish origin, it is said – in relation to the exile of Allal El Fassi. It seems difficult, due to the high number of records, to withdraw it from circulation'.

[57] CADN MA/200/193, letter from Civil Controller of Casablanca to Director of Political Affairs, 9 December 1938.

[58] CADN MA/200/193, 'Propagande par disques phonographiques: Disque subversif relatif à ALLAL EL FASSI', 28 November 1938.

[59] CADN MA/200/193, 'Disque subversif relatif à ALLAL EL FASSI', 12 November 1938: 'Many natives of Mogador, notably spice merchants, own a copy of this record, which they play from their stores'.

[60] Ibid.: 'In Casablanca, the same record is similarly broadcast in native milieus'.

[61] CADN/MA/200/193, 'Propagande par disques phonographiques: Disque subversif relatif à ALLAL EL FASSI', 18 November 1938.

[62] CADN/MA/200/193, 'Propagande par disques phonographiques: Disque subversif relatif à ALLAL EL FASSI', 27 January 1939.

[63] CADN/MA/200/193, 'Propagande par disques phonographiques: Disque subversif relatif à ALLAL EL FASSI', 13 July 1939.

76 *Jewish-Muslim Interactions*

et Hazan.[64] In the case of Oujda, a good number emanated from Maison Gabay (also known as 'Oudja qui chante' ['Oujda which sings']) but some were procured hundreds of kilometres away in Mostaganem, Algeria.[65] Those caught with 'Lellah yal ghadi lessahra' understood the stakes. In Agadir, for example, roughly half of those found with the record refused to incriminate either the store or the individuals from whence they had been purchased.[66] From 1938 to 1940, despite repeated raids on their stores, Jules Toledano and Raoul Hazan continued to stock the record in question.[67] Toledano and Hazan, hardly unwitting, were helping to distribute Labassi's 'disque subversif relatif à ALLAL EL FASSI' ['subversive record related to Allal al-Fasi'] – as a thick file in the office of Director of Political Affairs in Rabat was labelled – across Morocco.

Despite enforcement, the Labassi problem hardly abated. In late spring 1940, as France fell to Germany, the French military in Morocco focused at least some of their energy on the disruptive record by the Algerian Jewish veteran artist. On 30 May 1940, Secretary General of the French Residency in Morocco Jean Morize banned Lili Labassi's Polyphon disc, given that it 'est de nature à entretenir ou à exciter le désordre'.[68] Labassi's chance nationalism was legally silenced. As late as 1944, the military continued its operations against 'Lellah yal ghadi lessahra'. It found that Moroccans were still listening to the record, despite its supposed exile.

Salim Halali and 'Arjaâ Lebladek' ['Return To Your Country']

> Arja' ya bin adim li-biladak
> 'alash baqi gharib?[69]

In 1939, as French authorities in Morocco hunted Lili Labassi's 'Lellah yal ghadi lessahra', a nineteen-year-old Algerian Jewish artist by the name of Salim Halali launched his recording career in France. Born in Bône (Annaba)

[64] See, for example, CADN/MA/200/193, 'Propagande par disques phonographiques: Disque subversif relatif à ALLAL EL FASSI', 10 November 1938.

[65] CADN/MA/200/193, 'Propagande par disques phonographiques: Disque subversif relatif à ALLAL EL FASSI', 13 July 1939.

[66] CADN/MA/200/193, 'Propagande par disques phonographiques: Disque subversif relatif à ALLAL EL FASSI', 18 November 1938.

[67] CADN/MA/200/193, 'Disque subversif relatif à ALLAL EL FASSI', 21 May 1940.

[68] CADN MA/200/193, 'Ordre', 30 May 1940: 'is likely to cause or incite disorder'.

[69] Salim Halali, 'Arjaâ Lebladek' ['Return To Your Country'], Pathé, PR 230, 1939: 'O man, return to your country. Why do you remain estranged? For a postwar history of the song, see Silver (2020: 32–33).

in eastern Algeria in 1920, Halali settled in Paris in the early 1930s. Soon after, he was joined by his parents and siblings. In the French capital, the Halalis rented an apartment in the Marais, a largely Ashkenazi area where North African Jewish migrants had begun to settle between the wars. Their installation in the Pletzl, as it was referred to in Yiddish, therefore also placed them within earshot of a number of North African Jewish cafés and restaurants. At one of those venues, Au Petit Marsellais, the young Halali and his mother Chelbia began to sing Algerian and Tunisian popular songs for the patrons-turned-audience (Laloum, 2005). In time, the teenager also ventured out of the 4th *arrondissement* and into the infamous Pigalle quarter. By 1938, he could be spotted at a cabaret there known as Le Club, where he sang in Spanish and adopted a Latin persona. The act was convincing. One evening, celebrated Algerian Muslim tenor Mahieddine Bachtarzi, president of El Moutribia (the Andalusian orchestra that featured Labassi), caught what he perceived to be a Spanish singer in concert there. When Halali introduced himself to Bachtarzi as a fan (presumably in Arabic), his compatriot quickly comprehended that 'mon chanteur espagnol n'était pas plus espagnol que moi' (Bachtarzi, 1968: 358).[70] By Bachtarzi's side that fateful evening was another Algerian Muslim musician: Mohamed El-Kamal. The two began a collaboration with Mohamed Iguerbouchène, the world-renowned composer originally from Algeria's Kabylie region (Miliani, 2015; Ounnoughene, 2015).

In March 1939, Halali began recording for the Pathé label. El-Kamal and Iguerbouchène were by his side. The first record the three cut together was a nationalist one entitled 'Arjaâ Lebladek' ['Return To Your Country'].[71] While Habiba Messika had sung about Egypt with a march and Lili Labassi about exile in the Sahara with *ḥawzi*, Halali recorded an original and popular composition that left little to the imagination of his listeners – fans and foes alike. 'Arja' ya bin adim l-biladak' ['O man, return to your country'], Halali sang liltingly with a flamenco-like melisma, addressing his roughly 100,000 Algerian, mostly Muslim, compatriots labouring in metropolitan France, ''alash baqi gharib?' ['why do you remain estranged?']. By May 1939, hundreds of copies of 'Arjaâ Lebladek' had reached Algeria and Morocco.[72]

On 26 May 1939, five months after the record's release, Halali's 'Arjaâ Lebladek' came to the attention of the sub-Prefect of Mostaganem, Algeria. While the sub-Prefect was unfamiliar with Halali, the Bureau of Native Affairs in Algeria made clear to him the danger that the Jewish singer

[70] 'my Spanish singer was no more Spanish than me'.

[71] S. Halali, 'Arjaâ Lebladek' ['Return To Your Country'], Pathé, PR 230, CPT 4602, 1939.

[72] Les Archives d'E.M.I.-France, uncatalogued, 'Fiche de Stocks – Arabes'.

and his nationalist record posed. Since Messika, Labassi, and the spread of other records deemed seditious, a 1938 censorship order in Algeria had mandated translation for all imported discs 'in any "foreign" language (including Arabic) other than French' (Scales, 2010: 414). Halali's was no exception. The translation noted that significant wear to the copy obtained by the Bureau of Native Affairs rendered some of Halali's words difficult to understand. Presumably this was from repeated play. Nonetheless, the Jewish artist's decidedly nationalist lyrics, which not only included the titular call on Algerian labourers in France to return to their country but also implored them to stand up and be counted with lines like, 'qul ana 'arabi muslim' ['say that I'm an Arab Muslim'], made him quickly known to the sub-Prefect. In short order, the latter declared 'Arjaâ Lebladek' to be nationalist propaganda and ordered that its distribution be prevented.[73]

For two years, the demonstrably nationalist record by an Algerian Jewish and Muslim trio was played in Morocco as well, but either it eluded the authorities there or the chase for Messika and Labassi, coupled with the advent of Vichy rule, slowed efforts to suppress a new subversive disc. Almost suddenly then, on 1 July 1942, some two years into Vichy rule, 'Arjaâ Lebladek' was banned by official decree in much the same way that Messika's record had been.[74] This time, however, an additional line was appended to the order: 'Les exemplaires de ce disque que se trouveraient chez commerçants (marchands de musique, de disque, etc...) et dans les lieux publics, (cafés, etc...) seront retirés de la circulation et mis au rebut'.[75] The sounds of nationalism in the Maghrib were once again being shaped by Jewish artists, in collaboration with Muslims, and permeating public spaces and public consciousness alike.

Conclusion

Throughout the interwar period, the Jewish-Muslim relationship was sometimes at its most energetic when it came to the production and consumption of anti-colonial nationalist music. High-profile Jewish musicians, like the Tunisian Habiba Messika and Algerian Salim Halali, partnered with their Muslim colleagues to craft, record, and perform a diverse repertoire of song that delighted mixed Jewish-Muslim audiences and frustrated the French authorities. Beyond the musicians, Jews and Muslims

[73] ANOM ALG/GGA/15h/32, 'A/S.-d'un disque phonographique', 26 May 1939.

[74] CADN MA/200/193, 'Ordre', 1 July 1942.

[75] Ibid.: 'Copies of the record, which are found at businesses (like music stores, record stores, etc.) and in public places (like cafés, etc.), will be withdrawn from circulation and destroyed'.

collaborated to import and then distribute these records to the farthest reaches of the Maghrib through a Jewish-Muslim network of merchants and peddlers. In this manner, ordinary, non-elite Jewish and Muslim North Africans played a vital role in providing nationalism with a cosmopolitan soundtrack. Of course, the passing around of nationalist records was done at great risk. Nonetheless, when caught with musical contraband, Jewish and Muslim purveyors of nationalist music were seldom deterred and frequently recalcitrant.

Even when not deliberately nationalist, as with Lili Labassi's record, an inner circle of Moroccan nationalists could still hear the articulation of a powerful anti-colonial message in the music of an Algerian Jew. Indeed, voices otherwise muted in studies that focus on the nationalism of any one country in North Africa suddenly become audible when following records across national borders. It was thus throughout the interwar years that nationalist records made by Jews continued to reverberate across the Maghrib and, in certain cases, came to eloquently express the political desires of their Jewish and Muslim compatriots.

Works Cited

Bachtarzi, Mahieddine. 1968. *Mémoires, 1919–1939: suivis de Étude sur le théâtre dans les pays islamiques*. Alger: Éditions nationales algériennes.

Bouzar-Kasbadji, Nadya. 1988. *L'Émergence artistique algérienne au XXe siècle: contribution de la musique et du théâtre algérois à la renaissance culturelle et à la prise de conscience nationaliste*. Ben Aknoun, Alger: Office des publications universitaires.

Carlier, Omar. 2009. 'Medina and Modernity: The Emergence of Muslim Civil Society in Algiers Between the Two World Wars'. In Zeynep Çelik, Julia Ann Clancy-Smith, and Frances Terpak (eds.), *Walls of Algiers: Narratives of the City through Text and Image*. Los Angeles: Getty Research Institute; Seattle: University of Washington Press: 62–84.

Clancy-Smith, Julia. 2006. 'Migrations, Legal Pluralism, and Identities: Algerian "Expatriates" in Colonial Tunisia'. In Patricia M. E. Lorcin (ed.), *Algeria and France, 1800–2000: Identity, Memory and Nostalgia*. Syracuse: Syracuse University Press: 3–17.

'Entre histoire culturelle et histoire politique: La Tunisie des années vingt', 1998–1999. *Watha'iq*, no. 24–25. Tunis: Institut supérieur d'Histoire du Mouvement National, Université de Tunis.

Glasser, Jonathan. 2016. *The Lost Paradise: Andalusi Music in Urban North Africa*. Chicago: University of Chicago Press.

—–. 2017. 'Musical Jews: Listening for Hierarchy in Colonial Algeria and Beyond'. *Anthropological Quarterly* 90.1: 139–66.

Hamrouni, Ahmed. 2007. *Habiba Messika: Artiste Accomplie.* Tunis: L'Univers de Livre.

Jean-Darrouy, Lucienne. 1934. 'Grande Soirée Orientale'. *L'Écho d'Alger,* 14 January, p. 4.

Katz, Ethan. 2015. *The Burdens of Brotherhood: Jews and Muslims from North African to France.* Cambridge, MA: Harvard University Press.

Laloum, Jean. 2005. 'Des juifs d'Afrique du nord au Pletzl? Une présence méconnue et des épreuves oubliées (1920–1945)'. *Archives Juives, revue d'histoire des Juifs de Frances,* Les Belles lettres, 38: 47–83.

Miliani, Hadj. 2010. 'Crosscurrents: Trajectories of Algerian Jewish Artists and Men of Culture since the End of the Nineteenth Century'. In Emily Benichou Gottreich and Daniel J. Schroeter (eds.), *Jewish Culture and Society in North Africa.* Bloomington: Indiana University Press: 177–87.

—–. 2015. 'Diasporas musiciennes et migrations maghrébines en situation coloniale'. *Volume!* 12.1: 155–69.

Miller, Susan G. 2013. *A History of Modern Morocco.* New York: Cambridge University Press.

Ounnoughene, Mouloud. 2015. *Mohamed Iguerbouchène: Un Oeuvre Intemporelle.* Algiers: Dar Khettab.

Racy, Ali Jihad. 1976. 'Record Industry and Egyptian Traditional Music: 1904–1932'. *Ethnomusicology* 20.1: 23–48.

Scales, Rebecca P. 2010. 'Subversive Sound: Transnational Radio, Arabic Recordings, and the Dangers of Listening in French Colonial Algeria, 1934–1939'. *Comparative Studies in Society and History* 52.2: 384–417.

Silver, Christopher. 2016. 'Listening to the Past: Music as a Source for the Study of North African Jews'. *Hespéris-Tamuda* 51.2: 243–55.

—–. 2018. 'The Life and Death of North Africa's First Superstar'. *History Today.* Available at: https://www.historytoday.com/miscellanies/life-and-death-north-africas-first-superstar (consulted on 10 September 2019).

—–. 2020. 'The Sounds of Nationalism: Music, Moroccanism, and the Making of Samy Elmaghribi'. *International Journal of Middle East Studies* 52.1 (2020): 23–47.

Swedenburg, Ted. 2005. 'Against Hybridity: The Case of Enrico Macias/Gaston Ghrenassia'. In Rebecca L. Stein and Ted Swedenburg (eds.), *Palestine, Israel, and the Politics of Popular Culture.* Durham, NC: Duke University Press: 231–56.

Wyrtzen, Jonathan. 2015. *Making Morocco: Colonial Intervention and the Politics of Identity.* Ithaca: Cornell University Press.

Marie Soussan: A Singular Trajectory

Hadj Miliani and Samuel Sami Everett

Over the course of the early and mid-twentieth century in colonial Algeria, music-making was a significant site of encounter between Algerian Jews and Muslims (Bouzar-Kasbadji, 1988; Glasser, 2012; 2016; Theolyre, 2016). These encounters took place within sites of practice and performance of a local Andalusi musical tradition and carried over into the post-independence period. Among the Algerian female Andalusi artist-musicians of that time, Alice Fitoussi, born in 1916, was a particularly distinguished musician and singer who played and sang with both male and female ensembles.[1] She would continue her recording and performing career in Algeria, particularly at Muslim wedding ceremonies, well into the post-independence period until her death in 1978. Another female Jewish artist-musician to have remained in Algeria after independence was the great songstress Sarriza Cohen; singer of the Andalusi repertoire, she would train generations of Algerians at the municipal conservatoire of Oran until the mid-1970s. In France, among a more significant contingent of male Algerian Jewish singers and musicians, Lili Boniche (born Élie Boniche) and Maurice Médioni, who recorded and produced their chaâbi (popular) music with mixed male-female and Jewish-Muslim ensembles, would come to prominence in the 1970s.[2]

[1] At the time, single-sex ensembles were more common than mixed.

[2] The documentary film *El Gusto* (2011), written and directed by Safina Bousbia, tells the story of several of these Algerian Jewish and Muslim musicians,

During the colonial period, unlike for the Andalusi and later chaâbi musical traditions, the emergence of popular vernacular Arabic theatrical production saw few Jewish-Muslim collaborations.[3] Linked to the emergence of this popular cultural form, from as early as 1926, Marie Soussan, who was born in January 1895, was one exception to this. She started out as a Derbouka player at Jewish wedding ceremonies and festivals, and after two unsuccessful marriages (to Joseph de Cabriac Désiré, married in 1911 and divorced in 1913, and then Jean François Roessel, married in 1915 and divorced in 1921), she threw herself into an artistic career as a singer and actress (Labassi, 2019). She sang for the first time with the Moutribia troupe in 1925 at the Casino of Algiers. But it was when she would associate herself with Rachid Ksentini, who was a central figure in the emergence of popular Algerian theatrical production, that Marie Soussan's career would really take off. Soussan would be simultaneously Ksentini's stage partner and muse for almost a decade and half, a little more than ten years of which the couple were married, until Ksentini's death in 1943.

In addition to acting, Marie Soussan played a role as on-stage songstress during theatrical productions. She would record her songs from the Andalusi and *hawzi*[4] repertoire under the guidance of her cousin Edmond Nathan Yafil, known as Ibn Chebab, the great musical producer, entrepreneur, and stage director of Algiers' turn-of-the-century theatrical performance and song scene. Her first recorded song, in 1927, was 'Rimoun Ramatni' ['A Beautiful Lady Took My Heart']. El Moutribia, created by Yafil in 1911, was the first musical theatre company to specialize in Andalusi music, and most of the musicians initially involved were Jewish. Mahieddine Bachtarzi (1897–1986) was one of the first Muslims to get involved in the company and he would

many of whom played music together in the past. They reformed as an ensemble at the end of the 1990s to perform covers of the 1940s–60s chaâbi repertoire.

[3] We use the expression 'popular Algerian theatrical production' or 'popular cultural form' because the productions of this particular time and place did not reflect on-stage European proto-Greek amphitheatre productions with the modern trappings of a consumer culture and a separation between audience and actor. Rather, this popular cultural form was an assemblage of quite diverse street or public styles that took the form of sketches performed in public, which included songs, music, vaudeville, commedia del'arte, and *halqa* (Arabic storytelling circles in the public square). As these productions developed, it became common practice for them to provide a form of interlude outside picture houses such as Le Trianon in Bab el Oued (a district of Algiers), where narrative-based stories often took the form of songs.

[4] A tradition that incorporates poetry and Maghribi musical song, proximate to Andalusi.

go on to become its director in 1928, taking up Yafil's mantel. Thanks to Bachtarzi, as of 1929, the company's members would be intermediaries, situated between theatre and music. It was under his guidance that the company would produce the sketches of Rachid Ksentini and Marie Soussan. From the early 1930s onwards, the plays of El Moutribia would become broader and more political in theme.

Less frequently cited than Marie Soussan, other Algerian Jewish actresses also participated in the beginnings of popular Algerian theatrical production in the interwar period, although they are not identified in either of the main accounts that exist of this period and the artistic milieu of Algiers: Bachtarzi's memoirs or those of the playwright, actor, and theatre director Sellali Ali, known as 'Allalou'. Nor do these actresses figure significantly in the press reviews or surveillance reports of the colonial police.[5] However, some recordings of sketches refer explicitly to the Jewish community of Algiers making reference to, for example, the consistory (*le consistoire israélite*, 'consistoire' for short), such as those written by Yafil and 'Pépino' (Ouijjani, 2012), which feature among the comedies and parodies that made up the core of early popular Algerian theatrical production.

To understand the precarious cultural positionality of Algerian Jewish performers and producers vis-à-vis both Arabic- and French-language theatre and their involvement in both of these worlds, which were separate at the time, it is important to signal the role of the Karsenty family from Oran. The Karsenty family would produce and organize French theatre tours in Algeria and later on Algerian theatre tours in the French metropole. In other words, their work sometimes served as a bridge between the two countries. Given the substantial and disproportionate (in comparison to 'European' populations) Algerian Jewish involvement in anti-imperialist, communist, and socialist cultural endeavours (Le Foll-Luciani, 2015: 23), it is also worth

[5] Notes from surveillance reports in the Archives Nationales d'Outre Mer (ANOM) in Aix-en-Provence taken by Hadj Miliani (September 2012): 'Bacheterzi [*sic*] ne donne pas de nom, il s'agit de comédiennes de circonstance qui ont été distribuées une ou deux fois. Les rapports de police chargés de la surveillance notent israélite tout court' ['Bachtarzi does not give names as these were ad hoc actresses that only ever acted once or twice. In the police surveillance reports concerning these early sketches, the word "israélite" is noted beside the word "actors" on several occasions']. Allalou's real name was Ali Sellali. He was born in 1902 and died in 1992. He made his debut with Yafil and the El Moutribia company at the beginning of the 1920s, then wrote and starred in various sketches. He wrote and produced his first play, entitled *Djeha*, in 1929, and continued to produce plays until 1932.

84 *Jewish-Muslim Interactions*

mentioning two other later figures. First, Claire Harouimi, who was an actress and theatre critic for the *Liberté* newspaper, the official press of the Algerian communist party, which followed and publicized politically engaged Arabic-language theatre in the 1950s. Second, Marcel Harouimi, Claire's partner, who was director of the Art et Liberté theatre troupe, and produced a great deal of his work in tandem with a host of Jewish actors including Eliane Chouraqi and 'Smadja'. Together, they would produce politicized plays that mixed Jewish-Muslim casts in the 1950s.

In his *Petit dictionnaire du théâtre algérien de 1920 à nos jours*, Achour Cheurfi provides a short entry on Soussan: 'Comédienne et interprète. D'origine juive, compagne de Rachid Ksentini, elle fit ses débuts avec l'association musicale El Moutribia et a joué, entre autres, dans la pièce Aicha et Bandou présentée en janvier 1932 par Ksentini' (2012: 378).[6] The little-known artistic trajectory of Marie Soussan during the inter-war period is of particular significance to the place and role of female artists in colonized Algiers society, including exoticized and unrevealed bodies, as well as indicative of convergences and divergences between certain Jewish and Muslim stage actors. Her knowledge of autochthonous linguistic, cultural, and social codes from Algiers (albeit from within the lettered bourgeoisie of the *indigénat*) is what enabled her to both author sketches (always with Rachid Ksentini) and become something of a star in early popular vernacular Arabic theatrical productions. However, it was also her position as a French citizen that allowed her to operate autonomously and without apparent repercussion in this milieu (although we know very little about her interactions with local synagogal communities) and to adopt female lead roles, which was impossible for local Muslim *algéroises*, as well as have close relationships (amorous and otherwise) with men in both European and indigenous society. This position figures into the argument that, a generation on from the Crémieux Decree, Jews often played an 'intermediary' role between communities (Memmi, 2005 [1957]; Le Foll-Luciani, 2015), but such a perspective risks pushing Jewish Algerians outside of history and local social struggles. The case of Marie Soussan shows how the gendered dimension of her endeavour to make it as a singer-actress cannot be abstracted or reified and underlines her professional precarity. Moreover, that she found herself on the indigenous musical and dramatic circuits in the first place testifies to a continued historical anchoring of Jewish indigeneity.

[6] 'Actress and performer of Jewish origin and romantic partner of Rachid Ksentini, she made her debut in the musical association El Moutribia and acted in, amongst others, the play *Aicha et Bandou*, which was staged in January 1932 by Ksentini'.

Marie Soussan: A Solitary Figure in Early Popular Algerian Theatrical Production

Very early on in colonial Algeria, theatrical production was deemed necessary for European settler-colonial society in order to imitate both ceremonially and structurally the envied metropole. Meanwhile, cross-continental Algerian colonized society was also interested in theatrical production. In an 1832 article that appeared in *La Gazette des théâtres*, we read the following passage concerning an Algerian autochthonous component (only the various Berber tribes from Algeria are not mentioned) in the emergence of this popular cultural form:

> Enfin on peut se faire une idée, aujourd'hui, de l'attrait qu'aurait un spectacle français pour les Algériens. La foule de Maures, d'Arabes et de Juifs qui suivent assidument les représentations de *il célèbre Desorme*, chef d'une troupe d'écuyers italiens assez médiocres, dont le cirque est placé depuis peu en dehors de la porte *Bab-al-oued*, prouve évidemment qu'un théâtre, où la pompe des décorations serait en première ligne, obtiendrait une vogue longue et assumée parmi les Africains.[7]

As a matter of fact, the first ever play written in Algerian Arabic has been attributed to a Jewish intellectual from Algiers called Abraham Daninos. Daninos was known as a translator and interpreter in the early colonial period immediately after the French naval invasion of Algiers. In 1996, Philip Sadgrove and Shmuel Moreh discovered Daninos's text entitled *Nazahat al-Mushtaq wa-ghussat al-'ushshaq fi madinat Tiryaq fi al-'Iraq* ['The Pleasure Trip of Sweethearts Reunited after the Agonies of Love Unrequited in the City of Tiryaq in Iraq'],[8] which was published in Algiers in 1847 (Moreh and Sadgrove, 1996). In the 2000s, the play was re-edited and re-published in Algeria by Makhlouf Boukrouh (2002). However, in Moreh and Sadgrove's brief overview of Jewish involvement in Maghribi theatre, Marie Soussan's name does not appear.

[7] *Gazette des théâtres* 397, 10 May 1832: 'One can get an idea of the attraction that the French spectacle holds for Algerians today. The crowds of Moors, Arabs, and Jews who attentively follow theatrical representations of *il célèbre Desorme*, the leading production of a rather mediocre Italian troupe of knaves for whom a platform has been erected just outside the gates of Bab el Oued, proves beyond doubt that a theatre, or at least the pomp and decoration of its trappings, would garner a long and engaged enthusiasm among Africans'.

[8] This English title comes from Katharine Halls's translation of an excerpt from the play by Abraham Daninos (2019).

86 *Jewish-Muslim Interactions*

As many researchers have indicated (Cheniki, 2002; Kali, 2013), it is at the beginning of the twentieth century that Arabic-speaking intellectuals endeavoured to write and perform theatre pieces based on a Middle Eastern model that sought to combine an Arabic literary and poetic tradition with European theatre. In 1921, the Lebanese-Egyptian producer Georges Abiad organized a tour of North Africa with his classical Arabic-language theatre troupe. In Algiers, they performed *Salâh ad-dîn al-'ayyabi and Tha'râtu-l-'arab* ['The Revenge of the Arabs']. While in Libya and Tunisia these plays had some success, in Algiers this was not the case; the productions did not speak to the people (Roth, 1967: 22). Very soon after, from the mid-1920s, it was Algerian Arabic adaptations of the French classics, along with comedic sketches, that would gain increasing popularity, eventually gaining a foothold in the cultural spheres of colonial society. In 1925, Allalou established one of the first Algerian theatre companies called La Zahia. In 1926, La Zahia put on the play *Djeha*, named after the wise-fool hero of much folklore, perhaps the earliest creation of this new brand of popular Algerian Arabic theatrical production. Such early creations were innovative compositions and they were described in the following terms by early observers of Arab colonized society's cultural revolution, known as the *nahda*,[9] at the beginning of the twentieth century:

> En réalité, les œuvres tiennent à la fois de la comédie proprement dite, de la comédie lyrique, de la comédie bouffe, de la farce et de la sotie sans que, fort souvent, il puisse être fait une démarcation exacte de chacun de ses genres et il n'est pas rare de voir apparaître dans une comédie de mœurs, un élément farcesque, voir un procédé de cirque ou de Grand-Guignol. (Bencheneb, 1935: 81)[10]

We also know that in the interwar period the audiences of these theatrical representations were made up of a high proportion of Jews, thanks to the police reports on such cultural manifestations and the high degree of detail contained in them.

Bachtarzi was one of the pioneers of such Algerian popular theatrical production and one of the most important entrepreneurs of musical and

[9] Often termed the 'Arab renaissance', the *nahda* (literally meaning awakening) was a cultural movement that began in Egypt and the wider Levant and that promoted the use, and thus standardization, of a modern Arabic.

[10] 'In reality, these pieces are made up of proper theatre, lyrical comedy, vaudeville, farce, and slapstick, without any precise demarcation between these genres and it is therefore not unusual to see a farcical element or even a circus or hand-puppet act in a societal drama'.

theatrical spectacles in Algeria during the decades in which Algerian popular theatrical production emerged. In the first book of his *Mémoires*, Bachtarzi explains the beginnings of Marie Soussan from 1929:

> Une jeune chanteuse israélite que nous avions emmenée dans nos voyages en France, Marie Soussan, se montra disposée à essayer. Elle a commencé par jouer la Commère dans la revue « Tounès-ouel-djazair » dont j'étais le compère. Puis Ksentini lui donna un « vrai » rôle dans « Baba Kaddour Ettama ». Sans manifester un grand talent, elle a tenu convenablement les rôles des partenaires de Rachid, et elle fut pendant longtemps notre seule vedette féminine. (Bachtarzi 1968: 107–8)[11]

Despite Bachtarzi's misgivings regarding her acting, as a singer, the *Écho d'Alger* newspaper presents Soussan as a rival to the great Habiba Messika (1903–1930) after an El Moutribia concert on 24 July 1928.[12] She is even described as a 'chanteuse étoile' ['a star singer'] and a 'divette algéroise' ['mini diva from Algiers'] by the press at the time. On 8 April 1937, in an article for the newspaper *Le Journal*, Lucienne Favre would take such adulation one step further, qualifying Marie Soussan as the 'Sophie Tucker de l'Afrique du Nord' ['Sophie Tucker of North Africa'], an allusion to the American Jewish singer and actress who was born in 1887 and who was extremely popular both on stage and on the radio in the first half of the twentieth century.

Aside from her beginnings on the Algiers musical scene and then in theatrical production, information on Marie Soussan's biography is scarce. However, we do know that she would spend most of her career with Algiers-based Judeo-Arabic musical ensembles such as El Moutribia, El Mossilia,

[11] 'Marie Soussan, a young Jewish singer who we took with us on our travels to France, was willing to give it a go. She started by playing the step-mother in the show *Tounès-ouel-djazair* ['Tunisia and Algeria'] for which I was compere. Then Ksentini gave her a "real" role in *Baba Kaddour Ettama* ['Father Kaddour Ettama']. Without showing a great deal of talent she played the role of Rachid's partners reasonably well and was for a long time our only female star'.

[12] See 'La Superbe Marie Soussan, la rivale la plus directe de Habiba Messika', *L'Écho d'Alger*, 11 July 1928. See also 'Pour Mme Marie Soussan, la chanteuse étoile si réputée, qui connut également la grande faveur du public', *L'Écho d'Alger*, 23 September 1928; and 'La Vedette Marie Soussan, qui fait actuellement courir tout Alger', *L'Écho d'Alger*, 7 August 1928. The Tunisian Jewish singer and actress Habibi Messika had a huge audience across North Africa and the Middle East thanks to her songs and performances in theatre and film. She was committed to the Tunisian independence movement. Tragically, she was assassinated by one of her former lovers, which would prolong her mythical aura (see Silver, this volume).

El Enchriah, and El Andoulousia, and of course that she was the stage partner of Rachid Ksentini. According to her granddaughter Jocelyne Savaresse, Marie Soussan lived in Algeria from 1910 to 1962 and died in Marseille in 1977 where she had worked in the commercial sector.[13] Soussan's son Alfred Victor René was born in 1916 and became a projectionist in Algiers. He lived with his mother on Bab Azoun until 1950.

Marie Soussan met Rachid Ksentini during a show by the El Djazairia theatre company in 1929. Rachid Ksentini, whose real name was Rachid Bilakhdar, was born in 1887 (Cheurfi, 2012: 265) and, after experimenting with various different careers, made his theatre debut with the Zahia theatre company, directed by Allalou in 1926. He then founded his own theatre troupe called Le Théâtre algérien in 1927. In addition to his role as lead for Le Théâtre algérien, he would also act with various other theatre companies including El Moutribia. It was during his time with El Moutribia that Marie Soussan would become his official partner. Their relationship would alternate between the creation and representation of vaudeville sketches, singing tours, and heated arguments. Their partnership was described in the following terms by the newspaper *L'Afrique du Nord illustrée* on 28 January 1933: 'Nommer Ksentini, c'est appeler Marie Soussan: ils forment une alliance qui, dans l'ordre littéraire, n'a peut-être réussi qu'aux frères Tharaud. Ils créent ensemble, ils interprètent ensemble'.[14] In other words, while Rachid Ksentini's brilliance no doubt overshadowed Marie Soussan, she was an integral part of his success and yet her story has seldom been foregrounded.

Marie Soussan acted alongside Rachid Ksentini in many plays and sketches, including *Portrait de ma belle-mère* ['Portrait of my Mother-in-Law'] in 1930; *Le Serment* ['The Vow'] in 1931; *Mon cousin de Stambou* ['My Cousin from Stambou'], *Loundja l'Andalouse* ['Loundja the Anadalusi Woman'], and *El Morstane* ['El Morstane'] in 1932; *Ya lima Akheli* ['Oh Mother, He Ruined Me'] in 1933; and *Ah ya Ensa* ['Oh Women'] in 1935.[15] From this range of titles, we can see the wide variety of themes explored, and indeed there was a quite dramatic shift from the more story-like, even

[13] Post by Jocelyn Savaresse on JudaicAlgeria, 26 October 2016. Available at: https://www.judaicalgeria.com/pages/communautes-juives-d-algerie/communaute-d-alger.html#0OXLD5KW5d2CdiEO.99 (consulted on 7 August 2019).

[14] 'To name Ksentini is to conjure up Marie Soussan: they form an alliance that, in the literary world, hasn't seen a success as great since the Tharaud brothers. They create together and they act together'.

[15] Recordings of these plays feature in the Gramophone 1935 catalogue *La Voix de son maître*; of particular note is the only known recording of Ksentini and Soussan's most famous sketch, *Aicha et Bendo*.

mythical titles and everyday vignettes about individuals in 1929 and 1930, such as *Le Paysan chez la cartomancienne* ['The Peasant and the Fortune-Teller'] or *Toubib Skoli* ['Dr Skoli'], to the more politically inclined plays staged in 1932. These included *Toto M'hammed, champion de boxe de la Bouzaréah* ['Uncle Mohammed, Boxing Champion from Bouzaréah'], a play about Algerians becoming successful in colonial society as a result of sporting prowess (through boxing in this case), and *Faqo!* ['Stand Up!'] that was about standing up against imperialism, as implied in its imperative title. It is also worth noting the variety of languages used and their juxtaposition, from the funny-sounding *Ben Goudjou* ['Son of Goudjou'] in 1929 to the funny-meaning *Boucebssi* ['(Hash)pipe-Smoker'] in Darija to the more literary Arabic *Faqo!* ['Stand Up!'] as well as more typically French titles like *Le Paysan chez la cartomacienne* ['The Peasant and the Fortune-Teller'] and *La Table mystèrieuse* ['The Mysterious Table'] in 1934, and the sketches that are named after Algerian couples: *Aicha et Bendo* in 1932 and *Cheroueto et Zghreben* in 1930.

The characters played by Marie Soussan and Rachid Ksentini and the themes of their plays and sketches, which were mostly of an everyday, comic nature, would put forward caricatures of mythomaniacs and liars (the character Techerretche in the eponymous play is an example of one of these) or misers and racketeers (an example of such a character is Baba Kaddour Ettama ['Self-Serving Daddy Kaddour']). Among a plethora of such caricatures, there are the insane and the facetious (Bouborma and Toqba fel fayt) and, not infrequently, consumers of 'kif' (marijuana or hashish) or inveterate alcoholics (Cheroueto and Zgherben, as well as Ched Mlih), for whom Ksentini had much sympathy. Indeed, some of these characters may have been based on his own drinking buddies. In conjunction with Soussan, Ksentini put these characters and the themes arising from his impressions of them into conversation with other themes such as the domestic issues of married couples, whose arguments often slipped into a deliciously rich working peoples' spoken *algerois* Darija. Examples of this are *Le Revenant de ma belle-mère* ['My Mother-in-Law's Ghost'] and *Ya rassi, ya rasseha* ['My Head, Her Head'], both staged in 1931. However, it is above all *Aicha et Bendo*, whose interaction as a couple is full of both mischief and working peoples' common sense, that would make several generations of audiences laugh until they cried. That particular play was reworked and rerun constantly from the 1930s until well after the post-independence period. Modelled on a Jewish-Muslim couple, 'Aicha et Bendo' has even become a popular expression in Algerian Arabic, used to characterize two people who argue over the smallest things but nevertheless remain together.

Bachtarzi and Soussan

In his writings, Bachtarzi has underlined the importance of Marie Soussan's contribution to 'le théâtre arabe' during these early days of Algerian theatrical performance (1968). It is clear that Marie Soussan played a significant role as a female lead during the emergence of popular Algerian theatrical production. Moreover, she represented in many ways the colonized female body – amply depicted by postcards and a broader orientalist pictorial iconography (see Said, 1993; Shohat, 2006: 49) – or what a colonialist consensus would generically term 'mauresque' ['Moorish']. We know this from the frequency with which this term appears in the press of the time, qualifying Marie Soussan as a 'comédienne mauresque' ['a Moorish actress'] or a 'chanteuse mauresque' ['a Moorish singer'].[16] In popular Algerian theatrical production, female Muslim characters had, until the mid-1920s, been played by men; until then, it was impossible for Muslim women to be visible as artists outside of the domain of music and song. Thus, Marie Soussan by her actions managed to twice overcome the invisible boundary of the forbidden through her very presence as a woman on stage and her representation of belonging that was not bound to a religious community:

> Marie Soussan était « unique » non par son talent, mais par sa présence. Aucune femme musulmane n'avait consenti à monter sur les planches pour jouer la Comédie. Dans de telles conditions on comprendra que nous ne songions pas à chicaner Soussan et, elle, s'imposait comme « vedette ». Nous étions donc forcés de continuer à faire jouer les autres rôles de femmes par des hommes. Il faut rendre cette justice à Marie Soussan qu'elle avait une jolie voix et qu'elle était supérieure dans son tour de chant. (Bachtarzi, 1968: 176)[17]

However, Allalou, who, as we have seen, was another pioneer of Algerian theatrical performance, has since corrected Bachtarzi, citing the names of the few Muslim women who took the stage before or at the same time as Soussan.

[16] See, for example, an article entitled 'Les Arabes à Paris' in the newspaper *Commedia* (10 August 1936), in which Marie Soussan is described as a 'chanteuse mauresque de grand talent' ['a Moorish singer of great talent'].

[17] 'Marie Soussan was unique not because she was talented but because she just was. No Muslim women had consented to get on stage and play the comedian. Given the circumstances, it is understandable that we did not think to contradict Soussan and thus she established herself as a "star". We were forced to continue to have the other female roles played by men. One must give credit to Marie Soussan; she had a pretty voice and excelled in song and on stage'.

Allalou cites B. Amina in *Abou Hassan* ['Father Hassan'], Mademoiselle Z. B. Ghazala in *Le Pêcheur et le génie* ['The Fisher and the Genie'], and Mademoiselle Ch. A. Attiqa, who was Ksentini's acting partner before Soussan, in *Le Mariage de Bou Borma* ['The Wedding of Bou Borma'] and *Zirrebane et Cherroto* ['Zirrebane and Cherroto'] (2004 [1982]: 41).[18]

An *israélite*, to use the term of the day, and a French citizen since the Crémieux Decree, Marie Soussan predominantly acted in Arabic, more often than not in the role of a Muslim woman dressed in the style of an urban bourgeois *algéroise* (from Algiers). The photos of the era (see Figure 2 as an example) and the commentary from the press highlight her elegance, chic, and sass.

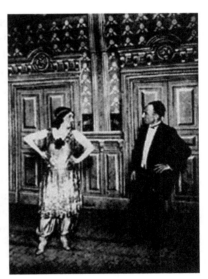

Figure 2: Marie Soussan and Rachid Ksentini performing one of their many sketches for the Union Sportive Musulmane in Blida, 1933. *L'Afrique du Nord illustrée*, 28 January 1933.[19]

Many Jewish artists at the time, such as Elissa Rhaiss,[20] would assert themselves in the literary sphere, by demonstrating their anchoring in a local variant of

[18] It was not until the 1950s that the forenames of female actresses would be given out publicly.

[19] The Union Sportive Musulmane was one of the many associations (which were sporting, musical, theatrical, and more generally civil society focused) that emerged and grouped together Algerian colonial society from the 1920s onwards.

[20] Rhaiss, whose real name was Rosine Boumendil, was born in 1876 into a Jewish family in Blida. In France, she passed as an Arab Muslim who had lived in harems. She is particularly known for her 'orientalist' novels based in the artistic milieu of the interwar period, such as *Saâda la Marocaine* ['Saâda the

92 *Jewish-Muslim Interactions*

Judeo-Arabic while simultaneously aligning themselves with the norms and values of metropolitan French culture. Marie Soussan was not one of them. She would live entirely in an urban Muslim universe, albeit a bourgeois one, through her songs and her engagement in popular theatrical production, and in choosing to live her life with Rachid Ksentini.

Allalou, never one to mince his words, would contest Bachtarzi's verdict regarding the quality of Marie Soussan's on-stage delivery and his claim that she had been an emergency solution to the fact that Muslim women were not able to appear on stage:

> C'est inexact. Marie Soussan avait non seulement des aptitudes pour la scène mais, de plus, c'était une chanteuse douée d'une belle voix. Elle n'avait qu'un petit défaut d'accent typique des femmes juives de Constantine, ce qui ne l'empêchait pas d'être une bonne comédienne. Rachid Ksentini fit d'elle sa collaboratrice et l'associa même à ses droits d'auteur comme je l'ai fait moi-même avec Dahmoun. (Allalou 2004 [1982]: 40)[21]

Marie Soussan is identified in the 1932 *Annuaire de la Société des auteurs et compositeurs dramatiques*[22] as the co-author alongside Ksentini (under his real name Bir Lakhdar) of three plays: *Qara Hmed le pêcheur* ['Qara Hmed the Fisherman'], *Retiens-moi* ['Hold On to Me'], and *Le Revenant de ma belle-mère* ['My Mother-in-Law's Ghost']. That status as co-author may, however, be questionable, as it was subject to a negotiation between the pair. Bachtarzi reports that, after an argument between Marie and Rachid in January 1931 and tours of the Oran and Constantine regions for their new play *El Kessa* (that were complete flops),

> Marie Soussan était partie drapée dans sa dignité offensée. Pendant quelques représentations données sans elle je faisais remarquer à Rachid combien elle nous manquait. Elle n'était peut-être pas géniale, mais nous n'avions jamais trouvé une autre. [...] Rachid est allé retrouver Soussan en

Moroccan'] (1919), *Le Café-chantant* ['The Singing Café'] (1920), *Les Juifs ou la fille d'Eléazar* ['The Jews or the Daughter of Eleazar'] (1921), *La Fille des pachas* ['The Fat Cats' Daughter'] (1922), and *La Fille du douar* ['The Country Girl'] (1924). She died in Blida in 1940.

[21] 'That is simply inaccurate. Marie Soussan not only had a great aptitude for the stage but she was also a singer with a great voice. She had one small failing in her accent which was typical of Jewish women from Constantine, which did not at all stop her from being a great actress. Rachid Ksentini made her his number one colleague and copyrighted their material together as I did with Dahmoun'.

[22] Gallica, the Bibliothèque Nationale de France's online archive portal (consulted on 7 August 2019).

faisant patte de velours. Elle est revenue avec la majesté d'une impératrice, et en posant ses conditions: elle exigeait en plus de ses cachets, une participation à toutes les pièces nouvelles de Ksentini, elle signerait comme co-auteur avec lui. Rachid accepta. (Bachtarzi, 1968: 127)[23]

Nevertheless, Bachtarzi would not refrain from expressing irony at this high drama displayed by the 'author' Marie Soussan, shedding light on the episode with caustic wit:

> Le plus difficile pour elle était de soutenir aux yeux de tous sa réputation d'auteur [...] Quand Madame Carde et Kubinsky ont su que la seule femme auteur dramatique de langue arabe de toute l'Afrique du Nord n'avait jamais su reconnaître un Djim d'un Alif, ils sont restés un peu pantois. Dame! Ils s'étaient fiés aux affiches et aux journaux, ces gens! Rachid ne s'est pas démonté pour si peu. Il a expliqué qu'il écrivait seul ses pièces, mais sur les idées lumineuses que Marie Soussan lui apportait. Ce qui effectivement pouvait justifier une collaboration et faire de Marie un auteur arabe n'écrivant pas l'arabe, à condition [...] qu'elle ait eu des idées de pièces. (Bachtarzi 1968: 128–29)[24]

Here Bachtarzi signals the Arabic-language illiteracy of Marie Soussan, which was relatively frequent in artistic milieux (including among Muslims) in which people tended to learn by listening or through transcriptions of the Arabic in Latinate letters. What is perhaps more unfair on Marie Soussan is the fact that Bachtarzi appears to deny her any influence in the themes of the plays. Nevertheless, Marie Soussan had the ambition to compose an

[23] 'Marie Soussan had left draped in her offended dignity. After several performances without her, I opined to Rachid the extent to which her presence was missing. She may not have been brilliant but we never found her equal. [...] Rachid went to find Soussan with his tail between his legs to present his apologies. She came back with great pomp and all the majesty of an empress stating her conditions: she wanted more money and a role in all of Ksentini's new plays, all of which she would sign as co-author. Rachid accepted'.

[24] 'It was difficult for her to maintain her reputation as an author in our eyes [...] When Madame Carde and Kubinsky found out that the only female Arabic-language theatre writer in the whole of North Africa had never known the difference between a *djim* and an *alif*, they were astonished. Why they had trusted the posters and the newspapers, these people! Rachid wasn't phased. He explained that he wrote his plays himself but that he took his inspiration from Marie Soussan's fantastic ideas, which could effectively justify a collaboration and make Marie an Arabic-language author who didn't write Arabic provided that [...] she did indeed have the ideas behind the plays'.

Gala organisé par la « Rachidia »

Dimanche 8 courant, notre jeune société « La Rachidia » a donné dans la coquette salle de l'Alhambra cinéma un gala oriental qui a remporté un éclatant succès.

Une affluence des plus choisies était venue apporter un tribut d'admiration aux artistes algérois dont la science musicale est bien connue dans les milieux musulmans de notre ville.

Après un début prometteur où la « Touchia » fut jouée avec un ensemble parfait, le comique Kesemtini et sa digne partenaire Mme Marie Soussan, ont emballé la Salle en interprétant d'une façon impeccable, la charmante comédie : « Retiens-moi ».

Puis le jeune ténor Hocine, digne émule du célèbre Mahieddine, dans son répertoire, conquit le public par sa voix chaude et prenante.

C'est le tour de Mme Marie Soussan. Dans un élégant costume algérois que rendait encore plus charmant le jeu de

lumière de l'opérateur, cette célèbre vedette obtint un succès formidable. Les chansonnettes, en particulier « Aïnine Lahbara » furent très applaudies par un public émerveillé tout simplement.

Enfin le comédien Rachid Kesemtini, l'artiste comique par excellence, emballa les spectateurs par ses Sketchs désopilants pleins d'esprit et de bonne humeur. Ses duos avec Mme Marie Soussan furent très goûtés par toute la salle qui ne ménagea pas ses applaudissements à ces sympathiques artistes.

Le piano d'accompagnement était tenu par la charmante pianiste Mlle Nénette à qui nous adressons toutes nos félicitations. A Madame Régina, danseuse et à nos petits gymnastes de la Bravoure qui ont prêté leur gracieux concours, vont aussi nos chaleureuses félicitations.

Nous terminons en adressant nos sincères compliments à MM. Gamgit, Baba-Aïssa Allal, Abderrahim Madjid, Chelouah Ameur les actifs dérigeants de la « Rachidia » qui ont su mettre sur pied cette belle soirée qui nous en sommes certains ne restera pas sans lendemain.

Z.

Figure 3: 'Gala organisé par la « la Rachida »'. *L'Écho de Bougie*, 15 June 1930.

independent artistic team with Rachid Ksentini outside of the large musical-theatrical ensembles such as El Moutribia and El Mossilia. There were many attempts at this, such as the creation of the Troupe algéroise ['Troupe from Algiers'] or other performances together given here and there for holidays, or galas for charity. At a gala organized by the theatre company La Rachidia in Bougie on 8 June 1930 (see Figure 3), Ksentini and Soussan introduce themselves as an independent team. This was also the case when they made a stage appearance with the musical association El Mossilia in Algiers on 2 March 1934 (see Figure 4).

For Bachtarzi, during the years 1931–1941, when he directed the El Moutribia ensemble after the death of Yafil, he experienced as something of a disappointment the organizational autonomy of the little team formed by Ksentini and Soussan, which he attributed to the latter:

L'impétueuse Marie Soussan avait fini par le comprendre, et devant le piteux résultat de ses tentatives d'indépendance, elle avait cessé d'exciter Rachid à voler de ses propres ailes. Il était clair que l'artiste algérien à cette époque ne pouvait vivre en dehors de l'étroite collectivité du Spectacle, qui englobait « Le Spectacle » sous toutes ses formes. Au reste, nous étions encore si peu nombreux que la concurrence, qui rend si aléatoires les

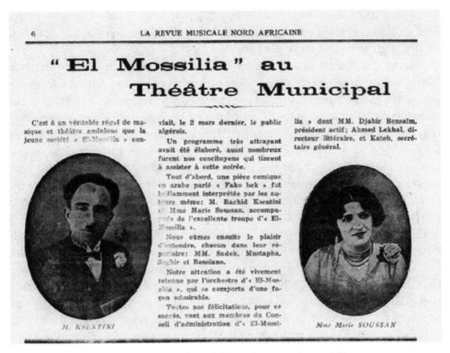

Figure 4: '"El Mossila" au Théâtre Muncipal'.
La Revue musicale nord-africaine, 3 March 1934.

professions artistiques dans les pays européens ne jouait pas chez nous. (Bachtarzi, 1968: 176)[25]

Bachtarzi had always defended the principle that a theatrical performance should be followed by a musical one, which he calls 'le Spectacle', that would enjoin musicians and actors. Ksentini's projects were all based on sketches and the songs of songwriters. We might speculate that Bachtarzi preferred having Ksentini and Soussan with him because Ksentini was held in very high regard for his humour and acting ability. Furthermore, the accusatory nature of his words towards Soussan, which appear to speak to his friendship

[25] 'Faced with the pitiful results of their attempts to become artistically independent, the impetuous Marie Soussan had finally understood and would stop inciting Rachid to go it alone. It was clear that during that era an Algerian artist could not live outside of the narrow collectivity of the entertainment business which incorporated "entertainment" in all of its forms. For the rest of us, we were still so few that competition, which renders so hazardous all artistic professions even in Europe, simply would not work'.

with Ksentini, characterizes the difficulties that women have had with being held in high professional regard. That Marie Soussan and Rachid Ksentini argued a great deal is clear but how exactly she was 'impetuous' is less so.

During her frequent arguments with Ksentini, which would distance Marie Soussan from the theatre for a time, she would continue to make appearances in singing tours, where she would demonstrate her great vocal talent and a deep knowledge of an Andalusi heritage and repertoire. In this regard, she was inevitably referred to as a 'chanteuse mauresque' ['Moorish singer'], just as in the case when she performed with El Moutribia in the concert hall of Le Petit Journal in Paris (*Commedia*, 10 August 1936). She would also perform regularly live on the radio until the end of the 1930s, in concerts, and with her own small orchestra that was made up of Jewish and Muslim musicians.

On 1 July 1940, the Jewish population of Algeria had their French citizenship revoked by the Peyrouton laws that saw them expelled from the public sector and prohibited from exercising certain professions. This meant that the vast majority of Algerian Jewish artists and performers were made redundant, even before 11 June 1942, the date on which the Vichy government promulgated a decree forbidding Jews from artistic professions in particular (Abitbol, 2008).[26] This was the case for Marie Soussan also. Bachtarzi testifies to this ostracism that led him to put a stop to the musical association El Moutribia so that he would not have to implement these legal measures: 'Personnellement, j'ai préféré dissoudre la société El Moutribia plutôt que de me séparer des membres israélites avec qui je travaillais depuis près de vingt ans' (Bachtarzi, 1984: 29).[27] Nevertheless, Bachtarzi recounts that, on the radio, in spite of the severity with which these measures were monitored under the Vichy regime, many Jewish musicians remained embedded within the Andalusi orchestras under Arab names (1984: 29).

Marie Soussan's last known public appearance was an on-stage performance as a singer with El Moutribia in Algiers on 30 January 1943, for a prize draw of the 'tranche musulman' ['Muslim round'] of the Algerian lottery. The following year, in June 1944, she was no longer among the 'Muslim' artists for the same event while Alice Fitoussi, Sassi, and Lili Boniche did appear. Her former mentor and partner Rachid Ksentini would pass away two months later. In his second book of memoirs, Bachtarzi would congratulate the

[26] The Crémieux Decree was reinstated in October 1943 and the anti-Jewish laws were revoked in November 1943.

[27] 'Personally, I preferred to disband the El Moutribia troupe rather than part company with those Jewish actors with whom I had worked for nearly twenty years'.

Marie Soussan: A Singular Trajectory

pioneer that was Marie Soussan when she finally distanced herself from the stage. In a final homage, he states:

> Celle qui fut longtemps notre seule vedette femme, celle qui a partagé les premiers succès de Ksentini, celle qui a été la grande *Actrice Algérienne* tant que nous n'avions pas d'actrice musulmane, notre Marie Soussan, a fini par abandonner le théâtre et elle vit en France depuis de nombreuses années. (Bachtarzi, 1984: 391)[28]

Here, Ksentini inscribes Marie Soussan into the Algerian creative landscape of performance, or rather recognizes the way in which she inscribed herself therein. However, he only infers her Jewishness through negation, that is, her non-Muslimness, and subordinates her to Ksentini by referring to his early successes rather than to her own. Nevertheless, he highlights her Algerianness in spite of her decision to move to France, and uses the possessive pronoun to claim her as Algeria's own – and for a long time, only – female star. Soussan died in 1977 in Marseille and is buried in the city's Jewish cemetery.

Conclusion

The trajectory of Marie Soussan, while in many ways individual and quite exceptional, has much to tell us about Jewish-Muslim cultural interactions in Algeria under the colonial regime, which were founded on a common linguistic and artistic heritage. The interwar period in which she rose to relative fame trapped her in a simultaneously exoticized and unrevealed indigenous body. It did not matter that she was Jewish; as she performed in Arabic, she was always considered a 'Moor'. Nevertheless, her access to French citizenship due to the Crémieux Decree meant that she was more autonomous to navigate between the invisible *fontières* of community boundaries and decide her own fate. In spite of these Jewish-Muslim proximities and differences however, a particular gendered dynamics of power structured much of Marie Soussan's trajectory, notably in her subordination to Rachid Ksentini's brilliance, as a woman in a male-dominated artistic milieu. Soussan was an outstanding female figure in a universe that was dominated by male supremacy and yet she managed to impose her vision in a variety of artistic circumstances, to be recognized in extremis as an author of Arabic-language theatre, contrary to the norm:

28 'She who would for many years be our sole female star, she who shared in the first successes of Ksentini, she who was a great *Algerian actress* at a time when we had no Muslim actresses, our very own Marie Soussan eventually abandoned the stage and has been living in France for a number of years now'.

Nous avons vu que les personnages féminins, à cause de la rareté des comédiennes, sont peu nombreux: il n'y a généralement guère plus de deux rôles de femmes dans une pièce. Au reste, le fait même que l'élément féminin est quasiment exclu du public ne laisse pas d'avoir une influence sur la nature du théâtre en y limitant le rôle de la femme, de sorte que le théâtre semble être un monopole masculin. (Bencheneb, 1935: 85)[29]

Marie Soussan was an exception due to the fact that she played only in popular Algerian theatrical productions that were performed in vernacular Arabic during a time when the majority of the Algerian Jewish community of Algiers were becoming more Gallicized, and were distancing themselves from a shared culture with their fellow Algerian Muslims (in terms of social practices, festivities, language, etc.), aside from the musical tradition in which, as we have seen, collaboration continued into the post-independence period.[30] The exceptionalism of this position is why a posteriori, and despite the fact that she died in France, Marie Soussan is described as an Algerian actress, a necessarily political statement. Yet, that Marie Soussan's story should be little known in spite of its remarkable symbolic power – Soussan was, after all, received and accepted as the Arab female heroine par excellence on stage – perhaps further highlights the continuation of the gendered dynamic that permeated her on-stage career. Hitherto, Marie Soussana's modest presence in the historiography of the emergence of popular Algerian theatrical production has rested on the subjective indication that her performances were often eclipsed by the exceptional and quite brilliant talent of her on-stage partner Rachid Ksentini who, it must not be forgotten, was also operating in a context structured by the cultural violence of French imperial standards. However, this chapter points out that such an indication should not be taken for granted and that Marie Soussan had a great deal of personal and professional merit in her own right. The improbable and perhaps unique artistic partnership of Soussan and Ksentini gives us a glimpse of the possibilities that were opening up to colonial society, which was moving rapidly towards its own cultural modernity through theatre, music, cinema, and radio in the interwar period,

[29] 'We have seen that female characters because of the scarcity of actresses are few in number: there are generally no more than two female roles in a play. For the rest, the fact that a female component was practically absent in terms of audience cannot help but have an influence on the nature of the theatre, limiting the role of women in such a way that the theatre appears to be an entirely male phenomenon'.

[30] On this very subject, see the thoughts and testimony of the philosopher and linguist Jean Cohen (1997) who was born in Oran, Algeria in 1919 and died in France in 1994. He was the grandson of the musician Sarriza Cohen.

perhaps the last time that religious and ethnic communities were able to openly cross-pollinate so physically in Algeria.

Works Cited

Primary Sources

L'Afrique du Nord illustrée, 28 January 1933.

L'Écho de Bougie, 15 June 1930.

'Les Arabes à Paris'. *Commedia*, 10 August 1936.

Gazette des théâtres 397, 10 May 1832.

Labassi. 2019. Conversation on 15 September.

'Pour Mme Marie Soussan, la chanteuse étoile si réputée, qui connut également la grande faveur du public'. *L'Écho d'Alger*, 23 September 1928.

La Revue musicale nord-africaine, 3 March 1934.

Savaresse, Jocelyn. 2016. Post on the website JudaicAlgeria, 26 October. Available at: https://www.judaicalgeria.com/pages/communautes-juives-d-algerie/communaute-d-alger.html#0OXLD5KW5d2CdiEO.99 (consulted on 7 August 2019).

'La Superbe Marie Soussan, la rivale la plus directe de Habiba Messika'. *L'Écho d'Alger*, 11 juillet 1928.

'La Vedette Marie Soussan, qui fait actuellement courir tout Alger'. *L'Écho d'Alger*, 7 August 1928.

Secondary Sources

Abitbol, Michel. 2008. *Les Juifs d'Afrique du Nord sous Vichy*. Paris: Riveneuve Editions.

Allalou (Selali Ali). 2004 [1982]. *L'Aurore du théâtre algérien (1926–1930)*. Oran: Éditions Dar El Gharb.

Bachtarzi, Mahieddine. 1968. *Mémoires*, I. Alger: SNED.

——. 1984. *Mémoires*, II. Alger: SNED.

Bencheneb, Saadeddine. 1935. 'Le Théâtre arabe d'Alger'. *Revue Africaine* 364–65: 79–84.

Boukrouh, Makhlouf. 2002. *Nazhat al mushtaq waghusst al 'ushaq fi madinat Tiryaq bi l'Irak*. Alger: MIM Editions.

Bousbia, Safinez (dir.). 2011. *El Gusto*.

Bouzar-Kasbadji, Nadya. 1988. *L'Émergence artistique algérienne au XXème siècle. Contribution de la Musique et du théâtre algérois à la renaissance culturelle et à la prise de conscience nationaliste*. Algiers: OPU.

Cheniki, Ahmed. 2002. *Le Théâtre en Algérie. Histoire et enjeux*. Aix-en-Provence: Edisud.

Cheurfi, Achour. 2012. *Petit dictionnaire du théâtre algérien de 1920 à nos jours*. Algiers: Editions Dalimen.

Cohen, Jean. 1997. *Chronique d'une Algérie révolue*. Paris: L'Harmattan.

Daninos, Abraham. 2019. 'The Pleasure Trip of Sweethearts Reunited after the Agonies of Love Unrequited in the City of Tiryaq in Iraq'. Trans. by Katharine Halls. In Elisheva Carlebach (ed.), *The Posen Library of Jewish Culture and Civilization, Volume 6: 1750–1880*. London: Yale University Press: 471–73.

Glasser, Jonathan. 2012. 'Edmond Yafil and Andalusi Musical Revival in Early 20th-Century Algeria'. *International Journal of Middle East Studies* 44.4: 671–92.

——. 2016. *The Lost Paradise: Andalusi Music in Urban North Africa*. Chicago: University of Chicago Press.

Kali, Mohammed. 2013. *100 ans de théâtre algérien. Du théâtre folklorique aux nouvelles écritures dramatiques et scéniques*. Algiers: Socrate News.

Le Foll-Luciani, Pierre-Jean. 2015. *Les Juifs algériens dans la lutte anticoloniale. Trajectoires dissidentes (1934–1965)*. Rennes: Presses Universitaires de Rennes.

Memmi, Albert. 1958. *Portrait du colonisé; précédé de Portrait du colonisateur*. Paris: Corrêa.

Moreh, Shmuel, and Philip Sadgrove. 1996. *Jewish Contributions to Nineteenth-Century Arabic Theatre: Plays from Algeria and Syria – A Study and Texts*. Oxford: Oxford University Press.

Ouijjani, Hinda. 2012. 'Le Fonds de disques 78 tours Pathé de musique arabe et orientale donné aux Archives de la Parole et au Musée de la Parole et du Geste de l'Université de Paris: 1911–1930'. *Bulletin de l'AFAS* 38: 1–14.

Roth, Arlette. 1967. *Le Théâtre algérien*. Paris: François Maspero.

Said, Edward. 1993. *Culture and Imperialism*. London: Chatto & Windus.

Shohat, Ella. 2006. *Taboo Memories and Diasporic Voices*. Durham, NC: Duke University Press.

Theoleyre, Malcolm. 2016. 'Alger, creuset musical franco-algérien: Sociabilités inter-communautaires et hybridations dans l'entre-deux-guerres'. *L'Année du Maghreb* 14: 23–41.

Retelling the Jewish Past in Tunisia through Narratives of Popular Song

Ruth F. Davis

Prelude: The Keyboard Controversy

On 7 September 1884, the French weekly *Journal des voyages et des aventures de terre et de mer* featured on its front cover a black-and-white engraving entitled 'Le samedi soir dans une famille juive à Tunis' ['Saturday Evening in a Jewish Family in Tunis']. The engraving by Horace Castelli (1825–1889) relates to the article by Daniel Arnauld entitled 'Les populations de la Tunisie: Une famille juive' ['The Populations of Tunisia: A Jewish Family'] (1884: 146–47). Set in the home of a bourgeois family in the Hafsia, the Jewish quarter of the old city, it portrays the father of the house seated on a low couch with his three daughters gathered around him. All are wearing the traditional costume peculiar to the Jews of Tunis: the young women with their pointed caps, short tunics, and leggings, and the man of the house with his baggy breeches, flowing cape, and pale-coloured turban setting off his bushy white beard. But the most remarkable and seemingly incongruous aspect of the picture is the strange keyboard instrument – a cross between a harmonium and an accordion – played by one of the daughters in the foreground. Referring to this feature, Arnauld writes: 'cette jeune fille, pour occuper agréablement ses loisirs, tire quelques accords sur l'harmoni-flûte dont le soufflet est mis en mouvement avec le pied. Elle fait l'admiration de son père et le bonheur de toute sa famille'.[1]

[1] 'This young girl amuses herself in her free time by striking a few chords on the *harmoni-flûte*, activating the bellows with her foot. She wins her father's

Figure 5: 'La samedi soir dans une famille juive de Tunis'.
Engraving by Horace Castelli (1825–1889). © Collection Bernard Allali.

In his lavishly illustrated *Les Juifs de Tunisie: un autre regard* (2014), Bernard Allali reproduces Castelli's engraving alongside a different print of the same family in a slightly enlarged group (see Figure 6), with the same daughter seated at the *harmoni-flûte*; this time, however, she appears to the left and in shade rather than to the right and in full focus as in Castelli's engraving. This second print, Allali observes, was used to illustrate the article 'Die Juden von Tunis' ['Jews of Tunis'] by Ernst von Hesse-Wartegg in the 1881 edition of the German journal Die Heimat. Yet the scene it depicts belongs to an earlier time. The design, by one D. Maillars, was taken from a

admiration and makes her whole family happy'. This and all subsequent translations are by the author of this chapter.

Figure 6: 'Judische Familie in Tunis'. *Die Heimat*, 1881.
Wood engraving designed by D. Maillars after a photographic negative
produced in 1865 by M. Catalanotti. © Collection Bernard Allali.

photographic negative produced in 1865 by M. Catalanotti, a pioneering early photographer based in Tunis (Allali, 2014: 56).

Combining the compactness and portability of the accordion with the upright position and playing technique of the harmonium, the 'harmoni-flûte' was invented by the Parisian instrument-manufacturer Constant Busson and made its first appearance in 1855 at the Universal Exposition in Paris. Even allowing for the possibility that the instrument was a prop, its reappearance only a decade later in the home of a Jewish family in Tunis as an instrument of leisure for young ladies suggests an affinity between the keyboard – that

104 *Jewish-Muslim Interactions*

most emblematic of European musical instruments – and the indigenous Jewish community that comfortably pre-dated the establishment of the French protectorate in 1881.

Exactly when and in what circumstances the keyboard made the transition from the world of female bourgeois domesticity to the male-dominated, lower-class world of professional music-making is unclear, but, by the turn of the twentieth century the harmonium had become a staple of the Jewish professional ensembles that accompanied male and, increasingly, female solo singers and dancers in popular venues such as cafés, taverns, and above all, the *kaféchantants*[2] that had sprung up around the edge of the medina in imitation of the European cabarets. By this time, the traditional instruments of Tunisian urban music – *rabab*, *'ūd 'arbī*, *naqqārāt*, and *tār* – had largely given way to an ensemble comprising a violin, an *'ūd 'arbī*, a harmonium or piano, and a darbukka or *tār*. As Bernard Moussali writes,

> Avant de se répandre chez la plupart des ensembles tunisiens de l'époque, cet éclectisme était caractéristique des instrumentistes juifs tunisiens, désireux de se libérer des contraintes modales et des échelles tradition-nelles. Ils étaient aussi attentifs à la qualité acoustique des instruments occidentaux et à l'étendue de leur ambitus que leur permettaient de varier leurs effets et d'interpréter à l'occasion des morceaux franco-arabes. (Moussali 1992: 4)[3]

Yet the use of European instruments of fixed pitch in Arab music was not without its detractors, particularly among European reformers. In his introductory essay to the fifth volume of his monumental six-volume work *La Musique Arabe*, the aristocratic patron and pioneering scholar of Arab music Baron Rodolphe D'Erlanger (1872–1932) identified the use of fixed-pitch instruments such as the piano, harmonium, and fretted mandolin as one of the principal 'causes' of 'decadence' in North African music. By imposing the equal-tempered diatonic scale on the variable, non-tempered intervals of the Arab scale, he claimed, such instruments destroyed the very essence of

[2] Literally, singing cafés; essentially, coffee houses where alcohol was served and staged performances were presented to audiences seated in rows.

[3] 'Before spreading among the majority of Tunisian ensembles of the time, this eclectic combining [of traditional Arab and European instruments] was a speciality of Jewish musicians eager to free themselves from the constraints of the traditional modes and scales, and equally attentive to the acoustical quality of the Western instruments and the extent of their ambitus, allowing them to vary their techniques and occasionally perform songs in the *franco-arabe* dialect [Tunisian colloquial Arabic mixed with French]'.

the *tubu'* (melodic modes) (D'Erlanger, circa. 1949: 341).[4] From his palace in Sidi Bou Saïd on the outskirts of Tunis, D'Erlanger countered the 'corruptive' effects of this trend by patronizing his own private ensemble comprising only the traditional Tunisian instruments and a male alto vocalist. It was D'Erlanger's ensemble that represented Tunisia at the First International Congress of Arab Music held in Cairo in the spring of 1932, where the European-dominated Committee of Musical Instruments recommended that the unmodified piano[5] and (for reasons of timbre) the cello, both widely used in Egyptian music, be outlawed from Arab music ensembles altogether (Racy, 1991: 76–77).

In the event, D'Erlanger was too ill to travel to Cairo; he died in October that year. Two years later, his musicians became founding members of the Rashidiyya ensemble, a grassroots initiative established in November 1934 with the aim of conserving and promoting traditional Tunisian music. Ironically, so entrenched was the keyboard in Tunisian music that, when the Rashidiyya gave its inaugural concert at the National Theatre on 5 June 1935, the ensemble was led not by a player of a traditional Tunisian instrument, but by the harmonium player Muḥammad al-Aṣram. The concert opened with a solo performance by al-Aṣram of songs attributed to the Rashidiyya's namesake – the eighteenth-century patron and musical amateur, Muḥammad al-Rashīd Bey, arranged for the harmonium (Moustaysir, 2014: 192).

Exploring the Nationalist Narrative

I encountered what was essentially the story of the harmonium in microcosm in my conversations with Yaakob Bchiri (1912–2007) – the last remaining Jewish professional musician in Tunisia – on my first visit to the island of Djerba in 1978.[6] Yaakob's paternal family had migrated to Tunis from Izmir; his mother came from Sfax, a port city to the south of Tunis. Yaakob's father Mordechai Bchiri had played the *nāy* in the beylical band, while his uncle Gaston Bchiri was a violinist and a prolific composer of popular song. The

[4] All but the first volume were published posthumously.

[5] Some members of the committee, including the Arabist Henry George Farmer, argued that the piano would be acceptable if its tuning were modified to reflect the microtonal tuning of the Arab scale (Racy 1991: 77).

[6] Tunisian independence in 1956 and the Israeli-Arab wars of 1967 and 1973 had triggered the mass exodus of almost the entire indigenous Jewish community. Those who remained were mostly concentrated in Tunis and on the island of Djerba, where the community traces its legendary origins to the exile following the destruction of the First Jerusalem Temple in 587 BCE. See Davis (2002; 2010).

family home in Hara Kebira (literally, 'big Jewish quarter' – the larger of the two Jewish villages on Djerba) was distinguished by the presence of a harmonium, the first on the island, which was played by his mother and sisters, and Yaakob learned to play the harmonium and sing their songs by imitating them. In the 1920s, Yaakob set off for Tunis where he apprenticed himself to his uncle Gaston. On his return to Djerba he made debut as a singer, accompanying himself on the harmonium.

When I met him in his mid-sixties, Yaakob was in high demand to perform at both Jewish and Muslim weddings, circumcisions, and other family and religious celebrations on Djerba and the mainland. Typically, he led a mixed band of Jewish and Muslim musicians playing violin, accordion, darbukka, and *tār*; Yaakob sang solo, accompanying himself on the *'ūd sharqī*, and the rest of the ensemble sang the refrains. The songs, in Tunisian Arabic and in *franco-arabe*, were mostly attributed to famous Jewish singers and composers of the protectorate era, such as Cheikh El Afrit, Asher Mizrahi, Gaston Bchiri, Louisa Tounsiyya, and a singer known as 'Dalel' (the singer/dancer Dalila Taliana). Essentially, Yaakob was singing the popular repertory of the *kaféchantants* that he had learned in his youth in pre-World War II Tunis.

A few years later, I returned to Tunis to carry out my doctoral research into the *ma'lūf* – the so-called Tunisian-Andalusian musical heritage, comprising the songs and instrumental pieces that had allegedly been imported by Jews and Muslims fleeing the Christian Reconquest. This was the repertory with which the Rashidiyya ensemble was primarily associated, and in its efforts to conserve and promote the orally transmitted melodies, the Rashidiyya had transcribed them into Western staff notation to provide a standard version for its performances. Since independence, the *ma'lūf* had been canonized and elevated to the status of the national musical heritage by the Ministry of Cultural Affairs, which had published the entire corpus of melodies and texts in a series of nine volumes entitled *Al-Turath al-musiqi al-tunisi/Patrimoine musical tunisien* ['The Tunisian Musical Heritage'].[7]

When I played my recordings of Yaakob Bchiri's band to my teachers in the musical establishment, their reactions were dismissive. These songs, they explained, belonged to a time when Tunisian culture and society, including its language, music, and the musical profession itself, had been corrupted by the colonial occupation. Since independence, they assured me, such inferior elements had been all but eradicated from the national culture, persisting only in such remote, isolated pockets as I had found among the Jews of Djerba.

Their attitude was underpinned by the narrative found in numerous government publications and outlined most comprehensively by Salah

[7] See Davis (2004) for a detailed account of these canonization projects.

el-Mahdi and Mohamed Marzuqi in their book on the Rashidiyya Institute (El-Mahdi and Marzuqi, 1981). According to the authors, Tunisian music had been in a state of decadence and decline since the dawn of the twentieth century, due largely to an unprecedented vogue for Egyptian music imported by visiting celebrities and promoted by the burgeoning record market. Tunisian musicians had jumped onto the bandwagon and were imitating the Egyptians in their music, their dialect, and even their costume. The new public performance venues such as the *kaféchantants* and, especially after World War I, theatres, cinema halls, and casinos, offered a ready platform for the new trends, which included a new, 'inferior' type of Tunisian song characterized by trivial, vulgar themes and linguistically corrupt texts: particularly deplorable were those that used *franco-arabe*, which degraded the Arabic language by mixing it with French (El-Mahdi and Marzuqi, 1981: 25). The authors single out two Jewish musicians (Maurice Benais and Gaston Bchiri) as responsible for perpetrating the 'degrading' songs. The nationalist writer Hedi al-Ubaydi is more explicit in his blame, describing فنّ ممجوج لا يتعدّى التّقليد المشوّه لما يرد على البلاد من إسطوانات تحنل الغناء الشرقي، أو ما تتفتق عنه قرائح الجهلة والسّوقة من المتطفلين على الفنّ من الإسرائيليين[8] Such practices, al-Ubaydi maintained, posed a threat to the national identity in as much as they عن هذا وذاك اضمحلال الشّخصيّة الفنيّة التي لابدّ من توفّرها لكلّ شعب، حتّى لا يذوب في غيره[9] (cited in Moustaysir, 2014: 77).[9] Clearly, for these and other Tunisian intellectuals and nationalists, the decadence of Tunisian music extended beyond the use of the wrong types of instruments to include the types of language, lyrics and venues, and even the behaviour of the musicians associated with them (Guettat, 2000: 238).

Yet, as Mokhtar Moustaysir observes in his recent critique of this narrative, in a society in which it was generally considered shameful for 'manly' Muslims (*aṣḥāb al-murūʾah*) to sing in public other than in the *zwayya* (meeting places of the Sufi brotherhoods), it was inevitable that the domain of professional music-making would be occupied disproportionately by Jews. Referring to the Tuwansa (indigenous Tunisian Jews), Moustaysir explains:

و تقطن أغلب عناصرهم في العاصمة "ب حَارَة الحفصية" وسط المدينة. و كانت بيّتهم الا

[8] 'a mixed art which does not go beyond the distorted imitation of the eastern songs which find their way into the country on records, or what the ignorant talents and vulgar sorts among the Israelites, who approach art so childishly, come up with'.

[9] 'resulted in a diminution of the artistic character which every people must have, so that it does not melt [and disappear] into another'.

108

Jewish-Muslim Interactions

جتماعية الفقيرة والمتجحّررة نسباً، أحد أهمّ العوامل في احتمار محنر في الغناء والرقص عندهم للوسط الفني الشعبي بالحاضرة، جيلا بعد جبل (Moustaysir, 2014: 39)[10]

Jews, moreover, were not alone in perpetrating the corruptive trends. Moustaysir lists a string of Muslim female vocalists, including some that sang with the Rashidiyya, who also performed الأغاني الهابطة و الهجينة ['vulgar and bastardized songs'] (2014: 77).[11] Mohamed Triki, veteran leader of the Rashidiyya who launched the original project to transcribe the *ma'lūf*, acknowledged in our conversations that he too had composed songs in *franco-arabe*.[12] Nor did the vogue for Egyptian song or the use of fixed-pitch instruments diminish with the departure of the Jews after independence. The Tunisian Radio ensemble, established in 1958, was modelled directly on its Egyptian counterpart. Like the Rashidiyya ensemble, it comprised a core section of Western bowed strings (violins, violas, cellos, and plucked double bass) and a smaller section of traditional Arab instruments, including percussion. However, while the Rashidiyya consistently eschewed instruments of fixed pitch, the Tunisian Radio ensemble included Western instruments such as accordions, electric keyboards, electric guitars, clarinet, timpani, and bongos, and its repertory consisted primarily of Egyptian media songs and Tunisian songs in a similar style (El-Mahdi and Marzuqi, 1981: 57–58). Surveying the state of Tunisian popular song in the early 1990s, Mourad Sakli proclaimed that Middle Eastern modes and rhythms constituted 'le moyen d'expression naturel des compositeurs tunisiens, et l'univers mélodique où les chanteurs se sentent le plus à leur aise' (1994: 139–40).[13]

Returning to the protectorate era, the activities of Jewish musicians were by no means confined to popular song. Many were equally active in *ma'lūf* circles, effectively functioning as intermediaries between the different musical domains. As Moustaysir observes:

[10] The majority of them lived in the capital in the Hafsid quarter, in the middle of the city. Their poor but relatively liberal social environment was one of the most important factors in their monopolization of professional singing and dance in the popular artistic milieu of the city, generation after generation.

[11] He names Faḍīlah Khatmī, Shāfiya Rushdi, Fatḥiyyah Khayrī, and Ḥasībah Rushdī. At different times, both Shāfiya Rushdi and Fatḥiyyah Khayrī sang as soloists with the Rashidiyya (El-Mahdi and Marzuqi, 1981: 34, 55).

[12] See Davis (2009: 199–200) for the lyrics and English translation of Triki's song 'Vous Dansez Madame' as performed by Amina Srarfi's all-female band El 'Azifet in 1998.

[13] 'the natural medium of expression for Tunisian composers, and the melodic universe in which singers feel most at ease'.

Retelling the Jewish Past in Tunisia

و تقطن أغاصرهم في العاصمة ب "حارة الحفصية" ويط المدينة. وكانت بيئتهم الاجتماعية الفقيرة والمتحرّرة نسبياً، أحد أهمّ العوامل في احكار محتر في الغناء والرقص عندهم للوسط الفني الشعبي بالحاضرة، جيلا بعد جبال (Moustaysir, 2014: 33)[14]

He notes that many Jewish lawyers, doctors, and businessmen participated in the founding of the Rashidiyya Institute and he names at least nine Jews among the founding members of the original ensemble. The Rashidiyya, he claims, was one of the few projects of the time that brought Jews and Muslims together (Moustaysir, 2014: 150–51).

As I pursued my doctoral research in the early 1980s, cultural officials, musicians, music critics, and journalists lamented the lack of support for Tunisian song shown by the state-owned broadcasting and recording media, and their relentless support for Egyptian song. Meanwhile, musicians and audiences alike bemoaned the sterility of the performance model promoted by the Rashidiyya and the state cultural institutions, and the loss of the spontaneity and vitality of the traditional ensembles. In a private conversation, in an unexpected reversal of the nationalist narrative, an official at the Rashidiyya Institute blamed the decline of the *ma'lūf* directly on the departure of the Jews: when they left, he claimed, the *ma'lūf* lost its vitality.

Matters came to a head when, following the coup d'état of 7 November 1987, President Habib Bourguiba, who had led Tunisia to independence in 1956, was succeeded by President Zine El Abidine Ben Ali. This change of regime, known as *al-Taghrīr* (literally, 'The Change'), was initially characterized by a loosening of nationalist agendas and a decentralization of cultural policy, paving the way for more inclusive models of Tunisian cultural identity. Nostalgia for the cultural and artistic expressions of the protectorate era led to the revival and rehabilitation of long-neglected songs and singers, developments manifested in the reissuing of vintage recordings showcasing Jewish artists; in films featuring Jewish subjects; in the emergence of a popular, journalistic, and largely biographical literature on prominent musical personalities; and in various scholarly initiatives.[15]

[14] 'Jewish singing circles were never devoid of artists skilled in *ma'lūf*, in spite of their distinct accent and their difficulty in understanding Arabic expressions. Their Sheikhs would meet with their Muslim counterparts, including Sufi practitioners, in the regular *ṭarab* meetings held by princes and notables. They represented the most important circles of contact between the supporters of "high" art and popular art'. The term Sheikh or Shaykh (Shaykhah/Shaykhat) is the traditional honorific for a 'master' musician – particularly one renowned for their knowledge of the repertory – in Arab music.

[15] Examples of the latter include Fārūq al-Sha'būnī's biography of Cheikh El Afrit (1991), Bernard Moussali's account of the emerging Tunisian record

110 *Jewish-Muslim Interactions*

Crucially, those spearheading these developments were Tunisian Muslims, many of whom had grown up in mixed Muslim-Jewish communities and still carried memories of Jewish neighbours and childhood friendships. For most of their compatriots, however, Jews had by then been relegated to history, existing only in the memories of an increasingly ageing segment of the population and in the stories they passed on. By the late 1980s, an entire generation of Tunisian Muslims, including many who had grown up in towns that for centuries had hosted thriving Jewish communities, had reached adulthood having never encountered a Jew.

As social, political and cultural conditions shifted through the 1990s and beyond, in Tunisia and globally, so attitudes towards the cultural heritage of the all-but-vanished indigenous Jewish community also shifted, moving between remembering and un-remembering, and from concerted efforts to reclaim that heritage through only partial acknowledgement and acceptance to outright denial, with contradictions and ambivalence marking each turn. It is these shifting attitudes, and the layers of ambivalence they reveal and conceal, that I explore in the following pages. I do so with particular reference to the musician who, perhaps more than any other of his generation, has come to epitomize the contradictions and ambivalence associated with the musical legacy of Tunisian Jews: the singer-composer known as Cheikh El Afrit.

Two Jewish Musical Encounters in Film: Yaakob Bchiri and Cheikh El Afrit

In an article surveying the representation of Jews in Tunisian cinema, the influential Tunisian film director and critic Ferid Boughedir identifies Nouri Bouzid's *Rīḥ al-sid / L'Homme de Cendres* [*Man of Ashes*] (1986), and the controversy it unleashed, as a watershed, forcing Tunisians to confront what for many represented 'la perte de cette dimension d'eux-mêmes qu'était la communauté juive de Tunisie' (Boughedir, 1994: 139).[16] Ostensibly a film exploring deep-seated societal taboos surrounding homosexuality and child sexual abuse, *Rīḥ al-sid* includes a sympathetic portrait of an elderly Jewish carpenter and amateur musician, named Levy, who acts as a mentor and friend to the young protagonist Hachemi on the eve of his wedding. The role

industry (Moussali, 1992), and Mourad Sakli's doctoral thesis 'La Chanson Tunisienne' (1994), in which he acknowledged the formative role played by Jewish artists in the development of popular song.

[16] 'the loss of that dimension of themselves that was the Jewish community of Tunisia'.

Retelling the Jewish Past in Tunisia

of Levy is played by Yaakob Bchiri, the Jewish musician from Djerba whose voice I recorded on my first visit to the island in 1978.

As the two men drink, make music together, and reminisce about the past – Levy recalling 'those happy evenings, the balconies full to overflowing with Arabs, Jews, French, Italians'[17] – Hashemi temporarily forgets his anxieties about his impending wedding. Against a symbolically laden backdrop of a lighted eight-branch candelabrum (*hanukiah*), a bottle of *bucha* (spirit of figs), and walls laden with photographs of deceased or departed family, Levy takes out his *'ūd* and sings:

> *I remember the days when the streets were so gay*
> *The neighbourhoods have lost their charm*
> *No-one sings in the courtyards and celebrates on the balconies*
> *The doors no longer dance and the locks are all silent*
> *The roofs break out in tears as the swallows fly away.*[18]

The controversy sparked by this scene when *Rīḥ al-sid* was selected as an official entry at the 1986 Cannes International Film Festival completely overshadowed any controversy arising from the film's sexual content. Responding to calls by Tunisian activists to boycott the film on grounds of its alleged 'Zionist' content, Bouzid protested: 'Vous voulez effacer une partie de ma mémoire! Je ne vous permettrai pas d'amputer une partie de ma culture' (cited in Boughedir, 1994: 142).[19] In an interview nearly two decades later, Bouzid explained:

> je voulais rendre hommage à ce vieux juif qui a élevé la musique tunisienne; comme je voulais rendre hommage à cette vieille prostituée qui est comédienne et qui a réellement existé. Elle est morte maintenant. Je voulais […] faire vivre des personnages qui sont presque comme ça dans la réalité, qui donnent une épaisseur au film, une sincérité, une authenticité. C'est cette Tunisie oubliée qui m'intéresse, on n'a pas le droit de les oublier, ces gens-là. (Bouzid, 2004)[20]

[17] Taken from the English subtitles to *Rīḥ al-sid / L'Homme de Cendres* [*Man of Ashes*] (dir. by Bouzid, 1986).

[18] Adapted by the author from the English subtitles to Yakoob Bchiri's song in *Rīḥ al-sid / L'Homme de Cendres* [*Man of Ashes*] (dir. by Bouzid, 1986).

[19] 'You want to erase a part of my memory! I will not let you amputate a part of my culture'.

[20] 'I wanted to pay homage to that old Jew who raised the bar for Tunisian music; just as I wanted to pay homage to that old prostitute-comedienne who really existed, but has since passed away. I wanted to bring to life characters

Bouzid's reference to 'cette vieille prostituée' points to another clear, if more discrete, Jewish reference in his film, whose presence, however, seems to have been eclipsed in the public discourse by the controversy surrounding Levy. In their attempt to allay the groom's anxieties, his companions persuade Hachemi and his friend Farfat, who share a secret history of childhood abuse, to visit the veteran prostitute Sejra, who in turn calls upon two young women to initiate the young men in the mysteries of making love. As the small party of men weave their way through the backstreets to the prostitute's house, the haunting, unmistakable voice of Cheikh El Afrit pierces the night air in the opening phrases of the *'arūbi* (introductory vocal solo in free rhythm) of his signature song 'Lay Guella'. The song tells of a bridegroom who is petrified at having to consummate his arranged marriage.

Cheikh El Afrit (literally, the devilish, or genius shaykh), otherwise known as Isserine Israel Rozzio (1897–1939), was born in the Hafsia, the traditional Jewish quarter of Tunis, to a Moroccan father and a Tripolitanian (Libyan) mother; among his formative musical experiences were the Tripolitanian and Tunisian songs he learned from his mother, who sang to entertain women at wedding parties. He also sang in various synagogue choirs, absorbing the Tunisian-Andalusian modes of the Hebrew liturgy (al-Shaʻbūnī, 1991: 15). Gifted with a voice of extraordinary power and ambitus, he took lessons from various Jewish masters of popular song and *ma'lūf* before rising to become one of the most popular and prolific of the Tunisian recording artists of the interwar years, with a reputation that extended across North Africa and spanned all social classes: he was one of the select number of musicians invited by Ahmad Bey II (1929–1942) to perform at his weekly Tuesday night concerts at the Bardo palace (Louati, 2012: 154; al-Shaʻbūnī, 1991: 20). Contrary to stereotype, none of Cheikh El Afrit's songs use the *franco-arabe* dialect and he eschewed the distinctive Jewish-Arabic pronunciation. As his biographer, Fārūq al-Shaʻbūnī, observed: ورغم جهله القراءة كان ينطق اللغة العربّية بشكل سليم دون
تحريف بعض أصواتها على غرار بقّية اليهود التونسسيين الذين ينطقون الشين سينا[21]

Yet Cheikh El Afrit never ceased to identify, and to be identified with, the Jewish community of Tunis and its customs. Throughout his life,

who are almost like that in real life, who give substance to the film, who give it a sincerity, an authenticity. It's that forgotten Tunisia that interested me; we have no right to forget people like that'.

[21] 'Although he couldn't read [Arabic] he pronounced Arabic correctly, without mispronouncing some letters like the other Tunisian Jews, who pronounced *al-shīn* instead of *al-sīn*'.

مؤدّيا فرائض دينه بلا تهاون ولا خلل (al-Shaʿbūnī, 1991: 25).[22] As wealthier Jews increasingly exchanged the narrow streets and cramped housing of the Jewish quarter for the more salubrious European neighbourhoods, Cheikh El Afrit remained in the Hafsia, raising his family there after his marriage. His accompanying ensemble, typical of Jewish professional ensembles, comprised a violin, *ʿūd*, harmonium (*ʿurghūn*), and *qānūn*, with Cheikh El Afrit leading on the *tār*; the musicians were all Tunisian Jews. The seamless blending of Cheikh El Afrit's Jewish and Tunisian Arabic identities is epitomized by his gravestone in 'The Borgel' – the Jewish cemetery on the outskirts of Tunis.[23] On it, his name 'Israel Rosio' (without reference to 'Isserine') is inscribed in Hebrew and Latin script, and 'Cheikh El Afrit' in Hebrew, Latin, and Arabic script. A poem in Tunisian Arabic, which he composed himself and requested to be carved on his gravestone, is inscribed in Hebrew letters.

Cheikh El Afrit

(i) The Consummate Performer – A CD Anthology

The fragments of 'Lay Guella' accompanying the prostitute's scene in Bouzid's *Rīḥ al-sid* are taken from the recording featured on the CD 'Cheikh ElAfrit: Les Succès des années 30' ['Cheikh El Afrit: The Successes of the 1930s'], released in 1992. The CD is the second of two volumes of songs described as 'les oeuvres les plus marquantes de cette carriere eblouissante' in the series *Musique Populaire Tunisienne* compiled by Ahmad Hachlef for his label Club du Disque Arabe – Artistes Arabes Associés.[24] Among the total of twenty-two songs are two of Cheikh El Afrit's most famous titles: 'Yā nās hmilt wa-ʿamiltu raḥla' ['O You Guys, I Wandered Alone': CD1, track 8] and 'Tasfar wa titgharrab' ['You Travel and Feel Like a Stranger': CD2, track 11].

Both these songs are widely believed to have been composed for Cheikh El Afrit by one of the most renowned musicians in his circle – the Jewish singer-composer and *paytan* (Hebrew poet) Asher Mizrahi (1890–1967).[25] Born in the Jewish quarter of Jerusalem's Old City or, as the Tunisian author Hamadi Abassi puts it, 'né sur les rives du Jourdain' ['born on the banks of

22 'he fulfilled his religious duties without negligence or fault'.

23 Named after Eliaou Borgel, the Chief Rabbi of Tunisia, who inaugurated the cemetery in 1894.

24 'the most outstanding works of [Cheikh El Afrit's] dazzling career'.

25 Abassi (2000: 10, 22, 23); Louati (2012: 154). See also the website of the Jewish Music Research Centre, The Hebrew University of Jerusalem, available at: http://www.jewish-music.huji.ac.il/content/asher-shimon-mizrahi (consulted on 3 September 2019).

114 *Jewish-Muslim Interactions*

the Jordan River'] (2000: 21), Asher Mizrahi left Jerusalem during the Balkan Wars (1912–1913) to escape the Ottoman draft, eventually arriving in Tunis where he remained until the end of World War I. In 1929, as Arab-Jewish tensions in Jerusalem mounted, Mizrahi emigrated permanently to Tunis where he pursued a dual career, serving as a cantor and *paytan* in the Jewish community while immersing himself fully in the popular musical scene.

Yet there is no attribution to Asher Mizrahi or to any other named composer in Hachlef's notes (in French, with English translation) accompanying the two-volume CD set. Hachlef characterizes Cheikh El Afrit as the singer who has contributed most to the diffusion of Tunisian folksong, both in Tunisia and in the wider Maghrib, and he attributes the singer's meteoric rise to fame to his powerful voice and the novelty of the Tripolitanian repertoire he learned from his mother. His achievement overall, according to Hachlef, was the result of his immense talent as a performer and his inimitable voice (Hachlef, 1990). Nowhere does Hachlef identify artistic creativity, whether that of Cheikh El Afrit himself or of any other individual artist, as a factor contributing to his extraordinary 'successes'. On the contrary, he is presented soley in terms of a consummate performer of a pre-existing repertory drawn from the vast repository of Tunisian folksong. Nor is there any reference in Hachlef's notes to Cheikh El Afrit's Jewish origins or social and professional milieu; curiously, in an inversion of the form that appears on his gravestone, Hachlef gives Cheikh El Afrit's birth name as Isserene Rozio, omitting his Hebrew name Israel.

(ii) An Absent Presence – A 'Folksong' Anthology

In 1997, the music publisher Mohamed Boudhina produced an anthology of anonymous songs, including musical notations and lyrics, entitled *Aghānī min al-turāth* (literally, 'songs from the [Tunisian] heritage'). The colourful front cover depicts a rural idyll, far removed from the world of interwar Tunis inhabited by Cheikh El Afrit (see Plate 3). In his substantial introductory essay, Boudhina emphasizes the purely Arab provenance of the songs in his collection, contrasting this with the various foreign (Persian, Turkish, and Andalusian) elements in Tunisian urban song. He draws particular attention to the songs' anonymity, marking them as products of collective rather than individual creativity:

لا يهتم الناس، عادة مجعرفة مؤافيها وملحنيها، ويشرك عادة أكثر من ناظم في تأليفها. وإنّ من أهم صفات الأغنية الشعبية شيوغها بين أفراد الشعب... ونغني بذلك أن كثيراً من الأفراد يشتركون في نظمهاوأدئها، بخلاف الأغنيةا لأخرى (Boudhina, 1997: 11)[26]

[26] 'The people are not usually interested in the composers of the words and the

Retelling the Jewish Past in Tunisia

Browsing through Boudhina's collection, I immediately recognized songs from Yaakob Bchiri's repertoire that he and others had attributed to Cheikh El Afrit and other Jewish composers and singers in his milieu. Indeed, nine of the twenty-two songs in Hachlef's 2-CD anthology of songs by Cheikh El Afrit, including the two widely attributed to Asher Mizrahi, are included in Boudhina's anthology. Yet there is no reference in Boudhina's text to Cheikh El Afrit, Asher Mizrahi, or to any other individual composer or singer.

Boudhina does not identify the sources of his transcriptions, nor are the songs linked to any particular time or place: on the contrary, they are presented in their entirety as an anonymous, timeless folklore: وبعض الألحان العريقة التي عايشت الأجيال الماضية (1997: 2).[27] Nowhere does he acknowledge the celebrated recording artists of the protectorate era through whose distinctive voices, arrangements, and original interpretations so many of the songs in his collection were disseminated from their regions of origin across the Maghrib and beyond, and with whom they became inextricably associated.[28] Nor does Boudhina mention the popular urban venues, theatres, and casinos where the songs were typically preformed, nor any of the recent CD compilations of those vintage recordings.

Cheikh El Afrit – A Master of 'Tunisian' Song

Record labels and catalogues of Tunisian song from the interwar era provide minimal information about the songs they document: it was customary to identify only the singer and the title – normally the opening or other salient words of each song.[29] In recent decades, however, various Tunisian writers, notably Cheikh El Afrit's biographer Fārūq al-Shaʿbūnī, have examined the multiple sources and influences at play in the singer's prolific output, allowing for a more informed appraisal of his creative contribution.

music, and usually more than one poet is involved in their composition. One of the most important qualities of folk (popular) song is the fact that it is the common property of all the individuals within the community [...]. By this we mean that many people share in their composition and performance, unlike with some other songs'.

27 'ancient tunes which were part of the lives of past generations, and which have survived [in oral tradition] until the present day'.

28 See Silver (this volume) for an indication of the transnational circulation of the artists and their repertory.

29 Certain traditional songs are identified by function such as *taalilet el aris* (wedding song) or *taalilet el mtahar* (circumcision song). See *Cheikh El Afrit*, Vol. 2.

116 *Jewish-Muslim Interactions*

In addition to the repertories he acquired in Tunis, Cheikh El Afrit travelled to El Kef in the northwest of Tunisia, where he collected folksongs from Bedouin singers (al-Shaʿbūnī, 1991: 27, 31, 39). It is to these Bedouin singers that writers such as Hachlef and al-Shaʿbūnī most readily attribute the sources of Cheikh El Afrit's repertory. As al-Shaʿbūnī observes:

فقد كان ينتقل الى الشّامال الغربي التنسي خاصةً إيى مدينة الكاف ليلتقي بالمطوبين الشّعبيين
ليحفظ عنهم أغانيهم جديدها وقديمها ثمَ يعود الى تونس ليؤدي هذه الأغاني البدوية في اسلوبه
الخاص وبطابع جديد (al-Shaʿbūnī 1991: 27)[30]

According to Ali Louati, Cheikh El Afrit's repertory consisted of all the vocal genres of the time, including songs from the *maʿlūf, funduwwāt*,[31] popular urban songs, Bedouin-inspired improvisations (*ʿarūbiyyāt*), 'chansons légères à thème humoristique ou grivois' ['light humorous or bawdy songs'], and songs for Islamic celebrations such as marriage and circumcision (Louati, 2012: 154). Crucially, according to al-Sha'buni, it also included songs that Cheikh El Afrit composed himself and songs composed for him by other Jewish musicians:

وغنّى أغان من شعره وألحانه كما غنّى أغاني وضع كلمته ولحّنها قنّانون يهود تونسيّون وهم
على التّوالي حسب أهمّية أعملهم بنست الفنّ الشّيخ العفريت: مرويس عطون وقسطون بصيوي
ومورويس بن يعيش وأشير مجراحي وكليمان بصيري (al-Sha'buni, 1991: 31)[32]

His renderings of Bedouin songs, moreover, were no mere appropriations. Cheikh El Afrit's genius lay in his ability to adapt the traditional melodies and lyrics to his own instrumental arrangements and unique vocal style, thereby interpreting them (quoting al-Sha'buni) في اسلوبه الخاص وبطابع جديد ['*in his own ways and new manners*'] (1991: 27; author's italics). And, notwithstanding the songs' rural origins, Cheikh El Afrit's own ways and manners were fundamentally those of Tunisian urban song. His arrangements do not only exploit to the full the contrasting timbres and articulation of the accompanying melody instruments, typical of urban professional ensembles;

[30] 'He went to the city of El Kef in Northwest Tunisia to meet two folk singers, and learnt from them their old and new songs, and then returned to Tunis to perform these Bedouin songs *in his own ways and new manners*'. Author's italics.

[31] Light, semi-classical songs in Tunisian dialect often included in recitals of *maʿlūf*.

[32] 'Cheikh El Afrit soon began to compose songs for the poems that he and other Tunisian poets, especially the Jewish ones, wrote [...] [he also sang] songs of his own composition (lyrics and music) and those of other Tunisian Jewish artists such as Maurice Atoun, Gaston Bchiri, Maurice Ben Ais, Asher Mizrahi, Kaliman Bchiri'.

Retelling the Jewish Past in Tunisia

for al-Shaʿbūnī and other Tunisian writers, the key to both the originality and the authenticity of Cheikh El Afrit's interpretations lay in his distinctive renderings of the *urūbiyyāt* – the Bedouin-inspired improvisatory vocal solos with which he opened each song:

ان الشسخ العفريت يتصوف فيها تصوفا شخصيا بكل حريّة بدون قيد في وزن فتظهر مقدرة العجيب في الخلق الفوري الازتجالي حين تخرج النغمة في طغة الجواب وبقدرة فية عالية بما فيها من تعانيخ وزخارف وذبذبات صوتية يعسرضبطها في الثُرقيم. وقد اتُخذ الشسخ العفريت من هذه العروتيات مدخلا و مطيّة (al-Shaʿbūnī, 1991: 43)[33]

For, paradoxically, it was precisely through his 'spontaneous invention' in the Bedouin-inspired *ʿurūbiyyāt* that Cheikh El Afrit displayed to the utmost his special ability to perform the modes of the city of Tunis بكل سهولة بدون تكلف متميزا عن النغمات الشرقية والعربية الأخرى (al-Shaʿbūnī, 1991: 43).[34] Notwithstanding his use of the harmonium, whose fixed diatonic tuning D'Erlanger and other European reformers considered so corruptive to the Arab modal system, it was his masterful vocal manipulation of the Tunisian urban modes – at the very moment, moreover, when other musicians were turning to Egypt for their inspiration – that assured Cheikh El Afrit his enduring place in the ranks of the legendary Tunisian singers. As al-Shaʿbūnī explains,

فصوت الشيخ العفريت فهو يبقى مقياسا لأغنية البلديّة (نسبة لمدينة تونس) كما سيتقى صوت وأداء صليحة مقياسا لأغنية الرّيف التونسي وصوت الطاهر غرية مقياسا للمالوف التونسي فالشيخ العفريت مع هاذين المطربين، يعتبرون مرجعا و حجة في مجال النغمات التونسية (al-Shaʿbūnī 1991: 44)[35]

Echoing al-Shaʿbūnī some two decades later, Mokhtar Moustaysir concluded that Cheikh El Afrit

33 'Cheikh El Afrit manoeuvred his singing with his personal style freely [...] He exhibited his special ability for spontaneous invention when he deviated from the melody at the level of octave and was able to make subtle vocal twists, ornaments, and oscillations. Cheikh El Afrit took from those *ʿurūbiyyāt* means and methods and incorporated them into his songs'.

34 'which are different from other Oriental and Arab modes, easily and without exertion'.

35 'The voice of Cheikh El Afrit [...] remains the standard of urban songs (attributed to the city of Tunis) [just as] the voice and performances of Saliha [female singer who performed with the Rashidiyya ensemble] serve as the standard of Tunisian rural songs [and the] voice of Ṭahar Gharsa is the standard of Tunisian *maʿlūf*. Cheikh El Afrit, together with these two singers, [...] is regarded as the source and authority in the field of Tunisian modes'.

118 Jewish-Muslim Interactions

التزم طوال مسيرته بأداء اللون الغنائي التونسي [...] تعتبر اليوم طوالع أغانيه المسجلة (المسماة عندنا بالعروبى)، أحسن مثال في أداء فنّ الارتجال التونسي والقدرة الفائقة على التصرف فيه، حسب خصائص وقواعد الطبوع التونسية والمغاربية الأصيلة؛ وهي المدرسة الفنية الأصيلة التى يتجنبها ذوو الأصوات المحدودة (Moustaysir 2014: 44)[36]

Captured on disc, the songs associated with Cheikh El Afrit became inextricably associated with his inimitable voice. Even the songs that allegedly originated as anonymous folksongs became famous through his interpretations, and owe their widespread popularity and status as part of a national, indeed transnational, song heritage, to his recordings. As al-Sha'būnī has observed:

إنّ الموسيقى والغناء تعدّ جزءاً لا يتجزأ من المقوّومات الذاتية الحضاريّة والهويّة القوميّة لكلّ شعب وبفضل تسجيلات الشيخ العفريت يمكن لنا التّوصّل والتّعرف على بعض هذه المقوّمات (al-Sha'būnī 1991: 44)[37]

Born in Tunis to parents of Moroccan and Tripolitanian origin, Cheikh El Afrit lived all his life in the Jewish quarter of the city, performed exclusively with Jewish musicians, was illiterate in Arabic, and rose to fame during a time of musical eclecticism and experimentation under French colonial rule. Yet, far from epitomizing the 'age of decadence', as nationalist writers designated the Jewish-dominated popular song culture of the protectorate era, Cheikh El Afrit – the Jewish 'Cheikh' – has come to be accepted by Tunisian intellectuals and musical connoisseurs as a pillar of Tunisian cultural identity, occupying a privileged place alongside iconic Muslim musicians as a source and reference for Tunisian urban song.

Works Cited

Abassi, Hamadi. 2000. *Tunis chant et danse: 1900–1950*. Tunis: Alif – Les Éditions de la Mediterranée et les Éditions du Layeur.

Allali, Bernard. 2014. *Les Juifs de Tunisie: un autre regard*. Paris: Bernard Allali.

[36] 'was committed throughout his career to the true Tunisian type of singing [...] His early recorded songs (called by us 'urūbī) [...] are considered today the finest examples of Tunisian improvised performance which exploits to the utmost the particularities and rules of authentic Tunisian and Maghribi ṭubū' [modes]. This is the original artistic school, avoided by those with limited voices'.

[37] 'Singing is considered an indispensable component of the civilized self and national identity [...] Thanks to the recordings of Cheikh El Afrit, we can now approach and get to know some of those components [of our civilization and national identity]'.

Retelling the Jewish Past in Tunisia

Arnauld, Daniel. 1884. 'Les Populations de la Tunisie: une famille juive'. *Journal des voyages et des aventures de terre et de mer* 374: 146–47.

Boudhina, Mohamed. 1997. *Aghānī min al-turāth*. Hammamet–Tunis: Mohamed Boudhina.

Boughedir, Férid. 1994. 'La Communauté juive dans le cinéma Tunisien'. *Confluences Mediterranée* 10: 139–44.

Bouzid, Nouri (dir.). 1986. *Rīḥ al-sid / L'Homme de Cendres* [*Man of Ashes*].

Bouzid, Nouri. 2004. 'Poupées d'argile: entretien avec Nouzi Bouzid'. *Le Monde libertaire* 1369, 30 September–6 October. Available at: https://www.monde-libertaire.fr/?page=archives&numarchive=12120 (consulted on 3 September 2019).

Davis, Ruth F. 2002. 'Music of the Jews of Djerba, Tunisia'. In Virginia Danielson, Dwight Reynolds, and Scott Marcus (eds.), *The Middle East. The Garland Encyclopedia of World Music*. New York: Routledge: 523–31.

——. 2004. *Ma'luf. Reflections on the Arab-Andalusian Music of Tunisia*. Lanham, MD: Scarecrow Press.

——. 2009. 'Jews, Women and the Power to be Heard. Charting the Early Tunisian *Ughniyya* to the Present Day'. In Laudan Nooshin (ed.), *Music and the Play of Power in the Middle East, North Africa and Central Asia*. Aldershot: Ashgate: 187–206.

——. 2010. 'Time, Place and Memory: Music for a North African Jewish Pilgrimage'. In Erik Levi and Florian Scheding (eds.), *Music and (Dis)placement*. Lanham, MD; Oxford: Scarecrow Press: 71–88.

D'Erlanger, Rodolphe. 1949. *La Musique Arabe*, 5. Paris: Librairie Orientaliste Paul Geuthner.

Guettat, Mahmoud. 2000. *La Musique arabe-andalouse. L'Empreinte du Maghreb*. Paris and Montreal: Éditions El-Ouns, Éditions Fleurs Sociales.

Hachlef, Ahmad. 1990. 'Cheikh ElAfrit'. Liner notes to *Cheikh ElAfrit*, Vol. I (1991) and Vol. II (1992).

Louati, Ali. 2012. *Musiques de Tunisie*. Tunis: Éditions Simpact.

El-Mahdi, Salah, and Muhammad Marzuqi. 1981. *Al-Ma'had al-Rasīdī li-l-Mūsīqā al-Tūnisiyya*. Tunis: Wizārat al-Su'ūn al-Taqāfiyya/Ministère des Affaires Culturelles.

Moussali, Bernard. 1992. 'Les Premiers enregistrements de musique tunisienne par les compagnies discographiques'. Unpublished paper read at the colloquium 'Liens et interactions entre les musiques arabes et mediterra-néennes – Programme d'inauguration du Centre des Musiques Arabes et Mediterranéennes'. Hôtel Abou Nawas, Gamarth, Tunisia, 9–12 November.

Moustaysir, Mokhtar. 2014. نشاة الرشيدة: المعان والمخفي *The Founding of the Rachdiyya: The Official and Unofficial Stories*. Tunis: Moustaysir.

120 *Jewish-Muslim Interactions*

Racy, A. J. 1991. 'Historical Worldviews of Early Ethnomusicologists: An East-West Encounter in Cairo, 1932'. In Stephen Blum, Philip V. Bohlman, and Daniel M. Neuman (eds.), *Ethnomusicology and Modern Music History*. Urbana and Chicago: University of Illinois Press: 68–91.

Sakli, Mourad. 1994. 'La Chanson tunisienne. Analyse technique et approche sociologique'. Unpublished thesis. (Université de Paris – Sorbonne) Paris IV.

Al-Sha'būnī', Fārūq. 1991. *Shaykh al-'Afrīt, muṭrib tūnisī* [Cheikh El Afrit: Tunisian Singer].

Al-Turath al-musiqi al-tunisi/Patrimoine musical tunisien 1–9. n.d. Tunis: Wizarat as-su'un at-taqafiya/Ministere des Affaires Culturelles.

Discography

Cheikh ElAfrit, Vol. 1. Musique populaire tunisiene. Notes by Ahmad Hachlef. Club du Disque Arabe, Artistes Arabes Associés (1991). AAA 035, CDA 401.

Cheikh ElAfrit, Vol. 2. 'Les Succès des années 30'. Musique populaire tunisiene. Notes by Ahmad Hachlef. Club du Disque Arabe, Artistes Arabes Associés (1992). AAA057, CDA 401.

'Free, but United'? Artistic and Political Issues of Intercommunal Solidarity in Tunisia and Algeria, 1940–1960

Fanny Gillet

Translated by David Motzafi Haller

It was at the moment of independence, as Tunisian artists clashed over the definition of a new cultural identity, that Pierre Boucherle, encouraged by several of his associates, co-founders of l'École de Tunis ['the Tunis School'] in 1949, gave an interview to the daily newspaper *La Presse de Tunisie* in 1964. In the interview, he recalled the origins of this movement that, in the spirit of l'École de Paris, sought to bring together 'quelques-uns des meilleurs peintres de Tunis sans distinction de tendance, de race et de religion' (Boucherle, 1964: 3).[1] This quotation often finds its way into retrospections on art in Tunisia by writers who wish to show the salience of the principles of tolerance in Tunisian society in the aftermath of World War II. In the context of radicalizing nationalist movements and an unravelling colonial system, Tunisian artists from various class and religious backgrounds came together to create a heterodoxic space autonomous from the institutional Salon de Tunis, at a time when, in neighbouring Algeria, the modes of inter-community collaboration seemed to be increasingly compartmentalized. Despite this remarkable difference, we nevertheless find that in order to gain recognition in both countries, Muslim artists (*artistes de culture musulmane*)[2]

[1] 'Some of the best painters in Tunis regardless of artistic style, race, and religion'.

[2] Translator's note: By using the adjective 'Muslim' here and throughout the article, in relation to artists, I mean of Muslim culture (*de culture musulmane*).

often depended on an asymmetrical system in which a European and assimilated Jewish elite mediated access to the local art scene, given their fluency in cultural codes and their easy access to social networks. But the two decades from 1940 to 1960 also saw the rise of independence movements, and, with these, the emergence of a new avenue for the social and political emancipation of Maghribi artists. These developments coincided with the introduction of abstract aesthetics in the Arab world in general, a dominant trend in contemporary European centres where most Maghribi artists trained. Historically associated with cosmopolitanism and universality, abstraction, by virtue of its non-referential aspect, would express the progressive ideas of an internationalist avant-garde (Mercer, 2006: 10–15), reaching the apex of modernity in the process. Still, the concept of abstraction must nevertheless be analysed through the mechanisms of competition and solidarity that are imposed on artists in their struggle for recognition (Joyeux-Prunel, 2015). This study will seek to identify the social, political, and artistic factors that restored and preserved inter-community solidarity in the Maghribi art world from the 1940s to the early 1960s, often opposed to the exclusionist nationalist politics used as a cudgel through which to reverse the power relations between the ascendant Jewish minorities and European expatriates and the underprivileged Muslim majorities. And although there are similar elements in both colonial Tunisia and Algeria, notably in the differentiated legal status accorded to the Jewish and Muslim populations[3] – the extension of French citizenship to Tunisian Jews was limited primarily to an educated and Westernized minority on the fringes of society whereas the Crémieux Decree automatically granted citizenship rights to the entire Algerian Jewish community (Allagui, 1998; 2016: 82)[4] – we will approach them distinctly, in recognition of the uneven nature of the colonial penetration (colonial protectorate and settler colonial) into local social structures in these two countries.

Modernity in Art, a Common Resource?

As in Algeria, entry into 'modernity' in Tunisia was marked by deep inequalities between communities (Valensi, 2016: 97); the art world was no exception to this. In Western European countries, the way dominant artistic norms were defined was based on the laws of naturalistic representation, the most virtuous degree of technical ability, and an aesthetic sensibility rooted in formative

[3] This teleological vision of art history, now discredited, was disseminated by the famous American art historian Alfred Barr (1902–1981) in the 1930s.

[4] Saharan Jews were an exception to this. See Abrevaya Stein (2014).

Figure 7: Artists from l'École de Tunis meet on the terrace of the Café de Paris in Tunis, 1953. From left to right: Emmanuel Bocchieri, Yahia Turki, Ammar Farhat, Mifsud, Moses Levy, Pierre Boucherle, and Abdelaziz Gorgi.

academic concepts in place since the seventeenth century. Perceived by the colonial elites as the culmination of progress in art, the fine arts remained the prerogative of the urban classes, a form of cultural capital whose fruits they enjoyed to the exclusion of marginalized peoples, the majority of whom were indigenous Muslims.[5] While the French government's policy of emancipation of the Jewish populations in the Maghrib meant that they were more familiar with the fine arts, this emancipation also made them more vulnerable to political fluctuations that racked the twentieth century. As a result, the social conditions conducive to the spread of a European model of artistic learning often led to alternative modes of professionalization, marked by a kind of idiosyncratic autodidacticism among Maghribi artists (Messaoudi, 2018). By selecting a historical moment conducive to intercommunal exchanges and examining it in detail, we will see how the interest in Muslim artists – or artists of Muslim culture – was closely related to a dynamic of co-optation dominated by a few assimilated figures deeply embedded in the European cultural world. Often attentive to aesthetic tendencies in the metropole, these individuals assumed the position of intermediary, not without a certain penchant for assigning essentializing identities.

[5] While the European avant-gardes strove to deconstruct the academic conventions of the fine arts, colonial Algeria acquired its first school of fine arts in 1881, followed by Tunisia in 1923.

124 *Jewish-Muslim Interactions*

Tunisia: Against the Institution, Unity is Autonomy

In 1944, Muslim artists appeared to be on the cusp of a new era, as evidenced in their participation in the Groupe des Dix, an outgrowth of the Groupe des Quatre, formed twelve years previously. It was from 1934 to 1936 that Moses Levy (1885–1968), Pierre Boucherle (1894–1988), Jules Lellouche (1903–1963), and Antonio Corpora (1909–2004) came together to form the nucleus of a movement that sought to revolutionize the art world, soon to be joined by Emmanuel Bocchieri (1910–1998), Edgard Naccache (1917–2006), and Nello Levy (Moses's son; 1921–1992).[6] Mostly graduates of schools specializing in Tunisian art and/or art schools overseas, these artists travelled widely and integrated the norms of Western modernity into their art, while immersing themselves in the local art scene, which they sought to reform according to those norms. In a 1936 pamphlet written on the occasion of their inaugural exhibition at the Art Nouveau Gallery, Boucherle, Levy, Corpora, and Lellouche declared their intention to unshackle themselves from the conventions of a commercial art beholden to academic prescriptions that dominated contemporary local art events. Open without exclusion to 'artistes tunisiens et étrangers d'avant-garde' ['Tunisian and foreign avant-garde artists'], the group defined the aesthetic criteria that reflected their conception of modernity in art as follows: 'Qu'on entende par là tous ceux qui, se servant de couleurs et de lignes, cherchent à exprimer leur vérité intérieure et à la communiquer. Cette Galerie n'est pas une entreprise commerciale, mais un événement purement artistique', a rejection of works they considered part of an artistic tradition now obsolete.[7] We can see in these artworks, conveyed by a colonial cultural elite, the influences of the avant-garde artist model, commonly associated with agnosticism, autonomy, and a contempt for the bourgeoisie.

The notable presence of Jewish Tunisian artists at the heart of these artistic movements allows for a discussion of the inter-community issues of professional recognition in the Maghribi art world.[8] It was indeed the

[6] See Allagui (2016: 130).

[7] 'Exposition des "quatre". Préface au vernissage de la galerie de l'Art nouveau', *La Dépêche tunisienne*, 31 January 1936: 'By that we mean all those who, using colours and lines, seek to express their inner truth and communicate it. This Gallery is not a commercial enterprise, but rather a purely artistic event'. My thanks go to Alain Messaoudi for providing me with this reference.

[8] One could also name Albert Braïtou-Sala (1885–1972), Maurice Bismouth (1891–1965), and Henri Saada (1906–1976) as painters from the same generation whose sociological backgrounds resembled those of the founders of l'École de Tunis.

Artistic and Political Issues of Intercommunal Solidarity 125

case that, alongside their European colleagues of French and Italian origins, Jewish Tunisians played a leading role in promoting an avant-garde that broke with institutional frameworks, whereas Muslims artists did not join this movement until a decade later. However, in comparison to Algeria, the Tunisian protectorate did carry out a policy of assimilation that was more reserved for, and oriented towards, Jews, while the latter were relatively receptive to the universal values advocated by the Republic. The spread of crude forms of antisemitism among colonial populations in the late 1930s only strengthened Jews' adherence to the ideals of freedom and equality (Valensi, 2003: 237–38). It is interesting to note, in this regard, that the radicalization of Tunisian artists' autonomization process vis-à-vis colonial power took place in an otherwise extremist political context. It could certainly be argued that the racial laws enacted in France and Italy in the early stages of World War II helped strengthen the faith of these artists in their art as a progressive medium that ultimately sets itself up against conventions, or even combats socially regressive forces. The a priori antagonistic, but highly innovative, attitude of this elite towards institutions seems, then, to be the salient feature of a distinctive ethic, with their benevolent – perhaps even paternalistic – support of Muslim artists being one of its symptoms.[9] Little is known about the involvement of Tunisian European and Jewish artists in the independence struggle. We can nevertheless deduce from this triangulation between colonial authorities, Muslim majorities, and Jewish elites that a complex hierarchical relationship existed between them in which art played a federative role, with the founding of the Groupe des Dix in 1944 as a prime example.

Yahia Turki (1902–1969), Ammar Farhat (1911–1987), Hatem El Mekki (1918–2003), and Abdelaziz Gorgi (1928–2008) took a more or less active role in the founding of the Groupe des Dix, and later, in 1949, in l'École de Tunis, an elaboration of the ideals of the earlier initiatives.[10] Their respective biographies

[9] Most of these artists regularly exhibited at the Salon Tunisien throughout their careers, while in Europe they tended to seek out the circles of avant-garde modernity. This could be understood as an attempt to maintain visibility and influence in the local art scene at a stage when it did not yet have the intellectual weight, infrastructure, and resources necessary to support any substantial reform movement in the arts.

[10] Reportedly, Yahia Turki and Abderlaziz Gorgi attended the Centre d'art (founded in Tunis in 1923, this would become l'École des Beaux-Arts de Tunis in 1930) only intermittently. Hatem El Mekki, a scion from a notable family, attended the Lycée Français de Tunis, but is generally understood to be a largely independent figure separate from the school of fine arts. Remaining illiterate throughout his life, Ammar Farhat was a self-taught artist par excellence. For biographical information, see Ounaina (2009) and Nakhli (2013).

teach us that, contrary to their colleagues, their education and training in the arts was for the most part either gained outside the fine arts institutions or only acquired formally after having been 'discovered' and encouraged to pursue such an education. It was therefore not until the second half of the 1940s that these artists of different generations, creeds, and artistic styles came together to turn the art world in which they found themselves upside down, with l'École de Tunis being their professional epicentre. Through its liberal spirit, this art school aimed to embody the ideals of artistic modernity, defined in opposition to the artistic canons still dominated by folklorist representations by Orientalist painters, both European and indigenous.[11] But as the various nationalist political movements were called upon to unite in securing the independence of the country, this collective force showed it was concerned not only with radicalizing institutions in an attempt to breathe new life into Tunisian art, but also with bringing about an aesthetically innovative style of painting. Recognition of artistic qualities deemed 'forward-thinking' was therefore the sole means by which to judge whether artists – regardless of their origins – would be allowed to practise their art as part of the group. In this respect, the wide range of their style – from figurative to abstraction, through expressionism – offers a glimpse into the degree of the group's openness. In other words, the project of professional autonomy carried out by l'École de Tunis could only be achieved through a strategy of parity across social, cultural, and aesthetic divisions. Even if this is not a matter of disputing the movement's liberalism, nor of idealizing its contents, but rather one of learning how these artists construed the meaning of their socio-denominational origins, one could nevertheless question the limits of this model of cosmopolitan cohesion often underscored – and sometimes instrumentalized – by art historians.

Algeria: Official Promotion and Identity Silos

One is hard-pressed to find artistic initiatives in Algeria that successfully overcame intercommunal cleavages. More than in Tunisia, the complexity and deeply embedded structure of the colonial regime in Algeria had created large gaps in the march towards modernity between the European expatriates and the indigenous Jewish and Muslim populations, a situation that numerous integrationist policies by the Third Republic helped produce,

[11] Tunisian artists successfully enriched the profession with a number of empowerment measures specific to the European Modernist model. For example, they allowed artists to secure a more stable income through the implementation of the 1 per cent law, which obliged the state to entrust them with works associated with architectural/urban planning.

Artistic and Political Issues of Intercommunal Solidarity 127

most prominently with the Crémieux Decree of 1870. Strategies for social climbing, too, were more limited by a system where religious affiliation was the principal marker of difference within the public sphere (Bozzo, 2006: 197–98). On the artistic level, since the early twentieth century, Algeria was dominated by European artists commonly grouped together under the diffuse label of l'École d'Alger ['The Algerian School'].[12] The specificity of this designation made it even harder to organize an artistic movement with a shared reformist vision of society as part of a common professional project. To illustrate this hypothesis, we will draw on the example of an artistic event synchronous to the foundation of the Groupe des Dix in neighboring Tunisia in 1944.

In the 1940s, colonial Algeria set out to demonstrate that the government had been making new strides towards facilitating a dialogue with the Muslim community. In the cultural sphere, the obvious man for the job was Mohammed Racim (1896–1975), a prominent figure in the contemporary art scene. The quintessential example of the indigenous artist approved by the colonial authorities, Racim's position as a professor at l'École des Beaux-Arts d'Alger effectively cemented his reputation and social status. It was not surprising, therefore, that the French authorities decided to entrust this pioneer of the Algerian miniature with the organization of the Première exposition de jeunes peintres et miniaturistes musulmans d'Algérie ['First Exhibition of Young Muslim Painters and Miniaturists from Algeria'], at the same time as the exceptional measures that had applied to Algerian Muslims were abolished by ordinance on 7 March 1944.[13] Hosted by the Cercle franco-musulman d'Algérie ['Franco-Muslim Circle of Algeria'], an association created on 25 April 1944 by Count Jean de Tocqueville, whose mission was to promote intercommunal dialogue through the hosting encounters between 'deux peuples vivant en insulaires' ['two insular people groups living separately'],[14] the exhibition took place from 8 to 14 December that same

[12] See Vidal-Bué (2002). A critical study of the artistic dynamics of colonial Algeria, however, remains to be written.

[13] Adopted by the Comité français de la libération nationale ['French Committee for National Liberation'], the lifting of these exceptional measures granted French citizenship to a given number of Muslims not at the expense of their personal status, provided them with access to all civilian and military jobs, and expanded their representation in local assemblies. These declarations followed the decision of 21 October 1943 to reinstate the Crémieux Decree that concerned the vast majority of Jewish populations in Algeria, abolished on 7 October 1940.

[14] See Robert (1958: 49). Born into aristocracy, Jean de Tocqueville was the nephew of the politician and philosopher Alexis de Tocqueville. Claude-Maurice Robert's

128 *Jewish-Muslim Interactions*

year under the patronage of General Georges Catroux, Deputy Minister of the French Government, and Yves Chataigneau, Governor General. This highly political event was nevertheless unprecedented on a symbolic level.[15] Indeed, for the first time in Algeria, an exhibition aimed to highlight artists of exclusively Muslim culture engaged in various artistic pursuits: one could find there traditional 'Muslim Art' works presented alongside oil on canvas paintings.[16] We should note, furthermore, that most of these artists had attended the various Algerian learning centres, whether the indigenous school of craftsmanship, the school for illumination, calligraphy, and miniature art created by Omar Racim,[17] the indigenous art department at l'École des Beaux-Arts d'Alger or its fine arts department. Some contributed to the collections of the National Museum of Fine Arts and even became members of the Société des artistes algériens et orientalistes ['Society of Algerian and Oriental Artists'], when they were unable to obtain a scholarship to attend l'École des Beaux-Arts de Paris. It would seem, therefore, that the artistic institutions of colonial Algeria exerted a strong centralizing authority, albeit non-exclusive, over those who wished to pursue an artistic career.[18]

article, published when the Algerian war entered its fourth year, emphasizes the universal and fraternal aspects behind the creation of Franco-Muslim circles by the Association Franco-Musulmane ['Franco-Muslim Association'] from 1937 onwards. See Debono (2012: 89–106).

[15] A note from Mohammed Racim, found in the archives of the Musée des Beaux-Arts d'Alger, provides details concerning the organization of this exhibition and the diplomatic role that the artist played in bringing Muslim and European communities together.

[16] The thirteen artists whose work featured in the exhibition, in alphabetical order, were A. Absi, Brahim Benamira (miniaturist, painter, d. 1975), Abdelkrim Benhassel (miniaturist, d. 1974), Ahmed Benslimane (painter, 1916–1951), Mahieddine Boutaleb (miniaturist, 1918–1994), Abdelkader Farrah (scenographer, decorator, 1926–2005), Mohammed Ferhat (miniaturist, illuminator), Abdelhalim Hemche (painter, 1908–1979), Ali Ali-Khodja (miniaturist, painter, 1923–2010), Mohamed Ranem (miniaturist, illuminator, ceramic artist, 1925–2014), Mohamed Temmam (ceramic artist, painter, 1915–1988), Bachir Yellès (painter, b. 1921), and Mohamed Zmirli (painter, 1909–1984). Biographical information about these artists appears in Abrous (2014).

[17] An illuminator and nationalist activist, Omar Racim founded his school from 1937 to 1939, while his brother Mohammed Racim taught miniatures at l'École des Beaux-Arts. Here, within the same family, we can discern two alternative modes of integration.

[18] La Société des artistes algériens et orientalistes ['The Society of Algerian and Orientalist Artists'] was founded in 1897 in Algiers by European painters based

Artistic and Political Issues of Intercommunal Solidarity

A clear diplomatic move demonstrating the colonial power's efforts to promote indigenous Muslims, the exhibition reflected a novel attempt to bring people closer together and engage with a community whose social and political aspirations were beginning to radicalize.[19] As in Tunisia, one could therefore argue that this cordial intercommunal outreach corresponded well with what the context called for. Still, any degree of visibility for Muslim artists in Algeria could only be achieved within the compartmentalized intercommunal framework that was directly controlled by colonial institutions,[20] even if we were to account for the fact that local artistic circles are often more open spaces than society at large. We are thus a long way from the project of professional autonomy promoted by l'École de Tunis, a vehicle that made it possible to momentarily set aside identity claims, in favour of an inter-communitarian rapprochement. But, on the eve of the outbreak of the Algerian War of Independence, in order to gain recognition, was it not still better '[d']être issu d'une famille de colons même analphabète (Camus) que d'une famille algérienne cultivée (Mammeri)' (Potie, 1987: 7)?[21]

A Vision of Society Challenged Through Art

If the Première exposition de jeunes peintres et miniaturistes musulmans d'Algérie ['First Exhibition of Young Muslim Painters and Miniaturists from Algeria'] provides a useful comparison for understanding the emancipation mechanisms of indigenous artists, there is also a whole world of mediation whose influence is exerted outside the realm of political instrumentalization. This model flourishes through the circles of the mostly European intelligentsia in the cultural context of a 'méditerranéisme' ['Mediterraneanism'] conducive to 'contacts' (Blanchard and Thénault, 2011) but also to the

in Algeria in the same spirit as the Société des orientalistes français ['Society of French Orientalists']. The vast majority of contemporary Algerian artists were members. Vidal-Bué (2002: 242).

[19] Decidedly emblematic, it should be noted that 1944 also coincides with the project of education reform for Muslim populations.

[20] There is a fleeting mention of an 'Exposition des peintres musulmans d'Algérie' ['Exhibition of Muslim Painters of Algeria'] that ostensibly took place in Algiers two years later, in 1946, in Abrous (2014: 812). The artist's official website does not mention this event, despite the likelihood that he would have been the organizer. See http://www.zmirlimohamed.com/actualite/exposition/ (consulted on 16 May 2019).

[21] 'to come from a family of settlers, even an illiterate one (Camus), than from a cultured Algerian family (Mammeri)'.

130 *Jewish-Muslim Interactions*

mobility of indigenous Muslim artists, now more likely to gain access to the circuits of academic training. It was at first mostly at the local level, later in Paris or in Italy, that a new generation built its vision of society and art. With the adoption of the aesthetic codes of abstraction, these artists experimented with a world previously inaccessible to those who remained outside of the circles of European modernity, all the more so since national independence movements now added a political dimension to discourses that were often critical of previous generations.

Abstraction: Between Internationalism and Political Emancipation
It was not until after World War II that indigenous Algerian and Tunisian artists could access art forms emerging from academic figuration, Cubist influences, or late expressionism. The European capitals still enjoyed an unmitigated prestige among Maghribi artists drawn by the prospect of an innovative education and a culturally enriching environment. Whether they underwent professional training or were self-taught, their education was often supplemented by programmes offered at l'École nationale des Beaux-Arts or in the various painting academies, such as the Grande Chaumière or the Académie Julian, before they entered the professional circuits of modern art salons, such as the Salon de Mai or that of the Réalités Nouvelles, in search of recognition. Continuing the tradition of cosmopolitan bohemianism of l'École de Paris during the 1920s and 1930s, Paris welcomed a new generation of artists from the colonies in the 1940s and 1950s.

Despite an environment that directed them towards artistic forms that continued to subscribe to naturalistic approaches to reality, most Algerian artists found in abstractionism a prime means to develop their sensibility after having arrived in the metropole. The Parisian context of the 1940s and 1950s plunged them directly into the heart of what art historians identify as the renewed conflict between figuration and abstraction.[22] After four years of German occupation, abstraction dominated the French artistic landscape once again and was celebrated as the embodiment of the ideals of freedom and universality, as opposed to the anecdotal figurative style predominately associated with particularism and conservatism.[23] It is this cultural climate

[22] This generic term, used here for the purpose of convenience, nevertheless covers different and sometimes contradictory artistic realities: lyrical abstraction, geometric abstraction, informal art, or outsider art. On the conflict between the proponents of the abstract current and those of figuration, see Verdes-Leroux (1979) and Delhaye (2013).

[23] The exhibition Vingt jeunes peintres de tradition française ['Twenty Young Painters of the French Tradition'], held in Paris in 1941, is a reference point in

that the Judeo-Algerian painter Jean-Michel Atlan (1913–1960) was to endure before definitively turning to experimental artistic initiatives by joining the group CoBrA after the end of World War II.[24] Like many of his coreligionists, he engaged in resistance and anti-colonial far-left activism. Eventually, his intellectual and political trajectory led him to an artistic movement that sought to clean the slate from the pathologies of modern civilization that had caused the tragedies of World War II: specialization, hierarchy, and individualism. CoBrA's proponents advocated social connection through the virtues of collective action. On an artistic level, it was therefore a question of favouring any expressive vocabulary that opposed norms and conventions. This is also why CoBrA's founders refused to associate themselves with any single pictorial style, choosing a middle-way approach to the conflict between figuration and abstraction that dominated the Parisian artistic scene in the years 1940–1950, even though Atlan's painting was most clearly more oriented towards abstraction. The innovative and sensitive quality of Atlan's work did not fail to attract the attention of Communist Algerian revolutionary artist Mohammed Khadda (1930–1991), who hailed him as a 'pionnier de la peinture algérienne moderne' ['pioneer of modern Algerian painting'] in *Éléments pour un art nouveau* (2015: 41), despite the fact that his work had almost completely disappeared from Algerian national historiography. Atlan's use of earthy hues and stylized forms convinced Khadda of his intimate connection with Algeria.[25] Aesthetic research conducted during the 1950s led Khadda himself to explore the graphic potential of his

the history of art. Demonstrating their resistance to the German occupation and the Nazi notions of 'degenerate art', the artists featured defended non-figurative painting as the only real way to express the universal, which was destroyed by modernity in favour of the individual. This theory was to symbolize the return of a new order – that of true humanism.

[24] CoBrA was officially created in Paris at the end of 1948, but Atlan earned his professional stripes and was admitted only in 1956. The acronym is derived from the names of the cities where most of the movement's founding artists originated: Copenhagen, Brussels, and Amsterdam. Atlan came from a well-to-do family of cloth merchants. In 1930, he went to Paris to pursue a degree in philosophy at the Sorbonne, where he graduated with a thesis on Marxist dialectics before becoming a secondary school teacher from 1939, a position he lost following the introduction of laws governing the status of Jews under the Vichy regime. Arrested and imprisoned in 1942, Atlan feigned madness to avoid deportation. Released in 1944, he devoted himself to painting. For an overview of the painter's career in activism, see http://maitron-en-ligne.univ-paris1.fr/spip.php?article10331 (consulted on 20 August 2019).

[25] There is no evidence to support the claim that the two artists met.

132 *Jewish-Muslim Interactions*

native land and create an abstractionist-inspired painting that reflected on Arabic script.

Indeed, the seemingly non-referential dimension of this internationalist style is one of the aspects that was to seduce many an artist in search of innovative approaches. And although it no longer really constitutes an aesthetic revolution in European artistic circles riveted by the radical ideas of Lettrism and the Situationist International, abstraction acquired an undeniable emancipatory attraction for artists who came of age in colonial cities with provincial tastes, outside the dominant fields of the prescriptions of modernity. On the other hand, this aesthetic experience is probably what allowed Muslim artists – as well as Jewish ones[26] – to escape the identities assigned to them, although they themselves did not hesitate to appropriate such discourses if need be. In this regard, the Algerian painter Abdallah Benanteur (1931–2017) suggested that Atlan's aesthetic work posed the problem of roots more forcefully than any other Maghribi artist,[27] running the risk of falling into the trap of prescribed cultural affinity (Bouayed, 2012). But it is likely that the vexations suffered by the Jewish and Muslim populations of Algeria helped them reaffirm, even reclaim, their origins and thereby participate in the development of new *algérianitiés* (Le Foll-Luciani, 2015). The embracing of abstraction demonstrates, then, a double movement: relatively speaking, it permitted Algerian artists to blend in with the institutional circuits of capital by using a diverse range of colours and compositional rhythms to express their attachments to their homeland.[28] In parallel, in a context marked by the Algerian War and, more broadly, by anticolonial struggles, Muslim artists openly used their art as a form of political commentary[29] – not resorting exclusively to the abstract

[26] See Jarrassé (2013).

[27] Some of his works have particularly evocative titles: *Peinture berbère* ['Berber Painting'] (1954), *La Kahena* ['The Kahina'] (1958), *Les Aurès* ['The Aurès Mountains'] (1958), *Pentateuque* ['Pentateuch'] (1958), *Le Livre des Rois I* ['The Book of Kings I'] (1958), *Miroirs du roi Salomon* ['Mirrors of King Solomon'] (1959), and *Rythmes africains I et II* ['African Rhythms I and II'] (1954 and 1959).

[28] The titles of numerous works testify as much: *Les Lignes des ancêtres* ['Ancestral Lines'] (1957), *Tribu* ['Tribe'] (1959), *Le Hoggar* ['The Hoggar Mountains'] (1960), *Méridien Zéro* ['Meridian Zero'] (1958), *Kabylie* ['Kabylie'] (1960).

[29] Benanteur, *Selon Charef* ['According to Charef'] series (1960); Mesli, *Sakiet Sidi Youcef* (1959), *20 août* ['20 August'] (1955), *avant 1962* ['before 1962'], and *Les Camps* ['The Camps'] (1958); Khadda, *Hommage à Maurice Audin* ['Homage to Maurice Audin'] (1960), *Dahra* (1961), *Les Casbahs ne s'assiègent pas* ['Restless Casbahs'] (1960–1982); Issiakhem, *Algérie* ['Algeria 1960'] (1960).

Artistic and Political Issues of Intercommunal Solidarity 133

style, significantly – while the issues of the European community of Algeria remain more discrete.[30]

The study of Maghribi artistic social life in the Paris of the 1940s and 1950s needs to be expanded, all the more so because art histories often inform us only of the vertical and centralized influence the metropole exerted on artists from the colonies, remaining more allusive with regard to the transversal forms of professional emulation on the national and regional levels.[31] Far from minimizing the effects of the colonial context on the artists, the role of emigration can serve as an example for a better understanding of the mechanisms of recomposing communitarian solidarities on the artistic or political level. In both cases, debates over the definition of a national identity that engrossed the Tunisian and Algerian scenes after independence bore the mark of such mechanisms.

Aesthetic Antagonisms and Identity Requalification

From the perspective of art history, the 1940s to the 1960s is the period in which a new figurative language emerged among Tunisian and Algerian artists, that of abstraction. Even though it did not elicit similar enthusiasm on behalf of all these country's practising artists, the introduction of this style by European art circuits – particularly Paris-based ones – is far from being an innocuous fact since it participated in crystallizing the issues of identity at the heart of the definition of modernity in art, often in opposition to figuration, at the moment when Algeria and Tunisia acquired their national independence. The appropriation of this concept serves to delineate an ideological framework in which each artist could be included or excluded based on the presence of certain elements in their work and style, which in turn would support the idea of authenticity in their definition of identity. From this perspective, the recourse to an ethno-denominational principle is likely to re-emerge in these debates, whereby aesthetics sometimes takes the form of alibis to disguise a struggle over legitimacy and professional recognition. This is clearly observable in Tunisia, where the European and Jewish segments of society did not take the path of mass exile as in the case of Algeria.

[30] In this regard, painters Louis Nallard and Maria Manton made known their support for the cause of independence, despite a feeling of unease (2004: 32).

[31] We do not know, for example, if the Algerians were able to meet their Tunisian counterparts either living in or visiting the French capital during this period, such as Jules Lellouche, Ammar Farhat, or Abdelaziz Gorgi.

Cultural Exchange, Social Classes, and Betrayal

The incompatibility between abstract art and the notion of a national identity is a question that was not exclusively raised in colonized countries on the march towards independence. Nor, for that matter, was that of cultural exchange, which Khadda does not fail to evoke in his writings on art.[32] His encounter with modern European artwork in his visits to Paris is what triggers his philosophy: since European artists drew from the exogenous sources of inspiration – Islamic, African, or Far Eastern art – to familiarize themselves with stylization or abstraction (Khadda cites Henri Matisse, Piet Mondrian, or Georges Mathieu), Algerian art had to be created to recuperate and exploit its lost heritage, through a kind of reparative dynamic. Painting, for Khadda, had to turn to the formal registers of pre-Islamic as well as Islamic art, and that of the Berber peoples, to incarnate the spirit of renewal of Algerian art, without compromising on the demagogic aspects of folklorism supported by its detractors.[33]

In the early 1960s, this form of nationalized art was denounced by the artist Edgard Naccache, a founding member of the Groupe des Dix and l'École de Tunis who, following Antonio Corpora, was one of the promoters of abstraction in Tunisia since the mid-1940s. Confronted with a restrictive post-independence discourse of identity in which l'École de Tunis was now taking part, he decided to move permanently to Paris in 1962 from where he would defend his vision of an international art, like Khadda. In 1964, the publication of an article called 'Je m'élève contre la notion de peinture tunisienne' ['Speaking Out Against the Notion of Tunisian Art'][34] revealed the intercommunal tensions at work in this endeavour. From an artistic perspective, the content does not depart from the debates that crisscrossed in the Algerian art world after 1962. It was about denouncing the populist tendency in art to privilege figurative representations that

[32] See, specifically, the articles 'L'Art arabe' ['Arab Art'] and 'La Colonisation' ['The Colonization'] (Khadda, 2015: 33–38).

[33] In 1964, Khadda published *Éléments pour un art nouveau* ['Elements for a New Art'], a critical reflection essay on art and society, in *Révolution africaine*, n°74. This widely debated intervention raised the question of the legitimacy of the Algerian artist in a socialist society and sought to affirm the value of abstraction as a sensible and authentic mode of expression for the edification of the people (Bossier and Gillet, 2014: 211–12).

[34] Originally published in the magazine *Afrique*, Edgard Naccache's article was reprinted in *La Presse de Tunisie* on 15 April 1964, only two months before the publication of Khadda's article in *Révolution africaine*. This citation and those to follow are taken from Alia Nakhli's doctoral thesis (2013).

are ostensibly legible, accessible to the majority of society, and therefore useful in the work of national consolidation, whereas, according to the article, abstract artists do nothing but sustain a hermetically sealed style that is therefore condescendingly elitist, irritatingly bourgeois, and pretentiously Western. These aberrations were denounced by Khadda: 'Au lendemain de l'Indépendance et même jusqu'à nos jours des peintres et des « critiques » irresponsables et mal informés se sont mis à dénoncer avec virulence la peinture non-figurative, qu'ils accusent d'être un art d'importation' (2015: 36–37).[35] In Tunis, one response to Naccache was laced with an ethno-religious element; Hatem El Mekki did not hesitate to disqualify Naccache based on his Judaism: 'à Tunis, les amateurs de ghetto en peinture surnommaient Naccache le Moses du Pauvre' (1964: 3).[36] This discrimination was, however, very quickly denounced across the Tunisian intellectual world.[37] Whether provocation or revendication, Naccache's attitude squarely responded to the atmosphere of post-colonial unanimity, which also accounted for, no doubt, his departure to Paris. It was at the time of this debate that Pierre Boucherle decided to clarify the objectives upon which l'École de Tunis was founded. Destined to reunite, in the image of l'École de Paris, 'quelques-uns des meilleurs peintres de Tunis sans distinction de tendance, de race et de religion', he recalled, 'Sur ses cimaises Naccache et El Mekki firent longtemps bon ménage, Moses Lévy s'accorda fort bien avec Bocchieri et Agnello, Berjole avec Bellagha et Farhat, Lellouche avec Arnaud et Hédi Turki, moi-même avec Yahia, Gorgi et Zoubeïr Turki' (Boucherle, 1964: 3).[38] In 1967, these dissensions took shape once again in the exhibition of *Six peintres maghrébins* ['Six Maghribi Painters'] in the municipal gallery of Tunis. The artists brought together,[39] all of them non-figurativists, denounced complacent painting

[35] 'In the aftermath of [Algerian] independence and even to this very day, irresponsible and ill-informed painters and "critics" vehemently denounce non-figurative painting, which they accuse of being an imported art form'.

[36] 'In Tunis, painting amateurs from the ghetto nicknamed Naccache "a poor man's Moses"'.

[37] In 1957, El Mekki would pronounce Yahia Turki a father of Tunisian painting.

[38] 'Some of the best painters in Tunis regardless of artistic style, race and religion [...] On its walls Naccache and El Mekki exhibited side by side for a long time; Moses Lévy corresponded well with Boccieri and Agnello, Berjole with Bellagha and Farhat, Lellouche with Arnauds and Hédi Turki, I myself with Yahia, Gorgi, and Zoubeir Turki'.

[39] The Morrocans Ahmed Chekaoui and André Elbaz, the Algerians Abdelkader Guemaz and Abdallah Benantuer, and the Tunisians Mahmoud Sehili and Edgard Naccache.

and the cultural dominion exercised by l'École de Tunis. The school's 'porte parole' ['spokesperson'], Zoubeir Turki, responded to those he derisively called 'Harkis de la peinture occidentale' ['Harkis of Western painting'],[40] that is, those abstract painters who, he quipped, mimicked modern trends, with no attachment to the traditions of their country (1967: 3).

These debates underscored the limits of the cosmopolitan model proffered by l'École de Tunis, while in Algeria the 'Jewish' dimension of the conflict was removed a priori from the debate, subsumed into that other omnipresent issue of the already departed European ex-colonizers.[41] Here, the anti-Western argument is pervasive but does not double as a struggle over institutional control and recognition, as in Tunisia. The European artists who presided over l'École de Tunis ceded their place to 'Muslim' Tunisians without emigrating (Ounaina, 2009) at the time when the European majority in the Algerian art world – among them the most liberal – left the country or decided not to return there after their studies, like Louis Nallard and Maria Manton. On the other hand, the collective dynamic of l'École de Tunis did not disappear with the political upheavals of independence, while in Algeria a complete reversal took place in favour of Muslim artists. And if, in the aftermath of independence, the quarrel between abstraction and figuration precipitated the formation of competitive spaces when it came to identity claims, it was also a means for artists who were excluded from training in the fine arts to assert their rights. The legitimate desire of some artists to integrate into modernity through the adoption of a universal aesthetic language was strongly questioned by others in the name of finding their roots in local traditions or consideration of the popular masses. This conflictual situation allows us to see what resources were used by artists to position themselves on the arch of professional success when the representatives of colonial domination were to either disappear or evolve.

[40] Translator's note: 'harkis' is a derogatory term for the native foot soldiers of French colonial armies in North Africa and is synonymous with traitors there.

[41] The mass exodus of Europeans and Jews from Algeria at the end of the Algerian War has had rare exceptions in the artistic world such as Jean Sénac, Myriam Ben (née Marylise Ben Haïm), and Denis Martinez.

Works Cited

Abrevaya Stein, Sarah. 2014. *Saharan Jews and the Fate of French Algeria*. Chicago: University of Chicago Press.

Abrous, Mansour. 2014. *Algérie. Arts visuels. Un siècle de création et de créateurs 1896–2014*. Alger: Éditions Dalimen. Allagui, Abdelkarim. 1998. 'Les Juifs face à la naturalisation dans le Tunis colonial'. In *Histoire communautaire, histoire plurielle. La communauté juive de Tunisie, Actes du colloque de Tunis, 25–27 février 1998*. Tunis: Faculté de La Manouba, Centre de publication universitaire: 203–15.

——. 2016. *Juifs et Musulmans en Tunisie. Des origines à nos jours*. Paris: Éditions Tallandier.

Blanchard, Emmanuel, and Sylvie Thénault. 2011. 'Quel monde du contact? Pour une histoire sociale de l'Algérie pendant la période coloniale'. *Mouvement social* 236: 3–7.

Bossier, Annabelle, and Fanny Gillet. 2014. 'Ruptures, renaissances et continuités. Modes de construction de l'histoire de l'art maghrébin'. *L'Année du Maghreb* 10: 207–32.

Bouayed, Anissa. 2012. 'Le Peintre Atlan (1913–1960) de Constantine à Paris ou la migration du regard'. In Frédéric Abécassis, Karima Dirèche, and Rita Aouad (eds.), *La Bienvenue et l'adieu. Migrants juifs et musulmans au Maghreb. XVe–XXe siècle*. Casablanca: Karthala, La Croisée des chemins, pp. 207–23.

Boucherle, Pierre. 1964. 'L'École de Tunis n'a pas la prétention de se situer sur le plan d'une école de l'art'. *La Presse de Tunisie*, 25 April, p. 3.

Bozzo, Anna. 2006. 'Islam et citoyenneté en Algérie sous la III^e République: Logiques d'émancipation et contradictions coloniales (l'exemple des lois de 1901 et 1905)'. In Pierre-Jean Luizard (ed.), *Le Choc colonial et l'islam*. Paris: La Découverte, pp. 197–222.

Debono, Emmanuel. 2012. 'Le Rapprochement judéo-musulman en Afrique du Nord sous le Front populaire. Succès et limites'. *Archives Juives* 45: 89–106.

Delhaye, Blandine. 2013. 'Le Conflit renaissant de la figure et de l'abstraction dans *Labyrinthe, journal mensuel des Lettres et des Arts* (octobre 1944– décembre 1946)'. *Les Cahiers de l'Ecole du Louvre. Recherches en histoire de l'art, histoire des civilisations, archéologie, anthropologie et muséologie* 3.

Jarrassé, Dominique. 2013. *Existe-t-il un art juif?* Le Kremlin-Bicêtre: Éditions Esthétiques du divers.

Joyeux-Prunel, Béatrice. 2015. *Les Avant-Gardes artistiques (1848–1918). Une histoire transnationale*. Paris: Gallimard.

Khadda Mohammed. 2015. *Éléments pour un art nouveau. Suivi de Feuillets épars liés et inédits*. Alger: Editions Barzakh.

Le Foll-Luciani, Pierre-Jean. 2015. *Les Juifs algériens dans la lutte anticoloniale. Trajectoires dissidentes (1934–1965)*. Rennes: Presses Universitaires de Rennes.

El Mekki, Hatem. 1964. 'Ne pas confondre fait national et nationalisme'. *La Presse de Tunisie*, 18 April: 3.

Mercer Kobena (ed.). 2006. *Discrepant Abstraction*. Cambridge, MA: Institute of International Visual Arts in association with MIT Press.

Messaoudi, Alain. 2018. 'Au croisement des cultures savantes et des cultures populaires: Baya et l'art des autodidactes dans le Maghreb des années 1945–1960'. In Morgan Corriou and M'hamed Oualdi (eds.), *Une histoire sociale et culturelle du politique en Algérie et au Maghreb. Études offertes à Omar Carlier*. Paris: Éditions de la Sorbonne, pp. 277-94.

Nakhli, Alia. 2013. *Le Discours identitaire dans l'art contemporain en Tunisie: de la tunisianité à l'arabité (1956–1987)*. Unpublished PhD dissertation. Université Paris X Nanterre.

Nallard, Louis, and Maria Manton. 2004. *Louis Nallard – Maria Manton, la peinture et la vie. Dialogue avec Djilali Kadid*. Paris: Marsa.

Ounaina, Hamdi. 2009. *La Double histoire des artistes de l'Ecole de Tunis. Ressources et stratégies de réussite des élites tunisiennes entre colonisation et État-nation*. Unpublished PhD dissertation. Université Paris III.

Potie, Anne. 1987. 'Montpellier – janvier 87: la vie culturelle à Alger entre 1900 et 1950'. *Impressions du Sud* 15-16: 7.

Robert, Claude-Maurice. 1958. 'Le Cercle franco-musulman d'Algérie'. In *Algeria. L'Afrique du Nord illustrée*. Alger: OFALAC: 48-52.

Turki, Zoubeir. 1967. 'Les « Harkis » de la peinture occidentale!' *L'Action de Tunisie*, 28 April, p. 3.

Valensi, Lucette. 2003. 'La Culture politique des juifs du Maghreb entre le XIXe et le XXe siècle'. In Sonia Fellous (ed.), *Juifs et Musulmans en Tunisie. Fraternité et déchirements*. Paris: Somogy Éditions d'Art: 231-41.

——. 2016. *Juifs et musulmans en Algérie, VIIe–XXe siècle*. Paris: Editions Tallendier.

Verdès-Leroux, Jeannine. 1979. 'L'Art de parti'. *Actes de la recherche en sciences sociales* 28: 33-55.

Vidal-Bué, Marion. 2002. *Alger et ses peintres (1830–1960)*. Paris: Méditerranée.

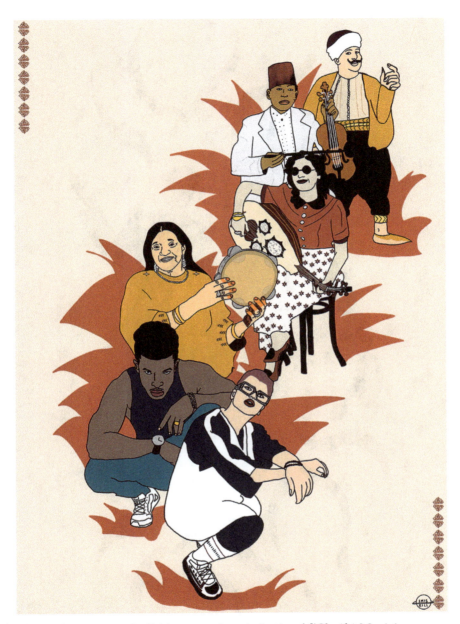

Plate 1: 'Musiciens chaâbi à travers les générations' ['Chaâbi Musicians across the Generations']. © Imis Kill.

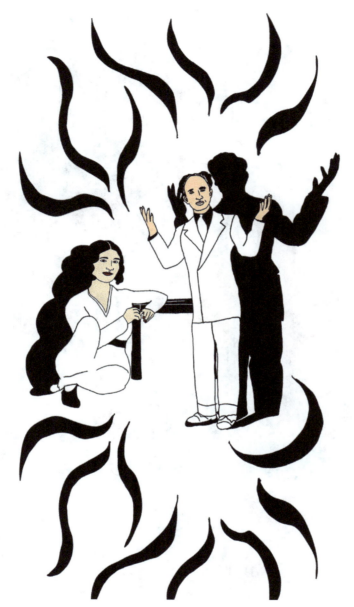

Plate 2: 'Soussan et Ksentini' ['Soussan and Ksentini']. © Imis Kill.

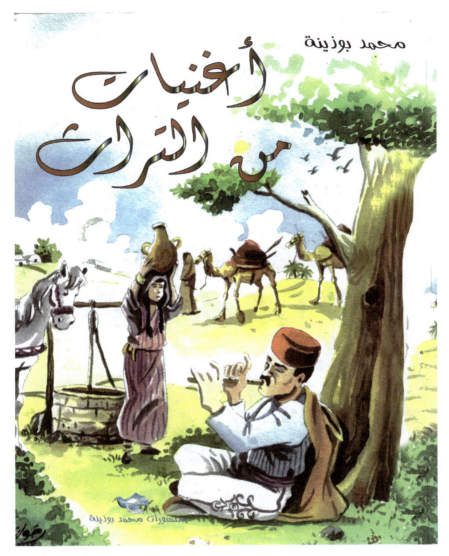

Plate 3: Cover picture. Mohamed Boudhina. *Aghānī min al-turāth*. Hammamet-Tunis, 1997. © Jamīʿ al-Huqūq Mahfūza Manshūrāt Muhammad Būdhīna Shārīʿ Faysal Bin ʿAbdulʾazīz – al-Hammāmāt 8050 – al-Jumhūriyyah at-Tūnisiyyah.

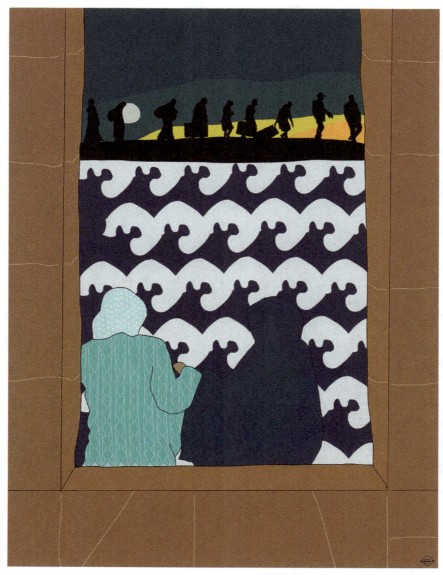

Plate 4: 'Film et exil' ['Film and Exile']. © Imis Kill.

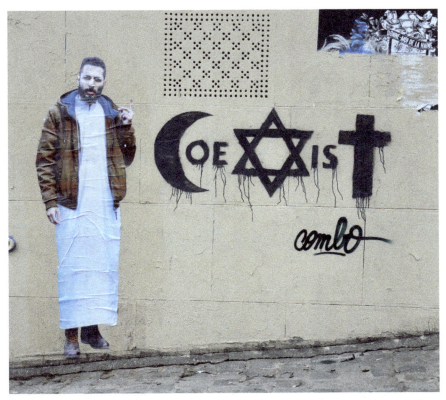

Plate 5: CoeXisT 1 ('Mohamed'/CoeXisT). © ADAGP, Paris, and DACS, London 2020.

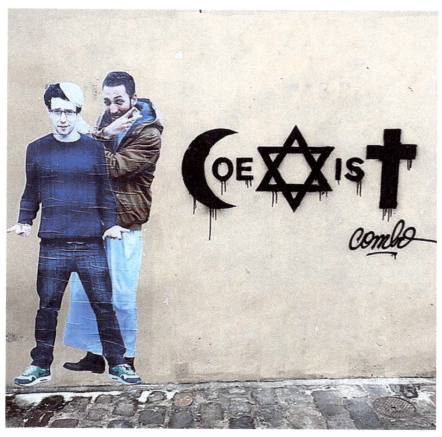

Plate 6: CoeXisT 2 ('Mohamed' and 'Moshe'/CoeXisT). © ADAGP, Paris, and DACS, London 2020.

Plate 7: 'Mohamed' and 'Moshe' (Tel Aviv). © ADAGP, Paris, and DACS, London 2020.

Plate 8: 'Loin des yeux, loin du cœur' (Tel Aviv). © ADAGP, Paris, and DACS, London 2020.

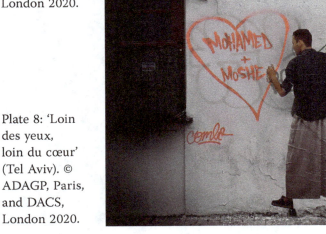

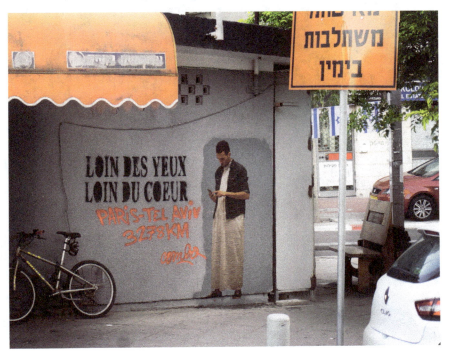

Plate 9: 'La plume ou le danger?' ['The Pen or the Sword?']. © Imis Kill 2018.

II. Absence, Influence, and Elision

Neglected Legacies:
Omissions of Jewish Heritage and Muslim-Jewish Relations in Algerian *Bandes Dessinées*, 1967 through the 1980s

Elizabeth Perego

Introduction

Algeria's vibrant cartooning industry is one of the longest-standing and most respected on the African continent as well as in the Middle East. The North African country has not developed this reputation by chance; beginning in the late 1960s, with the backing and support of the one-party system under the Front de Libération Nationale ['National Liberation Front'], or FLN, individual artists worked to create comic books that would carve out a common sense of 'Algerianness' among the general population. More often than not, this body of art dealt directly with questions of everyday life, national belonging, and what this supposed Algerian 'national' character naturally was or, conversely, should be. *Bandes dessinées* (or *BD*s) proved a particularly ripe space for contemplating this question within Algeria's borders after national independence in 1962.[1]

[1] 'Bande dessinée' is French for 'drawn strip' and constitutes a genre of comics and cartoons in and of itself. For more information, see Groensteen (2009: 130) and Miller (2007). Editorial cartoons/caricatures that stand alone in newspapers outside of the sequential boxes associated with *bandes dessinées* or comics existed in Algeria since the 1960s, but only became popular and widespread in the 1980s. They are often analysed together in works on Algerian cartooning, but I will treat them separately throughout this piece, honing my attention on earlier *bandes dessinées*.

142 *Jewish-Muslim Interactions*

As is often the case, this process of nation-inventing relied heavily upon a manipulative coaxing of history and, in this respect, Algeria was no exception; early state actors working in the field of culture built on a longer tradition of envisioning a nationalist past meant to exclude other, competing views of the nation or its populations.[2] While the country was still launching a film industry and resources for animation ran scarce, along with the plastic arts, cartooning and caricaturing afforded young creators and the government that sponsored them the clearest means of tailoring projects that could graft then present imaginings of 'the' Algerian nation back onto the country's ever contested past.[3] Armed with only a pen and paper, illustrators could fabricate images of the country along the lines that they pleased (although whether these sketches ever made it into the hands of readers depended upon the post-independence state that controlled licit publishing and distribution in the country).

Unlike films, painting, sculptures, and monuments, *bandes dessinées* were not rooted to specific spaces; like other print culture, they could circulate and be passed among multiple readers, necessitating no travel on the part of the consumer. They were additionally less costly for consumers than paintings or television shows, and required no framing material for enjoyment such as a movie theatre. Indeed, unlike their counterparts in Belgium and France, who often bound their work in costlier albums, Algeria's major cartoonists generally printed their work in newspapers or magazines such as the children's review, *M'Quidech*.[4] Cartoons could also reach a broader readership this way, and, with the heavy pictorial content, even audiences that were not fully literate, a significant accomplishment given that the United Nations has estimated that 90 per cent of the Algerian population was illiterate upon independence.[5]

Scholars working on Algerian *bandes dessinées* and editorial cartoons have considered these genres as prime space for artists to rethink and shape

[2] See McDougall (2006). Here, I am privileging Anne McClintock's view of nationalism as 'invented' (1991: 104–23) rather than imagined per the work of Benedict Anderson (1983).

[3] Algeria, of course, was by no means exceptional in the regards that post-independence actors sought to use culture as a means of re-inventing a singular definition of 'the Algerian nation'.

[4] *M'Quidech* was an illustrated children's publication launched in 1969 by a team that would later become the country's best-known cartoonists, including Slim. The bilingual (Arabic and French) review, which the state-controlled Société nationale d'édition et de diffusion ['National Publishing and Distribution Society'] put out, existed initially for six years and became a widely followed cultural phenomenon. For more about the magazine, see Ferhani (2012: 24–27).

[5] Lacheraf (1978: 313).

Omissions of Jewish Heritage and Muslim-Jewish Relations 143

the Algerian nation and various narratives of its past. Through much of this scholarship, however, the image of Algeria as a Muslim space surfaces as a given. What is more, post-independence states in the Maghrib have promoted a Muslim identity as one of the key tenets of national identity. Such literature and views promoted by states do not take into account previous historical patterns of mirth-making and laughter in Algeria and other parts of the Maghrib prior to the late 1960s, the moment when Algeria's earliest *bédéistes* began their work. Similarly, the works that these illustrators produced bore the label 'Algerian' regardless of the myriad of external influences and global references, localized of course in ways that could be inscribed as 'Algerian', that seeped into these same pieces.[6]

Humour can be ephemeral and deeply embedded into the precise moments in which comedic players spin their craft. For this reason, a study of comedic legacies in Algeria must take into consideration whether residents of the country themselves think of humour from the past as an important part of their cultural heritage. Writings on the history and social memories of the territory's comedic traditions do exist, though, and look back to periods such as the 1920s and 1930s, the so-called 'interwar period', when interreligious cultural production occurred through new forms of media and artistic genres. It is also worth noting that most of the literature examining patterns of Algerian comedy narrow in on humour transpiring from urban centres in the country's northern, Mediterranean region. Yet, if *bandes dessinées* and cartoons from the immediate post-independence era crafted out a specifically Algerian national character, or *algérianité*, a reality that will be elaborated upon below, these drawings may have taken inspiration from or leaned upon earlier comedic discourse.

This chapter will demonstrate that, rather than acknowledging or actively obscuring the legacy of Jewish performers, which they admittedly might not have been cognizant of, *bédéistes*, or *bandes dessinées* artists, reimagined an Algerian space where the default religion was Islam and default customs Islamic ones. The drawings do not allow for other faiths historically present in Algeria to enter into the scene. As a result, they present a picture of the country as homogenous, echoes of the country's past humour muffled in the post-independence era, and craft a genre of Algerian superhero who is gendered as male and marked as Muslim. This bias and neglect of earlier Jewish contributions, as well as women's roles in protecting the nation, most likely not intentional, have further made their way into contemporary accounts of the country's comedic heritage.[7] The resulting literature, coupled

6 See, for instance, McKinney (2008) and Douglas and Malti-Douglas (1994).
7 See, for example, Khelladi (1996) and Chaulet-Achour and Morsly (2002).

144 *Jewish-Muslim Interactions*

with gaps in archival material (especially surrounding oral forms of comedy), and compounded by Algerian writers' difficulties accessing French colonial archives owing to visa issues, forwards the notion of an Algerian comedic heritage bereft of any possible influence from Jewish actors. This finding runs counter to archival hints from earlier moments, often housed in France, that Algerian Jews like Edmond Nathan Yafil contributed to comedic patterns in the country that theatre in particular amplified for wide audiences in the late 1920s, 1930s, 1940s, and 1950s.[8] Because it does not appear that Algerian artists or writers have intentionally aimed to occlude Jewish contributions to the country's comedic heritage, I will refer throughout this piece to *omission* rather than outright obfuscation.

This chapter will trace the degree to which, with only a few notable exceptions, actors in post-independence Algeria have not accounted for the possibility of deeper intercommunal Muslim-Jewish comedic traditions in the territory. To accomplish this task, I begin by covering Jewish performers' work in giving form to wider-spread, more permanent forms of Algerian comedy, namely theatre and song, at a pivotal moment in the formation of an Algerian national identity in opposition to French colonialism and French colonial/European settler policies. I then analyse works by leading Algerian cartoonists of the post-independence era to show that they projected a uniform and uniquely Muslim identity back onto the past in ways that had specifically (then) presentist political implications. The latter included reimagining the nation, *algérianité*, or an Algerian national character, and national superheroes as exclusively 'Muslim' in nature, despite the existence of versions of *algérianité* that prove more inclusive.[9] Through an exploration of two distinctive moments in Algeria's history (the late colonial and early post-independence eras), I aim to reconstruct the processes by which earlier periods of interreligious exchanges have been muted and suggest what these absences may contribute to our understanding of memories of Jewish-Muslim cultural exchanges in Algeria over the post-independence era.

The present piece will demonstrate that post-independence humour provides especially fruitful insight into the omission of Jewish communities' contributions to cultural areas associated with national character. As Jan Plamper asserted in an *American Historical Review* conversation on the state of the history of emotions, 'Many modern nations have generated

[8] See Miliani and Everett, this volume.

[9] For instances of individuals connected to Algeria perceiving of Algerian belonging as encompassing diverse communities or not necessarily as singular in nature, albeit during a later period, see Everett (2017b: 64, 66–67).

Omissions of Jewish Heritage and Muslim-Jewish Relations 145

stereotypes that supposedly capture their emotional makeup'.[10] In the case of present-day Algeria, with the power of humorous discourse apparent and garnering the attention of journalists and academics in and outside of the North African country, that national emotional stereotype may prove one of self-deprecating comedy or humour bashing powerful figures.[11] At the time of writing (June 2019), the ongoing laughter-filled Algerian *ḥirāk* (movement) for political change in the country that gained momentum on 22 February 2019, the first day of mass protests across the country against then President Abdelaziz Bouteflika's run for a fifth term, has drawn international attention to the peculiarities, power, and popularity of 'Algerian' comedy.[12] For this reason, students of Algerian humour are engaging in high stakes work when exploring the territory's comedic traditions. Furthermore, as Claire Eldridge reminds us through her survey of Jewish Franco-Algerian memoires, for members of this community who grew up in Algeria it is precisely in the realm of culture that the lines separating 'Jew' from 'Muslim' became blurred (2012: 300). Yet Maghribi artists or artists of Maghribi origin in France have explored comedy as a force for reconsidering historical exchanges between Jewish and Muslim communities with links to North Africa.[13] They have often accomplished this task by using comedy to highlight similarities rather than differences cutting across the different religious minorities in France, as is the case with Algerian artist Farid Boudjellal's series, *Juif-Arabe* (1996).[14] Leaders of Moroccan and Tunisian cinema have also underscored the experiences of Jewish communities in their countries, including in films based on one-man shows (Kosansky and Boum, 2012: 428).[15] In line with the thinking of the 'superiority school' of humour and a number of humour theorists, comedy and laughter constitute powerful cultural tools for constructing communities, not least of which being 'invented national' ones.[16] All of these factors render an examination of identity in nationalizing humour a crucial and timely undertaking.

[10] Eustace, Lean, Livingston, Plamper, Reddy, and Rosenwein (2012: 1493).

[11] See, for example, Yelles (2016).

[12] See, for example, Cheurfa (2019) and Ciyow (2019). For lexicons of this revolution's constantly evolving vocabulary, or 'Hirakologie', including information regarding the term *ḥirāk*, see Ferhani (2019); Haleh Davis, Cheurfa, and Serres (2019); and 'Hirakologie' (2019).

[13] See Bharat, this volume.

[14] For a thorough analysis of this work, see Bourget (2008: 159–71).

[15] See also Davis and Paloma Elbaz, this volume.

[16] For an example of the 'superiority school' of humour theory, see Kuipers (2008: 382–85).

Jewish-Muslim Comedic Exchanges from the 1920s into the Post-independence Era

While, as Malika Rahal (2012b) and Natalya Vince (2015: 102–40), among others, have asserted, continuities span across the pre- and post-independence periods of Algeria's history, 1962 serves as an appropriate stopping point for the purposes of the present section of this chapter. As French colonial rule came to an end in Algeria, 110,000 Algerian Jews left the three former territories of France (Stora, 2006: 219). Uncovering patterns of Jewish comedy from Algeria after this moment remains a complicated task due to the reluctance of some members of the territory's still present Jewish community to identify themselves to researchers. How Algerian Jews remaining in Algeria have employed comedy after independence would translate to a fruitful line of future scholarship.

Prior to independence, though, Jewish players helped to launch and were integral contributors to one of the first widespread and standardized forms of political comedy and satire: sketches and theatre. A Jewish musician and Andalusi singer, Edmond Nathan Yafil, trained and served as a mentor to Mahiedinne Bachtarzi, nationalist playwright and performer of the 1920s through 1950s and the eventual first director of independent Algeria's National Theatre. He also founded El Moutribia (the 'female educator' or 'enchantress'), a major social organization devoted to promoting cultural performances as well as a general performance troop.[17] According to Jonathan Glasser (2012: 681), drawing upon French colonial archives, Jewish performers comprised the majority of the troop, at least in 1930. What is more, Marie Soussan, a Jewish Algerian, was the first woman of local origin to take to the stage when she appeared in Allalu's 1926 play, *Djeha*, an account of a popular folk figure associated with comedic acts of trickery.[18] Jewish businesses also seem to have financially promoted theatre through publishing advertisements with phrases in Hebrew in programmes such as the one for Bachtarzi's 1937 play, *Les Femmes*.[19] The role, then, of Jewish artists and patrons in forging some of the territory's earliest 'indigenous' (in the sense of being produced by populations with long-held roots there) modern comedy proves indisputable.

The next part of this chapter turns to Algeria's cartooning industry to determine how postcolonial artists, under the aegis of the state, obscured

[17] In the secondary literature on Algerian theatre from this period, scholars translate *al-Mutribiyya* as both *éducatrice* (the female educator) and *enchanteresse* (enchantress). See Roth (1967: 22) and Kali (2013: 65).

[18] Roth (1967: 62). See also Miliani and Everett, this volume.

[19] Roth (1967: 62).

or simply did not acknowledge Jewish contributions or spaces in the country's cultural pasts. As with the plays of Rachid Ksentini or Bachtarzi, post-independence cartoonists carved out characters who were supposed to stand in for wider stereotypes of figures in Algerian society. In fact, due to stringent state censorship of periodicals along with the government's monopoly and officials' desire to promote nationalism, the military-controlled regime ordered cartoonists to craft 'common heroes of an Algerian sort' for the children's review, *M'Quidech*.[20] Consequently, early Algerian comic artists' elaboration of invented 'Algerian' universes as strictly Muslim spaces, encompassing only Muslim Algerian characters and symbols, appears all the more striking. I consider *bandes dessinées* as falling under the category of 'comedy' in light of Algerian critics' own identification of comics as belonging to this genre.[21] Conceding that point, *BD*s from this era did contain rhetoric that could have provoked laughter, among other emotionally laden responses.

Imaginings of Algeria's Past as Strictly Muslim in Post-independence *Bandes Dessinées*

Cartoonist Menouar Merabtène, known more broadly in Algeria by his penname, Slim, was the territory's first major home-grown cartoonist. In the early years of independence, from 1967 through the 1980s, Slim attracted attention and distinction through drawings that appeared regularly in periodicals such as *Algérie-Actualité* and the Oran-based paper, *République*.[22] By the mid-1970s, the artist had become so famous among Algerian cultural and intellectual circles that he illustrated the poster for Merzak Allouache's classic film, *Omar Qatlato* (roughly translatable to 'Omar His Masculinity Kills Him', as *ar-rādjla*, Algerian Arabic for 'masculinity', is insinuated in the title by the feminine conjugation of the verb 'kill' in the past tense). In fact, it was Allouache who suggested the theme of Slim's first newspaper cartoon series cum album over dinner at the Brasserie des Facultés in downtown Algiers (the artist had been trained as an animator in Poland, but opportunities for televised cartoons were not yet available in the North African country). Slim published *Moustache et les frères Belgacem* in *Algérie-Actualité* in 1967. Later, the bimonthly magazine released all the pages together as a single volume.[23]

[20] Labter (1999: 11), citing a document between FLN officials and the 'principle directors' of the paper that he does not give a reference for in the article.

[21] See, for example, Labter (1999).

[22] For his biography, see Labter (2009: 247–48).

[23] Slim recounted this story in Zelig (2009: 46). Interview with Slim, 20 August 2014.

148 *Jewish-Muslim Interactions*

The book signals a broader trend in the artist's work towards envisioning Algeria and, by extension and in light of the editorial slants of the papers that he laboured for, Algerian nationalism, as exclusively Islamic. Quite tellingly, European settler or Algerian Jewish characters are absent from *Moustache*. Such an absence here proves particularly striking as the Casbah had served as a fruitful gathering place for Muslim-Jewish interreligious cultural production and as a home for interreligious communities, as evoked in the famed documentary *El Gusto* (2001) and the writings of Hélène Cixous and Daniel Timsit, among others.[24] With the stroke of his pen, Slim transforms the Battle of Algiers, a key struggle in the country's War of Independence that he was both geographically and temporally distant from and a city that he has admitted that he knew very little about at the time that he composed *Moustache*, into an event capable of representing the Algerian nation as a whole. The artist even stated in an interview about the album, 'La Casbah, ce n'était pas ma ville [...] mais en imaginant une Casbah humouristique, j'ai montré la bataille d'Alger d'un autre œil' (cited in Zelig, 2009: 46).[25] Here, the artist stresses that, through the album, he aimed to portray a world that would encapsulate the entirety of 'Algerian' societies and communities during the war, but for post-independence audiences.

As the titular figures suggest, the work tells the story of the treacherous *harki* brothers,[26] the Belgacems, and Moustache, a dashing nationalist fighter from the Casbah, an *algérois* neighbourhood that had been inhabited by Jewish as well as Muslim residents in reality but displayed here as solely Muslim. The album offers a take on the Battle of Algiers in which the wider War of Independence seems to have mainly pitted factions of the local

[24] Bousbia (2001), Cixous (2003: 84), and Timsit (1998). Cixous has expressed ambiguity surrounding her position in Algeria, including a sense of alienation in the wake of rising nationalism that she felt prior to independence (2003). See also Everett (2017a).

[25] 'The Casbah was not my city... But in imagining a humouristic Casbah, I showed the Battle of Algiers from another viewpoint'. This and all subsequent translations are by the author of this chapter.

[26] *Harkis* were Algerian Muslim soldiers who served in the Algerian War of Independence on the side of French authorities. Nationalists frequently attacked these individuals, who sometimes had little agency in their choice to work on the side of keeping Algeria 'French'. Today, many Algerians employ the term *harkis* or 'sons of *harkis*' as synonyms for 'traitor', and the French state and populations across the Mediterranean in France and Algeria continue to grapple with the historical aftermath of the mistreatment of Algerian Muslims who served as *harkis* during the war. For a sample of literature on the *harkis*, see Eldridge (2009), Roux (1991), and Hamoumou (1993).

Omissions of Jewish Heritage and Muslim-Jewish Relations 149

population against one another. French army officials appear only briefly in the piece. Instead, the major protagonists and antagonists are locals who more often than not are shown to be Muslim. The illustrator begins his album by portraying a *haïk*-clad woman, called Fatima throughout the album, visiting an army headquarters to report to French authorities on the movement of Moustache, a nationalist fighter. The white garment, which can vary from one region to another in Algeria, was generally donned by city-dwelling Muslim women. A French soldier guarding the military post's entrance refers to the woman as 'Fatma'. 'Fatma', a shortened version of 'Fatima', was a common Muslim name for women and has a religious connotation in Islam, as the name of the Prophet Muhammad's daughter. Furthermore, during the colonial period, some Muslim women traversed the barriers that separated Muslim and Jewish neighbourhoods from so-called 'European neighbourhoods', although nationalized 'French' Jews from Algeria could also reside in these areas, to work as domestic labourers. Individuals of European background commonly referred to female Muslim servants as 'Fatmas' in a derogatory manner and one seemingly intended to reduce the diversity of Muslim women into a singular, all-encompassing entity. It is perhaps telling, then, that Slim chose a name similar to Fatma, Fatima, for the first ostensibly Muslim character who appears in the serial and, like many of the other Muslim characters, will be furtively working to undermine the cause of 'French Algeria'; by selecting such a common Muslim name and one that settlers applied broadly to Algerian Muslim women, the artist may have wanted to have this 'Fatma' stand in for the wider community or to reclaim the name in a powerful nationalist manner. The French soldier at the beginning of the album uses the essentializing, derogatory nickname of the character to degrade her as they might any other 'indigenous woman'. Thus, the woman's garments along with the proximity of her real name to a racialized insult appear to signal her belonging to the territory's Muslim population, while no character in the album shows similar signs of being part of the indigenous Jewish community. Contrary to what the first page of the album suggests, where Fatima appears to provide intelligence to the French military, Fatima is assisting the major national party engaged in an armed struggle against French colonialism, the National Liberation Front or FLN, and gives the money that the French sergeant affords her over to Moustache, presumably to be used for the nationalist cause (Slim, 2011).

Other signs emerge from the album that lead readers to identify every indigenous person within the Casbah as Muslim. Slim quite tellingly places a poster with the word 'Allah', the Arabic word for God, on several background walls throughout the album. At one moment, when shots ring out during a heated moment in the *hammām*, a bystander who sports

similar garments and attributes to the other characters in the album pleads to Allah out of fear. At other instances, Slim has the letters 'FLN' for the National Liberation Front tagged onto walls across the Casbah and even onto the side of a minaret. The switching between these two words/ phrases on walls seems to suggest that the artist intends for the reader to draw a connection between them. A man is also shown engaged in Islamic prayer, given his posture in two sequences of the album. While religion remains largely absent from the album's dialogue, Slim scatters references to the Islamic faith throughout the work and in ways that place 'God' on par with the FLN, the only legal party in the country (Slim, 2011). Readers may have interpreted this sign to mean that the FLN's words and orders should be viewed as inviolable. However, given the artist's more widely known scepticism towards the politicization of Islam, as perceivable in his work from the 1990s (Slim, 1997), it is possible that Slim intended, through the gesture of placing the letters 'FLN' on a minaret, to subtly mock Boumédiène's regime and early reiterations of the FLN's embracing of Islam as a political strategy.

Indeed, in the same strip that the word 'FLN' graces a minaret, the man aloft the structure, the plausible muezzin of the mosque, warns Moustache down in the streets below that the dreaded Belgacem brothers are surrounding him. The successive drawing has Moustache rebuke the religious figure's aid by stating, 'J'ai pas besoin de vos conseils! Si je meurs, ce sera pour l'Algérie!'[27] The nationalist hero then evokes the devil in the next frame. With these words, Moustache and, by extension, Slim may have wanted to express their greater allegiance to their country and its independence than to the territory's predominant faith. In other words, the character would not be dying for Islam but instead for the nation. Even this eschewing of an overtly religious facet of the FLN's revolt, though, puts Algerian nationalism in opposition to one religion and one religion only, the one whose symbols could be seen throughout *Moustache*. Followers of the artist may have been cued into the intricate meaning of symbols and characters' actions in the album, but it remains unclear as to how it would have been read by contemporary Algerian audiences unfamiliar with Slim's stance on the place of religion in society.[28] This work was the artist's first, and the ambiguity of the graffiti leaves it open to various interpretations, including perceiving the FLN as representative of or tied to Islam.

[27] 'I don't need your advice! If I die, it will be for Algeria!'
[28] I am indebted to Mourad Yelles for explaining the potential room for interpretation concerning Slim's depictions of Islam and its relationship to the one-party FLN system from *Moustache*.

Figure 8: Slim marks the Casbah as a uniquely Muslim space (2011).

All in all, Algeria's second *bande dessinée* fashions a specific image of the country and War of Liberation resistant fighters as culturally, ostensibly, and seemingly exclusively Muslim, whose legacy in the late 1960s was so crucial to cementing Algerian national unity.[29]

Moustache's ally Mimoun eventually morphed into the character Bouzid. Slim used Bouzid as the protagonist of the cartoon series that bore his name to create a rural space from which to question and comment on 'Algerian' pastoral life at the moment of the Agrarian Revolution of the 1970s. The *Zid Ya Bouzid* sequences are rich, often textured, and stuffed

[29] For examples of literature on the mythology or 'hagiography' (term of Algerian writer Slimane Chikh, 1982) surrounding nationalist fighters during the post-independence era, see Branche (2011) and Rahal (2012a).

152 *Jewish-Muslim Interactions*

with graffiti, signs, symbols, and fanciful creatures capable of surrealist feats, including commentary from Gat, Bouzid's ever faithful, if wryly observant and sometimes critical cat. Admittedly, religiosity does not feature centrally in Slim's portrayals of small town 'Algerian' existence during the 1970s reforms to redistribute and reorganize farmlands, the height of socialism and Algeria's status as a leader of Third Worldism and the Non-Aligned Movement, and into the 1980s. As James McDougall (2017b) has demonstrated, state efforts to construct a national identity through cultural means inevitably involved an engagement with economic and technological policies. Slim's *Zid Ya Bouzid* albums along with his other work do tend to narrow in on socialism and the technical issues that it entailed. Whenever religion does pop up in the scenes from Oued Besbes, a Western Algerian town that functions as the setting for most of the *Zid Ya Bouzid* strips, the sole faith that Slim references is Islam.

Zina, the token woman of the *Zid Ya Bouzid* universe, who often serves as a plot device but can, on occasion, demonstrate agency, sports the *haïk* in Slim's drawings. In another strip, a poster with the word 'God' in Arabic graces a wall (Slim, 1986: 8), different from the Hebrew and Judeo-Arabic that Arabic-speaking Algerian Jews would most likely use for a religious text. The illustrator likewise has Bouzid envision a marriage in front of a *qadi*, or Islamic judge.[30] A frequent trope throughout Slim's *Zid Ya Bouzid* series is the titular character's desire to marry the naively seductive Zina despite offers that the woman receives from other men for her hand. Bouzid often speaks of needing to arrange an appointment with the *qadi*, or Islamic judge, to formalize their union. Thus, before this 'Algerian everyman' embarks upon a life of marital bliss with the woman whose name translates to 'pretty', Bouzid wants to ensure that he follows proper Islamic prescriptions in his intentions to form a holy union with Zina. He appears, then, as a devout Muslim and one who presents his respect for Islamic law to readers. He also becomes the default 'Algerian' personality, gendered as male, heterosexual, and an earnest disciple of Islam. These symbols and the characters' language subtly remind readers that the spaces dealt with in the cartoons are at least culturally and religiously Muslim. The albums on the whole critique the shortcomings of Algeria's socialist project, but with ever an eye to pinpointing corrupt, greedy officials as behind these failures rather than the programmes themselves. In the process, they pit everyday individuals who Slim (1986) imagines as Muslim against these overbearing, bureaucratic crooks who are also depicted as Muslim.[31]

[30] See, for example, Slim, *Zid Ya Bouzid 1 and 2*, reprint (1986: 7).
[31] Douglas and Malti-Douglas (1994: 192–94) drew a similar conclusion from Slim's drawings.

Other Algerian *bédéistes* from the 1960s and 1970s wielded their pens to draw imagined landscapes of Algeria, both past and present. As with Slim, these artists possessed a certain level of autonomy over the content of their albums. A series of these works wove tales of early forms of so-called 'nationalist' resistance against French imperialism and military conquest of the territory. Quite tellingly, these albums, sometimes published through the children's review *M'Quidech*, claimed to 'reconstruct' or 'return' to a past dating as far back as the early nineteenth century, a past that was bereft of any residents of the Jewish faith, contrary to reality. These albums also take on an educative tone. Works such as those of Brahim Guerroui and Mustapha Tenani incorporate explanations of Algeria's past into sequential drawings that were sometimes accompanied by excerpts from historical texts. These texts tend to be highly patriotic, bombastic, and, when exposed to the critical lens of historical fact, ahistorical in substance. In several instances, the Muslim character of the almost always exclusively male resistors shines through. For instance, Tenani's 1985 album *Le Fusil chargé* ['The Loaded Rifle'] contains a scene of confrontation between the 'Algerian people', as represented by armed men, and invading French forces outside of Algiers. In leading the charge, one 'Algerian' figure screams, 'Allah ou akbar! El-Djihad', translating to 'God is great! The struggle!' (Tenani, 2002 [1985]: 22). Both phrases contain strong religious connotations in Islam, harkening back to the early days of the Islamic community. Further on in the story, another group of male resistors chant 'El-Djihad' prior to engaging the enemy French troops. While, once again, religion does not play a central role in the album, the 'Algerian' populations appear to possess a default Muslim identity despite the presence of a sizeable Jewish minority at this time (5,000 or 10 per cent of the population in 1830) near Algiers, the site of action in *Fusil*, and Jewish involvement in the initial struggle against French occupations.[32] Similar patterns surface in *bandes dessinées* dedicated to purportedly retelling the history of Algeria's storied liberation struggle of 1954 to 1962. A work by Brahim Guerroui also has nationalist militants calling out, 'Allah ou akbar' ['God is great'] prior to launching an attack on the French military during the War of Independence (1986).

Finally, in perhaps the most remarkable undertaking that separated Algerian identity from a Jewish background or component, Rafik Ramzi's

[32] Tenani (2002 [1985]: 46) and McDougall (2017a: 35). For the response of Algerian Jews in Western Oran to French colonization in the 1830s and 1840s, see Schreier (2010: 28–29). For more on Algerian Jews' contributions to the pro-independence struggle of the 1950s and 1960s in the territory, see Le Foll-Luciani (2015).

album *SM15: Halte au Plan 'Terreur'* ['SM15: Halt to the "Terror" Plan'] (1983) recounts the tale of an Algerian special agent, Mourad Saber, who travels to Jordan and Israel/Palestine to thwart an evil plot of Israel and the United States against the so-called 'Arab World'. There, he encounters Israeli soldiers and spies who very much fulfil the trope of 'the enemy' that Oren Kosansky and Aomar Boum (2012: 426) have recognized as dominating representations of Jewish figures in Moroccan cinema up until very recently.

As Douglas and Malti-Douglas have asserted, the album served to drum up a strong sense of pan-Arab nationalism and solidarity with Palestinians among Algerian readers (1994: 184–88). At the same time, this piece, along with the novel that inspired it by Youcef Khader, represent an instance of what Olivia Harrison has included in her expansion of the concept of 'transcolonialism' (2015: 2); through references to Palestine and Israel, the artist and author covertly makes claims about Algeria and France, encompassing hopes for a fuller, more successful decolonization process across the region.[33] Yet the Maghribi artists that Harrison (2015) examines refer to Palestine in order to mount subtle opposition to the oppressive regimes that they exist under. *SM15*'s protagonist, on the other hand, is an agent of Algeria's government and the hero needed to secure the 'Arab World' from maleficent outsiders, namely 'Westerners'. Here, decolonization is equated directly with avoiding 'Western' influence rather than combatting postcolonial elites and governments that may be oppressing formerly colonized populations. The album paints the Algerian state along with its handsome and moral spy, Mourad Saber, as the saviours of the broader region. Ramzi's lumping together of 'Algeria' with 'Palestine' omits the roles and connections that Jewish Algerians had in fighting for independence and in the early years of the first Algerian national government, while conflating all Jews with 'Zionists'. More so than any other piece considered here, Ramzi's work displaces a Jewish identity from an Algerian one. It further enters into a broader corpus of literary imaginings of ties between the Palestinian-Israeli conflict and the Maghrib's colonial experience, with important repercussions for Algerian perceptions of their nation and its place in the world (Harrison, 2015). For instance, a 'Zionist' calls Saber a *'raton'* [*rat*], inciting the spy to reflect on his own experience under French colonialism (Ramzi, 1983: 33).[34]

All of the 'Zionist' personalities who cross Saber's path have a similar appearance. They are male and corpulent. At certain moments, their teeth also give the impression of being sharpened, offering them a heinous demeanour. In fact, the Israeli agents of *SM15* look like the antagonists

[33] Lionnet and Shih (2005: 11) originally developed the term 'transcolonialism'.
[34] Douglas and Malti-Douglas (1994: 186) arrived at a similar conclusion.

Omissions of Jewish Heritage and Muslim-Jewish Relations

that artists like Slim and Tenani presented readers in their broader corpus. The bodily heft of the Israeli military characters that their Palestinian, Jordanian, and Algerian opponents almost unfailingly refer to as 'Zionists' throughout the album resembles how Algeria's *BD* canons visualized antagonists. Villains tended to be much larger and fatter than the frequently svelte and spry heroes or 'everymen' of Algerian *bandes dessinées*. This plumpness may have emblemized the purported greed of these characters, furtive capitalists actively threatening the nation's collectivization efforts. For instance, in *Zid Ya Bouzid*, two of Bouzid's recurring adversaries, Sid es-Sadik ('master of the friend') and Ben Trust ('son of the trust', as in trust fund), undermine Algeria's socialist mission through attempts to accumulate wealth in Bouzid's hometown. They are both larger than Bouzid and his band of fellow collectivization participants, with Sid es-Sadik boasting about how 'big' he is along with his powerful family connections (Slim, 1986: 33). As mentioned previously, all Algerian *BD*s through the early 1990s produced within Algeria were published in newspapers funded by the FLN state, which wanted to enforce its socialist policies (Douglas and Malti-Douglas, 1994). Consequently, Bouzid's tales associated heftier bodies with capitalist consumption and schemes that would hurt the Algerian nation. The same may hold true for the larger-framed 'Zionists' of Ramzi's album who offer money at one point to a child to betray the Palestinian cause (he 'righteously' refuses; 1983: 41, 42, 44).

Furthermore, in addition to the effective 'Othering' present in the album (Said, 1978), SM15 collapsed differences between 'Jewish' or 'Zionist' identities at a few notable instances in the work. 'Arab' Jordanian, Palestinian, and Algerian characters apply historical terms linked to Judaism to 'Zionists' on at least two occasions in the album. For instance, the three ships involved in the Israeli and American plot are named after the 'three kings of Israel' (Ramzi, 1983: 27). A few panels later, the Algerian spy's Palestinian Fatah handler calls the same characters 'the *Macabées*' (Ramzi, 1983: 38). The origins of this word lie in the name of a Jewish family that opposed the Seleucid Empire in the second century BCE. Through the reduction of *SM15*'s 'Zionist' characters to historical Jewish figures, Ramzi and Khedar explicitly tie the group to the Jewish faith in a potentially essentializing manner. The album thereby further separates Arab identity from a 'Jewish' one despite indigenous communities of Jews existing throughout the so-called 'Arab World', including Algeria.

Beyond attributing villainous qualities and Jewish terminologies to 'Zionists', the depictions of Israeli soldiers in the album hew to earlier European antisemitic stereotypes of Jews. They possess hooked noses along with their sharpened teeth. 'Arab' characters also call 'Zionists' vipers and

156 *Jewish-Muslim Interactions*

serpents. This taunt harkens back as well to antisemitic portraits of Jewish individuals in Europe (see Ramzi, 1983: 44). By harnessing these stereotypes, Ramzi may have sought to further distance the 'Zionist' characters, whose Jewish faith he emphasizes once again is not from the Middle East or North Africa, all the while adding to their vilification.

The tradition of Algerian comics serving as a key vehicle for shaping sentiments related to 'Algerianness' means that readers would have considered the Israeli soldiers, replete with characteristics common in antisemitic depictions of Jews, as an 'Other' fundamentally distinct from Algerians. Thus, *SM15* forcefully centres a notion of Algerian belonging in resistance against colonial and 'Western' power while it separates Jewish identity and religious affiliation from the Algerian national community. As mentioned above, the creation of 'Algerian' superheroes in the 1960s, 1970s, and 1980s purposefully entailed the fashioning of ideal behaviours and attributes that members of the nation-state should similarly possess. Through this *BD*, individuals of the Jewish faith are placed beyond the boundaries of the Algerian nation-state and established as its enemy as well as the enemy of decolonization overall. At the same time, the work may have functioned to bring the historical dangers of colonialism back into the minds of readers for the political purpose of shoring up support for the one-party system that claimed to represent the ethos and spirit of Algeria's earlier anti-colonial revolt.

Conclusion

A lack of reference to earlier Jewish contributions, spaces, and populations in Algeria's post-independence cultural fields is not natural. Rather, such forgetting and omitting results from active processes on the part of artists and state patrons. This pattern of neglecting Jewish cultural legacies and presence in the country has perhaps never been clearer than in the case of Algeria's robust cartooning industry, one of the most significant sites of cultural production that Algeria's state and lead artists used in the post-independence period to instil a sense of 'Algerianness' as exclusively Muslim in culturally plural populations exhausted by war and internal divisions.

As this chapter has demonstrated, Jewish artists in the colonial era shaped the territory's comedic heritage. The state and artists alike latched onto humour, often in new forms, in the post-independence era, to craft specific visions of *algérianité* with deep connections to Algeria's past or how they wanted it to be remembered in order to create a strong and unified national identity. In the process, they often did not acknowledge the existence and legacy of the country's Jewish communities, both past and present. This absence has been further reiterated by intellectual writers over the past few

Omissions of Jewish Heritage and Muslim-Jewish Relations 157

years participating in a new wave of interest in humour from the country. The continued engagement of Jewish figures, as evidenced by Robert Castel's performance in post-independence cultural productions like the 1982 comedy *Hassan Taxi* (dir. Riad), remains an under-examined facet of the longer history of dynamic Muslim-Jewish interactions in this Maghribi nation.[35]

Works Cited

Anderson, Benedict. 1983. *Imagined Communities: Reflections on the Origin and Spread of Nationalism*. London: Verso.

Boudjellal, Farid. 1996. *Juif-Arabe: l'intégrale*. Toulon: Soleil Productions.

Bourget, Carine. 2008. 'Jews and Arabs in France in Boudjellal's Comic Books'. *Expressions maghrébines* 7: 159–71.

Bousbia, Safinez (dir.). 2001. *El Gusto*.

Branche, Raphaëlle. 2011. 'The Martyr's Torch: Memory and Power in Algeria'. *The Journal of North African Studies* 16: 431–43.

Chaulet-Achour, Christiane, and Dalila Morsly. 2002. 'Plus d'un siècle de rire en Algérie: essai de panorama'. In Mongi Madini.Besançon (ed.), *2000 ans de rire: permanence et modernité*. Besançon: Presses universitaires franc-comtoises: 55–66.

Cheurfa, Hiyem. 2019. 'The Laughter of Dignity: Comedy and Dissent in the Algerian Popular Protests'. *Jadaliyya*, 26 March. Available at: http://www.jadaliyya.com/Details/38495/The-Laughter-of-Dignity-Comedy-and-Dissent-in-the-Algerian-Popular-Protests?fbclid=IwAR3PUAaGtQRJBcQwGeY5T2ti bMLILSRy0xbkWHS3KsnD3shEgHbk4HYpBrY (consulted on 2 June 2019).

Chikh, Slimane. 1982. 'Faire, dire, écrire l'histoire'. *Le Monde*, 3 July. Available at: https://www.lemonde.fr/archives/article/1982/07/03/faire-dire-ecrire-l-histoire_2889812_1819218.html (consulted on 11 July 2019).

Cixous, Hélène. 2003. 'Letter to Zohra Drif'. Trans. by Eric Prenowitz. *College Literature* 30: 82–90.

Ciyow, Yassin. 2019. 'Les Algériens rivalisent d'humour pour braver Bouteflika et le «système»'. *Le Monde Afrique*, 17 March. Available at: https://www.lemonde.fr/afrique/article/2019/03/17/les-algeriens-rivalisent-d-humour-pour-braver-bouteflika-et-le-systeme_5437480_3212.html (consulted on 26 May 2019).

Davis, Muriam Haleh, Hiyem Cheurfa, and Thomas Serres. 2019. 'A Hirak Glossary: Terms from Algeria and Morocco.' *Jadaliyya*, 13 June. Available at: https://www.jadaliyya.com/Details/38734/A-Hirak-Glossay-Terms-from-Algeria-and-Morocco (consulted on 13 July 2019).

[35] I am indebted to Jonathan Glasser for calling my attention to Castel's participation in the film (Riad, 1982).

Douglas, Allen, and Fedwa Malti-Douglas. 1994. *Arab Comic Strips: Politics of an Emerging Mass Culture*. Bloomington and Indianapolis: Indiana University Press.

Eldridge, Claire. 2009. '"We've Never Had a Voice": Memory Construction and the Children of the *Harkis* (1962–1991)'. *French History* 23 (2009): 88–107.

——. 2012. 'Remembering the Other: Postcolonial Perspectives on Relationships between Jews and Muslims in French Algeria'. *Journal of Modern Jewish Studies* 11: 299–317.

Eustace, Nicole, Eugenia Lean, Julie Livingston, Jan Plamper, William M. Reddy, and Barbara H. Rosenwein. 2012. 'AHR Conversation: The Historical Study of Emotions'. *American Historical Review* 117: 1487–531.

Everett, Samuel Sami. 2017a. 'The Algerian Works of Hélène Cixous: At the Triple Intersection of European, North African and Religious Nationalisms'. *International Journal of Politics, Culture, and Society* 30: 201–17.

——. 2017b. 'The Many (Im)possibilities of Contemporary Algerian *Judaïtés*'. In Patrick Crowley (ed.), *Algeria: Nation, Culture, and Transnationalism, 1988–2005*. Liverpool: Liverpool University Press: 63–80.

Ferhani, Améziane. 2012. *50 ans de bande dessinée algérienne*. Algiers: Editions Dalimen.

——. 2019. 'Du hirak au harak, tentative du lexique'. *El Watan*, 17 May 2019. Available at: https://www.elwatan.com/edition/actualite/du-hirak-au-harak-tentative-de-lexique-17-05-2019 (consulted on 13 July 2019).

Glasser, Jonathan. 2012. 'Edmond Yafil and Andalusi Musical Revival in Early 20th-Century Algeria'. *International Journal of Middle East Studies* 44: 671–92.

Groensteen, Thierry. 2009. 'The Impossible Definition'. In Jeet Heer and Kent Worcester (eds.), *A Comic Studies Reader*. Jackson: University of Mississippi: 124–31.

Guerroui, Brahim. 1986. *Les enfants de la liberté*. Algiers: ENAL.

Hamoumou, Mohand. 1993. *Et ils sont devenus harkis*. Paris: Fayard.

Harrison, Olivia C. 2015. *Transcolonial Maghreb: Imagining Palestine in the Era of Decolonization*. Stanford: Stanford University Press.

'Hirakologie: le Hirak et ses langues'. 2019. Conference Proceedings. Faculté de Langue et Littérature Arabes et des Langues Orientales, University of Algiers II, Ben Aknoun. 26 June.

Kali, Mohammed. 2013. *100 ans de théâtre algérien: du théâtre folklorique aux nouvelles écritures dramatiques et scéniques*. Algiers: Socrate News.

Khelladi, Aïssa. 1996. 'Rire quand même: l'humour politique dans l'Algérie d'aujourd'hui'. *Revue du monde musulman et de la Méditerranée* 77/78: 225–37.

Kosansky, Oren, and Aomar Boum. 2012. 'The "Jewish Question" in Postcolonial Moroccan Cinema'. *International Journal of Middle East Studies* 44: 421–42.

Omissions of Jewish Heritage and Muslim-Jewish Relations 159

Kuipers, Giselinde. 2008. 'The Sociology of Humour'. In Victor Raskin (ed.), *The Primer of Humour Research*. Berlin: Mouton de Gruyter: 361–98.

Labter, Lazhari. 1999. 'Qui se souvient de *M'Quidèch?*' *Liberté*, 9 February, p. 11.

——. 2009. *Panorama de la bande dessinée algérienne*. Algiers: Lazhari Labter Editions.

Lacheraf, Mostefa. *L'Algérie, Nation, et Société*. Algiers: Société nationale d'édition et de diffusion, 1978.

Le Foll-Luciani, Pierre-Jean. 2015. *Les Juifs algériens dans la lutte anticoloniale: trajectoires dissidents (1934–1965)*. Rennes: Presses Universitaires de Rennes.

Lionnet, Françoise, and Shu-mei Shih (eds.). 2005. *Minor Transnationalism*. Durham, NC: Duke University Press.

McClintock, Anne. 1991. '"No Longer in a Future Heaven": Women and Nationalism in South Africa'. *Transition* 51: 104–23.

McDougall, James. 2006. *History and the Culture of Nationalism*. Cambridge: Cambridge University Press.

——. 2017a. *A History of Algeria*. Cambridge: Cambridge University Press.

——. 2017b. 'Culture as War by Other Means: Community, Conflict, and Cultural Revolution, 1967–81'. In Rabah Aissaoui and Claire Eldridge (eds.), *Algeria Revisited: History, Culture, and Identity*. New York: Bloomsbury Academic: 235–52.

McKinney, Mark. 2008. 'The Frontier and the Affrontier: French-Language Algerian Comics and Cartoons Confront the Nation'. *European Comic Art* 1: 175–200.

Miller, Ann. 2007. *Reading Bande Dessinée: Critical Approaches to French-Language Comic Strip*. Bristol, UK: Intellect Books.

Rahal, Malika. 2012a. 'Comment faire l'histoire de l'Algérie indépendante'. *La Vie des Idées*. 13 March. Available at: https://laviedesidees.fr/Comment-faire-l-histoire-de-l-Algerie-independante.html (consulted on 27 May 2019).

——. 2012b. 'Fused Together and Torn Apart: Stories and Violence in Contemporary Algeria'. *History & Memory* 24: 118–51.

Ramzi, Rafik. 1983. *SM 15: Halte au plan 'terreur'*. Algiers: ENAL.

Riad, Mohamed Slim (dir.). 1982. *Hassan Taxi*.

Roth, Artlette. 1967. *Le Théâtre algérien de langue dialectale*. Paris: François Maspero.

Roux, Michel. 1991. *Les Harkis: les oubliés de l'histoire, 1954–1991*. Paris: Editions la Découverte.

Said, Edward. 1978. *Orientalism*. New York: Pantheon Books.

Schreier, Joshua. 2010. *Arabs of the Jewish Faith: The Civilizing Mission in Colonial Algeria*. New Brunswick: Rutgers University Press.

Slim. 1986. *Zid Ya Bouzid 1 and 2*. Reprint. Algiers: ENAL.

——. 1997. *Retour d'Ahuristan*. Paris: Seuil.

——. 2011. *Moustache et les Frères Belgacem*. Self-published through Lulu.com.

Stora, Benjamin. 2006. *Les Trois exils: Juifs d'Algérie*. Paris: Editions Stock.

Tenani, Mustapha. 2002 [1985]. *Le Fusil chargé*. 2nd edn. Algiers: ENAG Editions.

Timsit, Daniel. 1998. *Algérie: récit anachronique*. Paris: Editions Bouchènes.

Vince, Natalya. 2015. *Our Fighting Sisters: Nation, Memory, and Gender in Algeria, 1954–2012*. Manchester: Manchester University Press.

Yelles, Mourad. 2016. 'Plusieurs langues et plusieurs cultures: une ressource pour l'humour algérien'. YouTube, 3 September. Available at: https://www.youtube.com/watch?v=aJ2fdIbRppw (consulted on 29 October 2018).

Zelig, Omar. 2009. *Slim, le Gatt, et Moi*. Algiers: DALIMEN.

Forgotten Encounters: Sounds of Coexistence in Moroccan Rap Music

Cristina Moreno Almeida

إننا نطمح إلى أن يسير المغرب في عهدنا قدما على طريق التطور والحداثة وينغمر في خضم الألفية الثالثة مسلحا بنظرة تتطلع لآفاق المستقبل في تعايش مع الغير وتفاهم مع الآخر محافظا على خصوصيته وهويته دون انكماش على الذات في كنف أصالة متجددة اوفي ظل معاصرة ملتزمة بقيمنا المقدسة[1]

On 30 July 1999, King Mohammed VI pronounced his first speech from the throne signposting key elements that would shape his reign in the years to come. With time, official discourses have been infused with the language of development, modernity, tolerance, and coexistence. *Ta'āyish*, the Arabic word for coexistence, is particularly interesting as it embodies Morocco's idiosyncrasy as a modern yet traditional, liberal, and peaceful country, especially concerning (although not exclusively) its religious identity. The

[1] 'We hope that Morocco, under our reign, moves forward on the path of development and modernity, and that it enters the third millennium with a vision of a future in coexistence with others and mutual understanding with each other preserving its identity and specificity, without self-isolating, as part of a renewed authenticity and modernity and under a modernity that is shaped according to our sacred values'. Mohammed VI Throne Day Speech 1999. Available at: http://www.maroc.ma/ar/صاحب-الجلالة-الملك-محمد-السادس-يوجه-خطاب-العرش/خطابات-ملكية (consulted on 27 August 2019). This and all subsequent translations (from Arabic and French to English) are by the author of this chapter.

notion of coexistence (*convivencia*) has its origin precisely in al-Andalus (wrongfully referred to as Muslim Spain or Islamic Spain)[2] where Muslims, Jews, and Christians lived in relative peace. Coexistence strategically ties contemporary Morocco to its golden age when the Almoravid and Almohad dynasties conquered much of the Iberian Peninsula. Creating a historical continuum that binds this idea of al-Andalus to contemporary times deliberately ties the country to an image of peace, tolerance, and unity. In remembering al-Andalus, the sense of a successful and long historical continuity bestows the monarchy with the legitimacy to remain in power.

The act of remembering golden times in history is related to the act of forgetting times of rupture, dissent, and division. For this reason, the monarchy and the country's elites that surround the King, the *Makhzen*, are keen on supporting and sponsoring cultural production and events that perpetuate this golden historical age in the collective imaginary. Narratives that criticize and threaten the elite's power have been met with others that promote peace, love, and unity. Particularly in times of ruptures, these narratives have resurfaced in the social and cultural fabric of Moroccan society. The aftermath of the 2003 terrorist attacks in Casablanca, the 2010–2011 popular uprisings in North Africa and the Middle East, or the Hirak Rif or Rif Movement demonstrations that started in 2016 are just a few examples of social and political ruptures experienced since Mohammed VI came to power. Cultural production acts therefore as a battlefield 'where no once-for-all victories are obtained but where there are always strategic positions to be won or lost' (Hall, 1981: 233). This chapter explores those cultural artefacts that have served to ward off the memory of struggles *remembered* in moments when the status quo is at risk. Specifically, it focuses on the adoption of narratives of coexistence by two emergent rap groups during the first crisis of King Mohammed VI's reign and their role in helping to contain and overcome this rupture.

The narrative of coexistence replicated in some rap songs at this moment of crisis serve, as I argue in the following sections, to align Morocco with messages of peace, love, and unity, and in turn to discourage actions and criticisms that could endanger the status quo. Official narratives aim to unwrite moments of rupture and thus *forget* them in the collective imaginary. The repetition of these narratives is required because new memories of struggle are also 'reset *as part of* previously forgotten ones' (Aouragh,

[2] Hispania was the term used by the Romans to refer to the Iberian Peninsula including what is today's Portugal. In 711, the Iberian Peninsula was formed of different Christian kingdoms and counties, therefore, before that date, Spain was never a united nation in the contemporary sense.

2017: 254). The repetitive character of music, therefore, plays an important role in what is remembered and what is forgotten. Through rap that chimes with the narratives of peaceful coexistence, this chapter traces how some Moroccan identities and groups such as Sufis, Imazighen, Moroccan Jews, and women are only strategically recalled when they serve to counteract oppositional discourses that threaten the rulers' power. These diverse identities (Arab and Amazigh; Sufi, Salafi, Jewish, and Christian; male and female) are segmented, opposed, forgotten, or absorbed to curb times of rupture. While these narratives may be successful in perpetuating a certain image of the country, as the last section of this chapter argues, everyday encounters of complex identities expose the shallowness of the narrative of coexistence. It is at the crossroads of everyday confrontations with official narratives that it is possible to break down coexistence and contend the importance of acts of remembering and forgetting in winning or losing strategic positions of power.

Love, Peace, and (National) Unity

Patriotic music maintains a privileged position in the musical history of North Africa and the Middle East. Because songs of love of the nation have been ubiquitous also in the Moroccan music scene, the State only became interested in Moroccan rap once rappers revisited these themes in the mid-2000s.[3] Until then, rap music was seen as a foreign genre and perceived as an attack on Moroccan identity. It is no coincidence that rap music and hip-hop culture emerged in mainstream media and became state-sponsored in an especially tumultuous year in Morocco. On 16 May 2003, twelve men strapped bombs to themselves in an attack on a five-star downtown hotel, a Spanish restaurant, and a Jewish community centre in Casablanca. Although the official discourse portrayed the attacks as violent Islamist groups aimed at religious spaces, the targets were mostly symbols of economic power. This event seriously damaged the image of the new King in his role as protector of the nation. Earlier that same year, protesters had taken to the streets to express their anger after the incarceration of fourteen metal heads accused of Satanism. In a time of crisis, with a weakened monarchy and political Islam gaining power, the State was in much need of *reminding*, especially young people, of official discourses whereby only the King could lead the country towards peace and development.

Moroccan rap albums were informally released as audiocassettes as early as the mid-1990s. At the beginning of the 2000s, things took a turn when

[3] For a detailed account on the relationship between Moroccan rap and the State, see Moreno Almeida (2017).

rap groups Fnaïre from Marrakech and H-Kayne from Meknes created songs more palatable to larger Moroccan audiences beyond rap fans. These songs, performed in Darija, refrained from using swearwords and spoke about topics that appealed to patriotic sensitivities and aesthetics. On the one hand, themes and aesthetics connected rap to traditional *ughniya wataniya* (patriotic song). On the other hand, the fact that these songs had a hip-hop flavour linked rappers with the 1970s music revolution headed by popular music groups such as Nass El Ghiwane, Jil Jilala, and Lemchaheb. These groups were icons for the following generations of artists re-inventing the Moroccan music scene, mixing genres like Gnawa music and incorporating European instruments. It was at this time that first the media and then music festivals started to engage with these young artists, interviewing them for TV and radio shows, and programming them to play on big stages all around the country.

Employing similar creative processes as Nass El Ghiwane had done decades earlier, Fnaïre and H-Kayne developed a sound fusing rap beats and Moroccan traditional music. Fnaïre labelled this new sound *taqlidi* rap (traditional rap). Together with their new sound aesthetics, these rappers released music videos imbued with Moroccan culture where their hip-hop XL clothes were combined with traditional djellabas and T-shirts with the group's name in Arabic. The themes of these songs encompassed the spirit of traditional patriotic music and popular culture resonating with younger and older generations. Two songs achieved national recognition once they were released: Fnaïre's song 'Matkich Bladi'[4] ['Don't Touch My Country', 2004] and H-Kayne's 'Issawa Style'[5] (2006). The notoriety reached by both songs, equally popular among audiences and music festivals, was mainly channelled by mainstream media and CDs as internet penetration was limited at that time. These songs turned out to be beneficial for State narratives because they proved to those conservative groups concerned with the interference of foreign culture that rap could be adapted and reshaped to the Moroccan context. Especially after the metal heads affair and the 2003 attacks, supporting this rap subgenre served the State to present itself as an ally to young people while preserving traditional culture.

'Matkich Bladi' is a response to the 2003 Casablanca attacks. In their lyrics, Fnaïre reproduce official sources that presented the event as a result of a plan plotted by violent young Islamists. In telling the perpetrators, 'don't touch

[4] Available at: http://www.youtube.com/watch?v=F0tKoJ_3GtE (consulted on 2 July 2019).

[5] Available at: http://www.youtube.com/watch?v=8TRhCRUvjR0 (consulted on 2 July 2019).

Sounds of Coexistence in Moroccan Rap Music 165

my country', the rappers paint a peaceful nation only disrupted by acts of terrorism:

Don't touch my country	*wa mat9ich bladi*
it's my land and my grandparents' land	*ardi w ard jdadi*
it's my land and my grandchildren's land	*ardi w ard 7fabi*
and the one who messes with my country	*wli nheb f bladi*
I will take him by force, and I shout	*nrfdou bchda w nadi*
Don't you touch my country	*mat9isouch bladi*[6]

Fnaïre introduce the idea of peaceful coexistence in another line: '*3chna kif lkhout nssara msslmie yhoud, likrhna f bladna mndoub*'.[7] The message of love, peace, and unity resonates with the idea of hip-hop culture and rap music exported by Afrika Bambaataa's Zulu Nation. Afrika Bambaataa, who had been a member of a New York street gang, had become a hip-hop activist adopting the motto 'Peace, Love, Unity and Having Fun'. In spite of the message of unity and love in response to an event that shocked the country to its core, this line remembers religious coexistence as a form of brotherhood, a concept that will be developed later in this chapter. The success of this song underpinned Fnaïre's career; they devoted many of their subsequent songs to patriotic themes and traditional sounds. From then onwards, the song has become an anthem against violent acts against civilians in the country.

H-Kayne's song 'Issawa Style' has been key in asserting the Moroccanness of rap music through an upbeat tune inspired by the style and sounds of Meknes and the ʿIssawa music tradition. The ʿIssawa are a religious brotherhood connected to Sufi orders originally from Meknes, as is H-Kayne.[8] For this mystic order, performances of music and dance are an essential part of their ceremonies. The rap group created an amalgamation of hip-hop and ʿIssawi music to claim their rap as part of the Moroccan music and spiritual

6 For text transcribed from Darija, I follow the alphanumeric Latinized Arabic widely used by youth in Arabic-speaking countries. In combining numbers and letters, this system facilitates the adaptation of regional specificities of the language allowing words to resemble their local sound. A difference in transcription highlights the contrast between Modern Standard Arabic and Darija, while recognizing the worth of a system created and used by Arabic-speaking youth in representing the uniqueness of their language.

7 'We lived like brothers, Christians, Muslims and Jews, we reject anyone who hates us'.

8 During the time I spent with H-Kayne as part of my fieldwork from 2011 to 2014, the group did not openly identify with this Sufi brotherhood or Sufism in general.

tradition. In other words, in devoting a song to the 'Issawa brotherhood, H-Kayne placed their Moroccan identity at the forefront of Moroccan rap music:

All Moroccans!	*lkoula mgharba*
H-Kayne brings the catchy 'Issawi rhythm	*H-Kayne britem issawi jadba*
get up, wake up, let's go crazy!	*raha nayda nouda, nhablouha nouda*
New Impact	*Nouvel Impact*
H-Kayne with an 'Issawi rhythm come back	*H-Kayne sur rhythme issawi, come back*
Don't be moody as usual, move!	*Ne boude pas comme d'hab, bouge*
rap green and red	*rap vert et rouge*

In the context of traditional sectors of Moroccan society accusing rappers of destroying Moroccan culture, this song stands as a response where H-Kayne tell young people to take agency. In the chorus, the rappers assert the Moroccanness of their rap through the colours of the flag (green and red) and connect their music to a modern (new impact) yet traditional sound ('Issawi rhythm). The song's music video reinforces this message by transforming the rappers into an animated 'Issawa music ensemble. Displaying Moroccan flags in the background, while the rappers perform on a stage wearing the brotherhood costumes, builds up an energetic atmosphere where sacredness encounters joy. In establishing an association with the 'Issawi brotherhood and aesthetic tradition, H-Kayne also capitalizes on narratives of historical continuity to create a bond with Moroccan audiences. What connects 'Issawa Style' and 'Matkich Bladi' is the interplay between tradition and modernity, and its success in emotionally tapping into the national collective imaginary as conceptualized by power. In reconstructing Morocco as an idealized continuous past, however, *taqlidi* rap chooses the folklorization of traditional culture (versus a past of rupture and dissent) to perpetuate a depoliticized present.

Depoliticizing Islam

The role of *taqlidi* rap in State discourses serves similar purposes to what Taieb Belghazi (2006) has referred to as the festivalization of Moroccan culture. Since King Mohammed VI came to power, music festivals have mushroomed across the country. Many of these big music events reproduce dominant narratives of conviviality between religions, ethnicities or 'races'. The Mawazine festival, for example, offers a taste of diverse music from around the world; the Festival d'Essaouira Gnaoua Musiques du Monde

Sounds of Coexistence in Moroccan Rap Music 167

focuses on the African and Black routes; the Fez Festival of World Sacred Music highlights religious diversity and the sacred character of Morocco. In this endeavour, location is key. A festival on sacred music in Fez, the city where the founder of the Moroccan state in the eighth century Moulay Idris is buried, sends a message of peace, piety, tolerance, and coexistence (Belghazi, 2006: 102). The reason behind this message is the fact that Moulay Idris's tomb is a site of pilgrimage connected with Sufism. That a member of the royal family attends the opening concert each year associates the monarchy with the festival, thereby reinforcing its religious and political message of tolerance and historical legitimacy (Belghazi, 2006: 106).

Depicting Morocco in terms of spirituality as opposed to politics is key in understanding *taqlidi* rap's success. In spite of the historical presence of Sufism in Morocco, Sufism is politically instrumentalized because it contributes to the depoliticization of religious language (Maghraoui, 2009: 206). The State supports Sufism to curb the influence of political Islam – in particular the Justice and Charity association (al-'Adl wa-l-Iḥasān) and Salafi groups.[9] Salafism is an Islamic reform movement inspired by the thinkers Jamal al Afghani and Muhammad Abduh who introduced the Salafi message of Islamic modernism and anticolonialism to North African students, including Allal El Fassi, leader of the Moroccan nationalist movement after World War I (Howe, 2005: 67; Tozy, 2009: 75; Joffé, 2011: 120). Although Salafism is sometimes described as a radical and violent jihadi movement (see, for example, Daadaoui, 2011: 79), this trend only depicts some sections within Salafism that are normally referred to as *al-Salafiyya al-Jihādiyya* or Salafi-jihadists. Salafist intellectuals condemn views of Islam established by *zawiyas* or Sufi lodges, *'ulema'* and mystics (Rachik, 2009: 350; Daadaoui, 2011: 82). The opposition of these groups to Sufism became evident in the decline in the number of visitors to the Sufi brotherhoods caused by the advance of Salafism (Addi, 2009: 339; Aboullouz, 2011: 174). The appointment in 2002 of Ahmed Toufiq as Moroccan minister of Islamic affairs was an attempt to counter Salafism, as he is Sufi and substituted Abdelkebir Alaoui Mdaghri, a figure considered to be close to the Salafis (Maghraoui, 2009: 206–7). Justice and Charity as well as Salafist groups have gained followers especially in poor areas due to their criticisms of class inequalities, *hogra* (the sense of humiliation or contempt as a source of anger that defines the relationship between ordinary people and the ruling elites), and the monarchy's legitimacy becoming an important threat to the King and State (Cavatorta, 2006: 213, 217; Storm, 2007: 110; Addi, 2009: 341; Daadaoui, 2011: 109).

[9] See Mohamed Tozy (2009) and Abdelhakim Aboullouz (2011) for an account of Salafism in Morocco.

168 *Jewish-Muslim Interactions*

The efficacy of a folklorization of Islam through the music and dance of particular orders is not unique to Morocco. Sufism as a depoliticized form of Islam is also preferred by the French government as it has been used to limit political demands of the Muslim community and is better suited to the policy of *laïcité*. French support of Sufism as the form of Islam that transmits the message of love and tolerance is evident in the sponsorship of cultural production. One example is the film *Monsieur Ibrahim et les Fleurs du Coran* ['Monsieur Ibrahim and the Flowers of Qur'an'] (2003), based on the eponymous book by Eric-Emmanuel Schmitt (2001). Here we encounter the story of friendship between a Jewish boy and a Muslim shop owner in a popular neighbourhood in Paris. The Muslim character, played by Egyptian actor Omar Sharif, belongs to a Sufi order, allowing the film to engage with the beautiful aesthetics of Islamic mysticism. The film emphasizes spirituality and artistic performances characteristic of many Sufi groups like meditation and dances, neglecting the struggle of many Muslims in France to gain political voice and visibility. Another example is the French State promotion of Sufi rapper Abd Al Malik, while neglecting his contemporary Médine. While Médine and other rappers critical of French politics and marginalization are ignored by mainstream media, Abd Al Malik receives official recognition from the French Ministry of Culture because of his positive message, which is non-threatening to the status quo (Aidi, 2011: 35–36; Puig, 2018: 133–34). Abd Al Malik's persona is constructed as a Sufi rapper, as evidenced in the English translation of his autobiography *Sufi Rapper: The Spiritual Journey of Abd al Malik* (original French title: *Qu'Allah bénisse la France*), more interested in narrating his spiritual life than reading the Qur'an (Puig, 2018: 137). The fact that preferred representations of 'good' Muslims in these cases are not of Arab or North African origin (Abd al Malik's background is Congolese and Monsieur Ibrahim is Turkish) does not seem to be coincidental. Sufi messages of love and peace contrast with the struggle against poverty and marginalization of groups that adhere to more overtly political forms of Islam.

Remembering the Foundational Myth

Besides political Islam, *taqlidi* rap has contributed to depoliticize other important social movements that seek to challenge the dominant Arabo-Muslim identity of Morocco. In 2008, the by then well-known rap group Fnaïre released the single 'Attarikh' ['The History'],[10] a song that draws on Andalusi music to narrate Morocco's foundational myth to commemorate twelve centuries of

[10] Available at: https://www.youtube.com/watch?v=nSdRcfEl0jk (consulted on 3 July 2019).

Moroccan history. The Andalusi music tradition is practised throughout North Africa, particularly in urban centres (Shannon, 2007; Langlois, 2009: 208).[11] Usually synonymous with its stylistic elements *al-āla* or *nūbat al-āla* (turn-taking of instruments), it received its contemporary name during the colonial era (Shannon, 2007: 321). This music embodies the nostalgia of al-Andalus that has played an important role in the formation of Morocco's national identity documented in the colonial and postcolonial eras (Shannon, 2015: 90).[12] It is particularly connected to Muslim religious festivities like Eid al Adha and Eid al Fitr and other types of ceremonies, even if both Muslim and Jewish communities have formed Andalusi ensembles,[13] which, as Langlois argues (2017: 168), complicates the nationalistic appropriation of the genre. Although it is said that its consumption is mostly marginal and relegated to a passive position by the majority of the population, the emergence of contemporary media like TV, radio, and digital media, as well as specialized festivals like the Fez Festival of World Sacred Music, means that Andalusi music is currently present well beyond its traditional centres of Chefchaouen, Fez, Oujda, Rabat, and Tetouan.

As patrons of the arts, the Moroccan upper classes have contributed to the promotion of Andalusi music to the detriment of other popular genres like Gnawa (Langlois, 2009: 213). This music became emblematic of a 'new national identity, providing a model of "high culture" to rival (or perhaps supplant) that of Europeans, authenticated by an unbroken historical tradition' (Langlois, 2009: 213–14). In other words, Andalusi music has been particularly important for the nationalist urban elites that recreated with this new name (from *al-āla* or *nūbat al-āla* to Andalusi) the linear narrative of a glorious past engaging with the nationalist urge during the struggle for independence to evoke the image of an ideal pre-colonial and unbroken history (Shannon, 2007: 321; Langlois, 2009: 213–14). In support of this historical continuity, the lyrics of 'Attarikh' establish the foundation of the nation with the first Arab-Muslim dynasty, the Idrisids, up until the current ruling Alawites (instead of challenging these narratives and claiming Morocco's longer history through the indigenous Amazigh and

[11] Although Andalusi music is mainly found in North Africa, it is also performed in contemporary Syria (see Shannon, 2015).

[12] Tony Langlois (2017) suggests a similar narrative when discussing Andalusi music in Algeria.

[13] An example is the experience recounted by renowned Arabo-Andalusi singer Abderrahim Souiri. Growing up in the Jewish neighbourhood of Essaouira, his father, an imam known for his powerful voice, joined their Jewish neighbours as part of their Andalusi ensemble.

170 *Jewish-Muslim Interactions*

Jewish presence in the region). Fnaïre's version of the foundational myth, however, includes an important variant to dominant Arabo-Muslim historical accounts. While Moulay Idris, as previously mentioned, is usually recognized as the founder of Morocco (Sater, 2010; Combs-Schilling, 1999), in 'Attarikh', Fnaïre sets the start of Morocco's national history with Idris II (802–28), the son of Moulay Idris. The reason is that Idris II was the first monarch to be born in Moroccan territory near the city of Meknes. Therefore, for Fnaïre, it is Idris II who best represents contemporary Moroccan identity because, as they claim in their lyrics, he was born from the marriage of an Arab man to an Amazigh woman. In this line, Fnaïre diverts from nationalist discourses that built postcolonial Moroccan identity as Arab and Muslim confirming the internalization of Amazighity as part of Moroccan identity.[14]

Amazigh culture had been favoured by the French colonial authorities in their attempt to divide and rule (Elkouche, 2013: 11). They established the Laboratoire de Musique Marocaine for musicological research. The main interest of the centre was to focus on Amazigh musical tradition, all the while disregarding the Arab music that was popular among the Moroccan ruling class at the time (Baldassarre, 2003: 80–81). The response of the Moroccan nationalist movement and its first government after independence in 1956 was the policy of educational Arabization and the Arabo-Islamic cultural campaign (Boutieri, 2012). As a result, Imazighen and those identities that did not fit the new postcolonial agenda were obliterated. In spite of this, the power of the Amazigh movement has forced changes in official attitudes towards Amazighity as reflected in 'Attarikh'.

Beyond a purely political urge and as previously argued with Sufism, the State's promotion of Amazigh culture has served to depoliticize and curb this strong political movement. This is important because in disputing the dominant Arabo-Islamic identity as unifier of the nation, the Amazigh movement also challenges the legitimacy of the King that mostly derives from his connection to Islam (Jay, 2016: 76), that is, belonging to the prophetic lineage (*sharafa*), holding the *baraka* (divine blessing), and being the *'amir al-mu'minin* (commander of the faithful). In the process of handling the demands of the Amazigh movement, its culture has been folklorized (Zanifi, 2019), becoming a commercial trademark where 'everything "Berber" is promoted by the government as a sort of living museum in an attempt to

[14] I employ the term Amazighity or Amazighness to broadly refer to identity traits of the Amazigh (pl. Imazighen) identity including the group's language, customs, and culture, and to Tamazigh as the languages spoken within the diverse Amazigh cultures, acknowledging the particularities and differences of the various Amazigh identities within Morocco (Elkouche, 2013: 5).

attract more and more tourists' (Errihani, 2016: 749). In this sense, we can argue that while the use of Andalusi music and the presence of Imazighen in Fnaïre's song may suggest the State finally welcoming Amazigh identity, this song and the group's body of work is void of any significant engagement with other ethnic or religious identities associated with the myth of al-Andalus or Moroccan history. That is to say that, in spite of superficial acknowledgements of Morocco's diversity, Fnaïre, for example, does not have songs in any Amazigh language or engage with Amazigh historical accounts. Furthermore, in a song devoted to Morocco's history it is surprising that the historical relationship between Imazighen and Jews is forgotten. Even if we should not romanticize the idea of coexistence between the three Aramaic religions or suggest hatred among them for that matter, Ben-Layashi and Maddy-Weitzman (2010: 90–91) argue that many Imazighen converted to Judaism and capitalize on this narrative nowadays. It is no coincidence that these communities, Imazighen and Moroccan Jews, were written out during and after the construction of Moroccan national identity in the struggle for independence (Ben-Layashi and Maddy-Weitzman, 2010: 96). For most Moroccans, the Jewish-Amazigh connection has been lost in the collective imaginary and left out of Moroccan identity. This is evidenced in the fact that contemporary youth popular cultural production such as *taqlidi* rap music has neglected the longstanding Moroccan Jewish community in their songs about the nation.

The Brotherhood

In spite of the songs here mentioned, narratives of tolerance, religious moderation, and coexistence have not played a significant role in contemporary youth popular music. In the everyday lives of most Moroccans, there is a lack of encounters between the Muslim majority and a small Jewish community. The population of Morocco is 99 per cent Muslim, 1 per cent Christian, and the 2010 estimate was of only 6,000 Jews[15] (much less, about 2,150, in 2018 according to other sources).[16] Therefore, religious diversity is barely experienced in Morocco in everyday life, with less than 2 per cent of the country being non-Muslim. This is revealed in data collected by the Pew Research Center on interfaith relations whereby 98 per cent of Moroccan Muslims interviewed asserted that most of their close friends are Muslims

[15] The World Factbook. 'Africa: Morocco'. 2010. Available at: https://www.cia.gov/library/publications/the-world-factbook/geos/mo.html (consulted on 3 July 2019).

[16] Berman Jewish DataBank. 'World Jewish Populations, 2018'. 2018. Available at: https://www.jewishdatabank.org/content/upload/bjdb/2018-World_Jewish_Population_(AJYB,_DellaPergola)_DB_Final.pdf (consulted on 3 July 2019).

172 *Jewish-Muslim Interactions*

too, and only 9 per cent admitted to knowing something about Christians.[17] Further, it is evident that official narratives of religious diversity are cosmetic as the State is not formally diverse. Article 3 of the Constitution clearly states that Morocco is a Muslim country: 'L'Islam est la religion de l'État, qui garantit à tous le libre exercice des cultes'.[18] Even if the State claims to guarantee the free exercise of religious practices, it does not in reality recognize freedom of conscience and religion (Madani, Maghraoui, and Zerhouni, 2012: 19). In the music field, the Jewish community is visible through André Azoulay, the supervisor of the Festival d'Essaouira Gnaoua Musiques du Monde as well as a close friend of the King and royal adviser. His position in the Festival d'Essaouira embodies the spirit of coexistence, as he declared that music festivals in Morocco are meant to support religious diversity (Boum, 2012: 25). As part of the country's elite, however, Azoulay does not account for the supposed diversity experienced by 'ordinary' Moroccans in their everyday lives.

In the five years I lived in Morocco (2011–16), researching its rap music and its hip-hop scene, I encountered many cultural stakeholders, yet dominant profiles were all very similar in terms of religiosity and gender. I only came across one Moroccan rapper of Jewish descent, known by the stage name of Hoofer. He stood out from the rest of Moroccan rappers I encountered when someone introduced him to me as David (and not his stage name), a rather uncommon name for a young Muslim Moroccan. I met Hoofer in Casablanca in 2011. At the time, he was a member of the now extinct group Ghost Project together with Moroccan (and Muslim) rapper M-Doc. Although I have known him for many years, we only spoke about his Jewish background when I was working on this chapter, as this topic never came up before. Hoofer was born in Medina Qadima, the old medina of Casablanca. He was adopted by a Jewish-Muslim family originally from Turkey and grew up in the upmarket neighbourhood of C.I.L. As he told me, his adoptive mother is Turkish Jewish, and his father is Turkish-Moroccan Muslim. This religious difference was not easy and created tension between both families. He explained that while growing up in Casablanca he was never identified by his friends as being Jewish but noticed a change when he was older and moved to France for a while. He said that the fact of being called David and his two religions together with being Jewish in Morocco did not go unnoticed. The change in attitudes, Hoofer suggests, was linked to adulthood, as before growing up

[17] Available at: http://www.pewforum.org/2013/04/30/the-worlds-muslims-religion-politics-society-interfaith-relations/ (consulted on 3 July 2019).

[18] 'Islam is the religion of the State that guarantees everyone freedom of religion'. Available at: http://www.maroc.ma/en/system/files/documents_page/bo_5964bis_fr_3.pdf (consulted on 3 July 2019).

Sounds of Coexistence in Moroccan Rap Music 173

no one asked him about his origins or his religion. As an adult, it seemed that he was forced to choose between being Muslim or being Jewish: 'C'était comme s'il fallait choisir'.[19]

After returning to Morocco, Hoofer started his career as a rapper in 2002. At the time, other rappers were also rapping in French and English although this practice was soon abandoned in favour of rapping in Darija. Darija is intimately associated with contemporary culture, being described by the Moroccan French-language magazine *TelQuel* (Benchemsi, 2006) as simply Moroccan. Even if the majority of words in Darija come from Arabic, it also contains words from diverse origins, including Tamazigh, French, and Spanish, all of them comprising a common language with its own variants. Darija is also associated with the everyday, vulgarity, and youth, conferring it the necessary aura of authenticity for rappers to use it as a mode of self-expression. While most Moroccan rappers had switched to Darija with the notable exception of one of the members of H-Kayne, the fact that Hoofer rapped in French despite his command of Darija, along with his name, conferred him a foreign demeanour. It may be argued that rapping in French opens other music scenes beyond Morocco for these rappers. French, however, being the language of the urban elites, creates a division between who is considered a Moroccan rapper and who is not. In other words, Darija plays a powerfully symbolic role in constructing Moroccan rap by associating itself with the everyday and the unprivileged majority. When Hoofer decided to rap in Darija, the number of criticisms grew, although he did not explain clearly the reasons for this. From our conversation it became evident that it was an issue related to the construction of Moroccan identity. His background as Turkish, his name David, and his rather rare Jewish-Muslim identity is far from the typical Arabo-Amazigh-Muslim young man from a popular neighbourhood. By employing Darija in his songs, Hoofer was perceived as an intruder in spite of being born and raised in Morocco.

In 2005, his group Bizz2Risk released the single 'Casa'[20] in collaboration with the group V-Mic. The song includes verses in Darija, French, and English, and became one of the hit songs captivating audiences and journalists alike. With notoriety came the questions regarding his name and past from radio hosts and other rappers:

> Un jour j'ai fait une émission radio à ASWAT, il y a longtemps, et quand je suis arrivé là-bas j'ai dit « Je m'appelle Hoofer », tu vois, et il me disait

[19] Interview with author, 9 November 2018: 'It was as if I had to choose'.
[20] Available at: https://www.youtube.com/watch?v=bNJhJOKqM8Y (consulted on 2 September 2019).

174 *Jewish-Muslim Interactions*

« David » dans l'émission radio. Après je lui dit « Arrête de me dire David, je m'appelle Hoofer – tu vois – Snoop Doggy Dogg tu connais pas son prénom – tu vois – donc, dit moi Hoofer ». Il m'a dit « Ok ». Et on venait de sortir un album, et la première question qu'il m'a posée, il m'a dit « Ah, je sais que tu es musulman et que tu es juif au même temps, c'est quoi ta religion aujourd'hui? ». La première question qu'il m'as posée! Moi je lui ai dit « Excuse-moi mais je suis venu pour faire la promotion d'un album, je suis pas venu pour parler de ma religion, c'est personnel ».[21]

Hoofer told me how uncomfortable these questions made him feel because he considers religion as something intimate. Hoofer's perceptions are supported by the fact that in-depth discussion of diverse religious beliefs is not a common topic in Moroccan rap or a subject matter of any interview that I have ever heard or read in Moroccan media concerning rap music. The lack of everyday encounters with non-Muslim rappers, or members of the Jewish community for that matter, justifies the curiosity of journalists and other rappers in hearing Hoofer's story. However, in enquiring about his religious background, Hoofer implicitly felt that his Moroccanness was being questioned, and his artistry overlooked in favour of his religious singularity. In the same way that Chong J. Bretillon (2018: 161) argues that Muslim Frenchness and French Muslimness are paradoxical categories, we can argue that Hoofer's experience reveals a paradox of Jewish Moroccanness or Moroccan Jewishness, at least in everyday encounters.

In spite of his multi-ethnicity (as he refers to his Moroccan-Turkish background and double religion), Hoofer identifies first and foremost as Moroccan: 'Alors que moi je me sens marocain, a 400%' ['I feel 400% Moroccan']. He is part of an overwhelming majority of Muslim Moroccan rappers who have dominated the narrative of Moroccanness in the national rap scene. As evidenced in previous sections of this chapter, *taqlidi* rap and other rap songs, especially during the 2000s, included significant references to national identity consistently depicted as a *brotherhood*. In 'Matqich Bladi', Fnaïre speaks of living like brothers: '*3chna kife lkhoute*' ['We live

[21] Interview with the author, 9 November 2018: 'One day I did a show on a radio station called ASWAT, a long time ago now. When I arrived, I said, "I'm Hoofer," you see, and he said to me, "David" during the show. I told him, "Stop calling me David, my name is Hoofer – you see – you don't know the name of Snoop Doggy Dogg – you see – so call me Hoofer." He said, "OK." We just released the album and the first question that he asked was, "Ah, I know you are Muslim and that you are Jewish at the same time, what is your religion now?" The first question he asked me! I said to him, "Excuse me but I came here to promote my album, I didn't come here to talk about my religion, that's a private matter"'.

like brothers']. In the song 'Yed el Henna'[22] ['The Hand of Henna', 2007], Fnaïre sings only addressing men: *'Semmi semmi khouya l3ziz noud tnammi'* ['Listen, listen dear brother, stand up to develop']. In 'Sma3ni'[23] ['Listen to Me', 2007], a song performed by rappers H-Kayne together with Don Bigg, the brotherhood is again recalled:

I want to say Moroccans are brothers	*bghit ngoul mgharba khout*
and they got together to open doors	*w 7bab tta7do 7ollo l bwabl*
hand in hand we can change and communicate	*yed f l yed nghayro nwasselo*

Don Bigg adds:

Moroccans, we are all brothers	*kolna khout lmgharba*
your brother is Moroccan in his heart	*khoukom f l galb maghribi*

H-Kayne have built their lyrics upon this notion of brotherhood since their first hit 'Issawa Style' (2006) where the phrase *'khouk ana'* ['I'm your brother'] is repeated in several lines. In a later single called 'Safi, Tfe Dow' ['Enough, Put the Lights Out', 2014],[24] they again relate the phrase *'khouk ana'* to the nation and its long continuous history: *'bladi bladna'* ['my country is our country']; *'bladi ard jdadi'* ['my country is the country of my grandparents']; *'mgharba dima mgharba'* ['Moroccans are always Moroccans'].

Finally, these songs delve into narratives of Moroccanness without any mention of religious identity but clearly illustrating a masculine nation. As rappers Don Bigg and those from H-Kayne focus on the role of men in talking about *khout* (brothers) they *forget* the role of women in the Moroccan national consciousness. This patriarchal narrative is not exclusive to these rappers. In the same speech quoted at the beginning of this chapter, the King claims,

إن جميع المغاربة بالنسبة إلينا اخوة من رحم واحد وأبناء بررة متساوون تشدهم إلينا روابط التعلق والولاء[25]

[22] Available at: http://www.youtube.com/watch?v=b5WkB9ZW8kE (consulted on 3 July 2019).

[23] Available at: http://www.youtube.com/watch?v=4J9X-cMJSbk (consulted on 3 July 2019).

[24] Available at: https://www.youtube.com/watch?v=PSp5DrDb7VA (consulted on 3 July 2019).

[25] 'For us, all Moroccans are brothers, from one womb and equal righteous sons to whom we are bound by bonds of attachment and allegiance'. Mohammed VI Throne Day Speech 1999. Available at: http://www.maroc.ma/ar/صاحب-الجلالة-الملك-محمد-السادس-يوجه-خطاب-العرش/خطابات-ملكية (consulted on 26 June 2019).

176 *Jewish-Muslim Interactions*

In the King's speech, the female body is reduced to a womb, one that only creates brothers and sons. The rap songs quoted above exhibit a similar gender-biased understanding of who belongs to the nation. In the use of such language, the State and these rappers exclude women from the collective memory and forget that women are a significant part of their audiences. These songs are therefore accomplices in creating a Moroccan *brotherhood* that, while creating an image of peaceful coexistence, effectively relegates non-hegemonic identities to the shadows.

Conclusion

The narrative of coexistence remains part of official discourses because it presents an image of Morocco that grants the monarchy legitimacy. The lexicon of love, peace, unity, development, tolerance, and historical continuity is embedded in cultural production that aesthetically and lyrically represents a depoliticized and folklorized image of the country. The fact that some rappers capitalized on these narratives after 2003 meant that rap started to be accepted by mainstream media and state-sponsored events. At the same time, however, these songs that side with dominant depictions of the country have reinforced power to the detriment of critical voices, minority groups, or non-hegemonic identities. Islamist groups critical of the King, Amazigh groups demanding recognition and visibility, Moroccan Jews, and even women struggling for their rights have been curbed, absorbed, forgotten, and ignored in favour of one hegemonic Moroccanness (Arab, Muslim, and male). Furthermore, Moroccanness in rap is defined by two connected traits: language (Darija) and social status (unprivileged).

In times of rupture, the Arabo-Muslim dominant identity and narratives of coexistence are recalled to support the State against threats to the status quo. Moroccan Jewish communities are encapsulated within the golden era of Morocco, but forgotten in accounts of contemporary national identity. Even if historically the monarchy has included the Jewish community as part of its political agenda to portray Morocco as a peaceful and moderate country, everyday lives remain distanced from the small number of Moroccan Jews that live in the country at the present moment. Equally significant is the damage that migration of Moroccan Jews to Israel in the 1960s and the Israeli occupation of Palestinians has done to Muslim-Jewish everyday relationships and perceptions of Moroccan Jews in the country. On top of that, a difference in class, particularly in urban centres like Casablanca, has further widened the bridge between Muslim Moroccans and their Jewish compatriots, who mostly inhabit wealthy urban neighbourhoods, curtailing everyday encounters with the rest of the city.

Sounds of Coexistence in Moroccan Rap Music

Rap songs have served to remind audiences of and reinforce dominant narratives engrained in the cultural fabric of Morocco's collective imaginary. Traditional sounds mixed with hip-hop beats have contributed to the folklorization of Islam by promoting Sufism as a depoliticized form of Islam and transforming the Amazigh political movement into a trademark to attract more tourists. In-depth critical reading of hip-hop cultural expressions unveils how *taqlidi* rap songs help to suppress narratives that challenge historical continuity or Morocco as a country of love and peace. These rappers, however, do not need to remind their audience of their Muslimness because of the overwhelming majority of Muslims in the country. In these songs, non-dominant groups become absorbed into the Arabo-Muslim male identity and forgotten within the lexicon of unity and brotherhood. Before finishing my interview with rapper Hoofer, I asked him if he wanted to add anything and he insisted on feeling Moroccan. Hoofer's lack of interest in representing (to use hip-hop jargon) the Jewish community, and his request to be seen as a *Moroccan* rapper, reflects the existence of oppositional identities (Jewish versus Moroccan) in the collective imaginary in spite of the state-promoted inclusiveness. Over the years, *taqlidi* rap songs have faded out. Even if H-Kayne and Fnaïre continue to release singles with lyrics lauding the nation and sounds inspired by traditional Moroccan music, the rap scene in contemporary Morocco has drastically changed as new groups do not seem to be interested in delving into patriotic themes. In this way, *taqlidi* rap has evolved into new forms such as trap *beldi* (trap from the country), a genre introduced by rapper Issam. Trap *beldi* also revisits the past but, contrary to *taqlidi* rap, it gets its inspiration from traditional chaâbi and raï sounds both musically and visually. New groups, new trends, and the penetration of social media are now shaping the extremely diverse ecosystem of Moroccan hip-hop culture. How rap songs will *remember* the nation in future times of rupture remains to be determined.

Works Cited

Aboullouz, Abdelhakim. 2011. 'Salafism in Morocco: Religious Radicalism and Political Conformism'. In George Joffé (ed.), *Islamist Radicalisation in North Africa: Politics and Process*. London and New York: Routledge: 160–78.

Addi, Lahouari. 2009. 'Islam Re-Observed: Sanctity, Salafism, and Islamism'. *The Journal of North African Studies* 14: 331–45.

Aidi, Hishaam. 2011. 'The Grand (Hip-Hop) Chessboard: Race, Rap and Raison d'État'. *Middle East Report* 260: 25–39.

Aouragh, Miriyam. 2017. 'L-Makhzan Al-'Akbari: Resistance, Remembrance and Remediation in Morocco'. *Middle East Critique* 26: 241–63.

Baldassarre, Antonio. 2003. 'Moroccan World Beat through the Media'. In Goffredo Plastino (ed.), *Mediterranean Mosaïc: Popular Music and Global Sounds*. London and New York: Routledge: 79–100.

Belghazi, Taieb. 2006. 'Festivalization of Urban Space in Morocco'. *Critique: Critical Middle Eastern Studies* 15: 97–107.

Benchemsi, Ahmed. 2006. 'Wa derrej a khouya!' *Telquel* 230.

Ben-Layashi, Samir, and Bruce Maddy-Weitzman. 2010. 'Myth, History and Realpolitik: Morocco and Its Jewish Community'. *Journal of Modern Jewish Studies* 9: 89–106.

Boum, Aomar. 2012. 'Festivalizing Dissent in Morocco'. *Middle East Report* 263: 22–25.

Boutieri, Charis. 2012. 'In Two Speeds (À Deux Vitesses): Linguistic Pluralism and Educational Anxiety in Contemporary Morocco'. *International Journal of Middle East Studies* 44: 443–64.

Bretillon, Chong J. 2018. '"Double Discours": Critiques of Racism and Islamophobia in French Rap'. In Kathryn Kleppinger and Laura Reeck (eds.), *Post-Migratory Cultures in Postcolonial France*. Liverpool: Liverpool University Press: 147–65.

Cavatorta, Francesco. 2006. 'Civil Society, Islamism and Democratisation: The Case of Morocco'. *Journal of Modern African Studies* 44: 203–22.

Combs-Schilling, M. Elaine. 1999. 'Performing Monarchy, Staging the Nation'. In Rahma Bourqia and M. Elaine Combs-Shilling (eds.), *In the Shadow of the Sultan: Culture, Power and Politics in Morocco*. Cambridge, MA: Harvard University Press: 176–214.

Daadaoui, Mohamed. 2011. *Moroccan Monarchy and the Islamist Challenge: Maintaining Makhzen Power*. New York: Palgrave Macmillan.

Dashefsky, Arnold, Segio Della Pergola, and Ira Sheskin. 2018. *World Jewish Population*, 23. Berman Jewish DataBank: 1–66.

Elkouche, Mohamed. 2013. 'The Question of the Amazigh Language and Culture in Morocco'. In Mohamed Dellal and Amar Sellam (eds.), *Moroccan Culture in the 21st Century*. Hauppauge, NY: Nova Science Publishers, Inc.: 5–38.

Errihani, Mohammed. 2016. 'Language and Social Distinction: Speaking Darija with the Right Accent'. *Journal of North African Studies* 21: 741–64.

Hall, Stuart. 1981. 'Notes on Deconstructing "The Popular"'. In Raphael Samuel (ed.), *People's History and Socialist Theory*. London, Boston, MA and Henley, UK: Routledge & Kegan Paul: 227–41.

Howe, Marvine. 2005. *Morocco: The Islamist Awakening and Other Challenges*. New York: Oxford University Press.

Jay, Cleo. 2016. 'Playing the "Berber": The Performance of Amazigh Identities in Contemporary Morocco'. *The Journal of North African Studies* 21: 68–80.

Joffé, George. 2011. 'Trajectories of Radicalisation: Algeria 1989–1999'. In George Joffé (ed.), *Islamist Radicalisation in North Africa: Politics and Process.* London and New York: Routledge: 114–37.

Langlois, Tony. 2009. 'Music and Politics in North Africa'. In Laudan Nooshin (ed.), *Music and the Play of Power in the Middle East, North Africa and Central Asia.* Farnham, Surrey: Ashgate Publishing, Ltd.: 207–27.

——. 2017. 'Music, Borders and Nationhood in Algeria'. In Patrick Crowley (ed.), *Algeria: Nation, Culture and Transnationalism: 1988–2015.* Liverpool: Liverpool University Press: 162–83.

Madani, Mohamed, Driss Maghraoui, and Saloua Zerhouni. 2012. 'The 2011 Moroccan Constitution: A Critical Analysis'. Stockholm. Available at: http://www.dustour.org/images/morroco/The_2011_moroccan_constitution_english-1.pdf (consulted on 3 September 2019).

Maghraoui, Driss. 2009. 'The Strengths and Limits of Religious Reforms in Morocco'. *Mediterranean Politics* 14: 195–211.

Moreno Almeida, Cristina. 2017. *Rap Beyond Resistance: Staging Power in Contemporary Morocco.* Cham, Switzerland: Palgrave Macmillan.

Puig, Stève. 2018. 'Redefining Frenchness through Urban Music and Literature: The Case of Rapper-Writers Abd Al Malik and Disiz'. In Kathryn Kleppinger and Laura Reeck (eds.), *Post-Migratory Cultures in Postcolonial France.* Liverpool: Liverpool University Press: 131–46.

Rachik, Hassan. 2009. 'How Religion Turns into Ideology'. *The Journal of North African Studies* 14: 347–58.

Sater, James N. 2010. *Morocco: Challenges to Tradition and Modernity.* London and New York: Routledge.

Schmitt, Eric-Emmanuel. 2001. *M. Ibrahim et Les Fleurs Du Coran.* France: Albin Michel.

Shannon, Jonathan H. 2007. 'Performing Al-Andalus, Remembering Al-Andalus: Mediterranean Soundings from Mashriq to Maghrib'. *The Journal of American Folklore* 120: 308–34.

——. 2015. *Performing Al-Andalus: Music and Nostalgia across the Mediterranean.* Bloomington and Indianapolis: Indiana University Press.

Storm, Lise. 2007. *Democratization in Morocco: The Political Elite and Struggles for Power in the Post-Independence State.* London and New York: Routledge.

Tozy, Mohamed. 2009. 'L'Évolution du champ religieux marocain au défi de la mondialisation'. *Revue Internationale de Politique Comparée* 16: 63–81.

Zanifi, Omar. (2019). 'Arab Broadcast Media in North Africa and the Middle East: The Amazigh Awakening'. 12 June. Available at: https://insidearabia.com/arab-broadcast-media-in-north-africa-and-the-middle-east-the-amazigh-awakening/?fbclid=IwAR3TXmf5oKTXHkwduBC63JWCMkyharvKgWi4YLpd0kVrH8MS7Hp-oKXQiFQ (consulted on 11 July 2019).

Unmuted Sounds: Jewish Musical Echoes in Twenty-first Century Moroccan and Israeli Soundscapes

Aomar Boum

On February 2019, I landed at Mohammed V International Airport in Casablanca after a long draining flight from Los Angeles with a short layover in Paris. I was scheduled to lead a cultural tour about Jewish history and Moroccan Judaism for a group of American Jews affiliated with the United States Holocaust Memorial Museum. As I arrived at my hotel not far from the bustling nearby coastline neighbourhood of the old medina overshadowed by the oversized tower of the Grand Mosque of Hassan II, I got a warning notice from UCLA Travel to avoid the affluent neighbourhood of La Corniche, Ain Diab, where a protest against Enrico Macias was already taking place in front of the Megarama cinema.[1]

Labelled as a pro-Israel Jewish singer and defender of the Israeli army by the Moroccan Palestinian Campaign for Academic and Cultural Boycott of Israel and the Moroccan National Working Group for Palestine, Macias, a French Jew of Algerian origin, challenged the protestors and vowed to perform in Casablanca. During the popular French television show 'Les Grandes Gueules', Macias openly stated:

> Je me fous [...] de cette menace de boycott, car je vais y aller, je le dis à tout le monde. Je vais y aller jouer au Maroc. Advienne qu'advienne [*sic*] [...] Je connais le peuple marocain [...]. Pour moi je compare le Maroc à

[1] 'BDS Maroc proteste contre le concert d'Enrico Macias'. Available at: https://www.youtube.com/watch?v=ecQqIvc3WQU (consulted on 31 October 2019).

l'Andalousie dans le temps avant l'avènement d'Isabelle la Catholique. Parce que c'est un pays de tolérance. C'est pas pour quelques individus que veulent me faire du mal comme ça que je fais changer d'avis sur la qualité, la tolérance du Maroc.[2]

In contrast to this political view, Macias continues to express feelings of nostalgia towards Algeria and a wish to return to his native town of Constantine. In Algeria and Morocco many view him as a supporter of what they see as Israeli discriminatory policies toward Palestinians, hence their call for boycotting his musical performance in Morocco and Algeria. Notwithstanding, Macias remains a vocal supporter of Israel which he regards as a final refuge from growing French antisemitism.

This incident is an example of a recent increasing wave of anti-normalization protests led by activists such as Sion Assidon against cultural events where Israelis of Moroccan and North African descent are included in the programme (Boum, 2010; Mdidech, 2016). For example, on 14 September 2017, Noam Vazana faced a similar campaign during the Tanjazz Festival in Tangiers. Born in Be'er Sheva, Israel, Vazana is a rising Ladino artist and creator of what is widely considered to be the first Ladino pop album.[3] Like many new young Israeli-Moroccan artists, Vazana has been a regular participant in musical festivals in Essaouira, Tangiers, Debdou, Agadir, Oujda, and others. Vazana has a special love for Fez and Casablanca where her parents were born and raised before they left Morocco. During her visit to Morocco, and Fez in particular, Vazana notes that she occasionally encounters sounds of Jewish songs that echo the hymns that her grandmothers sang in Ladino for her as a child. These memories of Jewish songs that she encountered in Moroccan streets have reconnected her with her family and allowed her to build new bonds with Morocco.

In the last two decades, an anti-normalization movement with regard to Israel, and therefore the North African Jews in Israel, has gained momentum

[2] 'Appel au boycott du concert d'Enrico Macias au Maroc'. Available at: https:// www.youtube.com/watch?v=Jp_gdvGWQnA (consulted on 28 October 2019). 'I do not care about this threat of boycott because I will go. I say this to everyone. I will go and perform in Morocco. Come what may [...]. I know the Moroccan people [...]. I compare Morocco to al-Andalus of the past before the ascension of Isabella I of Castile, because it is a country of tolerance. I will not let a few individuals who want to harm me change my mind about the quality and tolerance of Morocco'. All translations and transliterations from French, Darija, and Tamazight are by the author of this chapter.

[3] 'Nani-Morenika Morenica Sephardic Ladino'. Available at: https://www. youtube.com/watch?v=4aKMxd7Zk0s (consulted on 31 October 2019).

to the extent that it has called for the criminalization of Moroccan visitors to the Jewish state. This movement overlaps with a Jewish cultural revival that has been gaining ground since the early years of the new millennium (Boum, 2017). The revival of the Jewish sonic past throughout the cultural landscapes of Morocco is grounded in the Moroccan state policies that have made one of its primary economic objectives the repackaging of a Moroccan Jewish and Amazigh product for a global tourist, whether Jewish or non-Jewish (Boum, 2007; 2020). Unlike many countries in the Arab world where Jewish voices are muted and spaces are erased, Morocco and to some extent Tunisia have been able to preserve their Jewish cultural heritage, music, rituals, cemeteries, and synagogues despite anti-normalization discourse (Abadi, 2017; Boum, 2010; Maddy-Weitzman, 2011). In this context, the process of revival of Jewish sounds and cultural heritage has never presented a challenge to the state and tourism developers. Music and Jewish sounds are central to the process of revival. The musical tunes, sounds, and hymns were preserved in the national memory despite the fact that their Jewish singers left. According to a Moroccan café manager I met in Essaouira during the Festival of Andalusia, 'Jewish music has always been there; we just muted it. Today we are unmuting it because in the context of cultural festivals and interfaith meetings we need a musical Jewish background'.[4]

In this chapter, and drawing on recent historical and anthropological literature on sounds and music (Silver, 2016; Smith, 2004; Miller, 2007; Müller, 2012; Attali, 1977; Fahmy, 2013, Hirschkind, 2006; Kapchan, 2007; Kapchan, 2008; Jankowsky, 2010; LeVine, 2008), I argue that Moroccan Jewish sounds are increasingly becoming integral to the state project of Jewish cultural revival (Boum, 2007; 2012c). Festivals, movies, radio shows, cultural events, and conferences on different aspects of Moroccan Judaism have become central dimensions of the landscape of restoration of synagogues, conservation of cemeteries, and renovation of Jewish quarters (mellahs). Yet, despite the social and political challenges of the Arab-Israeli conflict, the government accommodates critical and sympathetic social debates on Jewish issues. The celebration of national indigenous Judaism is at the centre of the tourism industry even in times when the significant erstwhile Jewish community is today in perpetual demographic decline.

Between Israel and Morocco, music has been a venue through which Moroccan Jews have tried to claim their historical heritage in the context of the political and public spheres of both countries. I highlight this connection first by providing a short description of early Moroccan Jewish political and economic experience in Israel during the first years of migration. Second, I

[4] Personal communication, January 2016.

184 *Jewish-Muslim Interactions*

discuss how the disproportionate poverty and living conditions in marginal development towns and slums of Haifa and Jerusalem led to political protest of Moroccan Jews against what they perceived as a lack of concern at the hand of the Labor Party leadership and elite. I then highlight how Moroccan Jews relied on a new political affiliation with the Likud Party and how young Moroccan politicians and social leaders, especially Shaul Ben Simhon, advocated for the public display and performance of different religious, musical, and cultural aspects of Moroccan Judaism in mainstream Israeli society through the celebration of the Mimouna festival in public spaces. I argue that this attitude turned 'Moroccan identity' into a positive Israeli asset despite the lingering signs of prejudices. Finally, I note that, despite the unofficial relations between Israel and Morocco, the reproduction of these forms of cultural performance especially after the establishment of the Israeli Andalusian Orchestra in Ashdod, Israel, strengthens the Moroccanness of Israelis even in the context of the political and military violence of the Middle Eastern conflict and the continuous calls for the boycott of Moroccan Israelis.

Moroccan Jews between 'Diaspora' and 'Home'

During the twentieth century, Moroccan Jewish singers performed in public and private places in Tunis, Algiers, Oran, Casablanca, and other cities. Jewish sounds were part of the daily soundscapes that people encountered inside and outside homes, cafés, and music halls. One of the key representatives of the Andalusian musical tradition, Raymond Leyris, also known as Cheikh Raymond, was a symbol of a Jewish-Muslim culture in Algeria until his assassination on 22 June 1961 during the last stages of the Algerian War of Independence (Bensigor, 1995; Evans, 2012). A skilled *'oud* player, Cheikh Raymond epitomized the tradition of *malouf* whose origins go back to the Judeo-Arabic musical tradition of al-Andalus.[5] In January 1961, a few months before his targeted killing, rumours began to circulate that Cheikh Raymond was affiliated with the Organisation Armée Secrète (OAS), a far-right French organization with a paramilitary wing that carried out terrorist attacks against the Algerian National Liberation Front leaders and supporters to prevent Algerian independence (Dicale, 2011). Weeks after his assassination, the Jews of Constantine started to leave Algeria and never returned.

 Enrico Macias, son-in-law and disciple of Cheikh Raymond, fled Algeria with his wife Suzy, daughter of Cheikh Raymond whose body rested in the

[5] Christopher Silver. 'Music and Memory: The Life and Death of Cheikh Raymond'. 25 June 2013. Available at: http://jewishmorocco.blogspot.com/2013/06/music-and-memory-life-and-death-of.html (consulted on 31 October 2019).

new cemetery of Constantine. In Paris, he began a career that started with an album titled 'Adieu mon pays' ['Goodbye My Homeland'] mourning his exile:

> J'ai quitté mon pays
> J'ai quitté ma maison
> Ma vie, ma triste vie
> Se traîne sans raison
> J'ai quitté mon soleil
> J'ai quitté ma mer bleue
> Leurs souvenirs se réveillent
> Bien après mon adieu.[6]

Unlike Morocco where he was able to perform in 2019, Enrico Macias was denied entry into Algeria to visit his father-in-law's tomb and his home of origin. In 2007, he planned a musical tour of Algeria that the government blocked, ensuring that the soundscapes of the Disques Raymond record store remain muted. While the assassination of Cheikh Raymond in Algeria ended his personal involvement in the Algerian musical scene, Moroccan Jewish singers and artists mostly immigrated for religious, social, and political reasons to Israel where they established their indigenous musical traditions. In their new social and political environment, they were able to maintain a Moroccan Jewish sound despite political challenges and European Ashkenazi policies to tame their Moroccan culture, rituals, and music, and replace them with European styles of Jewishness.

In the newly established state of Israel, the first generations of Moroccan rural and urban immigrants faced the dilemma of choosing between the erasure of their indigenous Amazigh and Arab cultural backgrounds and the adoption of the dominant European culture. In the early 1950s, Moroccan Jewish immigrants were sent to camps located at the periphery of the state. These early development towns were established from 1952 to 1964 as transit camps called *ma'abarot* (singular *ma'abara*). By the early 1960s, the majority of the residents of Netivot and Sderot were Moroccan Jewish immigrants. Rachel Shabi describes their early immigration experience and settlement as follows:

6 For a recent performance of this song, see 'Enrico Macias & Jamel'. 2 December 2012. Available at: https://www.youtube.com/watch?v=sXoX-0BNF3M (consulted on 31 October 2019). 'I left my country / I left my home / My life, my sad life / Languishes without purpose / I left my sun / I left my blue sea / Memories of them reappear, / Long after my farewell'.

They left Morocco by boat from Casablanca to the French port of Marseilles, waited for sometimes months at an overcrowded absorption center, and then boarded another boat to the port of Haifa in the Jewish state—like the trip to France, a week-long journey. From Haifa, they were loaded on trucks, 'like cattle being taken to the market,' says one of the older residents of Sderot who made the journey. Like cattle, they were sprayed with disinfectant—something that remains a visceral memory today. The trucks were bound for Sderot and other peripheral areas, always at night and often with the assurance, once the destination was reached, that it was a small distance from the big cities like Tel Aviv and Haifa. (Shabi, 2008: 56)

For years, Moroccan Jewish communities in Israel have claimed that different informal and institutionalized modes of discrimination have reinforced structural barriers against their social acceptance and economic mobility in the wider society. In the Wadi Salib slums of Haifa, the Union of North African Immigrants called for demonstrations in 1959 in protest of the political parties and Israeli leadership marginalization of Moroccans. The riots ushered a new era of political opposition among Moroccans in Israel. On 3 March 1971, a group of youth from the slum of Musrara demonstrated in front of Jerusalem City Hall. In their twenties, they were mostly delinquent and elementary school drop-outs (De Martino, 2013). While the Jerusalem slum youngsters were mostly Moroccans, they were later joined by other protesters. Known as the Black Panthers, they demanded equal economic, political, social, and cultural rights (Bernstein, 1984). These structures reproduced cycles of poverty and despair (Ouaknine-Yekutieli and Nizri, 2016: 169).

As the 'peripheralization' of the community became the norm among the European leadership (Ouaknine-Yekutieli and Nizri, 2016), a growing Moroccan resistance movement began to push against Israel's official indoctrination and segregation. When Moroccan immigrants arrived in Israel, they were subjected to a hegemonic cultural discourse with the hope of engineering a new North African Jew through art, theatre, and cinema. Telem, a travelling theatre targeting transit camps, emerged as a space to showcase the ideal Israeli society for the new immigrant (Mamman, 2007). One of the most important cases of this cultural production is *Kasablan*, a play that highlighted the cultural and social frustrations of Moroccan immigrants in their new settlements through the experience of Kasablan, a young Moroccan Jewish immigrant. At the same time, the play maintained the traditional stereotypes of the archetypal Moroccan Jew described as 'hot-blooded, high-tempered, irrational, somewhat primitive, yet brave and loyal to his friends' (Ouaknine-Yekutieli and Nizri, 2016: 170; Urian, 2001).

Jewish Musical Echoes

In 2013, I met Haim in the coastal city of Essaouira, Morocco, during the Andalusia Festival that many Israelis of Moroccan descent attend annually. Donning a yamalke and a djellaba, Haim exhibited complex cultural signs of an Israeli cultural identity anchored in Moroccan religious, cultural, and historical roots. He spoke in Moroccan Arabic and made sure to pepper his conversation with French and sometimes Hebrew. Reflecting on his Israeli and Moroccan identity, Haim stated:

> We are torn apart between two nations: Israel and Morocco. Each country tries to claim our ownership. We belong to both. We made it clear to their leadership. Moroccans want us to sever links with our Holy Land. Israel wants us to cut all religious and cultural connections with our native home, Morocco. We refused to listen to either proposal and we maintained our peculiar ties to both places. Iraqis Jews, Egyptians Jews, Yemeni Jews, Kurdish Jews, Libyan Jews... all forgot their roots... For us Morocco was our history. Our Judaism would not exist without its Moroccan flavor [...] Labor leadership refused to acknowledge it; and therefore we refused their Israel... When the Likud and Begin welcomed our Moroccan heritage we welcomed their Israeli state and we accepted to partly accept and respect the Ashkenazi dimensions of Israel because we believed they reflected our Jewish history. We forced both Morocco and Israel to accept our strong belief that we have two homes and we will always travel between both of them.[7]

Today, the towns of Sderot, Kiryat Gat, Netivot, Beersheva, Ashdod, and Ashkelon, among others, are still largely North African Jewish settlements. Yet despite leaving Morocco, Jewish attachment to their native Moroccan culture, languages, religious customs, and traditions has prevailed. Moshe, a resident of Ashdod, described to me the cultural rejection he faced during his early years of migration: 'I felt inferior to other Jews. European Jews saw me and other Moroccans as less civilized. We were never regarded or treated as real Jews'.[8] After highlighting the difficult times he experienced in the 1960s, Moshe changed his tone to talk about what his Moroccan identity meant for him and his family in the makeshift homes of Ashdod:

> In Morocco, we were masters of our lives despite the occasional disagreement we had with our Muslim neighbors. Our *tsadiq* (holy men) protected us from harm for centuries. We were blessed so when we arrived we made

[7] Personal communication. Original Arabic notes were destroyed in a flood at UCLA, January 2020.

[8] Personal communication.

sure to hold on to our culture, religious traditions and beliefs. Some of us were ashamed of our language so they avoided speaking Arabic and Berber Moroccan dialects; others changed their names. Many refused to sing our songs or dance our *ahwash* [...] We demanded our rights. We revolted against the corrupt and racist leadership of the Labor [Party]. We finally felt free especially when our mothers felt proud to sing our Amazigh.[9]

This vignette like many others reflects the perception of suppression of Moroccan cultural identity since the establishment of Israel. Ben-Gurion saw Moroccan Jews as Arabs, traditionally religious and backward. By the 1960s, Moroccan Jews symbolized the 'social and cultural "illnesses" of Oriental Jewry as a whole [...] [They] were frequently the objects of the most racist kinds of disparagement from the Israeli European elite, often because of their tenacity to hold on to their own "Arab-influenced" customs and traditional religious heritage' (Zohar, 2005: 305). In the aftermath of violent uprisings in the 1970s, the Israeli Black Panthers was born out of the Musrara uprisings generating media attention in the United States and Israel. Led largely by Saadia Marciano and Charlie Biton, they partnered with 'members of a radical New Left group known as Matzpen (Compass)' (Frankel, 2008: 11). The then Prime Minister Golda Meir acknowledged the economic divide in her address to the Knesset while critiquing the choice of the name 'Black Panthers'. At the same time, she blamed the situation of Moroccan and other Oriental Jews on their native background and refused to link it with early Israeli policies. She noted:

Many immigrants from the Islamic countries brought deprivation and discrimination with them in their baggage from their countries of origin [...] It was their fate to live in countries that have not yet developed intellectually, industrially, and culturally. (Meir cited in Zohar, 2005: 312)

Mas'oud, a Moroccan-born Israeli teacher, noted that Meir's attitude and the Labor Party's patronizing stance towards Moroccans convinced many Moroccan Jews that the only way to change their economic and social situation was to seek a new political alliance. In 1977, their solution was to vote for the right-wing Likud Party under Menachem Begin. For Mas'oud, 'the Likud acknowledged us as human and real Jews not different from our Ashkenazi brothers and sisters. We felt respected and accepted for the first time'.[10] By the late 1970s, many Moroccan Jews felt empowered, and for the first time they could listen to their songs and pray for their saints in Israel.

[9] Personal communication.
[10] Personal communication.

Jewish Musical Echoes

Mas'oud observed how the state 'recognition of their musical traditions and rituals led many to feel they have a space'.[11] Unlike Iraqi Jews who protested Israeli policies in the early 1950s and were able to achieve significant rights, Moroccan Jews did not emerge as a political force until the late 1970s after the riots of Wadi Salib in Haifa in 1959 and the rise of the Black Panthers in 1970.

Jewish Sounds in a Moroccan Radio Programme

Throughout the twentieth century, radios in Morocco broadcast Moroccan Jewish singers. By the late 1950s, these artists began to migrate to Europe, Israel, and Canada. Moroccan society consequently became less exposed to Jewish singers and, by the 1980s, the younger generation knew little or nothing about the rich Jewish musical culture. After a wave of films and documentaries largely about Jewish migration (Kosansky and Boum, 2012; Stillman and Boum, 2016), the recent launching of a radio programme branded 'Nass El Mellah' by RadioMed, moderated by Zhor Rehihl, the curator of the Jewish museum of Casablanca, is regarded as an attempt to rekindle the memories of Jewish life and Jewish-Muslim relations through the personal stories of Moroccan Jews and occasionally Moroccan Muslims. The programme began in November 2018 as a weekly radio show where Rehihl interviews Moroccan Jews in their homes, synagogues, offices, or in the RadioMed studio in Casablanca. For Rehihl, 'Moroccan Muslims are usually surprised when they listen to our radio programme and hear Jews speaking Arabic like them'.[12] 'Nass El Mellah' has managed in a short period of time to reach a large audience of Moroccan Muslims who appreciate the stories of Moroccan Jews that they hear on a weekly basis in Moroccan Arabic dialect, locally known as Darija. This sonic Moroccan Jewish landscape through the radio programme that Rehihil managed to set up potentially enlarges Moroccan understanding of its Jewish heritage despite the anti-normalization discourse.

Trained in anthropology and journalism, Rehihl spent many years working with Simon Levy on the conservation of Jewish material heritage and the preservation of synagogues in rural and urban Morocco. By the late 1990s, they opened the first Jewish museum in Casablanca and since then she has served as its curator (Boum, 2010; 2013). While the Jewish Museum of Casablanca was able to break the dominating silence around Jewish heritage and presence in Morocco, 'Nass El Mellah' allowed Rehihl to expand the educational project of the museum to the airwaves and soundscapes, giving Moroccan Jews the 'opportunity to explain their Moroccan traditions and rituals to their Muslim

[11] Personal communication.
[12] Personal communication.

190 *Jewish-Muslim Interactions*

neighbors [...] to explain to them in Arabic the meanings of Passover, Rosh ha-Shana, Kippur, Sukkot, Hanukkah, Hiloula and others'.[13] In Morocco, these discourses of Jewish revival and celebration, and anti-normalization as well as anti-Zionism, have traditionally taken place going back to the early years of independence. In fact, many Moroccan Jews were central players in the anti-Zionist movement, including Simon Levy and Edmond Amran El Maleh. Yet, unlike Algeria and Egypt, this anti-normalization movement did not suppress Jewish life, as the Moroccan Makhzan maintained a favourable approach to its Jewish diaspora's return to visit their ancestral homes and neighbourhoods and celebrate their saints throughout the country.

Claiming Back Moroccan Sounds

Born into a Moroccan family in Algeria in 1942, Erez Biton became one of the critical voices of the early official erasure and silencing of Moroccan and North African heritage. Inspired by the Black Panthers movement, Biton used his poetry to shed light on the struggles of North Africans in the new homeland. Blending Moroccan Arabic and Hebrew, and combining liturgical Hebrew poetry with his own family memories, Biton, a blind poet and the 2015 recipient of the Israel Prize for Hebrew Literature and Poetry, managed to challenge Israel to open its cultural, educational, and political public spheres to Moroccans (*marokait*). In his poem 'Shir Zohra Al-Fasiya' ['Zohra Al-Fasiya's Song'], he uses the story of one of the most famous singers of Morocco to highlight the tragedy of displacement of North African Jews. Biton writes:

זַמֶּרֶת הֶחָצֵר אֵצֶל מֶחַמַד הַחֲמִישִׁי בְּרַבָּת בְּמָרוֹק.
אוֹמְרִים עָלֶיהָ שֶׁכַּאֲשֶׁר שָׁרָה
לָחֲמוּ חַיָּלִים בְּסַכִּינִים

לְפַלֵּס דֶּרֶךְ בֶּהָמוֹן
לְהַגִּיעַ אֶל שׁוּלֵי שִׂמְלָתָהּ
לְנַשֵּׁק אֶת קְצוֹת אֶצְבְּעוֹתֶיהָ
לָשִׂים כֶּסֶף לְאוֹת תּוֹדָה
זוֹהָרָה אַלְפַסִיָה,

הַיּוֹם נִתָּן לִמְצֹא אוֹתָהּ
בְּאַשְׁקְלוֹן, בְּעַתִּיקוֹת ג,' לְשָׁכַּת הַסַּעַד
רֵיחַ שְׁיָרִים שֶׁל קֻפְסָאוֹת סַרְדִּינִים עַל שֻׁלְחָן מִתְנוֹדֵד בֵּן שָׁלֹש רַגְלַיִם,
שְׁטִיחֵי מֶלֶךְ מַרְהִיבִים, מְרֻבָּבִים עַל מִטַּת סוֹכְנוּת,
בַּחֲלוּק בֹּקֶר בָּהוּי

[13] Personal communication with Zhor Rehihl.

Jewish Musical Echoes

שָׁעוֹת בַּמַּרְאָה
בְּצִבְעֵי אִפּוּר זוֹלִים
וּכְשֶׁהִיא אוֹמֶרֶת:
מֶחֱמַד הַחֲמִישִׁי אִישׁוֹן עֵינֵינוּ
אֵינְךָ מֵבִין בָּרֶגַע הָרִאשׁוֹן.

לְזוֹהָרָה אַלְפַסְיָה קוֹל צָרוּד,
לֵב צָלוּל וְעֵינַיִם שְׂבֵעוֹת אַהֲבָה.
זוֹהָרָה אַלְפַסְיָה.[14]

This song highlights the feelings of social frustration and economic precariousness of new Moroccan immigrants, and the lack of predictability and job security in the early years of their lives in Israel. Yet Biton also highlights the birth of a North African movement in Israel in the 1970s in his famous poem 'Summary of a Conversation', where he openly challenges Israel hegemonic structure when he announces:

מַה זֶה לִהְיוֹת אוֹתֶנְטִי,
לָרוּץ בָּאֶמְצַע דִּיזֶנְגּוֹף
וְלִצְעֹק בְּיהוּדִית מָרוֹקָאִית.
"אָנָא מִן אֶלְמַגְרֶב אָנָא מִן אֶלְמַגְרֶב".[15]

While Erez Biton and the Black Panthers challenged the establishment from outside, Shaul Ben Simhon opted to change European perception of Moroccan from inside as the Labor Party Secretary of the Workers' Committee and member of the MAPAI party led by Ben-Gurion. In the mid-1960s, Ben Simhon began sponsoring an annual public celebration of Mimouna. André Levy writes:

> The mimouna event was met with moderate success, gathering only 300 Fasi Jews (from Fes). Within a year, however, the event multiplied and

[14] 'Singer at Muhammad the Fifth's court in Rabat, Morocco / They say when she sang / Soldiers fought with knives / To clear a path through the crowd / To reach the hem of her skirt / To kiss the tips of her toes / To leave her a piece of silver as a sign of thanks. / Zohra El Fassia / Now you can find her in Ashkelon / [in the] Antiquities 3 [quarter] / by the welfare office the smell / of leftover sardine cans on a wobbly three-legged table / the stunning royal carpet stained on the Jewish Agency cot / spending hours in a bathrobe / in front of the mirror / with cheap make-up / when she says: / "Mohammed Cinque / Apple of our eyes." / You don't really get it at first. / Zohra El Fassia's voice is hoarse / Her heart is clear / Her eyes are full of love'. Translation by Alcalay (1996: 267–68).

[15] 'What does it mean to be authentic? / To run down Dizengoff St. / Shouting in Jewish Moroccan, / "Ana min al-maghrib, ana min al-maghrib"'.

embraced about 5,000 attendants. It seemed that Ben Simhon effectively hit a collective chord, as by 1967 the number doubled to 10,000 participants. Taking into account that most Moroccan Jews lived in the periphery of Israel and this relied on the poor public transportation [...]. Moreover, such an ethnic event stood against the overriding 'melting pot' policy that aspired to eradicate any diasporic remnants. The growing number of participants required more suitable space: a larger open space. The event shifted location to a place that became the emblematic space of the mimouna in Israel: Sacher Park, the largest public park in the center of Jerusalem. (Levy 2018: 11–12)

Meanwhile, in the 1950s, as Moroccan Jews continued to arrive at Haifa port and settle in southern border settlements, a new musical organization was founded by four Moroccan Jews, the Azoulay Brothers, who established a record label known as the Koliphone in Haifa. They soon produced the works of many Moroccan and North African singers marginalized by Israel production companies. Among the singers that benefited from the Azoulay Brothers' support were Zohra El Fassia, Samy El Maghribi, and Jo Amar. During the early protest period against their marginalization, Moroccan singers highlighted the social anxiety and anger of the 1950s to 1970s that the Black Panthers voiced in their political and cultural demonstrations.

While these political events continued to highlight the conditions of Moroccan Jews and increase their political consciousness, the arrival of Rabbi David Bouzaglo from Casablanca in the 1960s added a sense of cultural pride as he began to campaign for the celebration of indigenous Moroccan music. A cultural hero in Morocco and a respected religious figure, Bouzaglo started to play songs from the liturgical tradition and perform nightly shows in private homes, cinemas, and synagogues. His musical mastery of the *piyyutim* added another dimension to his early and immediate influence in the Israeli environment, ensuring that the musical traditions of Andalusian and Gharnati genres have been preserved in Israel after his death in 1975 through disciples such as Haim Louk.

In April 1979, two years after the Likud Party defeated the Labor Party in an election campaign that saw the overwhelming electoral shift of North African Jews to the right-wing Likud Party, Menachem Begin celebrated the end of Passover by attending the Mimouna in Jerusalem with a group of Moroccan Jews. In contrast to Begin who was greeted with jubilant support and ululations, Shimon Peres also made an appearance, but was heckled and pelted with tomatoes. This case, among others, demonstrated the beginning of a dramatic shift in Moroccan Jewish identity in Israel. In the eyes of my informant in Ashdod, 'When Begin and later other Israeli politicians began

to attend our *mimouna* on the last day of Pesach, we knew that we became not only Israelis but also Ashkenazi Moroccans'.[16]

Echoes at 'Home'

This shift is the beginning of what I argue to be the official unmuting of Moroccan musical sounds in Israel and the beginning of their echoes in Moroccan urban spaces. As Mimouna became a celebrated North Moroccan ritual in Israel politics and society, Moroccan Jewish music and food became slowly visible and positive cultural symbols in the larger Israeli society. In 1988, Eli Ben Hammou, Samy El Maghribi, and Aryeh Azoulay launched the Center for Sacred Sounds and Poetry. The objective was to train musicians in North African musical traditions and instruments. In 1994, Motti Malka and Yehiel Lasri officially established the Israeli Andalusian Orchestra in Ashdod. In his ethnographic work on the orchestra and its cultural influence in Israel, Meirav Aharon notes that it was

> established as a Western-style classical orchestra, with a preponderance of string instruments absent from the original 'traditional' format. There were 45 instrumentalists, consisting of two groups. The first was called, in local parlance, 'the authentic ensemble', and the second was called 'the orchestra'. Most of the 'authentic ensemble' were, and still are today, immigrants from North Africa and Israelis of Mizrahi origin. (Aharon 2012: 448)

Meanwhile, in Morocco, and especially in the political context, King Hassan II became involved in peace negotiations between Israel and Egypt and emerged as a significant player in Middle Eastern politics. At the same time, he started to look for ways to strengthen his relationships with Moroccan Jews and leaders abroad. In France, and despite his prior anti-monarchy political activities in the 1960s, André Azoulay was encouraged to establish Identité et dialogue with the broad aims of strengthening a Jewish-Muslim network and alliance, finding a solution to the Arab-Israeli conflict, and preserving Moroccan Jewish identity. In 1978, an international conference was organized by the group in Paris, where more than one hundred Muslim, Jewish, and Israeli participants attended its workshops. A new Muslim and Jewish political elite headed by André Azoulay, David Amar, Moulay Ahmad Alaoui, Adil Jazouli, and Ahmed Reda Guedira, among others, became the face of this movement of Jewish-Muslim relations (Boum and Park, 2016). In 1984, the Moroccan Jewish Community Council and its secretary general David Amar attended a

[16] Personal communication.

194 *Jewish-Muslim Interactions*

meeting held in Rabat where André Azoulay gave one of the keynote speeches. At the same time, Moulay Ahmad Alaoui established the Association of the Sons of Abraham as part of the larger movement to enhance Jewish and Arab alliance in the region and seek solutions to the political conflict.

By the 1980s, it was very clear that a cultural shift was beginning to take place in Morocco and Israel, driven by a dream to find a solution to the Arab-Israeli conflict. A new discourse about interfaith dialogue and culture emerged at the centre of this movement. A native of Essaouira, André Azoulay saw his hometown as a viable space where this discourse could be shaped in a sustainable manner. With its rich religious, political, and musical history, alongside its complex African, Arab, Amazigh, and Jewish demography, Essaouira quickly became a space of musical and theatrical encounters. In the early 1980s, the cultural Association Essaouira-Mogador was founded and included the renowned Moroccan actor and playwright Tayeb Seddiqi and André Azoulay among its members. In the early 1990s, Azoulay was officially appointed as an advisor to King Hassan II and soon became one of the patrons of the city of Essaouira where a well-defined and structured economic model for Essaouira's development was officially launched through art, music, and festivals under the name of the Essaouira Gnaoua Festival in 1997 (Boum 2012a; 2012b; 2012c).

It would require almost twenty years of stage preparation for the official celebration of Jewish sounds in Moroccan public stages. During the 1980s and 1990s, Morocco state officials focused largely on the political debates of conflict starting with Shimon Peres's visit to the Oslo agreement. With the nomination of Serge Berdugo as Minister of Tourism in 1995 came a major shift in the national discourse about Jewish identity and its importance in internal and external relations. The conservation of Jewish heritage sites including synagogues and cemeteries was the first phase of a long-term official discourse about Moroccan Jews and their role in nation-building. By the early 2000s, a culture of festivals spread throughout the country as each region or city began to capitalize on its cultural and musical traditions, and organized festivals in accordance with its local heritage. Moroccan festivals featured Jewish and Muslim singers such as Rabbi Haim Louk and Mohammed Briouel, and events honouring Muslim and Jewish singers such as Rabbi Samy El Maghribi, Zohra El Fassia, and Abdessadeq Chaqara.

Yet one of the most important festivals where the unmuting of Jewish and Moroccan Israeli voices has been underway is the Atlantic Andalusia Festival that takes place during autumn. In the November 2018 edition of the festival, Hajja Hamdaouia and Raymonde El Bidaouia, two celebrated Muslim and Jewish figures of popular music, sang together a number of popular songs that have historically been central to traditional Moroccan

festivities, including marriage celebrations. Dressed in traditional Moroccan kaftans, the music icons shared hugs and kisses in the middle of their performance.[17] The performance was widely reported by journalists in Israel and Morocco.

Today, young Israeli musicians of Moroccan descent are occasional participants in this revival of Jewish musical movement in Moroccan public festivals. Neta El Kayam and Amit Hai Cohen are two Israeli-born musicians who exemplify this movement. Born in the 1980s, they are part of a new wave of Israelis going back to Morocco to reconnect with the past and heritage of their parents.[18] Sound unmuting takes place in the context of numerous conferences and cultural meetings throughout the country. Recently, André Azoulay launched what I see as the last dimension of the project of Jewish musical echoes in Morocco: Le Centre de Recherches Haïm Zafrani sur l'Histoire des Relations Islam-Judaïsme [The Haïm Zafrani Centre for Research on the History of Relations between Islam and Judaism] (Boum, 2020). While Jewish guests such as Izza Genini have recently became casual honorees of cultural festivals in Fez, Oujda, Marrakesh, Essaouira, Debdou, and elsewhere, the establishment of a centre of research in Essaouira is meant to highlight, through scholarship and academic conferences, the long history of encounters and social relations between Jews and Muslims in Morocco. Like many guests that featured in Rehihl's 'Nass El Mellah' radio programme, Genini is part of the older generation playing a central role in the dissemination of knowledge about Jewish-Muslim relations before the immigration period. While recent Moroccan Jewish films such as Kamal Hachkar's *Tinghir-Jérusalem: Les échos du Mellah* ['Tinghir-Jerusalem: Echoes from the Mellah'] (2011) provide context for such emigration and ideas about Moroccan Jewish life in Israel (Kosansky and Boum, 2012; Stillman and Boum, 2016),[19] the radio and its guests highlight stories of Jewish life in Morocco through the voices of Moroccan Jews such as Izza Genini, Suzanne Harroch, Sonia Cohen Azagury, and Simone Bitton, among others. One of the most celebrated French Moroccan Jewish film producers and distributors Izza Genini produced *Transes*, a film about the popular music group Nass El Ghiwane in 1981. By the mid-1980s, she shifted her interest to documentaries, producing a series of projects on Ahwash and Gnaouas (Higbee and Martin, 2019; Genini, 1996). It is the recent cultural wave of unmuting of Jewish sounds that has allowed Genini and other Moroccan Israeli young

[17] Available at: https://www.youtube.com/watch?v=L9ednogUZ9I (consulted on 26 October 2019).

[18] See Kartowski-Aïach, this volume.

[19] See also Bahmad (this volume).

artists such as Neta El Kayam to be visible again in Moroccan spaces as they participate in the celebration of Jewish sounds in public spaces, squares, and conference halls throughout Morocco. For example, from 7 to 12 May 2018, the Association Anou Arts pour la culture et les arts sponsored a cultural week in recognition of Genini's work, reintroducing Moroccans to her documentaries on Jewish and Muslim music.

In the virtual world, scholars of the Maghrib, and Christopher Silver in particular, have played a significant role in the new revival of Moroccan and Jewish soundscapes. In April 2007, Silver, an assistant professor at McGill University and a contributor to this volume, launched a blog on 'Jewish Morocco' that he later titled 'Jewish Maghrib Jukebox', where he provided detailed historical information about Jewish life and music in Morocco, Algeria, and Tunisia. In October 2017, he renamed the blog gharamophone. com, starting a new 'online archive dedicated to preserving North Africa's Jewish musical past, one record at a time'.[20] Largely interested in Jewish musical traditions and what they signal about Jewish-Muslim relations, Silver notes that his North African collections of Jewish records

> provide a soundtrack to the twentieth century Maghrib. In fact, these brittle discs – surviving until the present against all odds – reveal not just their time and the music animating it but so too lay bare a world of Jewish-Muslim cultural entanglement from the not too distant past. In other words, when it came to music in Morocco, Algeria, and Tunisia, Jews and Muslims – performers and fans alike – were inseparable well into the twentieth century.[21]

This interest in the conservation of Jewish music and sounds is also part of the academic and community work of Vanessa Paloma Elbaz, also a contributor to this volume, who launched in 2007 the project 'Khoya: les archives sonores du Maroc Juif' ['Khoya: Sonic Archives of Jewish Morocco']. The archives attempt to preserve the musical memory of Moroccan Jews by capturing songs and stories through interviews with members of the older generation, especially in northern Morocco. While Genini filmed different musical repertoires of Morocco, the projects initiated by Silver and Paloma Elbaz focus largely on Jewish singers and music.

[20] Available at: https://gharamophone.com/2017/10/ (consulted on 26 October 2019).

[21] Available at: https://gharamophone.com (consulted on 26 October 2019).

Echo Chambers

In my article '"Soundtracks of Jerusalem": YouTube, North African Rappers and the Fantasies of Resistance', I discuss how a new generation of Moroccan rappers deploy different techniques to sing their own version of Jerusalem as a form of contestation of Israeli cultural narratives of the city (Boum, 2016). In their hip-hop songs, Moroccan Jews are absent, and the majority of Jews are described as Israeli enemies of Palestinians and the Arab world. While the developers of many festivals throughout Morocco have managed in recent years to attract youth and expose them to nuanced aspects of the complex musical tradition and histories outlined above, there is still a resistance to these festivals and the participation of Moroccan Israelis in these events. In this context, state officials continue to create spaces for Jewish sounds and link them to histories of Jewish-Muslim encounters. Moroccan Jews continue to return to their Moroccan homes to participate in conferences and festivals sponsored by the state and regional governments. In Israel, Moroccan Jews are also engaged in many projects of cultural revival. The discourse of Andalusian music and its appropriation by the community highlights what I call the Moroccan inheritance of an Andalusian model (Boum 2012b). Today a number of Moroccan Jewish singers in Israel are claiming this Andalusian heritage as part of their Moroccan identity to push for a discourse of tolerance and Jewish-Muslim entente that Morocco claims to have inherited from al-Andalus after the Inquisition and settlement of Jewish and Muslim refugees in Fez, Tangier, and Tetouan.

Works Cited

Abadi, Jacob. 2017. 'Tunisia and Israel: Relations Under Stress'. *Middle Eastern Studies* 53.4: 507–32.

Aharon, Meirav. 2012. 'Riding the Culture Train: An Ethnography of a Plan for SociMobility through Music'. *Cultural Sociology* 7.4: 447–62.

Alcalay, Ammiel (ed.). 1996. *Keys to the Garden: New Israeli Writing*. San Francisco, CA: City Lights Books.

Attali, Jacques. 1977. *Noise: The Political Economy of Music*. Minneapolis: The University of Minnesota Press.

Bensigor, François. 1995. 'Cheikh Raymond Leyris: la reconnaissance d'un maître du malouf'. *Hommes et Migrations* 1185: 58–59.

Bernstein, Deborah. 1984. 'Conflict and Protest in Israeli Society: The Case of the Black Panthers of Israel'. *Youth and Society* 16.2: 129–52.

Boum, Aomar. 2007. 'Dancing for the Moroccan State: Berber Folkdances and the Production of National Hybridity'. In Nabil Boudraa and Joseph Krause (eds.), *North African Mosaic: A Cultural Reappraisal of Ethnic and Religious Minorities*. Cambridge: Cambridge Scholars Publishing: 214–237.

——. 2010. 'The Plastic Eye: The Politics of Jewish Representation in Moroccan Museums'. *Ethnos* 75.1: 49–77.

——. 2012a. 'Festivalizing Dissent in Morocco'. *Middle East Report* 263 (Summer): 22–25.

——. 2012b. 'The Performance of "Convivencia": Communities of Tolerance and the Reification of Toleration'. *Religion Compass* 6.3: 174–84.

——. 2012c. '"Sacred Week": Re-Experiencing Jewish-Muslim Co-existence in Urban Moroccan Space'. In Glenn Bowman (ed.), *Sharing the Sacra: The Politics and Pragmatics of Inter-communal Relations around Holy Places*. London: Berghahn Books: 139–55.

——. 2013. *Memories of Absence: How Muslims Remember Jews in Morocco*. Stanford: Stanford University Press.

——. 2016. '"Soundtracks of Jerusalem": YouTube, North African Rappers and the Fantasies of Resistance'. In S. R. Goldstein-Sabbah and H. L. Murre-van den Berg (eds.), *Modernity, Minority and the Public Sphere: Jews and Christians in the Middle East*. Leiden: Brill: 284–309.

——. 2017. '"Curating the Mellah": Cultural Conservation, Jewish Heritage Tourism, and Normalization Debates in Morocco and Tunisia, 1960s–2017'. In Osama Abi-Mershed (ed.), *Social Currents in North Africa: Culture and Governance after the Arab Spring*. London: Hurst C & Company Publishers: 187–204.

——. 2020. 'Branding Convivencia: Jewish Museums and the Reinvention of a Moroccan Andalus in Essaouira'. In Virginie Rey (ed.), *The Art of Minorities: Cultural Representation in Museums of the Middle East and North Africa*. Edinburgh: University of Edinburgh Press: 205–23.

Boum, Aomar, and Thomas Park. 2016. *Historical Dictionary of Morocco*. Lanham, MD: Rowman and Littlefield.

De Martino, Claudia. 2013. 'Mizrahi Voices in Musrara: An Inter-Jewish Discriminative Spatial Pattern'. *EchoGéo* 25: 2–12.

Dicale, Bernard. 2011. *Cheikh Raymond: une histoire Algérienne*. Paris: First Editions.

Evans, Martin. 2012. 'Algeria's Jewish Question'. *History Today*, July, pp. 10–16.

Fahmy, Ziad. 2013. 'Coming to Our Senses: Historicizing Sound and Noise in the Middle East'. *History Compass* 11.4: 305–15.

Frankel, Oz. 2008. 'What's in a Name? The Black Panthers in Israel'. *The Sixties: A Journal of History, Politics and Culture* 1.1: 9–26.

Genini, Izza. 1996. 'Musique des juifs du Maroc'. In Mohamed Sijelmassi, Abdelkébir Khatibi, and El-Houssaïn El Moujahid (eds.), *Civilisation marocaine: arts et cultures*. Casablanca: Oum éditions: 238–41.

Higbee, Will, and Florence Martin. 2019. 'Adventures of a Transnational African Distributor: An Interview with Izza Genini'. *Expressions maghrébines* 18.1: 37–46.

Hirschkind, Charles. 2006. *The Ethical Soundscape: Cassette Sermons and Islamic Counterpublics*. New York: Columbia University Press.

Jankowsky, Richard. 2010. *Stambeli: Music, Trance, and Alterity in Tunisia*. Chicago: Chicago University Press.

Kapchan, Deborah. 2007. *Traveling Spirit Masters: Moroccan Gnawa Trance and Music in the Global Market*. Middleton: Wesleyan University Press.

——. 2008. 'The Promise of Sonic Translation: Performing the Festive Sacred in Morocco'. *American Anthropologist* 110.4: 467–83.

Kosansky, Oren, and Aomar Boum. 2012. 'The "Jewish Question" in Postcolonial Moroccan Cinema'. *International Journal of Middle East Studies* 44.3: 421–42.

LeVine, Mark. 2008. *Heavy Metal Islam: Rock, Resistance, and the Struggle for the Soul of Islam*. New York: Three Rivers Press.

Levy, André. 2018. 'Happy Mimouna: On a Mechanism for Marginalizing Moroccan Israelis'. *Israeli Studies* 23.2: 1–24.

Maddy-Weitzman, Bruce. 2011. 'Morocco's Berbers and Israel'. *Middle East Quarterly* 18.1: 79–85.

Mamman, Ophir. 2007. 'Telem, Theatre for Transit-Camps: The Beginning of the "Double Turn" in Israel Theatre' [in Hebrew]. *Katedra* 123: 125–54.

Mdidech, Jouad. 2016. 'Sion Assidon l'Antisioniste et militant des droits de l'homme'. *Majallat al-rabi'* 4: 181-85.

Miller, Flagg, 2007. *The Moral Resonance of Arab Media: Audiocassette Poetry and Culture in Yemen*. Cambridge, MA: Harvard University Press.

Müller, Jürgen. 2012. 'The Sound of History and Acoustic Memory: Where Psychology and History Converge'. *Culture and Psuchology* 18.4: 443–64.

Ouaknine-Yekutieli, Orit, and Yigal Shalom Nizri. 2016. '"My Heart is in the Maghrib": Aspects of Cultural Revival of the Moroccan Diaspora in Israel'. *Hespéris-Tamuda* LI.3: 165–92.

Shabi, Rachel. 2008. *We Look Like the Enemy: The Hidden Story of Israel's Jews from Arab Lands*. New York: Walker & Company.

Silver, Christopher. 2016. 'Listening to the Past: Music as a Source to the Study of North African Jews'. *Hesperis Tamuda* 51.2: 243-55.

Smith, Mark. 2004. *Hearing History: A Reader*. Athens: University of Georgia Press.

Stillman, Assouline, and Aomar Boum. 2016. 'Cinema: Muslim-Jewish Relations on Screen'. In Josef Meri (ed.), *The Routledge Handbook of Muslim-Jewish Relations*. New York and London: Routledge: 401–28.

Urian, Dan. 2001. 'The Birth of the Moroccan Stereotype in the Israel Theater: A Reexamination on the Play Kazablan, 1954'. *Bamah* 159–160: 48–66.

Zohar, Zion. 2005. 'Sephardic and Oriental Jews in Israel: Rethinking the Socio-Political Paradigm'. In Zion Zohar (ed.), *Sephardic and Mizrahi Jewry: From the Golden Age of Spain to Modern Times*. New York: New York University Press: 300–27.

Connecting the Disconnect:
Music and its Agency in Moroccan Cinema's Jewish-Muslim Interactions

Vanessa Paloma Elbaz

Music-making connects individuals and, in the case of Moroccan cinema, characters that would have otherwise been disconnected because of societal, political, or religious norms. This chapter will disentangle the multifaceted use of music as an embodied entity in the relationship of connection and disconnection in contemporary Moroccan cinema. I propose to explore the various ways in which music, and its role in Moroccan society, functions as an active third party in what is usually perceived as a binary relationship between Moroccan Muslims and Jews. I argue that music as a recurring central character in Moroccan cinema permits Jewish and Muslim men and women to connect across established communal divides. Current scholarship in the area of Moroccan film studies has not yet analysed the role and function of the representation of music in the Jewish-Muslim relationship in Moroccan films. This chapter will explore the issues concerning the lived reality of some of the few remaining Jews in Morocco, examining in particular the tension between the majority culture's view of Jews as 'foreigners' or 'outsiders' vis-à-vis the recent preponderance of their appearance in film and public presentations.

'Ana el Maghribi'[1] ['I am the Moroccan'] crooned the octogenarian Haim Botbol, otherwise known as Morocco's Jewish Frank Sinatra on the CD included in a special magazine edition of *VH*, 'the Moroccan men's magazine', in November 2013. Maxime Karoutchi, the currently popular Jewish music star, sings 'El Massira el Khadra' at practically every concert and television appearance. 'El Massira el Khadra', which means the Green March, is a song that celebrates Morocco's march in 1975 of 350,000 people into the Western Sahara to retake control from Spain and re-establish Morocco's 'territorial integrity'[2] from the Strait of Gibraltar to Mauritania. Similarly, in the 1950s, Sami El Maghribi chose to record under the name Sami *the Moroccan* instead of his given name Samuel Amzallag, at the behest of a friend, establishing him, a Moroccan Jewish cantor and popular singer, as 'the first patriot'[3] in the words of singer Maxime Karoutchi. In the 1960s and 1970s, other singers such as Felix El Maghribi, also known as *le petit Felix* (d. 2008) and Victor El Maghribi (*le petit Victor*) capitalized on this epithet around Sami's unquestioned Moroccanness, in an effort to legitimize their own Moroccanness for Muslim-majority Moroccan audiences, especially during moments of political tension with Israel. However, Felix El Maghribi's son, Victor Wizman, currently lives and performs in Tel Aviv. He continues the family's tradition of performing the Moroccan repertoire, but not in Morocco.

Morocco's Jewish public musicians seem indefatigably eager to confirm their loyalty to their inherent Moroccanness, their belonging to the post-independence state, and their unquestionable patriotism. Lawrence Rosen aptly describes Moroccan society when he writes, 'Territory is deeply intertwined with social identity, bled is not just physical territory, however regionalized, but a terrain of interaction, a domain of complex and crosscutting social relationships' (1984: 7). Jewish Moroccans today stress their belonging to the *bled* and the national narratives of territoriality through language and, most dramatically, through music.

[1] Even though readers might think that the 'Maghribi' reference is a connection to Jewish-Moroccan singer Sami El Maghribi, in this case, it may imply Moroccan male exemplarity, through the use of the definite article.

[2] This term is often used in Morocco's national discourse, and is even part of the Constitution of 2011 (see below).

[3] A description of this moment was expounded by Maxime Karoutchi in front of a group of Muslim Moroccans meeting for a 'tea of Friendship' at the SOC Simon Pinto organized by Association Marocains Pluriels in Casablanca to denounce recent attacks of antisemitism in France on Sunday 24 February 2019.

Before Morocco's independence in 1956, there were 250,000 or more Jews throughout the country in urban and rural populations. Following various waves of emigration caused by multiple socio-political reasons – such as the establishment of the State of Israel in 1948, Moroccan Independence in 1956, the rise of pan-Arabism in the early 1960s, the tensions after 1967's six-day war, decreasing economic opportunities for younger Jewish business owners after the year 2000, Moroccan taxation of foreign properties in 2014, and the Spanish and Portuguese offer of European passports to descendants of Sephardim in 2015 – the remaining population is at less than 1 per cent of what it was originally. Today less than 2,000 remain, concentrated predominantly in Casablanca, and one of the constant conversation topics for Moroccan Jewish families is the shrinking size of the community and the future of its survival.[4] This reduced visibility in the national landscape exacerbates the general unspoken perception that to be fully Moroccan one must be Muslim. Indeed, in my interviews and conversations, and in my analysis of oral histories, concerts, and the written press, Moroccan Jewish musicians constantly reiterate something that it seems should go without saying, but that needs to be repeated: *Ana el Maghribi* (I am Moroccan). Further complicating matters, even though Jews strive for this acceptance as fully Moroccan in the eyes of the general population, when they themselves describe the Moroccan population, they say *les feujs*[5] for Jews and *les Marocains* for Muslims, clearly separating themselves from a simple Moroccan descriptive and equating Muslim with Moroccan. Using the slang *feujs* for Jews is typical French Jewish jargon, which indexes *Casaoui*[6] Jews with French Jewry, and thus the outside world. This linguistic importation is a natural consequence of the longstanding history of the relationship between Moroccan Jews and Parisian Jews, which most notably was cemented by the schools founded by the Alliance Israélite Universelle that initiated its Mediterranean-wide educational project to teach French social and cultural mores in Morocco in 1862.

[4] From 2009 to 2018 I lived in Casablanca and was actively part of its communal life through research, performance, and the eventual founding of KHOYA Sound Archive. In 2016, I became part of the Board of Trustees of one of its Jewish social institutions, 'SOC Simon Pinto', where I founded a lecture series, started a concert series, and held a Jewish film festival. My children attended the Ittihad Maroc (Alliance) schools until 2019 and my husband's family is currently still living in Casablanca.

[5] French back slang for Jew, *feuj* is an 'inversion' of the word *juif*.

[6] French description of someone from Casablanca, correlating to the Arabic *Bidaoui*, which also means 'from Casablanca'.

204 *Jewish-Muslim Interactions*

Most Muslim Moroccans do not come into contact with the remaining Jewish community, and this makes many of the remaining Jews feel out of touch with the national social and political dynamics. The younger generation has only seen Jews on television, as Israeli soldiers within the context of the Middle East conflict (Boum, 2013). Many Moroccans have heard their family's stories of the Jewish neighbours or business partners who left. They try to piece together the stories of this shared life between Muslims and Jews in a Morocco that seems to appear more open, more tolerant, and more inclusive than the one that decades of pan-Arabism has created. In recent decades, the Moroccan *makhzen*[7] has supported and stimulated public discourse about Morocco's Jews through film, television, and the popular press. According to Kosansky and Boum,

> [the] recent treatments of Jewish themes and histories in Moroccan cinema reflect the shifting relationship between state and civil society in the postcolonial period [...] Film carves out relative autonomy from the state and, more specifically, with how Jewish subtexts of the Moroccan nation have suddenly become so vital in this space. (Kosansky and Boum, 2012: 423–24)

Jewish-themed films have become a way to negotiate not only the 'Jewish Question' in Morocco, but other societal and historical malaises that were suppressed during the *années de plomb* under the previous King Hassan II.[8] Through music, these films weave together the emotional elements of Morocco's connection to its Jewish population. Music appears in these films as character, backdrop, and shared emotional base between the Muslim and Jewish population.

[7] Literally means 'warehouse' in Maghribi Arabic (from *khazana* 'to store up' and 'ma', the prefix for places), where the King's civil servants used to receive their wages; but this usage of the word became in Maghribi Arabic synonymous with the elite. It refers to the governing institution in Morocco, centred on the King and consisting of royal notables, top-ranking military personnel, landowners, security service bosses, civil servants, and other well-connected members of the establishment. The term 'Makhzen' is also popularly used in Morocco as a word meaning 'State' or 'Government' or indeed used more pejoratively to imply 'system' with all of its implications in a post-2011 context (the so-called Arab spring was also prominent in Morocco).

[8] Period of political suppression in Morocco from the 1960s to the 1980s where dissidents and intellectuals were silenced.

Jews as 'Outsiders'

I have seen *Casaoui* Jews, on many occasions, informing Moroccan Muslims of the antiquity of their ancestors' presence in Morocco. Especially upon being greeted with the phrase *marhababikum* (welcome to Morocco), which is often said to Jewish Moroccans who have non-Muslim names. It represents the underlying perception that Jews are simply not Moroccan enough; their Jewishness marks them out as *outsiders – foreigners*. The way many younger Moroccans relate to them has the result of establishing that Jews are 'outsiders'; previous generations' intimate relationships have faded away. As Rosen states, 'a fog of unremembrance had begun to cloud any specific way of recalling the Jews. They have become a phantom memory, the felt presence of an absent limb' (2002: 103).

In this climate, one of the principal ways in which this layered identity is methodically integrated into Moroccans' experience of their full 'Moroccanness' is through the representations of music as a tool for cultural diversity. Since 2007, I have seen the growth of the public presence of Jewish Moroccan music on a national level. After the historic declaration of diversity within the preamble of the 2011 Constitution, many government-sponsored festivals began including Jewish music as one of the obligatory elements in musical performances of the variety of national music. Recent Moroccan cinema that represents the Jewish community deals with the sensitive topic of Jewish emigration, evoking their inherent 'foreignness'. However, music in these films has played a pivotal role in establishing their *marocanité*.[9] It is often presented as the 'glue' that holds these old friends together, despite the larger political currents affecting their lives – and ultimately serves as the backbone for the supra-narrative, which is the close relationships between Jewish and Muslim Moroccans.

The concept of *bled* (land) is deeply rooted in Moroccan society. Anyone from the *bled* is part family and requires respect and protection. Anyone who is foreign, *barrani*, can be tricked or taken advantage of, without any major moral consequence.[10] They are not part of the inner sanctum. As hinted at

[9] *Marocanité* can be defined as the combination of elements that confirms that you are truly Moroccan: your cooking, your music, the way you dress, the way you deal with medical issues, how you carry on a conversation, the weight you put on family relationships, etc.

[10] I first encountered the changing relationship towards *barrani* when travelling in the Todra Gorge area in August 2012. When I stopped for a tea on the side of the road, the owner of the café asked me where I lived. Upon answering in Arabic, 'Casablanca, I'm a *barrania* but please give me the local price', he repeated

above, Jews have occupied a complex and often contradictory position in relation to this concept of rootedness – while 'of the land', they are often demarcated as *barrani* because they may have additional allegiances to other lands (Israel, France, Canada, and Spain being the most common). By the 1930s, Moroccan Jews 'forced questions about how the boundaries of the national community should be drawn' (Wyrtzen, 2015: 217). In 1947, with the passing of the United Nations General Assembly's Resolution establishing the partition of Palestine into Jewish and Arab states, some Moroccan nationalists perceived Moroccan Jews as Zionists first and Moroccans second (Ben-Layashi and Maddy-Weitzman, 2010: 98). Since Moroccan independence in 1956, the government has been campaigning to establish the concept of a national belonging for all Moroccans, not just one that is connected to individual cities and local communities. Until then, most Moroccans' affiliations were limited to their family, city, and at most, region. This creation of a Moroccan national identity, which brought all Moroccans under one banner, culminated with the post-Arab spring constitution that was ratified in 2011. In effect, it was as if the nationalistic debates in the 1950s could only be upheld in modern times by ratifying diversity within the Moroccan fabric. In the 2011 constitution, the diverse elements forming Moroccan identity-composition are thus specifically named and ratified.

On the official website of the House of Representatives, an excerpt from the constitution is put on display in English, establishing the importance of the plurality of Morocco as well as its priority towards human rights, obviously as a window for foreign readers. The Jewish Museum of Casablanca also has a marble plaque at its entrance in Arabic, English, and French, with the text inscribing Moroccan Judaism into the integral influences on national identity.

This constitutional text is repeatedly evoked at official events relating to Jewish contributions to Moroccan culture, as well as at musical events and in television programmes where multiple Moroccan musics are presented as part of the country's rich heritage. It is the following core that constitutes the central piece: the key words that play over and over in Jewish circles are territorial integrity (relating to the Western Sahara); Hebraic influences; and values of openness, moderation, and tolerance. The constitutional text reads as follows:[11]

over and over, 'oh you are not a *barrania*. Now all of the Maghreb is one, and there's no more *barrani* from other villages or cities. *Koulna Mgharba*, we are all Maghrebi'.

[11] I have italicized the key words that reiterate the governmental tropes that the Jewish community has reacted to positively.

Etat musulman souverain, attaché à son unité nationale et à son *intégrité territoriale*, le Royaume du Maroc entend préserver, dans *sa plénitude et sa diversité*, son identité nationale une et indivisible. Son unité, forgé par la convergence de ses composantes arabo-islamique, amazighe et saharo-hassanie, s'est nourrie et enrichie de ses affluents africain, andalou, *hébraïque* et méditerranéen. La prééminence accordée à la religion musulmane dans ce référentiel national va de pair avec l'attachement du people marocain aux *valeurs d'ouverture, de modération, de tolérance et de dialogue* pour la compréhension mutuelle entre toutes les cultures et les civilisations du monde.[12]

Even earlier than this, in 2007, the Mimouna Foundation was founded. The driving force of this association of young Moroccans was a handful of students from Al-Akhawayn University. They dedicate themselves to promoting and educating Moroccan Muslims on the secular component of Jewish Moroccan identity and have *parrainage* (patronage) from André Azoulay, the Counsellor to the King. In 2009, the Marocains Pluriels association was founded to promote events facilitating diversity and understanding, which in recent years have garnered a significant amount of press over an interfaith Ramadan breakfast called the *ftour plurielle*. Their events also carry a *parrainage* from André Azoulay, and often have Kaisse Ben Yahia, another Counsellor to the King, in attendance. These non-governmental associations that have discrete support from the palace demonstrate non-official efforts that are pushing forward the concept of plurality in the Moroccan societal fabric.

[12] Royaume du Maroc, Secrétariat Général du Gouvernement (Direction de l'Imprimerie Officielle). 2011. 'La Constitution: Edition 2011'. Available at: http://www.sgg.gov.ma/Portals/0/constitution/constitution_2011_Fr.pdf (consulted on 25 July 2019). 'The Kingdom of Morocco is a sovereign Muslim State that is attached to its national unity and its *territorial integrity*, and committed to preserve in its fullness and diversity its national identity, one and indivisible. Its unity is forged by the convergence of its Arab-Islamic, Amazigh and Saharan-Hassanic components, nourished and enriched by its African, Andalusian, *Hebraic* and Mediterranean influences. The preeminence accorded to the Muslim religion in the national reference goes hand in hand with the attachment of the Moroccan people to the values of *openness, moderation, tolerance*, dialogue and mutual understanding between all human cultures and civilizations'. Royaume du Maroc, Chambre des Représentants. 'Constitution 2011 of Moroccan Kingdom'. Available at: http://www.chambredesrepresentants.ma/en/constitution-2011-moroccan-kingdom (consulted on 25 July 2019). Author's italics; modified translation.

208 *Jewish-Muslim Interactions*

The fact that Moroccan cinema has so many recent examples of the performance of diversity in Morocco, and that this is expressed through music, demonstrates a key idea that I argue throughout this chapter: that music as a recurring central character in Moroccan cinema permits Jewish and Muslim men and women to connect across established communal divides. Current scholarship in the area of Moroccan film studies has not yet analysed the role and function of the representation of music in the Jewish-Muslim relationship in Moroccan films. Multiple Moroccan films on Jews after 2005 have used music as the main catalyst for connection when depicting the time before, during, and after Jewish emigration. Often counterpointed with love affairs across religious boundaries or the painful moments tearing Jewish Moroccans from the daily fabric of the country's life from the 1950s to the 1970s, music appears repeatedly as a disembodied character whose presence changes and charges the plot. When placing these films in the context of their impact on contemporary social discourse, music's central role is further understood.

Parallel to the cinematic conversation, public performances in contemporary Casablanca feature Jewish male singers performing humorous songs in Judeo-Arabic that mock common tensions in marriage.[13] These performances use humour to break apart what is perceived as a solid unified front: the Jewish couple. Moreover, this use of humour connects the male Jewish singers to their Muslim audience solely on the basis of gender, regardless of their religious affiliation. The rupture between the solid societal unit of the Jewish couple created by interreligious love relationships appears as a leitmotif in Moroccan cinema and novels about Jews.[14] In cinema, when these relationships appear, music is a close second, appearing to negotiate an added intimacy where intimacy is forbidden by society. It is in these circumstances that music acts as an added cinematic character and that its role is to propel the narrative through an unspoken 'dialogue' that is evident on the screen from the character's interactions around music, rehearsal, and performance.

[13] Songs such as 'Mara Kbiha' ['The Hard Woman'], 'Tlata Shab' ['Three Brothers'], 'Kunt Azri' ['When I Was Single'], and 'Sidi Dayan' ['Mister Judge'] by Albert Suissa.

[14] *Mazaltob* (Bendahan, 1930), *Amor entró en la judería* (Vega, 1944), *Sortilège* (Chimenti, 1964), *En las puertas de Tanger* (Benarroch, 2008), and *Revoir Tanger* (Toledano, 2015) are all novels in which Jews and non-Jews struggle with the personal, familial, and communal decisions surrounding interreligious love affairs.

Diegetic Sound in Moroccan Films

In order to explore these moments of connection and disconnection between Jewish and Muslim protagonists in Moroccan cinema, I now wish to move to an analysis of specific case studies focusing on the use of diegetic sound. David Neumeyer describes diegetic sound as

> an onscreen character's speech, an object's naturalistic sound, or a character's singing or playing a musical instrument on screen; and non-diegetic sound is clearest in voice-over narration by an absent narrator or in orchestral underscoring using an ensemble without any obvious connection to the story. (Neumeyer, 2009: 31)

In the process of moving the narrative, the diegetic model established is as follows: anchoring – diegesis – narration.

1. Anchoring establishes the 'I' of the viewer and of the protagonist.
2. Diegesis is the sound or music that is featured.
3. Narration is the concluding arrival point that allows for the anchored 'I's.

For the purpose of this chapter, I am interested exclusively in diegetic music (when the viewer sees the music played/interpreted on screen) and how these moments anchor the relationships between Muslims and Jews in post-colonial Morocco. The semiotic function of music in these films serves to confirm the unspoken Moroccan belief that one of the ways that Jews confirm their *marocanité* is through their interpretation of Moroccan music. I am inclined to take this a step further and say that it is not only the interpretation of music on the screen, but its discussion and the engagement of the characters around music that firmly establishes the true indigeneity of the Jewish characters. So, the very fact of having, for example, a whole movie based on the reconstitution of a mythical orchestra (as in the film *L'Orchestre de minuit* ['The Midnight Orchestra'], 2015), and what this orchestra meant during post-independence Morocco, uses a diegetic model throughout the film, where music is an overarching presence and is the impetus for the narrative and the glue between the disparate characters.

I analyse four films where music is central in a diegetic manner, focusing on four key elements of national identity and history involving the Jewish population of Morocco. The first element is forbidden interreligious love, which appears in all but one of the films. The second is Jewish departure from Morocco. The third is the presentation of a mythical persona based on a famous Jewish Moroccan popular singer. The final element that appears is

210 *Jewish-Muslim Interactions*

Andalusi music and its shared cultural aspects between Jewish and Muslim Moroccans and their cultural intimacy.

Marock (2005) – Forbidden Muslim-Jewish Love

In 2005, Moroccan filmmaker Laïla Marrakchi released her film *Marock* about the upper-class youth of Casablanca, and opened the public discourse to a taboo subject: the forbidden teenage love between a Jewish boy and a Muslim girl. Her film, which carried political statements on Morocco's difficult transition into modernity, used the story of this transgressive love affair as a way of pushing against rigid interpretations of Islamic practice. As a female Muslim filmmaker, who herself is married to a Sephardi Jew, in her film Marrakshi pushes the male Muslim establishment in various directions by addressing issues around sexuality, women's freedom of expression, and Western-style lifestyles within Moroccan society. However, it was the taboo subject of sexuality between a Muslim woman and a Jewish man that brought about a backlash. In 2006, Marrakshi was accused of being a Zionist and anti-Moroccan (Hirchi, 2011: 93). In Morocco, Jews are sometimes conflated with Zionists, which consequentially makes them out to be traitors, since a double national allegiance is perceived as disloyalty. When a Moroccan Muslim is accused of being a Zionist, it is usually a tactic employed to destroy the reputation and legitimacy of the person under attack. This accusation comes about when someone makes a statement that might seem to be overly sympathetic to Jews to the detriment of the larger Muslim society. However, many times it is simply employed as a slur when someone expresses inordinate interest in Jewish culture or history.

Even though Marrakshi's film does not speak specifically to traditional music shared by Muslims and Jews, her title indicates the shared musical culture of urbanite upper-class Casablanca youth and its consequences. *Marock* plays on the phrase 'ma rock' that presents rock music clearly while subtly implying its personalization through the use of a feminine possessive pronoun. It should read 'mon rock' to be grammatically correct, but could be understood by French speakers to imply a slang used by adolescents. Marrakshi's film speaks to the shattering of communal boundaries around a forbidden musical culture in a society of traditional Islam. The youth connect around their love for rock music. In *Marock*, the Jew represents the harbinger of modernity and women's liberty. The intimate presence of Youri, a Jewish man, in the life of upper-class young *Casaoui* women, functions as the male permission for unrestrained female behaviour that had not yet been presented in the cinematic sphere. Youri symbolizes the familiar-enough unfamiliar world of the 'other' – the Jew within Moroccan society, who

was traditionally allowed into Muslim homes as a peddler in Cherifian and Protectorate days. Because of an unspoken societal pact between Muslim men and Jewish merchants, Muslim women were off-limits, thus Jewish men were considered a non-threat to the sexuality of Muslim women. This was a de-facto feminization of the Jewish male in Morocco's highly hierarchical patriarchal society.[15]

In *Marock*, the Jewish man becomes a sexual threat to the integrity of traditional Muslim society, turning the tables of accepted societal tropes about Jewish men and the sexuality of Muslim women. Youri might also have been more easily sexually active with a Muslim girl than the strictly controlled Jewish girls of his generation, and Leila's friend implies this possibility in one of their dialogues. Music is less of a central character in the plot than in the films to come after 2007, but it is important enough to be featured in its title, permeating the audience's understanding of the whole film. In *Marock*, music is a character and a backdrop to the story of sexual openness and the breach of traditional restraints. All boundaries appear to crack through these adolescents' way of life in contemporary Casablanca. However, Youri, the Jewish boy, dies in an accident towards the end of the film, exposing the impossibility of such a relationship in a society where family continuity and traditions are of utmost importance (Chreiteh, 2018). Rock culture, sexual openness, and interreligious love finish tragically for this couple.

Où vas-tu, Moshé? (2007) – Jewish Departure

In 2007, *Où vas-tu, Moshe?* ['Where Are You Going, Moshé?'] brought the story of Moroccan Jews' departure and the new problem of a Morocco emptied of its Jews to the silver screen. The main character, Shlomo, appears to be torn between allegiance to his 'people', the Jewish community, and his other people, his majority-Muslim musical community from the bar of Boujad, a small city in central Morocco. Shlomo comes to run the bar of Boujad after the emigration of the rest of the Jews from the city, because the liquor licence must be held by a non-Muslim according to law. In a scene towards the beginning of the film, the city council meets with the owner of the bar and sternly reminds him of the impending fate of his business

[15] Assia Bensalah Alaoui, itinerant ambassador for King Mohammed VI, spoke about this in her presentation of her memories of interaction with Jewish men when she was a child. As the daughter of the *Caïd* of the region, they had a Jewish tailor, dressmaker, jeweller, etc. They were the only non-family males allowed in the household. TALIM April Seminar, Tangier, 2 April 2019.

were all the Jews to leave. The hypocrisy of the system is highlighted as a group of traditionally dressed men sit around a table, drinking Moroccan tea and with long faces, discussing the gravity of the loss of the liquor licence. Shlomo, the character who will eventually save the fate of their gathering place, teaches 'oud, which establishes his complete indigeneity, and is portrayed as 'pious, musical and humble' (Kosansky and Boum, 2012: 432). One of his music students is in love with Shlomo's daughter, connecting this young Jewish woman to the future of her father's musical tradition. However, she eventually leaves for Israel with her mother, the ultimate rupture between a Moroccan man and a Jewish woman. Often in post-independence Morocco, young Jewish women who were being courted by Muslim men were quickly shipped off to Israel to avoid an interreligious marriage, which is seen as catastrophic to both sides, but specifically for the Jewish woman because her children, although Jewish according to Jewish law, would not be raised as such in Morocco with a Muslim father.

Even though Shlomo's daughter and wife leave the city along with the rest of the Jews of Boujad, Shlomo remains: he becomes the sole Jewish inhabitant of the village. When the whole Jewish community leaves, Shlomo – the character played by French-Moroccan actor Simon Elbaz, himself born in Boujad – decides to stay behind to continue the neighbourhood evenings of chaâbi music[16] and *mahia*.[17] His decision seems to be foreshadowed when he is mournfully playing the 'oud at home while his wife, who is portrayed as strident and angry, is packing their bags with family photos, clothes, and jewellery. The simple Shlomo chooses to actively rebel against the constraints of his society and break free to a world of shared music and revelry with his Muslim compatriots. The night that the Jews leave in the bus for Casablanca the scene cuts to Shlomo, in the bar that has been renamed *Shlomo's*. He is playing 'oud and singing 'Kaftanek Mahloul', a hit song written by Sami El Maghribi, while patrons sing and dance. This song has become a classic song of *chgoury* repertoire in contemporary Morocco, and it reiterates the position of the Jewish singer as one that will push the boundaries of the forbidden within Moroccan society. In its text, the singer tells the woman, your *kaftan*, your dress, is open – in the scene there is drinking and dancing, all forbidden by orthodox Islam, and the implication through the song's text of a man's desire for the woman he serenades. In the film, the song is used as a moment of social glue between Muslims and the remaining Jew, as well

[16] The music of the *chaab*, the people – in this case, contemporary popular Moroccan music.

[17] Literally 'Water of Life', an alcoholic beverage prepared by Jewish women from figs or cherries. It is comparable to arak and ouzo, clear and high proof.

Moroccan Cinema's Jewish-Muslim Interactions 213

as subconsciously reiterating for the viewers the Jewish performativity of the forbidden in Moroccan society through sex, liquor, and music.

The option of staying behind in a Muslim city without the rest of the Jewish community was easier for men. When women decided to break from their community, they usually did so because of marriage to a Muslim, and even conversion to Islam. Shlomo remains in Morocco and never leaves for Israel, unlike all the other Jewish members of his city. A later scene shows Shlomo teaching 'oud to his daughter's former boyfriend, and during the lesson the scene cuts to images of the Boujadi Jews at the port, leaving Morocco, carrying their heavy baggage and falling to the ground in exhaustion. His choice seems to have been the better one. Shlomo is transmitting his knowledge to the younger generation in the comfort of his own home. The Jews that left are struggling, burdened, and walking past a setting sun, a symbol for darkness and finality.

However, Shlomo's deeper connection to his Muslim compatriots distances him from his own family, exemplified by the scene where he receives a letter announcing his daughter's marriage in Israel. Since he does not know how to read, it is read to him by someone from Boujad who, reading ahead in the letter that she is to marry, omits that information when reading out loud to Shlomo. The townspeople are afraid that if he left for her wedding, he might not return, and their bar would close. The film finishes with the conclusion that at least one Jew was required in the village to hold the town's centre of alcohol and music, because of the law that the liquor licence must be held by a non-Muslim. This figure of 'the last Jew' recurs throughout international mainstream media and literature, such as in Noah Gordon's *The Last Jew: A Novel of the Spanish Inquisition* (1992), Miguel Angel Nieto's documentary film *El ultimo Sefardí* ['The Last Sephardic Jew'] (2004), and the iconic photograph *The Last Jew in Vinnitsa* that was circulated in 1961 by United Press (UPI) during the trial of Adolf Eichmann.

Ultimately, Shlomo's connection to the celebrative aspects of Moroccan music in his hometown disconnects him from his daughter, his wife, and the line of transmission being created in their new homeland. Similarly to *Marock*, the choice of connection across communal boundaries proves to disconnect him from his own family and self; in connecting to Moroccan nationalism, his affiliation to his own ethnic group becomes more tenuous. As Thomas Hylland Eriksen explains,

> Depending on the social context, then, nationalism may have socio-cultural integrating as well as disintegrating effects; it sometimes serves to identify a large number of people as *outsiders*, but it may also define an ever-increasing number of people as *insiders* and thereby encourage social

214 *Jewish-Muslim Interactions*

integration on a higher level than that which is current. (Hylland Eriksen 1991: 266)

By completely integrating socially to an *insider* group of Moroccan Muslims, Shlomo disintegrates the bonds to his own ethnic group of *outsiders*. Jewish law maintains that the Jewish line is passed through the mother, since she will transmit the culture no matter what to her children. Here we see that Shlomo's continued connection to Judaism is through the women in his family, while his male connections are his Muslim friends at the bar. Towards the end of the movie, when he finally decides to leave to join his wife and daughter, he finds a mentally unstable Jew that was purposely left behind in Casablanca by the Israeli immigration officers, who then becomes the holder of the liquor licence and the saviour of Boujad's bar. The final scene is a rousing party at the bar with the remaining mentally unstable Jew dressed as a military officer and sitting, smiling, and saluting the dancing crowd. This cuts to various statements: one about Israel's 2006 bombing of Lebanon, another reiterating the fact that many of these immigrants became soldiers and officers in the Israeli army, and finally questioning the decision that Arab nations made in encouraging their Jews to leave.

L'Orchestre de minuit (2015) – Myth of Moroccan Jewish Performer

In this film, director Jérôme Cohen-Olivar tells a story concerning the mythical figure of Botbol. When Botbol's son Michael arrives at the Casablanca airport at his father's behest, after many years of absence, he is taken aside by the immigration officer. Much to his surprise, the reason is that the head of immigration is a fan of his father's music. He has an old vinyl record in his office of Botbol and he asks Michael to ask his father to autograph it. The autograph is the last thing that his father does in his hotel room before dying in his sleep. This is the only film analysed here that does not involve a forbidden interreligious love affair, but that focuses on the profound relationships between a man and his colleagues, and the broken relationship he had with his son. It is only after his father's death while lying with violin in hand, that Botbol's son – played by Avishai Benezra, himself a Moroccan Jew from the diaspora – realizes the giant that his father was and, consequently, who he is himself, as the heir to this valuable cultural and musical legacy. He is aided in this quest by Aziz, a taxi driver, who becomes his confidante, guide, and alter-ego throughout the film.

In this example, the broken transmission of knowledge between a father and his son should be whole, as expected in a patriarchal society. As Jan

Bengualid told me in 2007, 'ése no sabe nada, no sabe sino lo que está en el libro'.[18] Bengualid went on to explain that those who *know* something of local Jewish liturgy or traditional knowledge are those who learned it through their father's transmission, not just from reading the prayer book. In *L'Orchestre de minuit* ['The Midnight Orchestra'], Michael, physically deaf to sound and only rarely able to hear music, is finally slowly reviving his memory and repairing the trauma of his family's departure from Morocco after the 1967 war. Cohen-Olivar presents Michael's deafness as complete, except for when he is wearing his hearing aid.

Towards the middle of the film, Aziz, his taxi-driver sidekick, takes Michael as the surprise gift to his niece's wedding; Michael, the heir of the famous Botbol, must perform as a gift to the newly-wed couple. He stands on the stage, and all sound comes flooding back as he makes music, as if his inner brokenness was suddenly repaired. During this symbolic moment, at a Muslim wedding, his hearing comes back. It is perhaps because of the 'completeness' alluded to in the moment when a couple gets married, and its centrality in Moroccan celebratory culture, that this is the moment chosen to embody his healing through music performed at the celebration of the public acceptance of a couple's union. It is important to note that this is *not* an interreligious union but one between two Muslim Moroccans. The 'real-life' Botbol, during the 1960s and 1970s, was the wedding singer *par excellence* at Muslim Moroccan weddings, so the fact that Cohen-Olivar chooses this moment as a semiotic climax is no coincidence. The unity of tradition, and the family's history with those celebrations, can be seen as a crucial catalyst that would permit the sound healing for Michael's inner brokenness.

A new form of nationalism was ebullient in the Moroccan street in the post-independence years. To add complexity, following the six-day war, as Cohen-Olivar shows in his film, Jews were faced with anti-Zionist marches on the streets, in addition to other societal tensions that are not all depicted in the film.[19] The visit of the then president of Egypt, Gamal Abdel Nasser, to Morocco in 1961 was a shock to many Moroccan Jews because of the public and official display of support of pan-Arabism, which seemed to propose a new Morocco with no place in it for its Jewish minority. The nationalist and pan-Arabist climate that was fomented during those years are what forced Michael's father to leave Morocco, his orchestra, and his rooted identity.

[18] 'That guy knows nothing; he only knows that which is in the book'. Interview with Jan Bengualid, Tangier, November 2007.

[19] Youness Laghrari's documentary film *Marocains Juifs, des destins contrariés* (2015) shows many of these previously unspoken tensions surrounding the aftermath of the 1967 war.

216 *Jewish-Muslim Interactions*

It was a moment in Moroccan nationalism in which a uniformity in the perception of the citizen was taking hold and, in the words of Eriksen,

> Nationalism – as the ideology which holds that the boundaries of the state should be coterminous with the boundaries of the cultural community – requires cultural uniformity in certain respects. (Eriksen 1991: 275)

The dis-uniformity of Moroccan Jews was just enough for many of them to be edged out of positions of institutional bureaucracy or, in the case of Michael's father, to be edged out of his position as leader of a popular and lucrative orchestra at a nightclub.

It is thanks to the reconstitution of his father's orchestra and their performance at his funeral in Casablanca that Michael's fractured memory of his painful departure from Morocco stirs and he is able to heal and reintegrate his truncated Judeo-Moroccan identity. It is the act of healing the ruptured orchestra, and their performance at Botbol's funeral in Casablanca, that rights a wrong that existed for decades. Cohen-Olivar's film, which began production only a few years after the new Moroccan Constitution of 2011, performs the musical healing of the previous radical break within Moroccan pan-Arabist nationalism. The Constitution wrote in a pluralistic identity to Morocco's nationalism that effectively eradicates the possibility of focusing on any opposing binary, such as Jewish-Muslim, in Moroccan identity.

Aïda (2015) – Andalusi Music

Director Driss Mrini is the former director of the RTM (Radio et Television Marocaine) and uses the tropes of Andalusi music to embed the complex story of Jewish departure, pain, and a truncated forbidden relationship in his 2015 film *Aïda*. Through Aïda's return to Morocco for a concert, she is able to reconnect to the forgotten traditional lifestyle that Moroccan Jews continue to this day. Throughout the movie, Aïda is haunted by images of her own death, and her fear at being buried alive. She wakes up from nightmares of having tarantulas walking on her body, seeing her body plunging into dark, deep waters, and knocking from within a casket as she sees the men bury her during her funeral. These death and fear scenes are immediately countered with scenes that show the ubiquity of live music that permeates her visit in Morocco, in the synagogue, in Essaouira with Gnawa musicians and Andalusian musicians, or in Rabat during rehearsals for her planned charity concert. These musical scenes represent her vitality and eventually lead her back to health.

Aïda, an expert of Andalusi music and a professor in Paris, returns to Rabat with an incurable brain cancer that is apparently caused by her deep

discontent in being rootless. This film is the only one out of the four here analysed that portrays Jewish rituals in the synagogue and in the home around a Shabbat table in various scenes when Aïda returns to Rabat and visits her sister's home and their family synagogue. This seems to imply that Moroccan Judaism and religious ritual are interconnected for Mrini. During her visit to the synagogue, while the men are singing the traditional Hebrew prayers, Aïda confesses to her sister that she has never been happy, and she believes this is the cause of her cancer. She concludes by saying, 'Tu as de la chance d'être restée au Maroc'.[20] The image immediately cuts to the men's voices and their Hebrew song, as the viewer is left with her bitterness at having chosen education and emancipation in France over tradition and marriage in Morocco.

In the same manner, Mrini's cinematic representation shows traditional Moroccan life as interconnected with Andalusi music and its public and private performance. Not only does the main character connect with the lost traditions of Moroccan Judaism, but when in Rabat, she seeks out her former Muslim boyfriend and reconnects with him, while always remembering the words of admonition from the women in her family about staying away from the Muslim boy. There is no romantic intention, just a deep human need to heal her past.

In this film, Mrini is able to capture the dichotomy between a profound identification with Moroccan culture and the social imperatives of the community towards their women to stay apart from the 'other'. Aïda heeded the women's advice, knowing that, when it could lead towards marriage and children born from an interreligious couple, it would be better to leave the country. The clash between the perfect communion through music and the breakdown of this communion with love is the irony evident throughout the film. Alexandra Chreiteh writes,

> The promise of resurrecting a past of *convivencia* largely operates in *Aïda* through the trope of Andalusian music. In her French classroom, Aïda lectures that Muslim, Jewish, and Christian harmony was transported to Morocco after the Inquisition of 1492. We are constantly reminded that Aïda and Youssef's musician fathers performed together for the affective community of Essaouira neighbours. In an effort to reconnect with Youssef, Aïda encourages him to play with an Andalusian troupe that performs in Arabic and Hebrew [...]. As Aïda shows, the affective nature of aural cohabitation might momentarily succeed in building alternative spaces. (Chreiteh 2018: 270)

[20] 'You are lucky to have stayed in Morocco.'

218 *Jewish-Muslim Interactions*

It is worth noting that it is Mrini, a filmmaker who represents the *makhzen* because of his previous government post, who uses the tropes of Andalusi music around the themes of *convivencia* that the Moroccan state has been espousing in the last ten years through music, film, festivals, and the written press. He also uses a play on the word Aïda, which in Arabic (*aidah*) means the returning one, as the title for the film (Bellarabi, 2018: 14); Aïda is the one who returns – to Morocco, to herself, to her previous relationships and lifestyle. However, at the end of the film, after her cancer has been miraculously healed by her reintegration into her truncated Moroccan life, she dies in a sudden traffic accident, while the orchestra she had sponsored and prepared in rehearsal is performing at the National Mohammed V Theatre. She, like the young Youri in *Marock*, is not allowed to live out her fulfilment. Death appears as the only alternative.

To summarize, in *Marock*, rock's connection to forbidden interreligious love and the death of a Jewish protagonist demonstrate the dangers of too intimate a connection between young Muslims and Jews. *Où vas-tu Moshé?* uses Andalusi music and chaâbi to present forbidden interreligious love and emigration from Morocco, alongside the issues of both connection and disconnection between Jews and Muslims and within their communal groups. *L'Orchestre de minuit* employs chaâbi music to elucidate the issues around emigration from Morocco and return to Morocco after years of exile, using the catalyst of the death of a Jewish protagonist. Finally, *Aïda* presents all four thematic elements: forbidden interfaith love, emigration from Morocco, return to Morocco after years of exile, and the death of a Jewish protagonist surrounded by the sounds, experiences, and performances of Andalusi music, in a bittersweet evocation of the rupture in Moroccan *convivencia*.

Conclusion

The four films analysed above use diegetic music as an additional character in order to highlight the uncomfortable negotiation around the connection and disconnection of Jewish and Muslim Moroccans during the twentieth and twenty-first centuries. The dance between *marocanité* and the 'outsider' character of many contemporary Moroccan Jews is addressed in varying ways in these films. *Aïda* and *L'Orchestre de Minuit* present Jews who have spent so many years outside of Morocco that they are torn between their new persona and their original and 'true' essence. Youri and Shlomo have never left, but are also considered outsiders in their own country. Solomon explains that 'music is an especially powerful tool for articulating diasporic consciousness' (2015: 214). *Aïda* and *L'Orchestre de Minuit* play on the primordial impetus of music as a call of return to the *bled* for healing. Youri and Shlomo find

Daniel Schroeter's statement that 'scholarship has all but ignored new patterns of coexistence, modern developments that enabled new encounters and a common ground to develop between Jews and Muslims in the period before the mass exodus that began in the late 1940s' (2016: 43–44) has been addressed with this study. Showing how music is portrayed in these films as 'glue' in the encounters between Muslim and Jewish characters demonstrates these alternate patterns of coexistence, outside the marketplace and the legal political realm, which have been the usual areas of scholarly focus. Through the use of traditional, popular, and contemporary music (Andalusi, chaâbi, and rock), the cinematic audiences are presented with a variety of musical situations in which Muslim and Jewish characters interact with music as the recurrent connecting element between them. Within these films, music acts as a connection between Jews and Muslims regarding the forbidden, such as interreligious relationships and alcohol consumption by Muslims. However, it is not so much the *sound* of this music that creates the connection as the very *embodiment* of music, its quasi-corporeality: the songs themselves, the tangibility of the spaces and experiences created while performing music on screen. Music represents vitality, health, happiness, and the non-fractured state of their lives pre-emigration. This embodied music is what drives the common supra-narrative of these different films. It is the *entity* of music itself that lives in the spaces and moments inhabited by Jews in Morocco. This very entity continues to exist even after the quasi-disappearance of the Moroccan Jewish community – the phantom limb. Both Cohen-Olivar and Mrini, whose films were produced in the aftermath of the 2011 Constitution, stress their characters' recurring memories of shared musical moments that can be reclaimed in contemporary Morocco. Both of their returning Jewish characters have a debilitating physical illness (deafness and cancer, respectively) that this shared music-making heals during the course of the film. The new national reality of institutional pluralism and post-Constitutional reform allows these filmmakers to present not only Jews living in Morocco (as do Marrakshi and Benjelloun pre-2011), but also those who emigrated during the years after the 1967 war that were the most difficult years in Moroccan-Jewish relations.

The 'social glue' of music (Solomon, 2015) operates between these populations that are disconnected either by social and religious laws (*Marock, Aïda*), by moments in history (*Où vas-tu Moshé?*, *L'Orchestre de minuit*), or by exile (*L'Orchestre de minuit, Aïda*). What I have demonstrated in this chapter is that, in its repeated appearances as a character or as the force connecting the disconnected (or potentially disconnected) Muslim and Jew

220 *Jewish-Muslim Interactions*

in recent Moroccan filmmaking on Muslim-Jewish interactions in Morocco, music is the most fundamental character in the casting of a film. These filmmakers demonstrate through their choices of diegetic music that the contemporary fractures between Jews and Muslims – caused by emigration, religious practice, or Middle Eastern politics – are healed and erased through embodied music.

Works Cited

Bellarabi, Ikram. 2018. *Routes and Roots: The Representation of the Jewish Returnees on the Moroccan Big Screen*. Paper submitted for the license in English studies, Department of English Studies, Mohammed V University, Rabat.

Benjelloun, Hassan (dir.). 2007. *Où vas-tu Moshé?*

Ben-Layashi, Samir, and Bruce Maddy-Weitzman. 2010. 'Myth, History and Realpolitik: Morocco and its Jewish Community'. *Journal of Modern Jewish Studies* 9: 89–106.

Boum, Aomar. 2013. *Memories of Absence: How Muslims Remember Jews in Morocco*. Stanford: Stanford University Press.

Chreiteh (Shraytekh), Alexandra. 2018. 'Haunting the Future: Narratives of Jewish Return in Israeli and Moroccan Cinema'. *The Journal of North African Studies* 23: 259–77.

Cohen-Olivar, Jérôme (dir.). 2015. *L'Orchestre de minuit*.

Eriksen, Thomas Hylland. 1991. 'Ethnicity versus Nationalism'. *The Journal of Peace Research* 28: 263–78.

Gordon, Noah. *The Last Jew: A Novel of the Spanish Inquisition*. New York: Macmillan, 1992.

Hirchi, Mohammed. 2011. 'The Ethics and Politics of Laila Marrakshi's "Marock"'. *South Central Review* 28: 90–108.

Kosansky, Oren, and Aomar Boum. 2012. 'The "Jewish Question" in Postcolonial Moroccan Cinema'. *International Journal of Middle East Studies* 44: 421–42.

Marrakchi, Laïla (dir.). 2005. *Marock*.

Mrini, Driss (dir.) 2015. *Aïda*.

Neumeyer, David. 2009. 'Diegetic/Nondiegetic: A Theoretical Model'. *Music and the Moving Image* 2: 26–39.

Rosen, Lawrence. 1984. *Bargaining for Reality: The Construction of Social Relations in a Muslim Community*. Chicago: University of Chicago Press.

——. 2002. *The Culture of Islam*. Chicago: University of Chicago Press.

Schroeter, Daniel. J. 2016. 'The Changing Landscape of Muslim-Jewish Relations in the Modern Middle East and North Africa'. In Heleen Murre-van den

Berg and Sasha Goldstein-Sabbah (eds.), *Modernity, Minority, and the Public Sphere: Jews and Christians in the Middle East*. Leiden; Boston: Brill: 39–68.

Solomon, Thomas. 2015. 'Theorizing Diaspora and Music'. *Urban People* 17: 201–19.

Wyrtzen, Jonathan. 2015. *Making Morocco: Colonial Intervention and the Politics of Identity*. Ithaca: Cornell University Press.

Jerusalem Blues: On the Uses of Affect and Silence in Kamal Hachkar's *Tinghir-Jérusalem: Les échos du Mellah* (2012)

Jamal Bahmad

Introduction

The Moroccan-French director Kamal Hachkar's debut documentary film *Tinghir-Jérusalem: Les échos du Mellah* ['Tinghir-Jerusalem: Echoes from the Mellah'] was the subject of much public debate in Morocco after its first airing on television in 2012. What was intended by the young director as a feature film about his feelings of nostalgia and attachment to the past of his hometown's Jewish community touched many nerves in the Moroccan political scene and wider society. The airing of the documentary on the state television channel 2M in April 2012 and its subsequent inclusion in the official selection of the National Film Festival in Tangier in February 2013 were enough to get Moroccan political parties, several public intellectuals, and civil society in general talking heatedly about the film for months on end (Bahmad, 2013). *Tinghir-Jérusalem*'s illustrious tour in the international festival circuit where it garnered many accolades and much critical acclaim in the following months further intensified the debate between the film's supporters and detractors. The present chapter opens with a short introduction to the life and times of Moroccan Jews in Morocco with a particular focus on Tinghir, followed by a brief account of the political reception of Hachkar's documentary film in Morocco, before moving to explore the documentary's reliance on the potentialities of affect and silence in exploring Tinghir's Jewish community between the past

223

224 *Jewish-Muslim Interactions*

and the present. This affective use of silence traverses the film's narrative voice as well as the characters' acts of past remembrance and speculation about the future of a millennial community that is today faced with loss and disappearance. The close analysis of Hachkar's *Tinghir-Jérusalem* is anchored by reflections on the uses of the affective power of silence on the screen, which will be explored critically through a Deleuzian framing of the non-representationality of affect.

Tinghir-Jérusalem opens with the young director en route from France, where he has lived with his parents since a very young age, to his native hometown, Tinghir, in southeastern Morocco. Until the 1960s, the market town of Tinghir was the Jerusalem of the desert with a significant Jewish community living side by side with the Amazigh (Berber), mostly Muslim, inhabitants of the town and its environs (Zafrani, 2005: 205). Hachkar's father, who features in the documentary through a Skype conversation with one of his own father's acquaintances now living in Israel, was born and came of age in this multi-faith and multicultural town before emigrating to France in the late 1960s like large numbers of the youth of the region. The film director's father migrated in search of better job opportunities, which were in great supply in the French mining and car industries (Ageron, 1985; Belbah and Veglia, 2003). Other native sons and daughters of Tinghir left for other reasons: most of the Amazigh town's old Jewish community also left at about the same time. Many migrated as part of the first wave of *aliyah* ('ascent') or mass migration to Israel in legal and secret voyages financed by the World Zionist Organization (WZO) and the American Jewish Joint Distribution Committee (AJDC), and organized by the Jewish Agency aided by other local Zionist agencies including Mossad Le'Aliya and, later, the Alliance Israélite Universelle (AIU), the main Jewish agency operating in Morocco since the nineteenth century (Laskier, 1994, 87–88; Kenbib, 2016: 168–69). This first wave of *aliyah* constituted a dramatic chapter in the history of Moroccan Jewry and other Jewish communities across the Muslim world. As historian Zvi Yehuda states,

> The mass immigration of Jews from Muslim countries to Israel in the twentieth century is an historical phenomenon yet to be satisfactorily explained. It is true that Jews wandered from country to country throughout history, and even entire Jewish communities were occasionally uprooted from their dwelling places. However, the uprooting of a Jewish community from the land in which it had lived for hundreds of years, and its transfer *en masse* to the Land of Israel, has occurred only in our time, and only from Muslim countries. (Zvi Yehuda 1985: 199)

Even before the creation of the Jewish state in 1948, Moroccan Jews had witnessed the strong mobilization of the Alliance Israélite Universelle, the Paris-based international Jewish organization established in 1860, whose primary function was to educate and 'modernize' Sephardi Jews according to French cultural norms and ideals (Kenbib, 2016: 56–58), but that later also contributed to preparing many of these Jews to migrate to Eretz Israel from the Diaspora (Boum, 2010: 15; Laskier, 1989: 337–41). Until the 1960s, Morocco had the largest Jewish community in North Africa and the Middle East outside Palestine. The existence of this community dates back to the exodus of Jews from the Middle East as early as 70 CE. Larger numbers of the indigenous Amazigh inhabitants of Morocco and across North Africa converted to Judaism and boosted the size and influence of the community (Feros, 2014: 90). The population further increased in size following the expulsion of Jews and Muslims from Spain in 1492. This living together in relative harmony between the Sephardi Jewish community and Muslims in Morocco continued until the mid-twentieth century.

The Land of Israel had always held a special place in the hearts and minds of Moroccan Jews:

> The traditional Jewish relationship to the Land of Israel and the messianic faith in the revival of Jewish independence and the redemption of the Jewish people from the oppression of exile, were still part of the spiritual baggage of the overwhelming majority of Moroccan Jewry in the first half of the twentieth century. (Yehuda, 1985: 199)

The intensive mobilization of international Zionist organizations such as the Jewish Agency and Mossad Le'Aliya, the birth of Israel and its dire need for Jewish settlers, and the rise of antisemitism in a post-colonial Maghreb under the hegemony of Arab nationalist parties and ideologies such as Nasserism, led to the exodus of Moroccan Jews to Palestine, with the better-off members of the community often opting to stay in Morocco or go to live in Europe and North America. The Jewish community in Morocco has declined from 250,000 in 1950 to less than 2,000 today (Haj-Hamou, 2018). The remaining Jews in the Kingdom are mostly elderly and concentrated in big cities, especially Casablanca. Inner towns like Tinghir have completely lost their millennial Jewish populations. Only oral memories are left today of this community, whose members and their offspring occasionally return as tourists or pilgrims for religious festivals, or to visit what remains of their homes or those of their parents and ancestors (Boum, 2013; Levy, 1997: 25; Driver, 2018: 47).

The Eloquence of Silence

It was against this gloomy backdrop that Hachkar conceived and made his film. A high-school history teacher in Paris and the son of a family of Moroccan immigrants from Tinghir, Hachkar was belatedly exposed to the history of his native town's Jewish community through the oral memories of his parents and the inhabitants of Tinghir during the family summer holidays, which his parents spent in Morocco every year. The ethnically mixed Jewish quarter of Tinghir still stands even though today its habitable parts are exclusively lived in by Muslim Amazigh families, as portrayed in the first part of *Tinghir-Jérusalem*. After his arrival in Tinghir in the first scenes of the film, Kamal visits the old Jewish quarter. He is shown around by his grandfather, who lived next door to Tinghirian Jews. The tour is charged with affects of nostalgia, incomprehension, and helplessness in the face of an entire community's loss. The culturally traumatic loss haunts the vacant houses and alleys of the old town. Asked about their feelings in the heat of the moment, the grandfather and other interviewed elders of Tinghir try to put into words their affects and affections for their lost friends and neighbours. Words prove insufficient to render what they feel. The drama is beyond words and representation. Human affects, as Gilles Deleuze and Felix Guattari assert, 'go beyond the strength of those who undergo them' (1994: 164). In his translator's notes to Deleuze and Guattari's *A Thousand Plateaus: Capitalism and Schizophrenia* (1987), Brian Massumi defines affect as 'a prepersonal intensity corresponding to the passage from one experiential state of the body to another and implying an augmentation or diminution in that body's capacity to act' (2005: xvi). Unlike basic human emotions, affects, both in everyday life and in the arts, are pre-personal and impossible to represent fully and adequately. Their power lies in this defiance of the language and codes of representation. For Deleuze and Guattari (1987), affects act as intensive variations of feeling or 'passages as of intensity, a reaction in or on the body' (O'Sullivan, 2006: 4). Affects are autonomous and non-representational. Affect's capacity to escape individual control and representation in everyday life and the arts has been conceptually captured by Massumi's notion of the 'autonomy of affect' (1995: 83). In this Deleuzian perspective, affect is 'a nonsignifying, nonconscious "intensity" disconnected from the subjective, signifying, functional-meaning axis to which the more familiar categories of emotion belong' (Leys, 2011: 441). In her elaboration on Deleuze and Guattari's conceptualization, Claire Colebrook comments: 'Affects are sensible experiences [...] liberated from organizing systems of representation' (2002: 22). As the characters of Hachkar's documentary demonstrate below, affects surrounding loss, nostalgia, and silence are 'felt as differences in intensity' (O'Sullivan, 2006: 169).

On the Uses of Affect and Silence 227

Hachkar's debut documentary film is punctuated by short and long moments of silence. These moments, which can be seen as unofficial memorials, often communicate better than what the characters are trying to convey with words. This is one of the unique strengths of the film and what makes it a memorable watch. It opens up the painful book of the past and leaves it to the viewers to feel and account for their feelings. This is an especially poignant experience for those members of the audience directly affected by the experience of Jewish mass migration from Morocco. This affective framing of history through silence and the present experiences of Tinghirian Jews living in Israel, and of their Muslim neighbours and acquaintances left behind in Tinghir or now dead was arguably intended by Hachkar to speak to his audience through their own affects. The affective viewing of the film allows the viewer to relate more and show empathy to the people featured in the documentary and their communities. Affective images, as Jill Bennett notes, can produce 'a form of empathy that is more complex and considered than a purely emotional or sentimental reaction' (2005: 24). Combining affective and intellectual modes of perception, this empathy involves 'a constant tension of going to and fro [...] of going closer to be able to see, but also never forgetting where you are coming from [...] empathy is about that process of surrender [...] but also the *catch* that transforms your perception' (Papastergiadis cited in Bennett, 2005: 10). *Tinghir-Jérusalem*, as we will see, triggers such moments of empathy that go beyond mere transient emotions. Empathy is effectively (and affectively) a mode of seeing built into the film.

But it was not these silences and their affective framing of the history of a small community that led to protests against the film in Morocco in 2012. It was rather the fact that the filmmaker had visited and shot parts of his film in the state of Israel. Visits to and interviews with former Tinghirian and other Moroccan Jews in different parts of Israel form the bulk of the documentary. The state of Israel is the object of real and imaginary boycotts among Moroccan political parties, Islamist associations, and pan-Arabist organizations. In reality, however, Israeli citizens do not need a formal visa to visit the country and the trade volume between the two countries is significantly high and continues to rise (Shehadi, 2018). In 2012, Morocco's largest Islamist political party, Justice and Development Party (PJD), and several pan-Arabist left-wing activists, including the Jewish-Moroccan militant Sion Assidon (a leading member of the Moroccan chapter of Boycott, Divestment and Sanctions), opposed the screening of Hachkar's film on 2M and at different film and cultural events in the country. They called on the government to ban it altogether because of what they saw as the film's normalization of relations with Israel, which they thought should be boycotted because of the

Arab-Israeli conflict. This call to ban or boycott *Tinghir-Jérusalem* came to a head during the National Film Festival in Tangier in February 2013. The boycott campaigners organized a sit-in outside the Roxy Cinema theatre in downtown Tangier, where Hachkar's documentary was about to be screened (Bahmad, 2014: 312). The festival organizers, led by the Moroccan Cinema Centre (CCM) with the secular intellectual Noureddine Sail at its head at the time, went ahead with the screening. Sail advocated that the general public should be allowed to watch the film before they pass judgement on it (Rhanem, 2013).

Following this heated reception, the film has often been seen through the narrow frame of politicized readings, thus missing the importance of critical readings of the work. In what follows, I propose a critical analysis of the film's representation of the past, present, and future of a numerically declining community through the affective lens of silence. The film, as already mentioned, is affectively charged and uses silence to speak to the viewer. Its use of the affective power of silence is twofold: first, it enables its subjects to evoke and address the traumatic past without the need to express verbally otherwise inexpressible and painful emotions; second, it allows the viewer to connect with the filmed community and its traumatic past without passing judgement. However, this affectivity of silence and memory and its uses in *Tinghir-Jérusalem* is never a straightforward affair. Affects, Deleuze and Guattari argue, are complex bodily and non-bodily emotions and energies with the power to defy the capacity of human language to represent them. This is especially poignant in works of art. Art is essentially 'a bloc of sensations, that is to say, a compound of percepts and affects' (Deleuze and Guattari, 1994: 164). Even more than ordinary emotions, affects are overwhelming by nature, hence the tears, long moments of silence, and confusing feelings among Hachkar's interviewed characters. Like other films made in recent years about the Moroccan Jewish community – including *Où vas-tu, Moshé?* ['Where Are You Going, Moshe?'] (2007), *Pour une nouvelle Seville* ['They Were Promised the Sea'] (2013), and *Return to Morocco* (2014) – *Tinghir-Jérusalem* is an affective film that relies on the eloquence of silence at key moments in the documentary. The films' affective language serves to tackle a topic that is still taboo in a Moroccan society where people do not yet fully understand the reasons behind the loss of the Jewish community and the enigmatic political and historical circumstances of the *aliyah* (Kosansky and Boum, 2012). The enigma and trauma of the event are such that they do not allow a more direct and factual film approach at the present moment in the history of Moroccan Jews and their global dispersion. In every film on the subject, both Jews and Muslims are at a loss for the right words to describe what happened and their feelings about it. Despite his eloquence and calm demeanour, the director's

grandfather in *Tinghir-Jérusalem* is akin to other characters in not being comfortably able to put into words the complexity of the trauma. He leaves it to long stretches as affectively charged moments to say what words alone cannot convey. When asked by the director about how he would have felt if he had to leave Tinghir himself without the prospect of ever coming back (like the Jewish members of the community fifty years previously), the old man immediately answers that it would have been impossible to leave his hometown under such circumstances. His answer leaves no room for doubt: '*La... la... Ma... mimk itg ad fey Tinghir? Mis yer teddux?*'[1] The director then asks him about what he and the Muslim population of Tinghir thought when their Jewish friends and neighbours were leaving Tinghir en masse. He responds, '*Eh... mas tinit? Mas tinit? Da nttini: "Shuf ddan igllin xwan tamazirt nsn. Tamazirt ns awd ntini ayd tesmma Tinghir"*'.[2] After a few moments of silence and thoughtful searching for the right words to put on his emotions, the old man adds: '*A-halak aynna gd tlulit, tgmt dis, hat tamazirt nk aynnax. Han taddart nk, han... tznzt kukchi txwuttit. Bssif nadak ishqqu lhal!*'[3] Despite the great efforts of the grandfather to control his emotions in the expression of sympathy for his lost Jewish countrymen, his mood betrays a deep and affective unease, which translates into a long silence after saying the lines quoted above. The camera zooms in on his face, which conveys the old man's genuine sadness and affective loss. Taking his cue from Deleuze and Guattari, Massumi argues that affect is not 'semantically or semiotically ordered', but 'is embodied in purely autonomic reactions most directly manifested in the skin – at the surface of the body, at its interface with things' (2002: 24–25). Hachkar's grandfather remains quiet and contemplates the skyline of Tinghir against an uncertain horizon. Pierre Janet and Bessel van der Kolk fittingly assert that 'traumatic memory is of a "non-declarative" type, involving bodily responses that lie outside verbal-semantic-linguistic representation' (cited in Bennett, 2005: 230). The old man's silence in *Tinghir-Jérusalem* signals the incapacity of words to express what he wants to say and how sad he feels. His silence is eloquent and allows the empathic viewer to identify with him as well as with the lost Jews of Tinghir, who are missed by the people they left behind.

The same affective charge of past remembrance and the eloquence of silence in trying to come to terms with loss through one's manifest and

[1] 'No... I could never leave Tinghir. Where would you want me to go?' All translations are by the author of this chapter.

[2] 'Eh... What did we say? What did we say? Well, we said: "Poor them, they are leaving their home, Tinghir. Tinghir is their home, too"'.

[3] 'The place where you were born and grew up, that is your country. You have a house... and suddenly you have to leave it. It's bound to be hard!'

230 *Jewish-Muslim Interactions*

hidden affects recur throughout the film. In Yavne, a city in the Central District of Israel, Hachkar meets Shalom Ilouz, who left Tinghir as a teenager in the 1960s. Shalom still speaks perfect Tamazight, the Berber language. He and Hachkar sit together and make a surprise video call to the director's father in Morocco, where he has just returned to live after reaching retirement in France. The Skype conversation starts with Hachkar telling his father that he has found somebody who knew his father. Shalom takes over and baffles Hachkar's father with his vivid memories of Tinghir in the 1950s and 1960s before both left their hometown for different reasons, one voluntarily in 1968 seeking a better future as a guest worker in France and the other forced by more complex circumstances to leave with his community as part of the great exodus of Moroccan Jews to the new state of Israel. Shalom knows the Hachkar family well and names several of its members, most of whom are now dead. In turn, Hachkar's father asks after some of his Jewish boyhood friends that he had known in Tinghir before he left for France. Shalom informs him that they are all long deceased. After the sad news of the death of acquaintances on both sides, Shalom is warmly invited twice in the conversation to visit Tinghir. As Kamal's father affectionately tells him, '*Iwa hat ixssa awd ky ad tddud s Tinghir, ad tzurt tamazirt nik. Lmyreb hat tamzirt nk ayd iga*'.[4] An emotional Shalom heartily accepts the invitation: '*Nsh'Allah! Nsh'Allah! Nniyt ad tnnit. Nsh'Allah, nsh'Allah ad nk.*'[5] The Skype conversation ends here, and Shalom becomes more emotional and ultimately tearful. He broods over his past and tells the director in short sentences with long silences in between:

> *Tinghir ahyyana! Nekkin ur djun tux Tinghir! Imddukkal... Llan yuri imddukkal imunslmn; nga imddukkal n lm'qul... Am Lhcen n Ait Qeddi meskin, iga amddakl inu; ar itxyyat serawl, ar itxyyat lqmayj. Nekkin ids nga imddukkal... Meskin! Ali, awd Ali bu girru dex, iga amddakl inu igllin [sg may] nsul nmzziy. La Lhcen wala Ali... Iwa luqt, mayrad tgt? Aynna ira Sidi Rebbi...*[6]

Shalom's silences, like those of the director's grandfather earlier, are eloquent, and fulfil two functions: allowing the characters to express what they are

[4] 'You must come and visit Tinghir. This is your country here. You are always welcome'.

[5] 'You're right. God willing, I will visit.'

[6] 'O Tinghir! I never forgot Tinghir... I had Muslim friends; we were really good friends... Like Lahcen n'Ait Kadi; he was a tailor. We were very close... Poor him!... Even Ali the cigarette seller was a great friend... They were all young... That's life... We're in the hands of God...'

On the Uses of Affect and Silence 231

incapable of saying with words, and enabling the audience to identify with them and their plight.

The same scenario is repeated many more times in the film. Israelis of Moroccan descent are happy to meet the director and talk to him. Sometimes they have conversations over old family photos, which bring up a lot of happy memories. The happiness is always cut short immediately when characters remember what they have lost by leaving their millennial homeland. This affective uncertainty and loss lends credence to Salman Rushdie's apt description of the exilic condition in his novel *The Satanic Verses*:

> Exile is a dream of a glorious return. Exile is a vision of revolution: Elba, not St Helena. It is an endless paradox: looking forward by always looking back. The exile is a ball hurled high into the air. He hangs there frozen in time, translated into a photograph; denied motion, suspended impossible above his native earth, he awaits the inevitable moment at which the photograph must begin to move, and the earth reclaim its own. (Rushdie 1988: 205)

The poignant moments of silence and speechlessness in *Tinghir-Jérusalem* are shot through with nostalgia for the past when these Israelis of Moroccan Jewish origin lived in Tinghir. They were a thriving community. This past is remembered with a lot of fondness by the characters in the film. Indeed, nostalgia is the most prominent affect in the film. This nostalgia is ambivalent not least because the characters feel and convey in clear terms and through affective silence to the audience that there is nothing they could have done against the large forces of history behind their displacement. Nostalgia here is the condition of helpless people wishing things had gone a different way perhaps, but struck by the inevitability of exile. Nostalgia as both verbal language and an affect traverses the film to convey the saga of the displacement of a millennial community from its homeland to Israel and beyond. Here also, words prove insufficient. Silence and folk music step in to convey what words alone cannot transmit. In a key scene in the film, a charming old lady from Tinghir is delighted to meet the young and jovial director. They have a conversation about her and her family life in Tinghir. She breaks into songs of *ahidous* with Hachkar and another elderly woman from Tinghir. Soon afterwards, she is filmed angry and prone to silence. The cheerful lady is now melancholic and badly missing her life in Tinghir despite admitting that some tensions amounting to a clumsy silence had risen between Muslims and Jews after the creation of the state of Israel in 1948. However, she explains that this situation was normal and how the community lived in peace in the oases of Tinghir. She is sad to have left her homeland. Her silences at this stage in the film become longer and

longer. Silence speaks louder than words; it speaks even louder when human beings try to talk about and represent the uncontrollable forces of history behind their displacement and suffering. They feel helpless, passionate, and confused. The more the lady in Hachkar's film speaks, the more emotional she becomes until, like other characters, she cannot command her words any longer. She leaves it to silence and sad Amazigh and Hebrew folk songs about exile to say the rest. The rest is silence, music, and memory.

Conclusion

The history of the Moroccan Jewish community did not end with the mass migration of most of its members to Palestine and beyond following the creation of the state of Israel in 1948 and the complex politics of Morocco in the post-colonial period. While the community has shrunk in size from a few hundred thousand in the mid-twentieth century to about 2,000 today, the enigma of the *aliyah* and its memory still haunt works of art and other cultural productions dealing with the Jewish element of Moroccan identity. Talking openly about the *aliyah* is still fraught with tension in the Moroccan public sphere. The ongoing Israel–Palestinian conflict has only added more intensity to an already sensitive question. This complex situation was brought to light by the release and controversial reception of Kamal Hachkar's documentary film *Tinghir-Jérusalem: Les échos du Mellah*. While some of the controversy was expected, it is regrettable how cultural productions get too much caught in muddy political waters and little effort is spared for cultural and academic readings of such filmic and other artistic products. As the power of affect and silence in *Tinghir-Jérusalem* makes plain, the story of Moroccan Jews and the traumatic memory of the *aliyah* are complicated and worthy of serious analysis beyond the narrow frames of political developments in Morocco and Israel-Palestine.

Works Cited

Ageron, Charles-Robert. 1985. 'L'immigration maghrébine en France: Un survol historique'. *Vingtième siècle. Revue d'histoire* 7: 59–70.

Bahmad, Jamal. 2013. 'Tinghir-Jerusalem-Tangier: The Jew, the Imam and the Camera in Morocco'. *Africultures*, 13 February. Available at: http://www.africultures.com/php/?nav=article&no=11305 (consulted on 20 March 2019).

——. 2014. 'Between Tangier and Marrakech: A Short History of Moroccan Cinema through Its Festivals'. In Dina Iordanova and Stefanie Van de Peer (eds.), *Film Festival Yearbook*. St Andrews: St Andrews Film Studies Publishing: 306–17.

On the Uses of Affect and Silence 233

Belbah, Mustapha, and Patrick Veglia. 2003. 'Pour une histoire des Marocains en France'. *Hommes & Migrations* 1242: 18–31.

Benjelloun, Hassan (dir.). 2007. *Où vas-tu, Moshé?*

Bennett, Jill. 2005. *Empathic Vision: Affect, Trauma, and Contemporary Art.* Stanford: Stanford University Press.

Boum, Aomar. 2010. 'Schooling in the Bled: Jewish Education and the Alliance Israélite Universelle in Southern Rural Morocco, 1830–1962'. *Journal of Jewish Identities* 3: 1–24.

——. 2013. *Memories of Absence: How Muslims Remember Jews in Morocco.* Stanford: Stanford University Press.

Bruneau, Charlotte (dir.). 2014. *Return to Morocco.*

Colebrook, Claire. 2002. *Gilles Deleuze.* New York: Routledge.

Deleuze, Gilles, and Félix Guattari. 1987. *A Thousand Plateaus: Capitalism and Schizophrenia.* 2nd edn. Minneapolis: The University of Minnesota Press.

——. 1994. *What Is Philosophy?* New York: Columbia University Press.

Driver, Cory Thomas Pechan. 2018. *Muslim Custodians of Jewish Spaces in Morocco: Drinking the Milk of Trust.* London: Springer.

Feros, Juan. 2014. 'Rhetorics of the Expulsion'. In Mercedes García-Arenal and Gerard Wiegers (eds.), *The Expulsion of the Moriscos from Spain: A Mediterranean Diaspora.* Trans. by Consuelo Lopez-morillas and Martin Beagles. Leiden: Brill: 60–101.

Hachkar, Kamal, dir. 2012. *Tinghir-Jérusalem: Les échos du Mellah.*

Haj-Hamou, Kamil. 2018. 'Mais Où Sont Donc Passés Les Juifs Du Maroc?' *Al HuffPost Maghreb*, 14 February. Available at: https://www.huffpostmaghreb.com/kamil-hajhamou/mais-ou-sont-donc-passes-les-juifs-du-maroc_b_19229608.html (consulted on 30 September 2019).

Kenbib, Mohammed. 2016. *Juifs et musulmans au Maroc: Des origines à nos jours.* Prefaces by Michel Abitbol and Abdou Filali-Ansary. Paris: Tallandier.

Kosansky, Oren, and Aomar Boum. 2012. 'The "Jewish Question" in Postcolonial Moroccan Cinema'. *International Journal of Middle East Studies* 44.3: 421–42.

Laskier, Michael. 1989. 'Jewish Emigration from Morocco to Israel: Government Policies and the Position of International Jewish Organizations, 1949–56'. *Middle Eastern Studies* 25.3: 323–62.

——. 1994. *North African Jewry in the Twentieth Century: The Jews of Morocco, Tunisia and Algeria.* New York: New York University Press.

Levy, André. 1997. 'To Morocco and Back: Tourism and Pilgrimage Among Moroccan-born Israelis'. In Eyal Ben-Ari and Yoram Bilu (eds.), *Grasping Land: Space and Place in Contemporary Israeli Discourse and Experience.* Albany: State University of New York Press: 25–46.

Leys, Ruth. 2011. 'The Turn to Affect: A Critique'. *Critical Inquiry* 37: 434–72.

Massumi, Brian. 1995. 'The Autonomy of Affect'. *Cultural Critique* 31: *The Politics of Systems and Environments, Part II*: 83–109.

——. 2005. 'Notes on the Translation and Acknowledgments'. In Gilles Deleuze and Felix Guattari (eds.), *A Thousand Plateaus: Capitalism and Schizophrenia*. Trans. and foreword by Brian Massumi. Minneapolis: University of Minnesota Press: xvi–ix.

O'Sullivan, Simon. 2006. *Art Encounters Deleuze and Guattari: Thought Beyond Representation*. New York: Palgrave Macmillan.

Rhanem, Karima. 2013. 'Kamal Hachkar: "Muslim-Jewish Coexistence Should be Taught in Moroccan Schools"'. *Morocco World News*, 27 January. Available at: https://www.moroccoworldnews.com/2013/06/95802/kamal-hachkar-muslim-jewish-coexistence-should-be-taught-in-moroccan-schools/amp/ (consulted on 10 September 2019).

Rushdie, Salman. 1988. *The Satanic Verses*. London: Vintage.

Shehadi, Sebastian. 2018. 'The Open Secret of Israeli-Moroccan Business Is Growing'. *Middle East Eye*, 5 November. Available at: https://www.middleeasteye.net/news/open-secret-israeli-moroccan-business-growing (consulted on 20 March 2019).

Wazana, Katy (dir.). 2013. *Pour une nouvelle Seville*.

Yehuda, Zvi. 1985. 'The Place of Aliyah in Moroccan Jewry's Conception of Zionism'. *Studies in Zionism* 6.2: 199–210.

Zafrani, Haim. 2005. *Two Thousand Years of Jewish Life in Morocco*. New York: KTAV Publishing House, Inc.

A Newfound Voice from across the Mediterranean: Kamal Hachkar's *Dans tes yeux, je vois mon pays* (2019)

Miléna Kartowski-Aïach

Translated by David Motzafi Haller

A Homecoming

« Peut-être, faut-il l'exil pour que la parole coupée de toute parole – et dès lors confrontée au silence – acquière sa véritable dimension. » Edmond Jabès

Cette situation semble correspondre au destin de nombreux artistes marocains juifs et de tous ceux qui, appartenant à la « troisième génération », ont été confrontés le plus souvent au silence, à l'absence de récit ou pour le moins à des bribes de souvenirs. Tous ces artistes en chantant, en peignant, en écrivant, tentent de recoller les morceaux d'une histoire interrompue. [...]

Exilé sans exil, l'interrogation surgit de ces bribes de mémoire de ceux qui nous ont précédés. On peut y voir un parallèle avec mon histoire d'enfant d'immigré sauf que j'ai encore une maison, des liens forts avec mon territoire d'origine. Alors que ces artistes n'ont plus ce lieu, et cette attache concrète de la maison, là où leurs ancêtres ont vécu sur leur terre natale.[1]

[1] Kamal Hachkar, *Dans tes yeux, je vois mon pays*, director's statement: "'Perhaps exodus and exile were indeed needed so that the word cut off from all words – and thus confronted with silence – could acquire its true dimension" Edmond Jabès [trans. by Joris, 2010: 68].

This situation seems to correspond to the fate of many Jewish Moroccan

236 *Jewish-Muslim Interactions*

Young French-Moroccan filmmaker Kamal Hachkar, born in the Amazigh village of Tinghir in the Atlas mountain range, chose a particularly striking name for his new film following the return of Neta Elkayam[2] and Amit Hai Cohen[3] – a Jewish Israeli artist couple of Moroccan descent living in Jerusalem who explore Jewish Moroccan music (particularly chaâbi) in their creative work[4] – to Morocco, their 'homeland'. This article, based on my doctoral research,[5] will analyse some key questions posed by this new cinematic opus both through insights gained from watching rushes and by means of an ethnographic study of the creative processes, led by filmmakers and artists alike, in Morocco, France, and Israel. In his documentary film, *Dans tes yeux, je vois mon pays* ['In Your Eyes, I See My Country'], Hachkar recounts the Odyssean return of these young Israeli artists to Morocco – a land that they feel themselves to be a part of, but also cut off from.

Indeed, upon their arrival in the 'promised land', Israel, Jews from the Arab-Muslim world were made to shed off their diasporic cultures and languages, and particularly their Arab-ness in order to become Israelis, a national collectivity that construed much of its identity in opposition to Palestinians, considered 'enemies' of the state (Shohat, 1988). These Jews

artists and all those who, as members of the "third generation", have been frequently confronted with silence, the absence of narrative or at most only snippets of memories. Through singing, painting and writing, these artists try to piece together the fragments of a disrupted history.
[...]
Exile without exile, the questioning arises from these fragments of memory handed down to us by those who precede us. You can see a parallel with my story as an immigrant child, except that I still have a house, and strong links to my home country, whereas these artists don't have that anymore, they have no concrete attachment to the house where their ancestors lived on their native land'. This director's statement is part of an artistic file compiled by Hachkar, which presents his project for the documentary *Dans tes yeux, je vois mon pays*, detailing his cinematographic intentions.

[2] Website of the singer and visual artist Neta Elkayam: https://www.netaelkayam.com (consulted on 6 August 2019).

[3] Website of the musician and filmmaker Amit Hai Cohen: https://www.amithaicohen.com (consulted on 6 August 2019).

[4] Moroccan chaâbi music is a popular music genre sung generally in Arabic. Numerous Jewish artists made a significant contribution to the spread and popular renown of chaâbi music during the 1940s and 1950s.

[5] Miléna Kartowski-Aïach, 'Un chant d'exil et ses échos en terre promise. L'art politique Mizrahi et ses devenirs, vers un Israël des possibles/un autre Israël?' PhD dissertation, in progress.

A Newfound Voice from across the Mediterranean 237

of the Magrib and of the Mashriq, baptized 'Mizrahim' in Israeli parlance,[6] were effectively precluded from reproducing their complex identities, which fused Jewish and Arabic influences from across the Middle East and North Africa. This broke the chain of intergenerational transmission and produced a historical trauma that is today resurfacing once again among third-generation Israeli Mizrahim who have begun an independent investigation into their roots. We might turn to the concept of 'postmemory', coined by Marianne Hirsch, to lend insight into the intergenerational heritage and trauma that pervades this young Mizrahi generation. Postmemory, Hirsch writes, relates to a relationship where 'the generation after' preserves the 'experiences of those who came before, experiences that they "remember" only by means of the stories, images, and behaviours among which they grew up' (2008: 106). And yet, the director's use of the term 'natal' ['native'] begs the question of how and why would you feel so attached to a land you had never been to, and could, very possibly, indefinitely revoke your right of entry to?[7] For Hachkar, 'la terre natale est le lieu de l'enracinement mental et affectif':[8] it is a subject of poetic longing, an emotional and spiritual connection in no way reducible to the confines of nationalism. Homecoming means reconnecting with one's ancestral lands, with one's realms of memory but also with the horizons of one's imagination. Finding such a mythical place from which our family supposedly originates is to both ground ourselves and put concrete images on what could have otherwise continued to haunt us in silence. Hirsch writes that 'to grow up with such overwhelming inherited memories, to be dominated by narratives that preceded one's birth or one's consciousness, is to risk having one's own stories and experiences displaced, even replaced, by those of a previous generation' without recognizing, much less understanding, these handed-down fragments of memory we inhabit in spite of ourselves (2008: 107).

Alternately an interlocutor, a director, and a silent witness to the events on screen, Hachkar assumes a major role in this film, which he calls an 'acte de réparation' ['a reparative act']. The attempt to weave anew the threads between Morocco – a country he himself had also emigrated from – and its Jews is an effort to break the historical and commemorative silence that had, for decades, stifled discussions on the subject. His is a desire to acknowledge

[6] 'Mizrahi', meaning 'oriental', is a term used in Israel to refer to Jews from the Middle East and North Africa. See Shohat (1999).

[7] Israeli citizens are currently barred from many Arab Muslim-majority states, including Israelis born in those countries or whose families originate from there.

[8] Interview with the director, December 2018: 'The native land is a place of mental and emotional rootedness'.

and restore Jewish Moroccan culture, which he considers an indispensable component in Morocco's cultural mosaic, using artistic expression to 'réunir ceux que l'Histoire a séparés si souvent dans les anciens empires coloniaux',[9] as Leïla Sebbar puts it in her preface to the edited collection *Une enfance juive en Méditerranée musulmane* (2012: 12).

In Morocco, Hachkar accompanies the young Israeli artist couple to the villages where their parents were born: Neta Elkayam to Tinghir and Amit Hai Cohen to Tizgui. In the labyrinths of the mellah in Tinghir, the city where Hachkar too was born, the three try to find Neta's familial home, and, with it, a confirmation of her family's place in the history of Morocco. The few traces left behind, however, are intangible, and the elders, guardians of the community's memory, are gone.[10] Neta subsequently tries to locate her last name in the municipal records, but finds nothing. The clerk asks her if she has a family record book, a passport, anything official. But she does not. All the documents had been confiscated when her family took flight, she explains. At the mellah she continues to interrogate everyone, painstakingly pursuing every possible lead. But no one remembers anything about the possible whereabouts of her familial home. The wound of 'l'exilé sans exil' ['the exile without exile'], in Hachkar's diagnosis, is acutely felt when one tries, and fails, to find the residue of the past, the familial home, and is therefore unable to (re-)inscribe the self onto a lost 'terre natale' ['native land']. The exile without exile lives with the unresolved pain of their ancestors etched in their bones, since while 'the effects of trauma are inscribed in the body', Hirsch postulates, they could also be transmitted to the bodies of one's descendants: 'These events happened in the past, but their effects continue into the present' (2008: 107). Is it the hope of healing this affliction that animates Neta's determination to trudge through the exhausting and often bewildering administrative official procedures to get her Moroccan passport? Is it an attempt to officialize her Morocanness? Is it a symbolic way to reinvest herself in her Moroccan identity, to redress the unresolved trauma of departure that she had inherited?

Hachkar often speaks of an 'alyah renversée' ['reverse *aliyah*'],[11] reclaiming the concept to provocatively invite the young generation of

[9] 'reunite those who the history of the former colonial empires has torn asunder'.

[10] Here the term 'elder' designates older Amazighs who lived together with Jews prior to the latter's mass emigration from Morocco when the French protectorate ended in 1956. The elders are the guardians of the community's memory and are the last ones who remember a Jewish presence in the Moroccan Atlas Mountains.

[11] Aliyah is a Hebrew word (Heb. עליה or עליות, pl. alyoth, lit. ascent) used to describe the act of a Jew immigrating to the Holy Land – Eretz Israel, in Hebrew.

A Newfound Voice from across the Mediterranean

239

Moroccan Jews born in the diaspora to (re-)discover the land of their ancestors, Morocco. He squarely poses here the political question which haunts him, 'qu'est-ce que le pays véritable, la terre natale?'[12] For Neta and Amit, there is no single country, but rather several different symbolic spaces of belonging. In their filmed visit to the mellah of Tinghir, standing either side of the director's father Ahmed, Neta and Amit cite in Hebrew, and then translate into Arabic, a famous lament by the twelfth-century *hakham* Rabbi Yehouda Halevy: 'לִבִּי בְמִזְרָח וְאָנֹכִי בְּסוֹף מַעֲרָב'.[13] After having located his ancestral home and re-stitched his history from the stories of the elders, Amit decides to stay a few days in Tizgui, where, he claims, he feels instinctively at ease, as if having come home after a long journey on the road. When Hachkar comes back a few days later to film him, he finds Amit transformed, having entirely taken to local life. Dressed in Berber-style clothes, he strolls around the village, greeting everyone he happens across in Arabic, evidently having acquainted himself with the local population. He has decided, Hachkar learns, that the ancient Jewish cemetery should be restored, a task he intends to complete with the help of the village's youth. As a 'Cohen', he himself is not allowed to enter the cemetery compound,[14] so he guides their work from a distance. As Hachkar films, Amit bursts into tears for the first time, overwhelmed by emotion. There, by the cemetery, he comes to terms with where he came from; he finally reconnects the thread with the world of the dead. This past has been long living inside of him, and now he can finally bring about some closure. Active in situ memorial work

Jewish immigrants are accordingly called 'olim', that is, 'those who ascend'. Jewish emigrants are called 'Yordim', that is, 'those who descend'.

12 Interview with the director, December 2018: 'what is one's true country, one's native land?'

13 'My heart in the East / and I at the farthest West' (trans. by Reznikoff, 2012: 91).

14 According to the Torah and the Hebrew Bible, *cohen* (Heb. כהן, plur. Cohanim, lit. 'dedicated, acolyte') is a title conferred to Aaron, Moses's brother and a man from the Levi tribe, and to all his male descendants, which indicates their commitment to serve as acolytes (the original meaning of כהן) in the Temple of Jerusalem. It implies, then, belonging to the ancient Hebrew clergy, who carried out the sacrifices and performed other tasks in the Temple, under the authority of the *cohen gadol* ('high priest') or that of his assistant, the *cohen gahak*. It is forbidden for a *cohen* to enter a compound where a corpse or a part of a corpse might be found. This effectively means that those with the last name Cohen are not allowed to enter cemeteries, participate in burial ceremonies, or be under the same roof as a corpse that is being kept or sheltered, unless one of his immediate family members passes away unbeknownst to him.

240 *Jewish-Muslim Interactions*

helps Amit to conjure the memory of these places, to reactivate history. This spot could be qualified as a 'wounded place', in reference to the work of Karen Till (2008: 107–9), because it is a sacred place, a cemetery, a last physical remnant of Jewish presence symbolically and physically left to ruin. This place, which neglect and the passage of time left in a state of disrepair, is renovated by the artist-inheritor who transforms the space through including the entire village in the project and making it a space of collective memory, honoured and restored. As Hachkar notes,

> Il est fort possible que ce vouloir compulsif à se remémorer, à conserver, à juxtaposer les bribes d'un monde révolu, en une nostalgie imaginaire soient une manière de combler le gouffre d'un monde sans ancrages ni repères stables.[15]

Upon his return to Israel, Amit creates an official website for the project of the cemetery's renovation,[16] makes a short film about Tizgui, which is projected at the diaspora museum in Tel Aviv,[17] and begins raising money from his family to continue the cemetery renovations.

Orphan of Otherness

> Je suis orphelin de cette altérité. On nous a arraché une partie de nous-même. C'est une tragédie dont le Maroc paie encore aujourd'hui un lourd tribut.[18]

Hachkar speaks of the mass emigration of the Jews of Morocco during the 1950s as an intense drama that had marked several generations and whose traumatic aftershocks still reverberate across the younger generations today. How to cope with this loss and negotiate identity with the weight of the

[15] Hachkar, *Dans tes yeux, je vois mon pays*, director's note: 'It is very likely that this compulsive desire to remember, to preserve, to juxtapose those pieces from a bygone world, to indulge an imaginary nostalgia, is a way to fill in the void of a world without anchors or stable points of reference'.

[16] Website of the 'Tizgui – Collecting History' project: http://amithaicohen. wixsite.com/tizgui (consulted on 5 August 2019).

[17] The Diaspora Museum, or Beit Hatfutsot (Heb. בית התפוצות, lit. 'the Diaspora House'), also called the Nahum Goldman Museum of the Diaspora, is situated in the campus of Tel-Aviv University in Ramat Aviv, a northern suburb of Tel-Aviv, Israel.

[18] Interview with the director, December 2018: 'I am an orphan of this otherness. A piece of ourselves has been hacked off. It's a tragedy for which Morocco pays a heavy price to this very day'.

A Newfound Voice from across the Mediterranean 241

absence of those long gone? Hachkar recounts that he had no other choice – being a young Moroccan who emigrated to France and became naturalized there at the age of 18, torn by his multiple identities – than to fulfil the role of the 'other', to be radically foreign and yet achingly intimate, in order to (re-)construct his Moroccanness fully and entirely. This other, absent and unknown, is the 'Jew' his ancestors told him about, who had been living in the Maghrib (Zafrani, 1998) for more than 2,000 years, concentrating particularly in Amazigh lands (Kartowski-Aïach, 2013), now both Moroccan and an immigrant in the 'promised land' or elsewhere, unable to return. Since the establishment of the state of Israel in 1948, Moroccan Jews have emigrated to Israel in increasing numbers. This migration, called *ailyah*, a figurative 'ascent' to Israel, has been considered by the majority of Jewish Moroccans as a return to the biblical 'fatherland', after more than 2,000 years of diasporic life in exile. After 1956 and the end of the French protectorate, the emigration accelerated until the 1970s, and especially after the Yom Kippur War in 1973. Upon their arrival in Israel, these Jews were told that returning to Morocco would be impossible. This prohibition was sometimes enforced by confiscating travel documents.

When the young Hachkar, a student of history simultaneously Amazigh, Moroccan, and Muslim, as well as French, discovered it was possible to be a Moroccan differently, without passing through the prism of Islam, he was astonished. Who were those 'others' who were a part of him without him ever being able to put faces to their names? His first film, *Tinghir-Jérusalem: Les échos du Mellah* ['Tinghir-Jerusalem: Echoes from the Mellah'], was a study of – or rather a reflection on – the Jews of Tinghir, the place of his birth, who made their *aliyah* some fifty years prior (see Bahmad, this volume). Little by little, he stitches together the 'fragments' of memory (Hovanessian, 2009) of the grand History of which the history of Judeo-Berbers is a part, long silenced on both sides of the Mediterranean, even rendered taboo. In Israel, it was left to the Mizrahim, to the Moroccan Jews, to sever their emotional, cultural, and historical bonds with their countries of origin in order to become fully Israeli, to be suffused by a new national Jewish culture and free themselves of the traces of exile, the vestiges of diasporic worlds (Ben-Amos, 2010).

In making this first film, he connects with family from whom he had been orphaned since birth. Today, many of the older generation of Jews from the Atlas Mountains that the director met and filmed have passed away. But their memory has been partially restored and honoured through the reparative artistic work of this cinematic oeuvre. Now, thanks to the film's wide circulation on both sides of the Mediterranean, the younger generations in Israel and in Morocco know that Jews and Muslims co-existed and shared

life together, particularly in Berber regions, and that their ancestors from the Atlas Mountains participated together in the Ahwashs[19] and the Ahidous[20] all-night-long ceremonies. This world no longer exists, but it persists in 'l'infra-mémoire' ['the infra memory'] of posterity, in touch, in feeling, and in recovered memories. Veronica Estay Stange wrote that 'l'infra-mémoire est la trace d'une trace, la « chose souvenue » (Ricoeur) étant inévitablement absente en tant que « souvenir » à proprement parler' (2017: 66).[21]

A foundational book for Hachkar is *Mille ans, un jour* ['A Thousand Years, One Day'] (1986) by the Jewish-Moroccan writer Edmond Amran El Maleh. In his literary work, the author argues for a 'continuum of Judeo-Arab Muslim affiliation' (Siegel, 2017: 17) in Moroccan history, all the while advocating a breakdown of the concept of identity, and taking the Jewish nationalist narrative in Israel to task. In a conversation not long before the author passed away, Hachkar revealed to El Maleh that he is haunted by these departures and that he constantly has the same painful recurring nightmare. He is at the airport with his grandmother, suitcases in hand. They must leave Morocco and they know they will not be coming back. Yet the young director insists he could not endure such an abrupt separation. He always returns, summer after summer, to his hometown, to his own people. His parents, too, worked to maintain this fragile thread of belonging between Morocco and France. After a long silence, El Maleh responds, 'vous auriez pu intituler, j'aurais pu être ce juif'.[22] And it is precisely because he does not understand how he was able to live so long detached from these absent Jews, and how they themselves could live so far from their country of origin, torn from their millennia-old

[19] The Ahwash is a secular Berber ceremony, combining music, poetry, and dance, which has elements similar to the entire Berber musical tradition in Morocco. The ceremony is connected to life cycle events, such as weddings and bar mitzvahs (among Jews), or to those of the agrarian calendar, such as the end of the harvest. The Ahwash ceremony is the last musical tradition of Berber Jews that is still practised in Israel.

[20] The Ahidous (which is the counterpart of the Ahwash) is a traditional dance performed by the Berber tribes of the Middle Atlas in Morocco, in which men and women, elbow to elbow, form flexible and undulating rounds, accompanied by songs (in Berber izli, izlan) and percussions by the bendir. The Ahidous is known for being the favourite entertainment of the Amazighs of central Morocco and their most complete and lively means of expression. It is danced at the smallest festivals and in the summer, after the harvest, almost every evening in the villages.

[21] 'the infra memory is the trace of a trace, the "thing remembered" (Ricoeur) has been inevitably absent as a "memory" per se'.

[22] 'you could have entitled it, I could have been that Jew'.

A Newfound Voice from across the Mediterranean 243

history, that Hachkar took it upon himself to use the tools of cinema to tell the story of these ruptured lives, the testimonies of those bearing witness to that separation.

Encountering the 'others', Muslim Moroccans who 'remained' in Morocco, is the dream of many young Israeli Jews of Moroccan descent, spun from stories told by uprooted grandparents, unable to concretize the images, the smells, and the sounds of these quasi-legendary family stories. This desire for return, often phantasmatic, is a theme central to Neta Elkayam and Amit Hai Cohen's project and a creative drive in their work. Both were born in Netivot, close to the Gaza Strip in the south of Israel, and moved, for political and artistic reasons, to Jerusalem, renting in the largely working-class and majority-Mizrahi neighbourhood of Katamonim, where they try to create with the 'other' – the 'other' in the sense of not being Jewish, speaking Arabic, and coming from the Arab-Muslim world, whether Palestinian or Moroccan. But the separation of the city between East and West, and the whole country from the Palestinians and more generally from the Arab-Muslim world, makes it difficult for them to cross boundaries and borders. Morocco remains somewhat of an exception in the Muslim world for its policy of giving tourist visas to Israeli passport holders despite not having official relations with the State of Israel. Unlike Mizrahi Israeli artists whose roots are in other Arab countries, Neta and Amit are able to travel to Morocco, a journey they have been making regularly in the past several years. The couple decided to name their newborn son Illigh, after a Berber village in the Atlas Mountains where Neta's grandfather was born. Thus, eponymy,[23] parentage, and a desire to revive a bygone Judeo-Berber world, but also an attachment to a land to which they wish to remain faithful and from which they draw inspiration, converge. They say they wish to draw lessons from the long centuries their ancestors lived in Morocco, where Jews and Muslims lived together and, according to them, in peace. They would like to be able to transpose a model of such cohabitation to their 'native' Middle East, where every encounter with the 'other' is a daily struggle. Neta, who grew up with the stories of her grandmother, would like to be able to live in peace with her neighbours, as was the case in Morocco. Amit and Neta's house in Jerusalem is a place of rest, of creation, and of Moroccanness. Jews, Israelis, Palestinians, Moroccans, artists, and activists from across the world come to knock on their door.

[23] Naming a child in Judaism is inscribing their own life, but also linking them into a chain of history.

Music as a Territory of Return

> Il s'agit de faire revivre quelques fragments, recréer des liens entre les nouvelles générations juives et musulmanes. Et surtout, faire connaître ces moments de territoires en partage au plus grand nombre, au-delà des clichés pour un jour aspirer « à de nouvelles Andalousie recommencées ».[24]

And so it is that Amit and Neta's house, their *Bayit* in Hebrew, has become the body inscribed by the spirits of its inhabitants – a body of memory that starts to vibrate as music is played, carrying with it all the rhythm and soul of a bygone world. Can music become the condition of possibility of a 'home at last' feeling? Is it the promised home*coming* (Tsuda, 2009; Markowitz and Anders, 2004)? Or is it only a flicker, ex nihilo, of home*making*, singing as an act of reparation and an extension from one world to another? 'C'est comme si elle habitait par le chant ce pays qui est le sien, son pays natal. Elle retrouve son propre territoire dans la musique, c'est le moment où elle est en accord total avec elle-même', Hachkar says about Neta Elkayam.[25] Yet the feeling of exile is pervasive for her, even though she did not acquire it directly, but by inheritance, revealing the paradox of the 'impossibility' of that sentiment in Israel, the 'promised land', a land where Jewish history is profound and deep-rooted and also a land from which Jews had fled. Svetlana Boym writes:

> Non-return home in the case of some exiled writers and artists turns into a central artistic drive, a homemaking in the text and artwork as well as a strategy of survival. Ordinary exiles too often become artists in life who remake themselves and their second homes with great ingenuity. Inability to return home is both a personal tragedy and an enabling force. (cited in Olick, Vinitzky-Seroussi, and Levy, 2011: 456)[26]

As Neta Elkayam sings on screen, she seems transfigured. Alive, vibrant, but also at peace, as if she can finally be herself and feel at home as an

[24] Hachkar, *Dans tes yeux, je vois mon pays*, director's statement: 'It's about reviving a few fragments, recreating the connections between the younger Jewish and Muslim generations. And above all, it's about making those times of shared territories known to as many people as possible, beyond the clichés, with the aspiration that one day a "New Andalusia" will again become a reality'.

[25] Interview with the director, December 2018: 'It's as if she lives by the songs of the country that belongs to her, her native land. She has found her own territory through music, and as she sings, she is at one with herself'.

[26] See also Boym (2001; 2007).

A Newfound Voice from across the Mediterranean 245

Israeli, Jewish, Moroccan woman, and more besides. Through her, the voices of the past resurface, as if the young singer had the power to summon them. Back from the world of the dead, the silent voice finds a space of expression in the present, in a non-place above ground, a threshold: her music. Through singing the repertoires of the world of yesteryear, the artist performs a ritual, one we might call a ritual of celebration and reparation, a *tikkoun*.[27] She breaks the inherited silence that muffles the past and gives it a voice in the present. Music as a unique patrimony, one's only country? An eloquent scene in *Dans tes yeux* invites us into a rehearsal by Neta and Abdelilah, a middle-aged Moroccan man residing in East Jerusalem who became her teacher-trainer in Darija. She asks herself how to interpret a patriotic Moroccan song she had been asked to sing in an official ceremony in Morocco that refers to the Qur'an. She does not wish to subscribe to any nationalist sentiment of whichever persuasion, but neither does she want to conceal her Jewish Moroccanness. Can she sing the song without betraying herself? Without offending Moroccan citizens? Such intimate and political pressures are the tug-of-war many artists find themselves forced to address: how to be politically engaged in Israel without losing one's public; how to return and sing in Morocco without becoming entangled in present-day politics; how to communicate ideas through art while controlling your image, your words, in an attempt to forge a career that could easily founder across the gulf separating Israel from the rest of the world.

In another scene of the film, Neta is in the archives of the Hebrew University of Jerusalem, at the Jewish Music Research Centre,[28] where she is looking for Judeo-Moroccan songs from the Atlas Mountains, particularly from Tinghir, the village she comes from. She is specifically interested in the voice of Myriam Illouz, an Amazigh Jewish woman from Tinghir. She carries out a vast vocal and musical research project following the footsteps of these Jews' *aliyah* journey, from Morocco to the Grand Arenas camp in Marseille,[29]

27 Tikkoun Olam (Hebrew, תיקון עולם, lit. 'repair of the world'), is a central concept in Jewish philosophy, literature, and mysticism, relating, for most adherents, to a Jewish iteration of social justice.

28 Jewish Music Research Center, Jerusalem: http://www.jewish-music.huji.ac.il (consulted on 10 August 2019).

29 Located in the Cayolle district, this transit camp, managed by the French state, sheltered hundreds of thousands of future Israelis, among them many Holocaust survivors repatriated to France and young people from North Africa and France. Hastily built in 1945, it housed the first Jewish emigrants bound for Palestine and would become a thoroughfare of incessant waves of emigration and flight from 1947 to 1965. Holding a maximum capacity of

246 *Jewish-Muslim Interactions*

and onwards to the ma'abarot[30] in Israel. After many hours' work, the archivist finally finds a recording of the voice of Myriam Illouz, and plays it on the digital screen, the electric glare lighting up Neta's face. Having found another piece in the historical puzzle, she listens intently to the words in Moroccan Judeo-Arabic and hastens to transcribe them using Hebrew letters. Later, at the home recording studio that doubles up as her painting workshop, she interprets this song based on a musical arrangement stored on Amit's computer. A breath of life animates the archive, passing through Neta's body, whose voice is immediately registered onto the playback. Their child is part of the creative process where Hebrew and Arabic mix together, where the borders bend and eventually disappear altogether. It is in this non-place of creation where they can be themselves: multifaceted and without compromise.

Apart from this filmed sequence, Neta also teaches the same song during a masterclass in Jerusalem whose students are conspicuously Moroccan Jewish women of a certain age. Indeed, it is the younger generation that is now taking charge of the transmission of this largely extinct oral heritage, as much in Israel as in Morocco. Neta and Amit also decided to create the project 'Grand Arenas Session', based on Neta's findings at the National Archives. These songs of Moroccan Atlas women were recorded in the transit camp of the Grand Arenas de Marseille, which thousands of North African Jews who had just left their country passed through before emigrating to Israel or elsewhere. The couple decided to compose electronic arrangements for these recordings and to go and film at the site of Grand Arenas camps in southern France. A traditional Amazigh headscarf wrapped around her head, the young woman sings in what is now a no-man's-land, piecing the fragments together, while Amit accompanies her live with his mini synthesizer and records the session. This is a moment of creation that reactivates the memory of a place and of a forgotten history, perhaps even carrying within it a counter-memory, that of a young generation that is struggling to rediscover and reinvent the heritage that is theirs. As Till writes: 'Rather than uncovering hidden histories, artist-scholars challenge dominant regimes of memory by creating spaces that revisit

10,000 residents at a time, more than 400,000 Jews passed through it. Almost one in ten Israelis will have passed either through Provence or Arenas, during their *aliyah*.

30 The ma'abarot (sing. ma'abarah, מעברה) were transit camps established in Israel that took in up to 250,000 Jewish refugees in the 1950s. The precarious living conditions in these camps left an indelible imprint on the Israeli collective memory, especially that of the Jews from Arab-Muslim countries, who were the camp's principal inhabitants.

A Newfound Voice from across the Mediterranean 247

historical social relations and imagine new possibilities' (2008: 104). Till's reference to 'dominant regimes of memory' relates to the capacity of official constructs of Judeo-Moroccan history in Morocco and Israel to dominate and regiment memory. Through creation, the artist couple brings to bear its sensitive vision of a fragile and political memory, which they unearth like archaeologists, while inscribing it in a contemporary artistic vision, but one that also claims its heritage and parentage.

One Friday in Jerusalem, a few hours before Shabbat, Neta prepares a traditional Moroccan dish in her cramped kitchen and sings a Moroccan song in Darija, accompanied by Amit's banjo. They are filmed by the young Palestinian director Jumana Manna,[31] who grew up in East Jerusalem and is making her first feature film, *A Magical Substance Flows into Me*, a documentary that follows the footsteps of Dr Robert Lachmann, who is described by Negar Azimi as 'an enigmatic Jewish-German ethnomusicologist who emigrated to 1930s Palestine'.[32] Manna tries here to walk in the footsteps of Lachmann and meets Kurdish, Yemeni, and Moroccan Jews, as well as Bedouins, Palestinians, and Copts, playing to them the musical tunes collected during the research process. The documentary addresses the history of Mandatory Palestine through their own history, which passes through the prism of traditional music of which they are the smugglers or heirs. As Gil Hochberg writes about this scene,

> Mizrahi music [acts] as a bridge with the potential to lead to a new shared future between Palestinians and Israelis in Israel/Palestine. And yet, while music certainly functions in the film as a 'magical substance' that has the potential to transcend ethnic and national borders, creating a shared cultural framework for Mizrahi Jews and Palestinians, Manna never fails to contrast this promise with the segregated and partitioned nature of present-day Israel and Palestine. (Hochberg 2018: 36)

[31] See Jumana Manna's website at http://www.jumanamanna.com (consulted on 9 August 2019).

[32] 'While attempting to establish an archive and department of Oriental Music at the Hebrew University, Lachmann created a radio program for the Palestine Broadcasting Service called "Oriental Music", where he would invite members of local communities to perform their vernacular music'. Negar Azimi is a writer and the senior editor of *Bidoun*, an award-winning magazine and curatorial project with a focus on the Middle East and its diasporas. She writes about the work of Jumana Manna, and this particular text can be found on the website of the artist: http://www.jumanamanna.com (consulted on 9 August 2019).

248 *Jewish-Muslim Interactions*

As Manna films this sequence while speaking Hebrew and Arabic, Hachkar and his team film her and her team filming Neta and Amit. In this *mise-en-abîme*, the stories and investigations overlap, in search of those crumbling memories that come together in order to be able to reconstruct themselves. Through the process of artistic creation, each in their own way is looking for the self through the other's mediation. And so it is that music allows them to unite and transcend what should, in principle, keep separate those who, through the prism of cinema but also through their political commitment, contribute in this way towards composing a new polyphony.

Home? 'La Maison de mémoire'[33]

Non seulement nos souvenirs, mais nos oublis sont « logés ». Notre inconscient est « logé ». Notre âme est une demeure. Et en nous souvenant des « maisons », des « chambres », nous apprenons à « demeurer » en nous-mêmes. (Bachelard, 1961: 19)[34]

For Hachkar, going to Israel, to Jerusalem, and meeting Neta is to recover some of his original Tinghir identity. He says he has to find his people in order to be able to find himself. The strangeness of the 'other' is a necessary stopping station on the way towards finding himself at last.

In a scene appearing in one of the final editions of the documentary prior to its release, Neta Elkayam is at her parents' house in Netivot, preparing tea and singing while Amit plays Moroccan melodies on the piano. There is a sense of witnessing an ancestral scene that easily could have taken place in Morocco fifty years ago. The borders between Israel and North Africa seem to recede into oblivion; time stretches without any discernible benchmark. The fragmented lands are now one, if only in this singular family home. In the Hebrew voiceover, the singer speaks of her desire not to be 'המרוקאית שכלואה בירושלים' / 'la marocaine enclavée dans Jérusalem' ['the Moroccan cut off in Jerusalem'], but to encounter the world in all its diversity. The next scene shifts to Jerusalem, where the couple continue to play Moroccan chaâbi songs. Above the piano are photos of their forefathers and a flag of Morocco, as if watching over the music that continues in spite of exile from the native country. On the screen, surrounding the musical couple, we see well-known

[33] This is a reference to the title of Joëlle Bahloul's book (1992), translated into English as *The Architecture of Memory* (1996).

[34] 'Not only our memories, but the things we have forgotten are "housed". Our soul is an abode. And by remembering "houses" and "rooms", we learn to "abide" within ourselves' (Bachelard, trans. by Jolas, 1994: xxxvii).

A Newfound Voice from across the Mediterranean 249

figures of the Mizrahi militant movement, such as Reuven Abergel, Moroccan Jew and former Israeli black panther,[35] who has become a mentor for several artists and activists of the third generation.

Later, in the same room where an alternative to Israeli geopolitics seems to be able to invent itself and borders seem to dissolve, the director asks one last question to Neta Elkayam. 'איפה את מרגישה בבית?' [*eifo at margisha babayit*, lit. 'Where do you feel at home?'], he asks her in Hebrew, subtitled in French as 'Où te sens-tu à la maison?' The young woman, so often in full control of herself, appears upset for the first time and quickly moves out of the frame, so as not to let the camera see her tears. After a moment, she returns and tells the camera how intimate the question is for her, although she is at home in the house she created in Jerusalem. She replies, holding back tears, that Amit and her son Illigh are her home: 'ביחד נהיה מה שנרצה, אמריקאים, קנדים, צרפתים, כל עוד הם יהיו איתי'.[36] Her home is unbounded to a physical territory or nation. Together with Amit, she built their intimate home as a threshold, free and open to the world, an island of resistance and music, which seeks to create bridges between those who history has separated.

Works Cited

Bachelard, Gaston. 1961. *La Poétique de l'espace*. Paris: Presses Universitaires de France.

——. 1994. *The Poetics of Space*. Trans. by Maria Jolas. Boston, MA: Beacon Press.

Bahloul, Joëlle. 1992. *La Maison de mémoire. Ethnologie d'une demeure judéo-arabe en Algérie (1937–1961)*. Paris: Métailé.

——. 1996. *The Architecture of Memory: A Jewish-Muslim Household in Colonial Algeria, 1937–1962*. Trans. by Catherine Du Peloux Ménagé. Cambridge: Cambridge University Press.

[35] The black panther movement in Israel was initiated in the early 1970s by young Mizrahi activists (including a majority of Moroccan Jews) who demanded greater social justice and more rights for Jews from the Arab-Muslim world, many of whom live in great precariousness on the periphery of the country. They wanted to make heard the Mizrahi voices largely absent in an Ashkenazi-dominated political discourse and to put an end to the racism to which they were subjected due to their ethnic background. Inspired by the civil rights movement of black Americans, they decided to lead this civic revolution in Israel. Some Israeli black panthers later joined the Israeli government.

[36] Subtitled as 'Ensemble on sera ce qu'on veut devenir, américains, canadiens, français, du moment qu'ils sont avec moi' ['Together we will be whatever we want to be, American, Canadian, French, just so long as they are with me'].

Ben-Amos, Avner. 2010. *Israël: La fabrique de l'identité nationale*. Paris: CNRS Editions.

Boym, Svetlana. 2001. *The Future of Nostalgia*. New York: Ingram International Inc.

——. 2007. 'Nostalgia and its Discontents'. *Hedgehog Review* 9.2: 7–18.

Estay Stange, Verónica. 2017. 'Survivre à la survie, Remarques sur la post-mémoire'. *Esprit* 10: 62–72.

Halevi, Yehouda. 2012. 'The Cantor of Zion (Toledo, 1075–Cairo, 1141)'. Trans. by Charles Reznikoff. In Pierre Joris and Habib Tengour (eds.), *Poems for the Millenium: The University of California Book of North African Literature*, Vol. 4. Berkeley, CA and London: University of California Press: 91–92.

Hirsch, Marianne. 2008. 'The Generation of Postmemory'. *Poetics Today* 29: 103–28.

Hochberg, Gil. 2018. 'Archival Afterlives in a Conflict Zone: Animating the Past in Jumana Manna's Cinematic Fables of Pre-1948 Palestine'. *Comparative Studies of South Asia, Africa and the Middle East* 38: 30–42.

Hovanessian, Martine. 2009. *Crossing Places of Exile: Sewing the Fragments Back Together*. Unpublished doctoral dissertation. University Paris-Diderot – Paris VII, Paris, France.

Jabès, Edmond. 2010. *From the Desert to the Book*: *Dialogues with Marcel Cohen*. Trans. by Pierre Joris. Barrytown, NY: Station Hill.

Kartowski-Aïach, Miléna. 2013. *Sur les traces des Juifs Berbères du Maroc. Histoire – Identité – Culture et Transmission*. Unpublished research masters dissertation. Université Michel de Montaigne Bordeaux 3.

El Maleh, Edmond. 1986. *Mille ans, un jour*. Grenoble: Éditions La Pensée Sauvage.

Markowitz, Fran, and Stefansson Anders. 2004. *Homecomings: Unsettling Paths of Return*. Oxford: Lexington Books.

Olick, Jeffrey K., Vered Vinitzky-Seroussi, and Daniel Levy (eds.). 2011. *The Collective Memory Reader*. Oxford: Oxford University Press.

Sebbar, Leïla. 2012. 'Ce serait la même histoire'. In Leïla Sebbar (ed.), *Une enfance juive en Méditerranée musulmane*. Saint-Pourçain-sur-Sioule: Bleu autour: 11–13.

Shohat, Ella. 1988. 'Zionism from the Standpoint of its Jewish Victims'. *Social Text* 19/20: 1–35.

—— 1999. 'The Invention of the Mizrahim'. *Journal of Palestine Studies* 29: 5–20.

Siegel, Irene. 2017. 'In Judeo-Arab-Muslim Continuum: Edmond El Maleh's Poetics of Fragments'. *PMLA* 132: 16–32.

Till, Karen. 2008. 'Artistic and Activist Memory-Work: Approaching Place-Based Practice'. *Memory Studies* 1.1: 99–113.

A Newfound Voice from across the Mediterranean 251

Tsuda, Takeyuki. 2009. *Diasporic Homecomings: Ethnic Return Migration in Comparative Perspective.* Stanford: Stanford University Press.

Zafrani, Haïm. 1998. *Deux Mille Ans de Vie Juive au Maroc: Histoire et Culture, Religion et Magie.* Casablanca: Maisonneuve et Larose.

Creative Coexistence or Creative Co-resistance?[1] Transcultural Complexity in the Work of Street Artist 'Combo'

Nadia Kiwan

Introduction

This chapter will explore the work of Paris-based street artist Combo Culture Kidnapper (hereafter referred to as Combo) with a focus on the ways in which his work challenges the rise of antisemitism and Islamophobia in our contemporary period, understood here as 'prejudice against Jews and Judaism, Muslims and Islam' (Renton and Gidley, 2017: 8). Combo's work appears to question the polarizing narratives surrounding Jewish-Muslim relations in contemporary France and Israel, against the backdrop of renewed concerns regarding antisemitism in France and the recent wave of attacks from 2015 onwards (see Judaken, 2018 and Mandel, 2014 for further discussion regarding such narratives).[2] I argue that Combo's

[1] In the broader context of the Israeli-Palestinian conflict and thus beyond the scope of this chapter, the term 'co-resistance' is used by Leanne Gale in her study of the Solidarity movement. Here, a politics of co-resistance refers to a strategy of joint Israeli-Palestinian political action that emerged after the Second Intifada. This strategy marked a bid to challenge the status quo, something it was felt had not been achieved under the coexistence strategies of the previous decade (Gale, 2014: 49).

[2] Judaken argues that Judeophobia and Islamophobia are intertwined via the 'interlocked vulnerabilities and insecurities of both Jews and Muslims' (2018: 1).

artistic practice is significant because of the multiple ways in which it places emphasis on transcultural creative production, co-production, and interaction. Transcultural creative production is understood here as a mode of artistic practice that combines cultural repertoires, such as symbols, languages, or cultural reference points that are transnational in nature, that is, which cannot be contained within the space of one national context. Co-production and interaction refer to the ways in which Combo collaborates with other street artists and members of the general public in order to create his works of art. In particular, my chapter will explore whether Combo's work on the theme of coexistence might have the potential to change preconceptions regarding Jewish-Muslim relations. Combo's street art has involved him in a range of transnational projects located in places as diverse as Beirut, Paris, Saïda, Tel Aviv, and Tunis. His CoeXisT street art project in Paris and Tel Aviv and his subsequent 2016 Institut du monde arabe (Paris) exhibition about religious diversity will be the main focus of this chapter. I will also discuss Combo's more performance-oriented work that arises out of the CoeXisT project, whereby the artist plays with three interchangeable 'characters', known as 'Mohamed', 'Michel', and 'Moshe', who all recur in his street art and exhibition work in Paris and Tel Aviv. These staged encounters or artistic portrayals of coexistence simultaneously explore cultural stereotypes and cultural connectedness via interfaith friendships and artistic collaboration.

The street artist Combo was born in Amiens in 1987 to a Christian Lebanese father and a Moroccan Muslim mother. He spent much of his childhood in Oujda, then Rabat, Morocco, as well as the Central African Republic, before returning to France (Troyes, then Nice). Having been a graffiti artist in Nice since the age of sixteen with his collaborators, under the guise of the Graffiti Elite Section (GES), Combo started his formal artistic career at the Villa Arson after taking the *concours de l'école des Beaux-Arts de la ville de Nice*, but was asked to leave after only a year because his understanding of art did not correspond to the expectations of his professors.[3] After working as an artistic director for an advertising agency in Paris for four years from 2010 onwards, designing artwork for well-known brands such as Peugeot and

Maud Mandel similarly focuses on the connected histories of France's Jews and Muslims and seeks to challenge what she regards as the 'gross simplification' of narratives of Jewish-Muslim polarization (2014: 1).

[3] See Combo speaking about this during a TEDx talk at Panthéon-Assas University, 27 September 2018; 'Le street art: un coup d'État à l'échelle d'un muret'. YouTube, 13 December 2018. Available at: https://www.youtube.com/watch?v=QOgYzLcLLn0 (consulted on 27 June 2019).

Canal+, Combo decided to leave advertising behind and dedicate himself entirely to street art. His previous career in advertising is something that Combo speaks about as pivotal in his approach to street art in an interview with journalist Linda Mestaoui. He claims that it is the strategic choice of tag lines, impactful images, and minimal text, in order to arrest the attention of the viewer/consumer, which has had far more effect on him as a street artist than his initial training in Fine Arts:

> J'ai fait du street art pour arrêter un passant [...] Je me demande simplement comment arrêter quelqu'un en sachant qu'il est accaparé par 200 images à la seconde. [...] Ça m'est venu en regardant « Writers », un documentaire culte sur l'histoire du graffiti en France dans lequel l'artiste Bando remarque que de toute façon, le graffiti, c'est comme la publicité. On s'inspire de la pub et la pub s'inspire de nous. (Combo cited in Mestaoui, 2016: 12)[4]

Combo's work in Paris has tackled a number of issues, from contemporary electoral politics to postcolonial critiques of Romantic painter Antoine-Jean Gros, from deconstructive readings of cinema promotion to calls for unity in diversity following the wave of terror attacks in the capital, via the slogans 'CoeXisT' and 'Paris encore debout'. Combo's alias, Combo Culture Kidnapper, reflects the street artist's tendency to engage in pastiche and parody of both popular culture (Tintin, Disney characters, video games) and the masters (Gros, Vermeer, Rembrandt, da Vinci).[5] In all his work, Combo uses similar techniques: paint, illustration, photography, posters, stencils, and graffiti. However, about 90 per cent of his work no longer physically exists (it rapidly gets whitewashed or is vandalized, but survives virtually, online).[6]

[4] 'I've done street art to stop passers-by [...] I simply ask myself how it is possible to stop someone, bearing in mind that they are saturated by 200 images per second. [...] The idea came to me when watching *Writers*, a cult documentary about the history of graffiti in France in which the artist Bando notes that in any case, graffiti is like advertising. We are inspired by ads and ads are inspired by us'. Unless otherwise stated, all English translations in this chapter are the author's own.

[5] Examples of Combo's work can be viewed at https://www.combo-streetart. com/ (consulted on 27 June 2019).

[6] See Combo's TedX talk, 'Le street art: un coup d'État à l'échelle d'un muret'. YouTube, 13 December 2018. Available at: https://www.youtube.com/watch?v= QOgYzLcLLn0 (consulted on 27 June 2019).

256 *Jewish-Muslim Interactions*

Challenging the Status Quo? Street Art as Aesthetic Irony

Combo presents much of his artistic project as being about socio-political and cultural critique. Indeed, in his recent TEDx talk at the Panthéon-Sorbonne, Combo described his work as 'un coup d'état à l'échelle d'un muret'.[7] The exploration of his work in this chapter will therefore ask to what extent his artistic practice could be regarded as political, in the sense of Jacques Rancière's (2011) conceptualization of the relationship between aesthetics and politics. In Rancière's exploration of politics and aesthetics in works such as *Le Spectateur emancipé* (2008) and the subsequent and revised English translation *The Emancipated Spectator* (2011), three concepts emerge that are particularly useful for the present analysis: the aesthetic community, the notion of emancipation, and the triggering of dissensus through art. Rancière recognizes that artists often wish to embed a socio-political dimension into their artistic practice, arguing: 'Many contemporary artists no longer set out to create works of art. Instead, they want to get out of the museum and induce alterations in the space of everyday life, generating new forms of relations' (2011: 53).[8] The notion of seeking to create 'new forms of relations' resonates with Combo's mise en scène of religious coexistence following the Paris attacks. Rancière's discussion of art and community is pertinent here, whereby he argues: 'The operations of twisting, seizing and rending that define the way in which art weaves a community together are made *en vue de* – with a view to and in the hope of – a people which is still lacking' (2011: 57). Such a process seems to be visible in some aspects of Combo's performative work, whereby he invites community participation and thus the creation of a 'new' people or collective consciousness that transcends perceived religious and ethnic antagonisms. However, Rancière stresses that an aesthetic community is not a cohesive or harmonious 'community of aesthetes' (2011: 57) but, rather, should be regarded as 'a community of dis-identified persons' (2011: 73). This understanding of an aesthetic community is political in so far as it breaks with the '"police distribution of the sensible"' or 'harmoniously structured community' where 'everyone is in their place, their class, taken up with the duty allocated to them' (Rancière, 2011: 42). In contrast, an aesthetic community is political because 'political subjectivation proceeds via a process

[7] 'a coup d'état via a low wall'. Ibid.

[8] There is no French original version of this quote because it comes from an English-language essay, 'Aesthetic Separation, Aesthetic Community', which replaced the third chapter ('Les Paradoxes de l'art politique') of the French original *Le Spectateur emancipé* (Rancière, 2008) in Gregory Elliott's translation *The Emancipated Spectator* (2011).

Transcultural Complexity in the Work of Street Artist 'Combo' 257

of dis-identification' (Rancière, 2011: 73). As such, members of a dis-identified community no longer fit into their pre-allocated role/class/identity. Instead, they break out of ascribed social positions and roles in order to produce new ways of being in the world. This rupture underpins Rancière's conceptualization of the process of emancipation, which he variously describes as 'la sortie d'un état de minorité' or the 'démantèlement du vieux partage du visible, du pensable et du faisable' (Rancière, 2008: 48; 53).[9] So, for example, 'An emancipated proletarian is a dis-identified worker' (Rancière, 2011: 73). Whether Combo's collective and participative artistic interventions lead to emancipation in the Rancièreian sense is a question to which we will return via an evaluation of whether his work leads to dis-identification or whether it unwittingly reifies some of the religious identities and religious divisions it explores. The third concept of relevance to Combo's work in Rancière's discussion of the relationship between politics and aesthetics is dissensus, a process that disrupts the established 'sensible order' that structures existing frameworks of perception, thought, speech, etc. For Rancière, dissensus forms the condition of possibility for 'subjectivation politique' ['political subjectivation'] (Rancière, 2008: 55) since it dissents against existing consensus. Dissensual artistic practices 'contribuent à dessiner un paysage nouveau du visible, du dicible et du faisable. Elles forgent contre le consensus d'autres formes de « sens commun », des formes d'un sens commun polémique' (Rancière, 2008: 84).[10] This chapter will explore Combo's work in light of whether it can be regarded as forging new ways of framing the dynamics between French Jews and Muslims against the backdrop of the dominant narratives of polarization.

In a similar vein to the notion of dissensus, one could ask whether Combo's work is informed by an 'aesthetics of resistance' (Shilton, 2014: 357) to dominant discourses surrounding francophone Jewish and Muslim communities. Siobhán Shilton defines an 'aesthetics of resistance' as

> tend[ing] to allude to apparently stable visual forms while simultaneously exceeding them through the use of disjunctive signifiers and sensorial elements. Such art involves the viewer in the formation of discourse, while raising their awareness that any 'reading' is contingent, partial and provisional. (Shilton, 2014: 357–58)

[9] 'emergence from a state of minority'; 'the dismantling of the old distribution of what could be seen, thought and done' (Rancière, 2011: 42; 47).

[10] 'contribute to the drawing of a new landscape of the visible, sayable and doable. Against consensus, they create other forms of "common sense"; forms of polemical common sense'.

258 *Jewish-Muslim Interactions*

In the specific context of Combo's work, the notion of a trajectory from coexistence to (co-)resistance is discussed in this chapter through a consideration of his artistic portrayals of interfaith friendship: does Combo successfully challenge perceptions of Jewish-Muslim relations as being polarized? Such perceptions have arguably been the focus of increasing media, political, and academic attention in the post-2000 Second Intifada period and have been further heightened in the wake of the murder of Ilan Halimi, the Merah attack on the Ozar Hatorah Jewish school, the Hyper Cacher attacks, and the murders of Sarah Halimi and Mireille Knoll in particular (see Mandel, 2014; Judaken, 2018).[11] To this end, what Shilton describes as 'an aesthetics of resistance' is a useful lens through which to explore Combo's artistic practice.

Shilton's focus on an aesthetics of resistance that 'involves the viewer in the formation of discourse' is linked to the question of how artists may 'represent cultures or communities that have been essentialized' (2014: 357). Shilton thus draws on Abdelkebir Khatibi's notion of a 'double critique' of tendencies to both essentialize Western and non-Western cultures, whereby in the place of essentialization, Khatibi proposes 'une pensée autre qui parle en *langues*, se mettant à l'écoute de toute parole – d'où qu'elle vienne' (Khatibi 1983, cited in Shilton, 2014: 357).[12] Bearing in mind some of the features of an aesthetics of resistance as outlined by Shilton (formation of alternative discourse, de-essentialization), my approach to the work of Combo in the field of Jewish-Muslim relations is fundamentally concerned with the question of whether or not his portrayal of Jewish-Muslim friendship and interaction enables the development of new or alternative discourses about Jewish and Muslim communities in contemporary France. Does Combo's work articulate 'une pensée autre' ['a thinking otherwise'], which is embedded in a critique of essentialization of both French Jews and Muslims or is it, perhaps paradoxically, reliant on such processes of essentialization in its visual and discursive elements? And if it is somehow reliant on the stereotypes it seeks to destabilize, is visual satire an equally fruitful lens through which to approach Combo's work?

In his discussion of *Charlie Hebdo* and theories of humour, Matt Sienkiewicz evokes the French mode of comedic intervention known as 'l'humour du

[11] See, for example, the 'Manifeste contre le nouvel antisémitisme' (Val, 2018), published in *Le Parisien*, which makes a clear connection between 'islamisme' and violent antisemitic acts, and the collective volume on the same issue, *Le Nouvel antisémitisme en France* (de Fontenay, et al., 2018).

[12] 'thinking otherwise, in *multilingual* ways, listening to any utterance – wherever it may be coming from'. Shilton's translation.

deuxième degré' or second-degree humour, that is, humour that should not be taken at face value. Indeed, Sienkiewicz argues that second-degree humour is 'based on exaggeration of that which is inherently unpleasant (such as racism, homophobia, misogyny etc.) to the point at which adherents of such dreadfully unfunny worldviews become the butt of the joke' (2018: 22). Of course, such a process of comedic exaggeration is not without risk and in his analysis of *Charlie Hebdo*'s portrayal of Muslims and Jews, Sinekiewicz engages with Linda Hutcheon's concept of 'irony's edge'. The notion of 'irony's edge' is premised on the claim that 'irony is an inherently "risky business" in which the ironist, must, by definition, cede agency to a group of diverse interpreters who will necessarily attribute a range of meanings to the statement in question' (Hutcheon, 1994, cited in Sienkiewicz, 2018: 23). Finally, Sienkiewicz's reference to Mikhail Bakhtin's notion of carnivalesque mockery, whereby the humourist seeks to develop 'norm-breaking public events' (Sienkiewicz, 2018: 24–25) may open up another effective way of approaching Combo's street art, as it unsettles some of the assumptions about conflictual relations that French Jews and Muslims are often perceived to have in contemporary France (Hargreaves, 2015; Mandel, 2014).[13] Much of Combo's street art is both culturally hybrid and ironic, both in visual and linguistic terms (he frequently uses ungrammatical English, for example), and in this sense one may speak of a certain heteroglossia that has the potential to challenge established modes of being within secular-universalist Republican discourse about public space.[14] The use of space in both physical and discursive (political) senses is clearly important in any consideration of street art. Accordingly, the next section of this chapter will discuss critical approaches to street art and the city in an attempt to evaluate the extent to which Combo's work is inscribed in public space.

Street Art: From City Space to Political Discursive Space?

Nicholas Riggle argues that 'for street art, the artistic use of the street must be *internal* to its significance, that is, it must contribute essentially to its meaning' (2010: 246; 248). Some of Combo's most well-known work in Paris is

[13] Sienkiewicz (2018) also engages with debates about some of the potential power asymmetries at play in *Charlie Hebdo*'s depiction of Muslims whereby he argues that it is not the mockery of religion that is questionable but rather the mockery of Muslims, some of whom can be regarded as culturally, politically, and socio-economically disadvantaged. For additional discussion of this issue, see Klug (2016), Fernando and Raissiguier (2016), and Todd (2015).

[14] See Cécile Vigouroux's (2015) work on heteroglossia in multi-cultural performance cultures.

inscribed in specific sites of the eleventh *arrondissement*, which is known for its diverse mix of inhabitants, but that is also recognized as the site of recent terror incidents, in particular the 13 November 2015 attacks at the Bataclan concert hall, the Bonne Bière bistro, the Comptoir Voltaire, and La Belle Équipe café. By choosing to inscribe the walls with messages of coexistence and co-resistance to terror via his 'Paris Encore Debout' and 'Fluctuat Nec Mergitur' collage series in spaces such as the Passage Saint-Sébastien, the Rue Jean Pierre Timbaud, or the Rue Montorgueil, Combo's interventions into the physical spaces where such events occurred acquire a particular set of meanings.[15] Similarly, Combo pasted one of his 'Paris Encore Debout' posters at the Porte de Saint Denis, in reference to the suicide bomb attack outside the Stade de France where the France-Germany football match was being played on the same evening.

Other critical approaches to street art focus on its political significance, such as in the work of Hakki Taş (2017) on the Egyptian Arab Spring and the Gezi uprisings in Turkey. Taş emphasizes that street art is often associated with youth sub-cultures and regarded as illegal or vandalism, but that in the wake of the Arab and Gezi revolts, street art has increasingly been seen as part of a movement of political dissent or resistance that not only represents that spirit of opposition but that performs and embodies it by reclaiming spaces in the city for those who are marginalized from power (Taş, 2016). In his series of interviews with Linda Mestaoui for the book *Combo: artiste à risques*, Combo certainly presents some aspects of his work in such terms, arguing, 'Avec le street art, j'ai cette possibilité de descendre dans la rue pour m'exprimer quand un fait d'actualité me révolte. Pour moi, c'est un outil politique. Un outil d'insoumission et de révolte' (cited in Mestaoui, 2016: 161).[16] The language that Combo uses here is striking in the way in which it draws on a French political lexicon of popular rebellion. The reference to non-submission is also significant, since it stands very markedly in opposition to its counterpart 'la soumission' ['submission'], and once again indexes a critical vocabulary of resistance.

[15] The Latin motto of Paris meaning 'it is tossed by the waves but does not sink'. 'Paris: Facts & Data'. *Encyclopaedia Britannica*. Available at: https://www.britannica.com/facts/Paris (consulted on 27 June 2019). See http://www.combo-streetart.com/gallery/paris-encore-debout/ (consulted on 11 September 2019) and Demoulin (2015).

[16] 'With street art, I am able to go out on the street to express myself when a news story outrages me. For me, it's a political tool. A tool of non-submission and revolt'.

Transcultural Complexity in the Work of Street Artist 'Combo' 261

'Culture Kidnapping' in Paris, Tel Aviv, and Beyond

Keeping in focus the issue of resistance, the next part of this chapter will examine four artistic interventions that Combo has made since 2015. First of all, I will consider Combo's CoeXisT project (see Plates 5 and 6), which saw him pasting posters around Paris, featuring the slogan CoeXisT, with the 'C' stencilled as the Islamic crescent, the 'X' as the Jewish star of David, and the 'T' as the Christian cross in the weeks following the *Charlie Hebdo* and Hyper Cacher attacks of January 2015. The stencilled symbol is not Combo's creation, and he acknowledges the fact that the image was first designed by the Polish artist and graphic designer Piotr Młodożeniec in 2001 in Jerusalem for the Museum on the Seam 'Coexistence' exhibition, which featured fifty original artworks on the walls of the Old City that links the gates to the Jewish, Christian, and Muslim quarters.[17] Combo claims that Młodożeniec deliberately never patented his slogan in order to facilitate its artistic reproduction and the spread of its underpinning pacifist message (see Mestaoui, 2016). Furthermore, Combo has adapted the image, often including a huge satirical drawing of his alter ego 'Mohamed', bearded and dressed in a white djellaba, spray-painting the logo onto the walls. The alter ego that Combo created plays on stereotypes since, a priori, he appears to be fairly 'rigorist', given his clothing, full beard, and raised index finger – suggesting a proselytizing stance (see Plate 5). However, the message of tolerance and interfaith coexistence in the text clearly attempts to de-stabilize stereotypes about so-called 'Muslim extremism' and 'fundamentalism'. If we also compare it to another collage of CoeXisT (Plate 6), where this time a euphoric-looking 'Mohamed' is posing with his friend and fictive character 'Moshe', and making a V-sign, once again we are obliged to rethink about who 'Mohamed' may actually be as well as about the notion of interfaith communities of friendship.[18] Is the V-sign a victory or peace sign, or is it a two-fingered gesture of defiance or insult, perhaps with British punk overtones?[19] In this sense, Plate 6 could be regarded both as a dissensual artwork (Rancière, 2008; 2011) and as engaging in an 'aesthetics of resistance' (Shilton, 2014: 357). The apparently orthodox Muslim whose gesture indicates an uncompromising

[17] See http://coexistence.art.museum/coex/voyage/jerusalem.asp (consulted on 4 December 2018).

[18] See https://www.facebook.com/combo.culturekidnapper/photos/a.42688739 0739395/829427043818759/?type=3&theater (consulted on 4 December 2018).

[19] For a musical debate on the multiple meanings of the V-sign, see Stromae's video 'Peace or Violence'. YouTube, 8 April 2011. Available at: https://www.youtube.com/watch?v=KzMWZXPCGUo (consulted on 4 June 2019).

position – so often conjured up in the more exclusionary discursive forms of *laïcité* (Almeida, 2017) – is transformed by Combo into a more complex figure. This complexity is achieved by the suggestion that secularism is not necessarily a guarantee for living together. Rather it is the visibly Muslim 'Mohamed' who becomes the custodian of the social bond. To suggest this within a political culture where *laïcité* is the consensus watchword in matters of religion does indeed seem to resonate with Rancière's claim that dissensual art forms sketch out 'un paysage nouveau du visible, du dicible' (Rancière, 2008: 84). Similarly, Plate 5 also seems to 'allude to apparently stable visual forms' – the visibly pious Muslim with his beard and djellaba – 'while simultaneously exceeding them through the use of disjunctive signifiers and sensorial elements' (Shilton, 2014: 357), namely the CoeXisT slogan. In its religious rather than secularist framing of peaceful coexistence, Combo does indeed seem to invite the viewer into a discourse that offers an alternative to the consensual framework of *laïcité*. In its staging of Jewish-Muslim friendship, Plate 6 also suggests dissensus or a 'dissensual community' (Rancière, 2011: 59) in so far as the visible complicity of the two friends and their playful defiance pushes back against ambient narratives of Jewish-Muslim polarization. Furthermore, Plate 6 exhibits 'dissentuous forms of temporality' (Rancière, 2013: 6) because it interrupts the dominant narrative about 'Muslim intolerance' that immediately followed the *Charlie Hebdo* and Hyper Cacher attacks and it does so in the immediate aftermath of the events.

The CoeXisT project is arguably what brought Combo to the public's attention since Combo was assaulted by four aggressors as he was attempting to paste one of his CoeXisT posters on a wall at the Porte Dorée in Paris's twelfth *arrondissement* in January 2015. The aggressors objected to the tongue-in-cheek and interfaith message of the CoeXisT poster and ordered him to take it down. When he refused, he was attacked, recalling both Sienkiewicz's claims about how humour and violence can be 'intimately entwined' (2018: 19) and Combo's own self-styled image as 'un artiste à risques' ['an artist who takes risks'] (Mestaoui, 2016). Combo posted photographs of himself after the attack on his social media account. This was picked up by the French and international media, leading to widespread coverage of the artist, who refused to discuss the identity of his attackers, in order to avoid fuelling further divisions. Combo's response to the attack on his social media account was markedly defiant: 'Demain, je retournerai dans les rues pour continuer à afficher mon travail. Et je recommencerai le jour suivant. Et encore celui d'après. Peur de personne. Peur de rien' (cited in Mestaoui, 2016: 175).[20] Jack

[20] 'Tomorrow, I'll go back to the streets to carry on displaying my work. And I'll start again the day after that. Fear no-one. Fear nothing'.

Lang, former Minister of Culture and current president of the Institut du monde arabe (IMA) in Paris, became aware of Combo's CoeXisT project as a result of the media attention and Combo's interview on Canal+'s Grand Journal. He subsequently contacted the artist, inviting him to distribute copies of the CoeXisT logo outside the Institut du monde arabe and to paste a huge poster of CoeXisT onto the façade of the Institut in the days that followed the assault.[21] The encounter between Lang, the IMA, and Combo could be seen as the starting point of Combo's incorporation into the art world, what Samuel Merrill (2015: 369) critically refers to as 'heritagisation' of street art. Indeed, following this episode, Combo was commissioned to put on a solo exhibition at the IMA (which took place from January to March 2016 – opening on 7 January, exactly one year after the *Charlie Hebdo* attacks).

This process could be interpreted as affecting Combo's credibility as 'un artiste à risques' as a result. Certainly not all street artists are invited to exhibit their works in national cultural institutions and a useful counter-example might be what Annelies Moors refers to as the 'subversive street art' of Princess Hijab (PH). Princess Hijab's 'hijabization' of adverts and billboards in the Paris metro, where s/he paints black hijabs onto images of models in a visual attack on consumer capitalism and 'la marchandisation des corps' has not been met with the same enthusiasm as Combo's CoeXisT project (Moors, 2011: 128).[22] PH's work has even been regarded as Islamist or right-wing by some critics, with its hijabization techniques being likened to advertising censorship in Gulf countries such as Saudi Arabia, where images of 'underclothed' women are covered up to make them appear more 'modest'

[21] Combo had sent out a call to his followers on social media to paste the CoeXisT poster around Paris with him in reaction to the attack, in order to further reinforce the message of 'le vivre ensemble'. In an interview, Combo used the term 'le vivre ensemble' to describe the purpose ('vocation') of his IMA CoeXisT exhibition. Institut du monde arabe. 'Exposition – Coexist – Combo Culture Kidnapper'. 2011. Available at: https://www.youtube.com/watch?v=xTA-4lyK7-s (consulted on 4 June 2019). The expression is also used by Mestaoui in her discussion of Combo's CoeXisT project (2016: 6; 178). Of course, the term 'le vivre ensemble' has a history of its own and has been associated with cultural democratization initiatives such as the 'Mission: Vivre ensemble' launched by the Ministry of Culture in 2004. See Ministère de la Culture. 'Mission: Vivre ensemble'. *Culture.gouv.fr.* Available at: http://www.culture.gouv.fr/Thematiques/Developpement-culturel/Mission-Vivre-ensemble (consulted on 4 June 2019). See also Kiwan (2020), which discusses how the term further developed under Hollande's presidency as it became increasingly associated with the upholding of *laïcité*.

[22] 'the commodification of bodies'.

(Moors, 2011).[23] However, this is not to say that Combo has not playfully challenged dominant discourse surrounding the *hijab* or veil in France. His vast 'Vénus de Clichy' mural on the façade of the Ministry of Culture portrayed a reclining woman wearing a full-length *jilbab* in a visual parody of Manet's 'Olympia'.[24] In a political context that is hostile to veiling, this mural could be regarded as dissensual, given its large-scale depiction of a Muslim woman from the *banlieue* on a government building at the significantly named Rue des Bons-Enfants. Nevertheless, unlike Princess Hijab, Combo had been given 'carte blanche' by the Ministry of Culture in this instance, which suggests that he may have come to occupy a certain 'insider' status within the French national context. By contrast, in the next section I will consider Combo's work in a national context unfamiliar to him, by focusing on his work in Tel Aviv, Israel.

Combo went to Tel Aviv in the spring of 2015. He travelled with two friends, Clément and Atome (a fellow street artist) who work with him on the creation of the Jewish, Catholic, and Muslim fictive alter egos, and who feature in Combo's street art, in his Institut du monde arabe exhibition, and on the streets of Tel Aviv. While Combo has created the fictive alter ego of 'Mohamed' for himself, Clément plays the role of 'Mohamed's Jewish friend 'Moshe', and Atome plays the role of his Catholic friend 'Michel'. In an interview with the online magazine *Rootsisrael*, Combo presented his trip to Tel Aviv as a sort of quest by 'Mohamed' to find his French Jewish friend 'Moshe', who has made *aliyah* to Israel, in order to convince him to come back to France:[25]

> Moshé a décidé de partir vivre en Israël, il a fait son Aliyah. Et moi je suis Mohammed, son pote de toujours, resté en France et à qui il manque.

[23] Other reasons that might explain the less favourable responses to Princess Hijab may be linked to the fact that their work defaces already-existing visual displays and is thus perceived as more 'destructive' than Combo's 'constructive' CoeXisT project. Hostility towards PH could also be related to the fact that s/he has not engaged in the same degree of self-promotion as Combo and remains anonymous. It could also be connected to gender, since although there is uncertainty about the artist's gender identity, the project has often been understood as making a statement in favour of the veil, even though PH denied that hijabization is a priori about veiling in a 2009 interview (Khan, 2019).

[24] See http://www.combo-streetart.com/gallery/coexist-2/ (consulted on 11 September 2019).

[25] It is significant to note here that Combo challenges French perceptions of *aliyah* as permanent by suggesting that return migration (*yerida*) is possible. Indeed, research shows that it is not uncommon (see Pacalet, 2015).

Transcultural Complexity in the Work of Street Artist 'Combo' 265

Je viens donc à Tel-Aviv pour lui rendre visite mais surtout pour le convaincre de revenir en France. Parce que oui, la France n'est plus la même sans lui.

Je pense qu'il faut prendre ses responsabilités. Pourquoi laisser partir les gens qu'on aime. Mohammed s'adresse à tous les Français partis, il cherche à reconquérir le cœur de ceux que la France a perdu. La démarche de Mohammed est de récupérer son pote, pour se [*sic*] faire il s'est rasé la barbe! (cited in Ninio, 2015)[26]

Here Combo is clearly referencing current debates about what is known as the new antisemitism in contemporary France (Silverstein, 2008; Jikeli, 2015; Judaken, 2018; Bharat, 2018). During the same interview, Combo talks about the constraints and difficulties in Tel Aviv during his visit, and a heavy police presence, but he nevertheless managed to stencil his CoeXisT logo around the city, and to paste posters of 'Mohamed' declaring his love for 'Moshe' (Plate 7). On the Dizengoff/Nordau street intersection, he also pasted a further self-portrait accompanied by the melancholic proverb, 'Loin des yeux, loin du cœur' ['Out of sight, out of mind'], referencing the 3,278 kilometres separating, yet also paradoxically connecting, Paris and Tel Aviv (see Plate 8).

In Plate 7 (collaged into Nachalat Benyamin Street in Tel Aviv), Combo's clean-shaven 'Mohamed' indicates a partial 'make-over', which seeks to play down the previously pious image (see Plate 5). But by putting 'Mohamed' and 'Moshe' into a love-heart bubble, Combo's artwork could be regarded as dissensual on two levels – through its subversion of heteronormative models of masculinity, on the one hand, and through its message of transnational and interfaith coexistence, on the other. The fact that Combo chooses two stereotypical forenames to embody his fictive characters might be seen as problematic, but it is perhaps through doing just that that he exposes and thereby lampoons the spectator's own expectations, in turn creating a message that deconstructs and disarms both Islamophobia and antisemitism. Returning to Rancière's notions of aesthetic community and emancipation,

[26] 'Moshe has decided to leave [France] and live in Israel; he's made his Aliyah. And I'm Mohamed, his friend for life, who is left in France and who misses him. So I've come to Tel Aviv to visit him but most of all, to convince him to come back to France. Because France is not the same without him. I think that you have to face up to your responsibilities. Why let the people we love leave? Mohamed is addressing all those French people who have left; he sets out to reconquer the hearts of those that France has lost. Mohamed's mission is to get his friend back, and to do this, he has shaved his beard!' NB.: *Rootsisrael* magazine uses two 'm's in 'Mohammed', unlike Combo's spelling that uses just one 'm'.

one can read Plates 7 and 8 in a number of ways. They both simultaneously gesture forwards into the future towards a religiously diverse community 'which is still lacking' (Rancière, 2011: 57) and back towards the past as though to remind viewers of the existence of a former interfaith friendship. In that sense, Plates 7 and 8 index multiple chronologies (and multiple spaces) and thus resonate with Rancière's (2013) use of Foucault's notion of heterochrony.[27] Furthermore, Plate 7 can be regarded as alluding to a process of emancipation whereby 'Mohamed' and 'Moshe' are not portrayed as the habitual enemies as per the broader polarization narratives, but instead become 'dis-identified' from their stereotyped and ascribed identities in order to make their affinities visible (sensible) (Rancière, 2011: 73).

At a distance of 3,278 kilometres from Tel Aviv, Combo's CoeXisT exhibition opened at the Institut du monde arabe (IMA) in Paris on 7 January 2016. This was Combo's first solo exhibition within an established cultural institution and, following the acceptance of his project in June 2015 by the IMA, Combo embarked on an intense creative period, producing one hundred photos and forty original artworks for the mixed-media exhibition, which included sound and video as well. The exhibition was organized in three parts: 'Neoclassicism', 'DjiArt', and 'Clichés'. The theme of communities of interfaith friendship was once again foregrounded, this time via a photograph of 'Mohamed', 'Moshe', and 'Michel' – whereby fragments of their three faces are collaged together, thus creating the impression of one face.[28] While this could be read as embodying the CoeXisT message via the notion of multiplicity, Combo argues that, as an artwork, it also plays on misplaced stereotypes and false perceptions of the 'Other's' faith since he portrays himself as the Muslim 'Mohamed', even though he might not be Muslim himself. Combo highlights that this facial depiction of CoeXisT as 'l'homme multiple' ['the multiple man'] hints at the notion of the frontier since the three faces are not seamlessly fused together digitally but are collaged by hand with the tears of the different sections clearly visible to viewers (Mestaoui, 2016: 196). This piece could thus be regarded as a further example of a process of emancipation via 'dis-identification' (Rancière, 2011: 73) or an 'aesthetics of resistance' that de-stabilizes established regimes of perception (Shilton, 2014: 357).

[27] It is arguable that both figures also refer to heterotopias or spaces that 'are normally incompatible' (Rancière, 2013: 8).

[28] See Meziani (2016) for a link to the image. Available at: https://www.france24. com/fr/20160113-combo-street-art-exposition-institut-monde-arabe-paris-coexist (consulted on 27 June 2019). On the theme of inclusive communities of friendship between majority and minority groups in contemporary French fiction and film, see McQueen (2018).

Transcultural Complexity in the Work of Street Artist 'Combo' 267

The IMA exhibition also included sketched portraits of 'Moshe' and 'Michel' as so-called humouristic 'representatives' of their respective faiths, whereby each friend holds up a different coloured sign in front of his partially obscured face, which states his alter ego's name in English as follows: 'Hello my name is Moshe' (in yellow); 'Hello my name is Mohamed' (in red); 'Hello my name is Michel' (in blue).[29] The theme of names and the potential dangers of naming the 'Other' in reductive ways is clearly prevalent here, as demonstrated by the accompanying quotes from William Shakespeare's *Romeo and Juliet* ('What's in a name? That which we call a rose'), Marek Halter ('Changer de nom, c'est changer de destin'), and Virginia Woolf's *The Waves* ('Rien ne devrait recevoir un nom de peur que ce nom ne le transforme').[30] The inclusion of these handwritten citations (parts of which are scribbled out), the use of primary colours, and the gaze of the three friends all contribute to a childlike aesthetic and connect to some of Combo's other work around friendship, such as an IMA exhibition sketch of 'Moshe', 'Mohamed', and 'Michel' where the accompanying text reads: 'Quand j'étais petit, il n'y avait pas d'arabes, de noirs, de gays, de musulmans, de juifs, de cathos... Il n'y avait que des copains'.[31] Both sketches thus offer a critique of categorization and othering, 'une pensée autre', which works against essentialization (Khatibi, 1983 cited in Shilton, 2014: 357) and that opens up a process of emancipation through dis-identification and a dissensual aesthetic community (Rancière, 2011).

Concluding Remarks

'Combo' as an artist name clearly alludes to an approach to creativity that is bound up with transcultural complexity and combination. Combo's CoeXisT project, in its various guises, is testament to this approach, whereby his use of second-degree humour via the alter ego of 'Mohamed' allows him to perform an at times conflicted 'vivre ensemble', via his street

[29] See https://www.combo-streetart.com/gallery/coexist-1/ (consulted on 9 August 2019) for a link to the image in question.

[30] Combo cites Shakespeare's *Romeo and Juliet*. See Shakespeare (2004: act 2, scene 2). The reference to Marek Halter, who founded the International Committee for a Negotiated Peace Agreement in the Near East in 1967, is significant in the broader context of Combo's work: 'To change one's name is to alter one's destiny'. Combo cites Virginia Woolf in French; English original: 'Nothing should be named lest by doing so we change it' (1992: 381).

[31] 'When I was little, there weren't any Arabs, Blacks, homosexuals, Jews, Catholics... There were just friends'. See image and accompanying text at https://www.combo-streetart.com/gallery/coexist-1/ (consulted on 9 August 2019).

268 *Jewish-Muslim Interactions*

art, exhibitions, and social media presence. It is arguable that the use of irony and artistic subversion maintains a mode of creative expression that mitigates the risk of simplistic and utopian visions of Jewish-Muslim interaction, and upholds an acknowledgement of contemporary tensions between Jews and Muslims. So, in this sense, then, Combo's use of 'le deuxième degré' in both his visuals and text (tags) would seem to suggest a potential for moving from a simple representation of coexistence to the articulation of dissensus (Rancière, 2008; 2011) and an aesthetics of (co-) resistance or revolt (Shilton, 2014). Indeed, the fact that Combo insists on making religious affiliation visible via his CoeXisT collages in the public space of the secular French Republic, where religion is expected to be contained in the private sphere and where citizens' religious origins are deemed to be irrelevant to their citizenship (at least in theory), suggests a 'norm-breaking' akin to Bakhtin's carnivalesque mockery, as discussed by Sienkiewicz (2018: 24–25).

However, it could also be argued that Combo's work is ambivalent in a number of ways. By focusing on the religious affiliations or origins of the three friends 'Moshe', 'Michel', and 'Mohamed' – and via the 'vivre ensemble' spotlight on the religious symbols of the star of David, the Islamic crescent, and the Christian cross – it is arguable that Combo potentially runs the risk of essentializing the very communities to whom he seeks to give visibility. As Hutcheon argues, irony is a 'risky business' (Hutcheon, 1994, cited in Sienkiewicz, 2018: 23) and its impact on audiences is contingent. The fact that Combo also makes no distinction between Ashkenazi and Sephardi Jewish heritage via his representation of 'Moshe', and that his 'Muslim' persona appears to be of Maghribi Arab heritage, is perhaps also a further indication that some aspects of his work could paradoxically reinforce an essentializing dynamic rather than more fully gesturing towards transcultural complexity. One can certainly argue that Combo's street art seeks to challenge the ambient discourse around the polarization of French Jews and Muslims and in such a way contributes to the formation of new relations (Rancière, 2011). However, in his insistence on the staging or performance of interfaith friendships, one wonders if there is something defensive in his approach – as though he has been interpellated by a dominant clash of civilizations discourse, even if he sets out to prove that such polarization does not apply to his own experience and artistic practice.[32] Finally, Combo's co-optation into the French institutional landscape via the Institut du monde arabe exhibition might suggest that his work has undergone a process of political neutralization or that he ends up aligning himself with the approach to anti-racism currently being

[32] On interpellation and dominant discourse, see Althusser (1971).

promoted by the French government, which conceptualizes religious prejudice as a barrier to coexistence.[33] However, these ambiguities in Combo's work are, to a certain extent, tangential if we accept Rancière's argument about 'the aesthetic cut that separates outcomes from intentions' (2011: 82). Indeed, the fact remains that Combo does engage in a dissensual artistic portrayal of Jewish-Muslim 'entangled histories' (Abrevaya Stein, 2014, cited in Schreier, 2015: 361) at a fraught moment in France's recent history where hegemonic discourses about Jewish-Muslim polarization have been particularly audible. Combo's work thus seeks 'new possibilities of collective enunciation' (Rancière, 2011: 72) for Jewish-Muslim coexistence against the backdrop of polarization narratives. It achieves this through the exploration of the tensions between being 'apart' and 'together' (Rancière, 2011: 78; see Plates 7 and 8), and that is where its transcultural and transgressive power lies.

Works Cited

Abrevaya Stein, Sarah. 2014. *Saharan Jews and the Fate of French Algeria*. Chicago: University of Chicago Press.

Almeida, Dimitri. 2017. 'Exclusionary Secularism: The Front National and the Reinvention of *laïcité*'. *Modern and Contemporary France* 25.3: 249–63.

Althusser, Louis. 1971. 'Ideology and Ideological State Apparatuses'. In *Lenin and Philosophy*. Trans. by Ben Brewster. London: Monthly Review Press: 127–86.

Bharat, Adi S. 2018. 'Next Year in Jerusalem? "La nouvelle judéophobie", Neo-crypto-Judaism and the Future of French Jews in Éliette Abécassis's Alyah'. *French Cultural Studies* 29.3: 228–43.

Combo Culture Kidnapper. 2018. 'Le street art: un coup d'État à l'échelle d'un muret'. YouTube, 13 December. Available at: https://www.youtube.com/watch?v=QOgYzLcLLn0 (consulted on 27 June 2019).

Combo, and Alexandra Jupillat. 2017. *Down in Town. Quand on arrive en ville*. Mouans-Sartoux: Editions Omniscience.

De Fontenay, Elisabeth, Georges Bensoussan, Pascal Bruckner, Luc Ferry, Noémie Halioua, Barbara Lefebvre, Eric Marty, Lina Murr Nehmé, Boualem Sansal, Daniel Sibony, Jacques Tarnero, Monette Vacquin, Philippe Val, Caroline Valentin, Jean-Pierre Winter, and Michel Gad Wolkowicz. 2018. *Le Nouvel antisémitisme en France*. Paris: Albin Michel.

[33] See Délégation interministérielle à la lutte contre le racisme, l'antisémitisme et la haine anti-LGBT, 'Plan national de lutte contre le racisme et l'antisémitisme'. Available at: https://www.gouvernement.fr/sites/default/files/contenu/piece-jointe/2018/05/plan_national_de_lutte_contre_la_racisme_et_lantisemitisme_2018-2020.pdf (consulted on 27 June 2019).

Demoulin, Anne. 2015. '#SprayForParis: La riposte des street-artistes contre le terrorisme'. *20 minutes*, 20 November. Available at: https://www.20minutes. fr/culture/1734683-20151120-sprayforparis-riposte-street-artistes-contre-ter-rorisme (consulted on 27 June 2019).

Fernando, Mayanthi, and Catherine Raissiguier. 2016. 'Introduction: The Impossible Subject of *Charlie Hebdo*'. *Contemporary French Civilization* 41.2: 125–44.

Gale, Leanne. 2014. '"The Coloniser Who Refuses": Co-Resistance and the Paradoxical Reality of Israeli Solidarity Activists'. *Journal of Peacebuilding & Development* 9.2: 49–64.

http://www.combo-streetart.com/ (image credits; consulted on 4 December 2018).

Hargreaves, Alec. 2015. 'French Muslims and the Middle East'. *Contemporary French Civilization* 40.2: 235–54.

Hutcheon, Linda. 1994. *Irony's Edge: The Theory and Politics of Irony*. London; New York: Routledge.

Institut du monde arabe. 2016. 'Exposition – Coexist – Combo Culture Kidnapper'. YouTube, 14 June. Available at: https://www.youtube.com/watch?v=xTA-4lyK7-s (consulted on 4 June 2019).

Jikeli, Günther. 2015. *European Muslim Antisemitism: Why Young Urban Males Say They Don't Like Jews*. Bloomington: Indiana University Press.

Judaken, Jonathan. 2018. 'Introduction: Judeophobia and Islamophobia in France Before and After *Charlie Hebdo* and Hyper Cacher'. *Jewish History* 32.1: 1–17.

Khan, Imran. 2019. 'Making Concrete Speak: Postcolonial Graffiti, European Secularism and Art Stars as Improvised Delegates'. *Interventions* 21.7: 928–41.

Khatibi, Abdelkebir. 1983. *Maghreb pluriel*. Paris: Denoël.

Kiwan, Nadia. 2020. *Secularism, Islam and Public Intellectuals in Contemporary France*. Manchester: Manchester University Press.

Klug, Brian. 2016. 'In the Heat of the Moment: Bringing "Je suis Charlie" into Focus'. *French Cultural Studies* 27.3: 223–32.

Mandel, Maud S. 2014. *Muslims and Jews in France: History of a Conflict*. Princeton: Princeton University Press.

McQueen, Fraser. 2018. 'France's "Elites", Islamophobia, and Communities of Friendship in Sabri Louatah's *Les Sauvages*'. *Modern and Contemporary France* 26.1: 77–90.

Merrill, Samuel. 2015. 'Keeping It Real? Subcultural Graffiti, Street Art, Heritage and Authenticity'. *International Journal of Heritage Studies* 21.4: 369–89.

Mestaoui, Linda. 2016. *Combo: artiste à risques*. Paris: Editions Gallimard.

Meziani, Allaoua. 2016. '"CoeXisT": le street art de Combo s'expose à l'Institut du monde arabe de Paris'. *France 24*, 13 January. Available at: https://www.france24.com/fr/20160113-combo-street-art-exposition-institut-monde-arabe-paris-coexist (consulted on 27 June 2019).

Ministère de la Culture. 'Mission: Vivre ensemble'. *Culture.gouv.fr.* Available at: http://www.culture.gouv.fr/Thematiques/Developpement-culturel/Mission-Vivre-ensemble (consulted on 4 June 2019).

Moors, Annelies. 2011. 'NiqaBitch and Princess Hijab: Niqab Activism, Satire and Street Art'. *Feminist Review* 98.1: 128–35.

Ninio, Charlotte. 2015. 'Combo, le graffeur qui n'a pas sa bombe dans sa poche était à Tel Aviv'. *Rootsisrael*, 4 May. Available at: http://rootsisrael.com/combo-le-graffeur-qui-na-pas-sa-bombe-dans-sa-poche-etait-a-tel-aviv/ (consulted on 9 November 2018).

Pacalet, Arthur. 2015. 'Israël, terre d'exode'. *Esprit* 5: 115–17.

'Paris: Facts & Data'. *Encyclopaedia Britannica.* 26 November 2019. Available at: https://www.britannica.com/facts/Paris (consulted on 27 June 2019).

Rancière, Jacques. 2008. *Le Spectateur émancipé.* Paris: La Fabrique éditions.

——. 2011. *The Emancipated Spectator.* Trans by Gregory Elliott. London; New York: Verso.

——. 2013. 'In What Time Do We Live?' *Política común* 4. Available at: http://dx.doi.org/10.3998/pc.12322227.0004.001 (consulted on 5 March 2020).

Renton, James, and Ben Gidley (eds.). 2017. *Antisemitism and Islamophobia in Europe. A Shared Story?* Basingstoke: Palgrave Macmillan.

Riggle, Nicholas Alden. 2010. 'Street Art: The Transfiguration of the Commonplaces'. *The Journal of Aesthetics and Art Criticism* 68.3: 243–57.

Schreier, Joshua. 2015. 'Recent Titles on the History of Jews and Muslims in France and North Africa'. *Jewish History* 29.3: 361–71.

Shakespeare, William. 2004. *Romeo and Juliet.* Ed. by Burton Raffel. New Haven, CT and London: Yale University Press.

Shilton, Siobhán. 2014. 'Alterity in Art: Towards a Theory and Practice of Infra-thin Critique'. *Paragraph* 37.3: 356–71.

Sienkiewicz, Matt. 2018. 'The Carnival's Edge: *Charlie Hebdo* and Theories of Comedy'. *Jewish History* 32.1: 19–32.

Silverstein, Paul A. 2008. 'The Context of Antisemitism and Islamophobia in France'. *Patterns of Prejudice* 42.1: 1–26.

Stromae. 2011. 'Peace or Violence'. YouTube, 7 August. Available at: https://www.youtube.com/watch?v=KzMWZXPCGUo (consulted on 4 June 2018).

Taş, Hakki. 2017. 'Street Arts of Resistance in Tahrir and Gezi'. *Middle Eastern Studies* 53.5: 802–19.

Todd, Emmanuel. 2015. *Qui est Charlie? Sociologie d'une crise religieuse.* Paris: Seuil.

Val, Philippe. 2018. 'Manifeste contre le nouvel antisémitisme'. *Le Parisien*, 21 April. Available at: http://www.leparisien.fr/societe/manifeste-contre-le-nouvel-antisemitisme-21-04-2018-7676787.php (consulted on 3 June 2019).

Vigouroux, Cécile. B. 2015. 'Genre, Heteroglossic Performances, and New Identity: Stand-Up Comedy in Modern French Society'. *Language in Society* 44.2: 243–72.

Woolf, Virginia. 1992. *Collected Novels of Virginia Woolf: Mrs Dalloway, To the Lighthouse, The Waves.* Ed. with an introduction by Stella McNichol. Basingstoke: Palgrave Macmillan.

Shalom alikoum! Challenging the Conflictual Model of Jewish-Muslim Relations in France through Stand-up Comedy

Adi Saleem Bharat

Introduction

Younes and Bambi are a young Jewish-Muslim stand-up comedy duo of Maghribi heritage who began playing in comedy clubs in France in 2012. The two comedians, who often greet their audiences by shouting, 'Shalom alikoum',[1] have gradually gained a degree of prominence in France through televised performances on Canal+'s *Jamel Comedy Club* and the comedy festival *Marrakech du rire* ['Marrakesh of Laughter'], both initiated by the French-Moroccan comedian Jamel Debbouze, thus concretely underscoring the Maghribi genealogy of their comedy. Indeed, Younes and Bambi are not the first Maghribi Jewish-Muslim comic duo in France. Throughout the 2000s, multiple collaborations between celebrated French-Moroccan comedians Jamel Debbouze and Gad Elmaleh provoked audiences to think about Maghribi self-identification, banlieue life, racism, cultural clashes, and hybridity. In addition, an earlier antecedent to Younes and Bambi can be identified a decade earlier in the French stand-up duo Élie and Dieudonné. From 1990 to 1997, Élie Semoun (of Moroccan Jewish heritage) and Dieudonné M'Bala M'Bala (of Breton and Cameroonian heritage) enjoyed commercial success toying with issues of racism and

[1] 'Shalom alikoum' combines the Hebrew greeting *Shalom aleichem* with the Arabic *As-salamu alaykum*, both meaning 'peace be upon you'.

274 *Jewish-Muslim Interactions*

antisemitism on stage.[2] While some aspects of Younes and Bambi's work may be reminiscent of Debbouze and Elmaleh (or Élie and Dieudonné), unlike them, the younger Franco-Maghribi comedians display a more sustained focus on relations and interactions between Jews and Muslims as ethnic categories. At a time when the categories of 'Jews' and 'Muslims' are increasingly thought of as inherently mutually exclusive and conflictual, the duos' focus on the question of Jewish-Muslim relations is unlikely to be a coincidence. Rather, it can be read as a corrective.

Especially since the 1960s and 1970s, the immigration of Muslims from North and sub-Saharan Africa, as well as their supposed lack of integration into French society, has provoked much debate in French politics and media. Such continued debates take place in the inflamed contemporary context of anti-Muslim and anti-Jewish discourse and acts of violence, bombings and terrorist attacks, sometimes related to Middle Eastern conflicts; the growing electoral success of the far-right political party Front National; and a series of legislations and rulings on (both legal and illegal) immigration, racial discrimination, and the public display of religious symbols mostly affecting Muslim women who veil. During the same period, relations between Jews and Muslims in France have been increasingly depicted in binary and conflictual terms. Historians Maud Mandel (2014: 80–124) and Ethan Katz (2015: 242–78) have carefully charted how, over several decades in the mid-twentieth century, Jewish and Muslim activists and communal leaders as well as, more importantly, French authorities and media professionals blurred the lines between domestic Jewish-Muslim interactions and international conflicts, encouraging North African Jews and Muslims to identify with Israel and Palestine, respectively. Conflict increasingly became the primary framework for understanding Jewish-Muslim relations, especially in the wake

[2] In the early 2000s, however, Dieudonné's comedy veered towards overt antisemitism. In December 2003, on the TV show *On ne peut pas plaire à tout le monde* ['You Can't Please Everyone'] Dieudonné performed a sketch dressed as an orthodox Jewish Israeli settler. Dieudonné's character invites the audience to join the 'American-Zionist axis' and ends the sketch with a Nazi salute, while shouting 'Isra-heil'. Since then, Dieudonné has frequented far-right figures, such as Jean-Marie Le Pen and Holocaust denier Robert Faurisson. Dieudonné has also become known for the *quenelle*, a gesture that involves keeping one arm down by the side of the body and the other touching the shoulder. Originally performed as a visual demonstration of symbolic sodomization – the gesture was first performed to these words: 'il va nous la foutre jusque-là' ['he's gonna fuck us right up the ass'] – in a sketch in 2005, Dieudonné's *quenelle* has, at least since 2013, been widely interpreted as a reverse Nazi salute. See Altglas (2012) and Jikeli (2015) for an assessment of Dieudonné's antisemitism.

Challenging the Conflictual Model of Jewish-Muslim Relations 275

of the 1967 Arab-Israeli War. This 'narrative of polarization' (Mandel, 2014: 7) obscures a more nuanced history and on-the-ground reality of interactions between Jews and Muslims in France. In the course of my research on representations of Jewish-Muslim relations in contemporary France, I have found that this narrative of polarization, which consists of constructing Jews and Muslims as homogenous and exclusive communities with tense and conflictual relations, still wields considerable influence in news reporting on Jewish-Muslim relations in France in the contemporary period. Younes and Bambi's comedy is situated within and, in part, responds to this polarized socio-political context.

Stand-up comedy about race or ethnic/ethno-religious identification often plays on and with stereotypes. However, when does highlighting stereotypes become a way of challenging these very stereotypes, and when does it become an endorsement of them? How do comedians rely on essentialized representations, while highlighting the constructed nature of such representations, if this is indeed their intention? How do they 'reuse stereotypes' (Rosello, 1998: 9) without merely repeating and reinforcing them, bearing in mind that the survival and longevity of stereotypes are premised on repetition and 'iterativity' (Rosello, 1998: 37)? These are the driving questions of this chapter. Whether or not a comedian challenges these stereotypes is largely dependent on two factors. First, the intentions, performative style, and content of the performance: following Rosello, it is crucial that the comedian is aware of the iterativity of stereotypes and seeks not to merely critique them, but to 'decline' them, that is, to interrogate and undermine the very structure of the stereotypes in question. Second, the audience's social experience of stereotypes, as well as their familiarity with the comedian. In other words, whether or not stereotypes are challenged in stand-up comedy depends on both the comedian and the context in which they are performing, that is, audience reception. While research on audience reception is clearly important, this chapter focuses on the first factor: how Younes and Bambi encode their message for their audience, in such a way that stereotypes are 'reused' and 'declined'. My exclusive focus on the content of their stand-up comedy is justified because this chapter represents the first academic appraisal of Younes and Bambi's work. Further research might place content analysis in relation to reception analysis.

Analysing YouTube clips of stand-up shows by Younes and Bambi,[3] this chapter examines the extent to which Younes and Bambi's stand-up comedy

[3] These include clips from seasons 7 (2014), 8 (2015), and 9 (2016) of the *Jamel Comedy Club* (JCC), the comic duo's 2015 appearance on the Canal+ TV show *Le Before du Grand Journal*, and the international comedy festival *Marrakech du rire* (televised by M6) in 2016.

276 *Jewish-Muslim Interactions*

allows them to 'decline' widely held stereotypes of Jews and Muslims in France *as well as* of Jewish-Muslim relations. I argue that Younes and Bambi's stand-up routine echoes American comedian Jerry Seinfeld's understanding of stand-up as dialogue and not monologue (Borns, 1987: 16).[4] Through their comedy sketches, Younes and Bambi put forward their ideal model of Jewish-Muslim relations, namely one of collaboration, *complicité*, empathy, humour, and, most importantly, dialogue. The comedians subtly draw upon a nuanced history of Maghribi Jewish and Muslim interactions in postcolonial France and, for the duration of their sets, construct a convivial socio-cultural space based on shared histories, religious affinities, and marginality, expressed through North African Jewishness and Muslimness. In this intimate setting, Younes and Bambi identify, exaggerate, and attempt to decline various (negative) stereotypes about Jews and Muslims and their intergroup relations in a way that potentially invites their audiences to reimagine contemporary Jewish-Muslim interactions beyond the conflictual model that dominates discussions in contemporary French political and media discourse.

Muslims and Arabs: A Note on Terminology

Younes and Bambi subtitle their stand-up comedy routine 'l'arabe et le juif' ['the Arab and the Jew']. The comedians, however, use the terms 'arabe' ['Arab'] and 'musulman' ['Muslim'] in an interchangeable manner. While the term 'Muslim' properly refers to a follower of Islam, it extends beyond the purely religious in contemporary France. Politicians, media professionals, and the public often have a specific group of individuals in mind when they use the term 'Muslim'. In general, they are referring to North African 'Arabs' and not, for example, South and Central Asian Muslims, 'black' Muslims, or 'white' Muslims from countries like Albania, or 'white' French-European converts.

[4] While stand-up comedy can sometimes seem to be a monologue, Jerry Seinfeld argues, 'Comedy is a dialogue, not a monologue – that's what makes an act click. The laughter becomes the audience's part, and the comedian responds; it's give and take. When the comic ad-libs or deals with a heckler, it gets an explosive response because it's like, "Hey, this is happening now! This isn't just some preplanned act." So whatever lends itself to that feeling is what makes comedy work – that live feeling. That's why comics ask, "Where are you from?" It brings a present moment to the show' (cited in Borns, 1987: 16). In the case of Younes and Bambi, the dialogic nature of stand-up comedy is even more pronounced due to the fact that their entire show is premised on conversations between the two comedians as well as with the audience.

Challenging the Conflictual Model of Jewish-Muslim Relations 277

Thus, the interplay between 'arabe' and 'musulman' in Younes and Bambi's stand-up comedy reflects the racialization of Muslimness in France. Racialization is 'the extension of racial meaning to a previously racially unclassified relationship, social practice or group' (Omi and Winant, 1994 [1986]: 64). When religion is racialized, then, it is perceived as an innate trait or linked to a specific ethnicity or 'race'. In France, Islam and Muslims are racialized and associated with a particular ethno-national group. In such contexts, Islam and being Muslim almost cease being purely religious and become associated with phenotype, culture, and heredity. Research on the racialization of Islam and Muslims in Europe and North America suggests that the religion and its followers are racialized as being generally and abstractly non-'white' and 'foreign' (Davidson, 2012; Meer, 2012; Moosavi, 2014; Galonnier, 2015). This is even the case when the Muslims in question are 'white' and natives. White French Muslim women who wear the hijab encounter racial slurs and are told to return to their country of origin, demonstrating both how Islam has been racialized as 'Arab', which in turn mostly refers to 'North Africans', and how the hijab in particular is a powerful gendered marker of racialized difference (Galonnier, 2015).

A Short History of Stand-up Comedy in France

There exists a distinction between 'one-man/woman show[s]' and 'stand-up', which is a newer category in France used by 'the younger generation of comics of North and sub-Saharan African origins' (Vigouroux, 2015: 244). The longer-established category of one-man/woman shows generally consisted of impersonations and sketches, and these were less interactional than contemporary stand-up routines, where comedians give the perception of speaking *to* and *with* the audience in a seemingly extemporaneous manner. There were, of course, exceptions; Pierre Desproges, who incarnated the character of an angry intellectual ranting about life and death, politics, and racism in the 1980s, certainly falls within the framework of extemporaneous, interactional stand-up comedy. In general, however, Desproges was an exception to French one-man/woman shows.

Moreover, there is a fundamental difference in the way ethnicity has been represented in older one-man/woman shows versus newer stand-up performances. First, in France, one-man/-woman show comics were largely white and of Christian heritage (an important exception is Smaïn, a French comedian of Algerian descent who gained popularity in the 1980s and possibly represents the transition from one-man/woman shows to stand-up comedy), while contemporary stand-up is highly diverse and, in fact, mainly non-white. Second, the older generation of one-man/woman show comics tended to

caricaturize ethnic minorities in problematic and racist ways.[5] Consider, for example, comedian Pierre Péchin's imitations of Maghribis in his 1975 sketches *S'il vô plait !* ['Please!'] and *La Cèggal è la foôrmi* ['The Grasshopper and the Ant'], and actor-comedian Michel Leeb's imitations of Africans, for example in his 1980 sketch *L'Épicier africain* ['The African Grocer']. In both cases, the punch line is simply the foreignness and intellectual inferiority of Maghribis and Africans and their 'funny'-sounding, unintelligent accents. This is not to say that all one-man/woman shows represented ethnic minorities in a racist manner. Sophie Daumier and Guy Bedos's 1975 sketch *Les Vacances à Marrakech* ['Holiday in Marrakesh'] ridicules the quotidian anti-Maghribi racism in French society. Yet, here again, such sketches represent the exception to the rule.

In this context, Vigouroux argues that the stand-up comedy of French comedians of Maghribi or sub-Saharan heritage, which emerged in the mid-2000s, represents a way for minority ethnic performers to collectively claim 'a new space of visibility and hearability' (244). Stand-up comedy in France only begins (as something identifiable as *stand-up*) in the mid-2000s, and was notably popularized by the *Comic Street Show*, the first televised stand-up show in France, followed by Jamel Debbouze and his *Jamel Comedy Club*, featuring a number of promising young comedians of immigrant background, which was broadcast on the French television channel Canal+ beginning in 2006.[6] Stand-up increasingly became a way for minority performers to claim a visible space to challenge external, stereotypical, negative representations, and to project more diverse and positive self-representations.[7] One of the factors accounting for the emergence of stand-up *qua* stand-up as a minority performance genre in the 2000s is the fact that French theatre and television in the 1990s were overwhelmingly white. With theatre and television excluding minorities – and minorities

[5] This is not to assume that contemporary non-white French comedians are never themselves guilty of racism in their performances. Dieudonné's unambiguous antisemitism is the most prominent example, but there are also other examples of ethnic minority comedians invoking racist stereotypes to laugh *against* and not *with*, including Sephardi comedians Gad Elmaleh and Kev Adams's 2016 'les chinois' ['the Chinese'] sketch that invoked a number of racist East Asian stereotypes and involved 'yellowface'.

[6] See Ervine (2019) for a more detailed discussion of the origins of the Jamel Comedy Club.

[7] See Quemener (2013) for an analysis of how ethnic minority comedians in France, from Smaïn in the 1980s to Jamel Debbouze in the late 1990s and 2000s, have used humour to combat dominant negative stereotypes.

more often than not appearing in the evening news as rioters and criminals – stand-up, explicitly differentiated from the older one-man/woman shows by its minority performers, became a way for ethnic minority performers to assert a more nuanced and positive image, drawing on (African- and Jewish-) American comedians, such as Eddie Murphy and Jerry Seinfeld.

Narrative Structure: Dialogue, Conflict, and Resolution

In general, Younes and Bambi sketches share a common structure. The two comedians are usually introduced by a compère and then enter to generic hip-hop or RnB music. They then energetically greet the audience (for example, 'ça va le comedy club ou quoi?!' ['Comedy Club, how's it hanging?!']. They proceed to introduce themselves stating 'on s'appelle Younes et Bambi – un arabe et un juif' ['we're Younes and Bambi – an Arab and a Jew'], thereby explicitly reminding their audience of their ethnically marked stand-up comedy. They take care to clearly enunciate each syllable in 'un arabe et un juif', emphasizing to their audience the remarkable and unlikely nature of the duo. The emphasis placed on them being 'un arabe et un juif' also breaks the taboo of ethnic self-identification in the context of French republican universalism as the dominant political ideology. The order of the next two segments is interchangeable. The comedians might immediately tell their first joke, which is usually directed at a particular member of the audience. Alternatively, Younes might ask if there are any Moroccans, Algerians, and Tunisians in the audience. This is always greeted by loud cheers and applause. Bambi will then follow up by asking if there are any Jews in the audience. At most, only a handful will make themselves heard. The comedians will then proceed to make a joke about this, which will allow them to launch into other material about Jews and Muslims.

At this point, the comedians intentionally perform a point of contention that arises between them. This usually occurs around the topic of the Israeli-Palestinian conflict. The conflict between the two comedians then intensifies to the point where it is no longer focused on the Israeli-Palestinian conflict, but just general assumed tensions within the Jewish-Muslim binary.[8] The conflict between Younes and Bambi is always resolved by the end of the sketch, either by a final joke that highlights the duo's friendship followed by a declaration such as 'on n'a pas du tout la même religion, mais on a la même passion' ['we don't share the same religion, but we have the same passion'] or by the intervention of a third party, such as Jamel who, during the duo's

[8] See Wieviorka (2005) and Hecker (2012) for an analysis of the Israeli-Palestinian conflict as a language for the voicing of domestic discontent.

280 *Jewish-Muslim Interactions*

sketch at the *Marrakech du rire* festival in 2016, forces Younes and Bambi to embrace or face not being paid. Thus, by going from conflict to resolution where everyone is encouraged to laugh at themselves and with one another, Younes and Bambi's sketches provide a cathartic release for their mixed audiences who may encounter conflictual, oppositional representations of Jewish-Muslim relations in popular cultural, media, and political discourse.

Antisemitism and Islamophobia

Younes and Bambi highlight physical and behavioural Jewish and Arab-Muslim stereotypes to deconstruct both anti-Jewish and anti-Muslim racism through repetition and exaggeration, while promoting a sense of shared Franco-Judeo-Muslimness. The antisemitic stereotypes most commonly invoked in their sketches are a combination of physical features (long noses), behavioural traits (greed and miserly behaviour), professions (the stereotype of the Jewish lawyer), and broader generalizations of Jews as an influential people (controlling media and politics). The anti-Arab/Muslim stereotypes mostly relate to low educational attainment, accented language, *communautarisme*,[9] and terrorism. Unlike comedians like Michel Leeb and Pierre Péchin, who invoke stereotypes to ridicule individuals and groups of individuals, Younes and Bambi draw on a set of Jewish and Muslim stereotypes in order to ridicule, and thus challenge, the stereotypes themselves. In essence, by using these stereotypes, they are not laughing at those targeted by stereotypes, but laughing *with* them at the process of stereotyping, those who stereotype, and the stereotypes themselves.

Laughing-*with* can be achieved by having the comedian who might be ethnoreligiously associated with the stereotype embody an exaggerated version of that stereotype. For example, Bambi often pretends to be wealthy (even though his character also implies being from the same socio-economic background as Younes). In one sketch, after Younes accuses Bambi of acting as if he owns the theatre they are playing in, Bambi insinuates that he could buy the theatre if he wanted:

Younes: Tu crois que c'est le théâtre de ton père ?

[9] *Communautarisme* is a normative term used, often pejoratively, in France to refer to the making of political claims in the name of ethnic, religious, gender, and sexual minority groups that are considered to not be fully integrated into the nation. It can be translated as communalism or factionalism and refers to individuals and groups perceived to be acting in the interest of their particular communities over that of the national community.

Challenging the Conflictual Model of Jewish-Muslim Relations 281

Bambi: Hé, ho ! Déjà, c'est pas le théâtre *de* mon père. Enfin, pour le moment hein...[10]

Representations of this variant of economic antisemitism (assuming all Jews to be rich) abound in their stand-up routine. In another sketch, Bambi 'reveals' the 'truth' behind the practice of placing notes in the Western Wall:

Younes: C'est quoi les petits mots que vous mettez dans le mur?
Bambi: C'est pas des mots, c'est des notes de frais – enfin non! C'est des vœux qu'on met à l'intérieur.[11]

In this way, the sketch places money (instead of, for instance, religious practice and the worship of God) at the centre of Judaism. Similarly, when Younes asks why French actor Danny Boon was able to convert to Judaism relatively quickly (Bambi earlier cited seven years as the length of time required for conversion), Bambi's reply highlights the actor's income:

Younes: Ah bon, tu peux m'expliquer pourquoi Danny Boon il n'a mis que deux ans à se convertir?
Bambi: Mais ça n'a rien à voir... Danny Boon, il a pratiqué la religion très vite. Il a lu beaucoup de livres sur la torah. Il a gagné 27 millions en 2008. [Audience laughs] Donc ça n'a rien à voir, monsieur.
Younes: L'argent, l'argent. Money, money, money. [Mimes holding money.][12]

If the large nose remains the most prevalent physical Jewish stereotype, the most common character trait attributed to Jews throughout the centuries, especially in the West because money-lending was one of the few professions Jews were allowed to practise (as medieval laws prohibited Catholics from lending for profit), relates to money, greed, and avarice. Perhaps, the most enduring depiction of the moneyed, avaricious, and miserly Jew is the character of Shylock in William Shakespeare's *Merchant of Venice*.[13] This

[10] 'Younes: Do you think this is your dad's theatre?
Bambi: Hey! First, this isn't *my* dad's theatre. Well, for the time being...'
[11] 'Younes: What are those little notes that you guys put into the wall?
Bambi: They aren't notes... They are expense claims – well, no! They're wishes that we put inside [the wall]'.
[12] 'Younes: Oh really, can you explain to me why it only took Danny Boon two years to convert?
Bambi: Well, that's different... Danny Boon, he started practicing really quickly. He read lots of books on the Torah. He earned 27 million in 2008. [Audience laughs] So it's not the same, sir.
Younes: Money, money. Money, money, money. [Mimes holding money.]'
[13] See Anidjar (2003: 101–12) for a discussion of Shakespeare's *Merchant of*

282 *Jewish-Muslim Interactions*

stereotype still holds sway in contemporary popular representations of Jews, from the French trilogy of films *La Vérité si je mens* ['Would I Lie to You?'] (1997–2012) – in which, as Joseph McGonagle (2017: 171–72) notes, religion gives way to 'the worship of money' in a 'facile and cliché-ridden' depiction of Jewishness – to a recent street celebration in Belgium (March 2019) that featured a float of giant puppets of Orthodox Jews with large, hooked noses sitting atop bags of money. The association of Jews with money is not anodyne. The combination of Jewish greed for money and power (and the fear that Jews are everywhere and control the world) is a major component of modern and contemporary antisemitism.

Unlike comedian Dieudonné who perpetuates these physical and behavioural stereotypes, Younes and Bambi, like Desproges before them, perform these stereotypes ironically and thus help break them down. For example, while Bambi's character occasionally pretends to be wealthy, he also emphasizes that he grew up with Arabs – 'j'ai grandi avec des Arabes' – and suggests that he shares a similar socio-economic background to Younes. Thus, when Bambi performs the stereotype of the moneyed, miserly Jew, he is doing so ironically. Moreover, the format of a duo allows Younes and Bambi to trade and contrast stereotypes of Jews and Arab-Muslims. It is important to note that they do not overtly reject stereotypes and replace them with accounts that are more factual. Rather, as in Rosello's model of declining the stereotype, they 'refuse to replace the stereotype with a discourse of truth and prefer to push stereotypes around on the social chess board as if they were manipulating delicate symbolic weapons' (1998: 64). For example, when Younes jokes that Bambi is jealous because 'vous, les Juifs, vous avez pas l'option "partager" sur Facebook' ['you Jews don't have the "share" button on Facebook'], Bambi responds that it is, in fact, Younes who is jealous because 'dans vos iPhones, ils vous ont coupé le mode avion depuis 11 septembre' ['since 9/11, they have removed the airplane mode from your iPhones']. By trading insulting, generalizing stereotypes (the Jewish miser and the Muslim terrorist) in such a flippant and friendly manner – each insult is met with faux outrage from the comedians and laughter from the audience – Younes and Bambi neutralize the divisive power of these stereotypes, transforming them instead into elements of social bonding. In this way, the comedians are engaged in a 'conscious cultural reappropriation of ethnic stereotypes' (Rosello, 1998: 18–19).

Younes and Bambi's performance of stereotypes as a form of in-group banter that solidifies the bond between them (and by extension their

Venice in relation to his *Moor of Venice* in terms of the relational representation of Christianity's 'theological enemy' (Jews) and 'political enemy' (Muslims) through a set of stereotypes that have come to constitute these categories.

perceived ethnoreligious communities) depends on two elements: first, the at times dialogic, at times contrapuntal nature of their performance; and, second, the framing of their interactions as amicable. The duo frequently begin and end their sketches by saying 'on s'appelle Younes et Bambi' ['we are Younes et Bambi']. The use of the collective, neutral, and indefinite pronoun 'on', rather than two separate 'je' pronouns, performs a double collective identity that reflects the often contrapuntal nature of their performance, in which their independent *and* interdependent voices intertwine harmoniously. In addition, the very greeting 'Shalom alikoum' blends the Hebrew *Shalom aleichem* with the Arabic *As-salamu alaykum* to form a conjoined neologism representing an imagined future language of Hebrew-Arabic, Jewish-Muslim dialogue. Younes and Bambi suggest that, within this hybrid language of dialogue, the Jewishness or the Muslimness of its speakers would be difficult to determine.

However, they do not appear to wish to 'melt' Jewish or Muslim specificities away in a universalistic, republican *creuset*. After all, every time they begin their sketches with the words 'on s'appelle Younes et Bambi', they add 'un arabe et un juif'. The stand-up comedy hinges on the fact that they are Younes and Bambi, *l'arabe et le juif.* At the same time, however, they often play with the audience's perception of who is the Jew and who is the Arab:

> Younes: Bonsoir, messieurs, dames, on s'appelle Younes et Bambi.
> Bambi: Un juif [places hand on Younes's chest] et un arabe [places hand on own chest].[14]

In this way, their goal is neither to pit Jews against Muslims nor even to unite Jews and Muslims *qua* Jews and Muslims – that is, as a function of their ethnoreligious difference. Rather, the comedians suggest, like Yulia Egorova's study of Jews and Muslims in South Asia, that 'Muslims have always already been Jewish in the European imagination, while Jews have always already been Muslim' (2018: 168). While there are differences between the figure of the 'Jew' and the 'Muslim' throughout European history, their significant similarities allow for a conceptual rapprochement between the terms:

> Judaism and Islam share a similar fate in certain ways. First, they are both religions with, moreover, a troubled relationship to Christianity. Second, they were thrown together in the Enlightenment. Third, they are both part of the history of what Edward Said calls 'Orientalism'. These three

[14] 'Younes: Good evening, ladies and gentlemen. We are Younes and Bambi. Bambi: A Jew [places hand on Younes's chest] and an Arab [places hand on own chest]'.

284 *Jewish-Muslim Interactions*

ways overlap and between them give rise to a number of affinities between antisemitism and Islamophobia. (Klug, 2014: 452)

Younes and Bambi highlight these 'affinities between antisemitism and Islamophobia' in two main ways. One, by switching between Jewish and Muslim identities (for example, in JCC 8). Two, by highlighting similarities between the traumatic historical events such as the Holocaust and the Paris massacre of 1961 (in JCC 9), ordered by Maurice Papon who was also responsible for the deportation of Jews during World War II. The comedians thus embrace a 'multidirectional' – and not a competitive – model of memory that recognizes 'the productive interplay of disparate acts of remembrance' (Rothberg, 2009: 309). In doing so, the comedians emphasize the liminal position shared by Jews and Muslims in modern and contemporary France, despite the fact that the former were separated from their Muslim counterparts in either politico-legal terms in Algeria (Crémieux Decree) or socio-cultural terms in Morocco and Tunisia (greater access to European acculturation via the protégé system or the efforts of the Alliance Israélite Universelle) by virtue of their Jewishness.

Le Vivre-ensemble and Conviviality

In Season 9 of the *Jamel Comedy Club*, the comedians begin their set as per usual by greeting their audience and stating their names. Younes declares that he is sure the audience must be wondering which comedian is Arab and which is Jewish. He clarifies that he is 'l'arabe'. Bambi then addresses the audience: 'Et très logiquement, messieurs, dames, vous aurez compris que si c'est lui l'arabe, eh bien c'est moi... le coproducteur du spectacle!'[15] As in an earlier sketch, when Bambi wrongly identifies Younes as the Jew and himself as the Arab, the comedians decentre assumptions of ethnoreligious identifications right from the beginning of their performance. This challenging of the centrality of their Jewishness and Muslimness – even as they perform stereotypes of Jewishness and Muslimness – is reflected in their self-description on their YouTube page: 'Bienvenue sur notre chaîne ! Le chauve c'est Younes, le bouclé, c'est Bambi... voilà les présentations sont faites'.[16]

Subsequently in their JCC 9 performance, Bambi declares that they are not just comedians, but rather 'nous sommes le vivre-ensemble' ['we are the

[15] 'And very logically, ladies and gentlemen, as you can well imagine, if he is the Arab, then I must be... the co-producer of the show!'

[16] 'Welcome to our channel. The bald one's Younes and the curly-haired one's Bambi... there you go, we've been properly introduced'.

Challenging the Conflictual Model of Jewish-Muslim Relations 285

vivre-ensemble'], at which point a song begins to play and the pair dance in coordination with each other:

> [Song lyrics] *Nous sommes le vivre-ensemble, l'amour est la seule loi, nous sommes le vivre-ensemble, c'est nous, c'est toi, c'est moi.*
> Bambi: Applaudissez le vivre-ensemble, messieurs, dames![17]

Following the song and dance routine, Younes and Bambi remark that they are heartened to perform in front of a diverse audience. Younes begins listing the different groups of people in the audience, while Bambi finishes his sentences:

> Younes: Il y a des Maghrébins...
> Bambi: ...musulmans.
> Younes: Il y a des Français...
> Bambi: ...musulmans.
> Younes: Il y a des gays...
> Bambi: ...musulmans.
> [Younes looks horrified.][18]

The humour in this segment is derived from both the notion that the audience is not as diverse as it appears and from Younes's visceral reaction to the idea that there could be gay Muslims, which provokes Bambi to ask him if he has a problem with gay people. Younes considers this insinuation to be preposterous since he has gay friends, gay colleagues, and *des Portu-gays*. Younes's reply (especially with the addition of the *Portu-gays*) mocks the some-of-my-best-friends-are [insert minority group] defence often used by those accused of racism.[19] Bambi then asks what Younes would do if his son came out as gay:

[17] '[Song lyrics] We are the *vivre-ensemble*, love is the only law, we are the *vivre-ensemble*, it's us, it's you, it's me.
Bambi: A round of applause for the *vivre-ensemble*, ladies and gentlemen!'
[18] 'Younes: We've got Maghrebi...
Bambi: ...Muslims.
Younes: We've got French...
Bambi: ...Muslims.
Younes: ...We've got gay...
Bambi: ...Muslims.
[Younes looks horrified.]'
[19] Consider, for example, French politician Nadine Morano, who responded to accusations of racism in 2012 by stating that she had 'des amis qui sont justement arabes' ['friends who are actually Arabs'] and that her 'meilleure amie [était] tchadienne, donc plus noire qu'une arabe' ['best friend was Chadian, so darker than an Arab'] (see *Le Monde*, 2012).

Bambi: Et si ton fils, il est gay ?

Younes: Non, non, non, non, c'était pas prévu ça! Et toi, tu réagirais comment?

Bambi: Mais moi, ça ne me dérange pas. [Pause] Si ton fils, il est gay, moi, ça me fait plaisir, ça.[20]

Bambi's remark immediately unleashes a heated, unintelligible argument between the two that only ends when the *vivre-ensemble* song begins to play and the two dance together again, following which they note 'c'est important, le vivre-ensemble' ['the *vivre-ensemble* is important']. The rest of the sketch plays out following this model of a conflict provoked by a seemingly minor remark that is then punctuated by *vivre-ensemble* song and dance routines.

As the sketch progresses, Younes and Bambi perform the *vivre-ensemble* dance with visibly less enthusiasm. Towards the end, they immediately start bickering right after the song fades. At this point, their compère shouts from the audience, 'oh, les gars, le vivre-ensemble là!' ['hey guys, the *vivre-ensemble*, come on!'] Younes and Bambi stop arguing and turn to hug each other. Almost immediately, however, Younes pulls out, accusing Bambi of jabbing him with his nose. Younes and Bambi start furiously arguing again:

[*Vivre-ensemble* song begins to play]

Younes and Bambi [in unison towards the DJ]: Ferme ta gueule avec ton vivre-ensemble!

Younes: Casse les couilles!

Bambi: Il est sérieux ? On adore s'engueuler, nous!

Younes: Ça fait des siècles qu'on s'embrouille!

Bambi: Ça va pas terminer aujourd'hui! [To Younes] Enfoiré!

Younes: [to Bambi] Banane!

Bambi: Connard!

Younes: Andouille! [Amical, almost amorous tone]

Bambi: Tête de citron! [Laughing]

[Younes and Bambi draw close, hold hands, hug, and giggle uncontrollably]

Younes and Bambi: C'était Younes et Bambi, merci beaucoup![21]

[20] 'Bambi: And what if your son were gay?
Younes: No, no, no, no, that's not part of the plan! And you, how would you react?
Bambi: It wouldn't bother me. [Pause] If your son were gay, that would make me happy.'

[21] '[*Vivre-ensemble* song begins to play]
Younes and Bambi [in unison towards the DJ]: Shut it with your *vivre-ensemble*!
Younes: Piss off!

To understand Younes and Bambi's comic disdain for *le vivre-ensemble*, it is useful to contrast it with Paul Gilroy's use of the term 'conviviality', which he uses to describe 'the processes of cohabitation and interaction that have made multiculture an ordinary feature of social life in Britain's urban areas and in postcolonial cities elsewhere' (2004: xv). *Le vivre-ensemble*, on the other hand, is a political neologism that French politicians have increasingly used (along with other hollow signifiers such as *le métissage* or *le lien social*), since the end of the twentieth century, to refer to harmonious coexistence between different ethno-cultural communities in French society. Conceptually, *le vivre-ensemble* and conviviality invoke the need for something more than tolerance in multicultural contexts. However, in the Republican French context, politicians often use *le vivre-ensemble* synonymously for *intégration*, which, because it is a difference-blind assimilationist integration, merely hides the reality of racial discrimination and inequality. In this way, *le vivre-ensemble* is a top-down elite concept used primarily by politicians and media personalities who have found another word (other than assimilation and integration) to implore minorities to assimilate and 'get along' within the Republic. In the case of Jewish-Muslim relations, the deployment of *le vivre-ensemble* could be read as suggesting that Jews and Muslims would 'get along' better if only they ceased being so different from the universal (that is, white) French citizen. In this sketch, Younes and Bambi demonstrate their wariness of calls to *vivre ensemble*, while suggesting that Jews and Muslims already do *vivre* and *rire ensemble*. Thus, Younes and Bambi critically contrast the Republican universalism that underpins *le vivre-ensemble* with a more or less convivial multiculture. The comedians constant bickering does not represent division between separate groups, but rather strengthens social bonds. This in-group-bickering model of Jewish-Muslim interactions can be found more widely in other cultural productions, such as Farid Boudjellal's comic series *Juif-Arabe* (2006) and Joan Sfar's graphic novel *Le Chat du rabbin* (2011). Indeed, Younes and Bambi's comedy is reminiscent of the two main characters of Farid

Bambi: Is he for real? We love arguing, us two!
Younes: We've been fighting for centuries!
Bambi: It's not about to end today! [To Younes] Bastard!
Younes: [to Bambi] Silly billy!
Bambi: Jerk!
Younes: Numpty! [Amical, almost amorous tone]
Bambi: You great noodle!
[Younes and Bambi draw close, hold hands, hug, and giggle uncontrollably]
Younes and Bambi: We're Younes and Bambi, thank you very much!'

Boudjellal's comic series *Juif-Arabe* who are constantly bickering while being, at the same time, quite fond of each other.[22]

Conclusion

Racially marked comedy can accomplish one of two things. It can demarcate group boundaries into an 'us' and a 'them', reinforcing differences (and possibly hierarchies of differences). Alternatively, it can defy stereotypes through caricature. In both cases, humour is derived from ridiculing someone or something deemed worthy of ridicule. In the first case, the physical or behavioural differences of an out-group is targeted, while the racial anxiety produced by these differences is navigated and mitigated through humour. In the second case, the perceived absurdity of rigid group boundaries is the target of ridicule. In this case, by parodying, through exaggeration and repetition, an oppositional 'us' and 'them' binary, the comedian highlights sameness over difference and the constructed nature of group identifications, while dissipating racial anxiety over differences through humour.

The content of Younes and Bambi's comedy firmly belongs to the second category. It satirizes antisemitism and racism – in the context of their impact on Jewish-Muslim relations – from *within* the logic of antisemitic and racist discourse. Younes and Bambi perform, to the point of ridicule, rigid categories of 'Jews' and 'Muslims' in a way that provokes audiences to laugh their way out of the dominant, politicized model of oppositional relations and towards a jovial reimagining of what it means to be Jewish *and* Muslim *together* in contemporary France. Their comedy not only parodies and challenges the 'us' versus 'them' binary, but creates a new 'us' through their sustained use of 'on' and hybrid Hebrew-Arabic neologisms. The comedians' critical engagement with the Israeli-Palestinian conflict and the symbolism of the Holocaust is an attempt to resist the decades-long political and polemical transformations of 'Jewish-Muslim relations'. They achieve this by evoking these rigid, mutually exclusive categories and ridiculing them in order to suggest the possibility for a more fluid form of Jewish-Muslim coexistence that is not defined by the loaded category of 'Jewish-Muslim relations'. Their performative embodiment of physical and behavioural stereotypes of Jewishness and Muslimness challenges these stereotypes and blurs the lines between Muslim and Jewish identities. In addition, the trading of insults and stereotypes in a dialogic or contrapuntal manner implies in-group bickering and not out-group dispute. The comedians also subtly highlight their shared liminality in white Western European imaginaries.

[22] See Vitali (2018).

Challenging the Conflictual Model of Jewish-Muslim Relations 289

Conceptually, the two possible endpoints of racially marked comedy are distinct. However, in practice, the distinction between the two can be subtle and, therefore, partly relies on the audience. In the case of Younes and Bambi, whose stand-up comedy emphasizes mutual respect and dialogue facilitated by their duo structure, how much of what they achieve is already determined by the prior, ingrained expectations and perspectives of the viewer? To understand this question, a different type of analysis is required: one that examines audience reception. While the above analysis of the content of their stand-up comedy demonstrates how the duo challenges rigid, homogenous categorization of 'Jews' and 'Muslims' and oppositional understandings of interactions, the effects of this on the audience is unclear. In interviews, Younes and Bambi themselves are keen to emphasize the limits of comedy in terms of its effects on broader political discourses. Following their performance on *Le Before du Grand Journal*, television host Thomas Thouroude asks, 'Est-ce que vous constatez les effets de ce que vous faites, de cet humour qui normalement est censé faire voler en éclats tous les clichés? Est-ce que ça marche vraiment?'[23] The comedians reply that, while they have dubbed themselves 'l'arabe et le juif', they do not see themselves as having a moralistic or political objective. Instead, 'on est là [...] pour vraiment rigoler avec le public'.[24] In another interview, they seek to emphasize that there is no political objective to their comedy: 'Et le but du spectacle – c'est vrai que le spectacle s'appelle l'arabe et le juif – mais à la fin du spectacle, on montre aux spectateurs que voilà, il n'y a plus de rebeu, il n'y a plus de feuj. On est tous là pour rigoler ensemble' (MCE TV, 2015).[25] Yet, laughing *with*, as I have been arguing throughout this chapter, is an inherently political gesture in the contemporary French climate. The comedians might not see themselves as having a political objective, but their work, nonetheless, is politically inclined. Through their interplay, the comedians challenge the top-down republican model of *le vivre-ensemble* by contrasting it with a grassroots convivial model of *le rire-ensemble*. The effect on the audience of this laughing *with*, which challenges the troubled Jewish-Muslim binary, remains to be explored. Indeed, one could ask if Gilroy's *conviviality* – not the empty signifier of *le vivre-ensemble* – can truly exist in a contemporary political framework that invariably emphasizes tension and polarization and that presently remains a persuasive and dominant discourse

[23] 'Do you notice the effects of what you do, of your comedy that's supposed to break down stereotypes? Does it really work?'

[24] 'We are here to really laugh *with* the audience'.

[25] 'The goal of the show – it's true that the show is called the Arab and the Jew – but at the end of the show, the audience sees that there is no Arab, there is no Jew anymore. We are all here to laugh *together*'.

290 *Jewish-Muslim Interactions*

on Jewish-Muslim relations in the public sphere. In this context, what impact can any counter-discourse – or even actual, on-the-ground interpersonal and intergroup relationships – have on public discourse without the complete overhaul of such a framework itself?

Works Cited

Primary Sources

Le Before du Grand Journal. 2015. 'L'Arabe et le Juif – Sketch de Younes et Bambi – Le Before du Grand Journal'. YouTube, 26 June. Available at: https://www.youtube.com/watch?v=LJ1HZA-PIBQ (consulted on 3 September 2019).

Depardieu, Younes. 2014. 'Younes et Bambi – Jamel Comedy Club (Saison 7)'. YouTube, 28 July. Available at: https://www.youtube.com/watch?v=0kv2VtyoeXI (consulted on 3 September 2019).

Depardieu, Younes. 2015. 'Younes et Bambi – Jamel Comedy Club (Saison 8)'. YouTube, 15 August. Available at: https://www.youtube.com/watch?v=uYqLNPsuJfI (consulted on 3 September 2019).

MCE TV. 2015. 'Jamel Comedy Club: découvrez Younes et Bambi alias l'Arabe et le Juif!' YouTube, 16 October. Available at: https://www.youtube.com/watch?v=CIkeyxZQZUQ (consulted on 3 September 2019).

Younes et Bambi. 2016. 'Younes et Bambi – Jamel Comedy Club (Saison 9)'. YouTube, 2 July. Available at: https://www.youtube.com/watch?v=mks--migUXc (consulted on 3 September 2019).

Younes et Bambi. 2016. 'Younes et Bambi au Marrakech du rire 2016'. YouTube, 30 June. Available at: https://www.youtube.com/watch?v=F8w-m91ata0 (consulted on 3 September 2019).

Secondary Sources

Altglas, Véronique. 2012. 'Antisemitism in France'. *European Societies* 14: 259–74.

Anidjar, Gil. 2003. *The Jew, the Arab: A History of the Enemy*. Stanford: Stanford University Press.

Borns, Betsy. 1987. *Comic Lives: Inside the World of Stand-Up Comedy*. New York: Simon and Schuster.

Davidson, Naomi. 2012. *Only Muslim: Embodying Islam in Twentieth-Century France*. Ithaca, NY: Cornell University Press.

Egorova, Yulia. 2018. *Jews and Muslims in South Asia*. Oxford: Oxford University Press.

Ervine, Jonathan. 2019. *Humour in Contemporary France: Controversy, Consensus and Contradictions*. Liverpool: Liverpool University Press.

Galonnier, Juliette. 2015. 'The Racialization of Muslims in France and the United States: Some Insights from White Converts to Islam'. *Social Compass* 62.4: 570–83.

Gilroy, Paul. 2004. *After Empire: Melancholia or Convivial Culture?* London: Routledge.

Hecker, Marc. 2012. *Intifada Française? De l'importation du conflit israélo-palestinien.* Paris: Ellipses.

Jikeli, Günther. 2015. 'A Framework for Assessing Antisemitism: Three Case Studies (Dieudonné, Erdoğan, and Hamas)'. In Alvin H. Rosenfeld (ed.), *Deciphering the New Antisemitism.* Indiana: Indiana University Press: 43–76.

Katz, Ethan. 2015. *The Burdens of Brotherhood: Jews and Muslims from North Africa to France.* Cambridge, MA: Harvard University Press.

Klug, Brian. 2014. 'The Limits of Analogy: Comparing Islamophobia and Antisemitism'. *Patterns of Prejudice* 48: 442–59.

Le Monde. 2012. 'Nadine Morano: «Je ne suis pas raciste, j'ai une amie plus noire qu'une arabe!»', *Le Monde*, 22 June. Available at: https://www.lemonde.fr/politique/video/2012/06/22/nadine-morano-je-ne-suis-pas-raciste-j-ai-une-amie-plus-noire-qu-une-arabe_1723176_823448.html (consulted on 3 September 2019).

Mandel, Maud. 2014. *Muslims and Jews in France: History of a Conflict.* Princeton, NJ; Oxfordshire: Princeton University Press.

McGonagle, Joseph. 2017. *Representing Ethnicity in Contemporary French Visual Culture.* Manchester: Manchester University Press.

Meer, Nasar. 2013. 'Racialization and Religion: Race, Culture and Difference in the Study of Antisemitism and Islamophobia'. *Ethnic and Racial Studies* 36.3: 385–98.

Moosavi, Leon. 2014. 'The Racialization of Muslim Converts in Britain and Their Experiences of Islamophobia'. *Critical Sociology* 41.1: 41–56.

Omi, Michael, and Howard Winant. 1994 [1986]. *Racial Formation in the United States: From the 1960s to 1990s.* 2nd edn. New York: Routledge.

Quemener, Nelly. 2013. 'Stand up! L'humour des minorités dans les médias en France'. *Terrain* 61: 68–83.

Rosello, Mireille. 1998. *Declining the Stereotype: Ethnicity and Representation in French Cultures.* Hanover, NH; London: University Press of New England.

Rothberg, Michael. 2009. *Multidirectional Memory: Remembering the Holocaust in the Age of Decolonization.* Stanford: Stanford University Press.

Vigouroux, Cecile. 2015. 'Genre, Heteroglossic Performances, and New Identity: Stand-Up Comedy in Modern French Society'. *Language in Society* 44: 243–72.

Vitali, Ilaria. 2018. '"Nos ancêtres n'étaient pas tous des Gaulois": Post-Migration and Bande Dessinée'. In Kathryn A. Kleppinger and Laura Reeck (eds.), *Post-Migratory Cultures in Postcolonial France.* Liverpool: Liverpool University Press: 219–38.

Wieviorka, Michel. 2005. *La Tentation antisémite: haine des juifs dans la France d'aujourd'hui.* Paris: Laffont.

Post-face

Valérie Zenatti

Un aveu, pour commencer : l'idée de prendre la plume à la suite de savants ayant minutieusement étudié leur sujet, soigneusement choisi leur problématique, génialement trouvé l'articulation d'une thèse est très intimidante, voir paralysante pour l'écrivaine qu'elle place d'emblée devant la question : Et vous, comment justifiez-vous votre place ici ? D'où tirez-vous votre légitimité? – en d'autres termes, le fameux : *D'où parlez-vous ? D'où écrivez-vous ?* et soudain la question, au lieu d'entraîner une tentative de justification vaine et maladroite qui ne ferait qu'accentuer le sentiment d'imposture de l'écrivaine (incapable de prouver quoique ce soit et ne cherchant surtout pas à prouver quoique ce soit d'ailleurs, donc délicieusement coupable de n'avoir ni sujet ni thèse), cette question donc, dévoile des pays, une mer, deux continents et un siècle englouti, elle ramène à une histoire tissée d'Histoire et d'oubli, de récits et de non-dits, de langues qui s'entrechoquent pour tenter d'approcher ce qui a été perdu, et les traces qui demeurent.

Le Kef, Tunis, Miliana, Alger, Constantine n'ont pas été pour moi des points géographiques que je pouvais situer sur une carte, ils étaient le décor invisible des souvenirs de ceux qui m'ont précédée et dont les vies ont abouti à la mienne, comme tant d'autres, nés en France de parents français et qui portaient en eux une histoire africaine, nord-africaine, dont les échos dans la France des années soixante-dix résonnaient de folklore, de caricatures, du mépris des uns, de la fierté des autres et du refoulé d'autres encore. Comment admettre et transmettre l'unité de ce qui avait volé en éclats ? Comment ne

294 *Jewish-Muslim Interactions*

pas trahir ce qui avait été le lieu de la trahison ? Comment accepter que se mêlent mélopée juive, prosodie arabe, chanson française ? Dans quel port trouver refuge lorsque le Nord et le Sud semblent se disputer jusqu'à la grâce bleutée de la Méditerranée ?

Seul le temps, et les marques qu'il imprime au creux des sensations et des mémoires, pouvait prendre en charge ces contradictions, en leur permettant de se déployer.

Le temps de l'enfance pour commencer, période d'éveil et d'acuité où les corps sont autant d'éponges qui se gorgent de chants et de plats de fêtes, de phrases incompréhensibles, de visages exprimant le mystère du passé, et dans l'intimité des familles où ce que l'on nomme le passé, et l'identité, sont donnés en bloc et dans l'anarchie la plus totale, se niche très tôt l'intuition que « la vie », dans sa quotidienneté la plus banale, dans ses rites les plus ancestraux, dans ses préoccupations les plus vitales a été bouleversée par ce que l'on nomme l'Histoire, et ne s'en est pas tout à fait remise.

Mais l'Histoire, en France, dans ces années-là, ressurgit dans un mouvement collectif de « retour du refoulé ». La diffusion, durant l'hiver 1979 de la mini-série américaine en quatre volets, *Holocaust* (réalisée par Marvin J. Chomsky) aux fameux *Dossiers de l'écran* présentés par Armand Jammot. Pour la première fois à la télévision, une fiction sur l'extermination des Juifs d'Europe est diffusée à travers le destin de la famille Weiss. La série est fortement déconseillée aux moins de 12 ans, la petite fille qui écrira ces lignes quarante ans plus tard n'en a pas encore neuf, qu'importe : elle devine que dans cette fiction dont la France entière parle, une fenêtre est ouverte sur une réalité qui la concerne. Comment ? Pourquoi ? Parce que le mot « Juif » y semble associé à quelque chose de terrible et indicible, elle veut savoir à quoi exactement. Un épisode suffira à enclencher une année de sidération et de cauchemars, mais aussi une vie entière de curiosité pour le monde englouti des Juifs d'Europe, avec le sentiment curieux d'y être intimement reliée, plus encore qu'à l'histoire des siens, pourtant, elle fait partie des enfants de la première génération qui a suivi le « rapatriement » d'Algérie, et dans sa famille, les noms de Varsovie, Lodz, Vilno ou Czernowitz n'ont jamais été prononcés (Zenatti, 2011).

Ces enfants de la « première génération » (mais je ne me souviens pas qu'on les nous définissait ainsi) ont grandi en France en entendant parler une langue dont on leur disait que c'était de « l'arabe », et cette langue était utilisée pour exprimer tour à tour l'amour (*ana behabèk*), l'exclamation de désarroi, qui se transformait en appel (*Ya rabbi Sidi*), l'insulte (*kahba*). Le sens de ces mots demeurait opaque pour les enfants qui, dans le même temps, apprenaient les fables de La Fontaine et les poèmes de Maurice Carême à l'école, lisaient les histoires de la comtesse de Ségur ou celles du Club des

Post-face

Cinq, regardaient « *la Dernière Séance* » à la télé ou les émissions de variété, autant d'espaces où ces mots n'existaient pas, où personne jamais ne les prononçait, tandis qu'ils fleurissaient dans l'espace intime, et livraient tout de même un sens malgré leur opacité, car ils étaient toujours accompagnés de gestes, mimiques et intonations qui donnaient à ces mots la force d'une vérité, et induisaient qu'il y avait eu un autre lieu, un autre temps, où il avait été *naturel* de s'exprimer ainsi, où le langage de l'intérieur et de l'extérieur était identique.

La langue n'était bien sûr pas la seule « étrangeté » avec laquelle il fallait composer. Au hasard des fêtes, des musiques « arabes » mettaient les hommes et les femmes en transe ; des plats dont les recettes ne figuraient dans aucun livre, et qui n'étaient servis par aucun chef de restaurant, provoquaient des joies ou des déceptions à la hauteur de l'attente ; des angoisses aigües concernant les enfants, des traits, des corpulences, une manière de s'habiller racontaient une autre psyché et une autre esthétique et cela nous mène à une deuxième période de la vie, à la frontière mouvante entre l'enfance et l'adolescence, et au-delà.

C'est le moment où ce qui est donné par la famille ne suffit plus à constituer un monde. On veut aller voir ailleurs, derrière la limite invisible mais sûrement tracée entre « nous » et « les autres ». On ouvre plus grand les yeux, les oreilles, plonger dans un album de photos en noir et blanc ou sépia équivaut à faire du sur-place, or, ce que l'on souhaite plus que tout, c'est prendre son envol, marcher à grands pas vers une vie désirable et cette vie semble parsemée de pousses fraîches nourries de terre et de pluie européennes. On coupe le cordon, brutalement ou en douce, on renie, on dénie, on veut bien accepter de temps à autres les rituels et les fêtes qui continuent de rythmer le temps mais ce sont des rendez-vous secrets, dictés par un sens du devoir, de la famille, et une culpabilité incommensurable, on découvre la gêne, la honte peut-être, on se forge une certitude : la « culture » est absente de cette histoire dont l'exubérance égale les non-dits, la modernité exige d'autres codes, d'autres langues, d'autres intérieurs où les bassines en émail et en cuivre, les pilons qui ont miraculeusement traversé la Méditerranée lors de l'exode qui a eu pour nom *rapatriement*, les piments suspendus dans les couloirs pour protéger du mauvais œil n'ont plus leur place. L'adolescent(e) découvre la Révolution Française et Mai 68, *Nuit et brouillard* et *Holocaust*, Romain Gary et Stefan Zweig. Il (elle) accepte de faire parfois une incursion de l'autre côté de la Méditerranée pour plonger dans les livres d'Albert Cohen, qui a honte de ses *Valeureux* et les aime pourtant, d'Albert Camus, qui fond la condition humaine, l'illettrisme et le soleil écrasant dans la littérature mais la certitude s'amplifie : le monde, la vie, le mouvement, sont ailleurs que dans ce mot qui semble factice et désuet : le Maghreb.

Deux syllabes fermées, dont on met du temps à comprendre le territoire qu'elles désignent et dont le « h » médian, muet, ressemble à un indice, mais de quoi ? Sur quelle piste nous place ce nom ? On ne savait déjà pas très bien si, parlant des Juifs d'Algérie l'on devait dire « pieds-noirs » ou pas, tant le mot faisait immédiatement surgir la nécessité d'aller prendre une douche longue et décapante ; on avait remarqué que chez ces mêmes Juifs la façon d'allonger la dernière syllabe du mot « rapatriés » exprimait plutôt un profond déracinement ; on en était à rire de bon cœur ou avec un brin d'ironie sur les rivalités qui opposaient Oran et Tlemcen, Le Kef et Sfax, Alger et Constantine, et, dans un cercle plus large Marrakech et Rabat ; on avait deviné que chaque ville avait sa topographie, ses quartiers chics et ses rues pauvres, on avait appris à reconnaître ce que signifiait cette façon de s'arrêter dans la rue ou au beau milieu d'une conversation, yeux écarquillés, souffle coupé, « C'est pas vrai ! » et l'exclamation avait valeur de reconnaissance incrédule, on reconnaissait une voisine, on s'apercevait qu'on avait vécu dans la même rue, face au même boulanger au visage rougi par le four à bois, devant le même cordonnier qui chérissait ses ortolans en cage. L'adolescente témoin de ces retrouvailles commençait à considérer le monde avec le prisme de l'Histoire, elle découvrait simultanément que Maghreb signifie Occident, ce qui lui apparaissait comme un paradoxe avant de comprendre la condition relative des points cardinaux. Elle découvrait aussi que l'Occident, ou le Nord, ou la France, avait inséré l'Histoire européenne dans celle des Juifs d'Algérie, par la grâce du décret Crémieux tout d'abord, puis par la honte des lois de Vichy. Elle faisait siennes (même s'il était d'une autre génération) ces phrases de Jacques Derrida évoquant son exclusion de l'école parce que Juif, et plus tard elle découvrira que Jacob, le jeune frère de son grand-père avait vécu le même sort et la même honte avant de s'engager dans la deuxième armée française pour libérer ce pays qui l'avait rejeté, et auquel il donnera sa jeune vie de « 19 ans, sept mois et dix jours » (Zenatti, 2014):

> Ce traumatisme a provoqué en moi deux mouvements quant aux communautés diverses. D'un côté, le désir de me faire, de nouveau, accepter par les copains, les familles et le milieu non juifs, qui était mon milieu. Et, par conséquent, de rompre aussi avec le mouvement juif de grégarité qui s'était, de façon légitime, constitué pour répondre à l'agression et au traumatisme. Je ne voulais pas appartenir à ce qui était la communauté juive [...] je ne supportais pas l'enfermement dans cette communauté. En même temps, j'étais plus que sensibilisé, extrêmement vulnérable à l'antisémitisme. Les injures et insultes fusaient à chaque instant. Insultes [...] pas seulement verbales, qui m'ont marqué à jamais et m'ont rendu vulnérable et hypersensible à toute manifestation d'antisémitisme et de

racisme. Mais, simultanément, une rupture affective, profonde, avec le milieu de la communauté juive et tout ce qui pouvait rappeler d'une manière ou d'une autre ma propre famille ou communauté. Et cela, je dois dire, est resté. A la fois le sentiment, le désir de solitude, de retrait par rapport à toute communauté d'une certaine manière... je dirais presque, 'nationalité'. J'ai senti qu'au fond, j'appartenais à cette solitude [...] Dès que je vois se constituer même le mot de 'communauté' [...], dès que je vois se constituer une appartenance un peu trop naturelle, protectrice, fusionnelle, je disparais. (Derrida, 1998)

C'est dans ces années d'adolescence qu'un bouleversement familial redistribue les cartes, en élargissant précisément la cartographie d'une histoire personnelle et ses composantes linguistiques. Au début des années 80, mes parents choisissent de quitter la France pour aller vivre en Israël. C'est la plongée dans une langue nouvelle – l'hébreu – et la collusion avec la complexité de la réalité israélienne qui, après avoir été elle aussi dans le déni de l'extermination des Juifs d'Europe, donne à cette dernière une expression centrale dans l'espace public (musées, cérémonies du Souvenir), dans le domaine de l'éducation (l'enseignement de la Shoah est alors une « matière » obligatoire au bac) et dans les domaines artistiques (voir par exemple le film « L'été d'Avia », d'Eli Cohen, sorti en 1988). Dans le même temps, la première Intifadah qui éclate en décembre 1987 remet « la question palestinienne » au cœur du débat politique.

Cette période laissera plusieurs traces en moi : la découverte du déracinement, de l'exil ; la conscience que les Juifs d'Europe semblent avoir en Israël à ce moment-là une importance plus grande que celle des Juifs orientaux (voire, pour certains, une supériorité) ; la conscience que le conflit israélo-palestinien est aussi une déchirure interne, même si je ne sais pas la nommer.

L'âge adulte advient. On ne saurait dire quand exactement, le glissement s'opère imperceptiblement, c'est sans doute la période où, sortis de l'enfance, on est en mesure d'embrasser le temps avec plus d'amplitude. Passé, présent, futur n'apparaissent plus comme des catégories distinctes, scellées, mais comme une expérience dans laquelle on peut se permettre des mouvements. La honte, le déni et la gêne se sont mués en curiosité. On peut regarder en arrière puisque l'on est allé voir ailleurs. On se surprend à scruter de nouveau l'album de famille, des visages attirent le regard en particulier, on pose des questions à ceux qui sont encore là pour répondre, on fouille des archives, des musiques reviennent en mémoire, les transes des femmes, les larmes cachées des hommes, on se rend un jour au Maroc et un sentiment de familiarité inédite s'infiltre par tous les sens, on ose dire oui à une

invitation en Algérie pour présenter un film tiré d'un livre écrit quelques années plus tôt : *Une bouteille dans la mer de Gaza*. On s'étonnera que ce soit précisément ce geste de dialogue entre Jérusalem et Gaza, au cœur de la déchirure donc, qui permettra d'aller sur les lieux d'une autre déchirure, accomplir l'inenvisageable, retourner là où on nous a seriné qu'il n'y avait « plus rien, plus personne », là où « on a laissé nos morts » et ce qui était dans la mémoire familiale un continent englouti, une Atlantide, devient un sol ferme sous les pieds, les rues sont animées, vivantes, on les arpente avec la même incrédulité que les parents s'exclamant des années auparavant « C'est pas vrai ! ». Si, tout est vrai, les tombes cernés d'herbes folles au cimetière, le pont suspendu au-dessus de gorges vertigineuses, les bains maures, et les êtres aussi sont « vrais », leurs vies se sont poursuivies ici, ont donné naissance à d'autres vies, et dans la maille chatoyante des conversations surgissent les fils qui retissent une histoire à la fois distincte et commune, entre anecdotes personnelles (« en 1950, j'ai monté », nous dit cet ancien professeur de Français « *Le malade imaginaire* avec des enfants du quartier, juifs, chrétiens, musulmans »), et idéalisation (« on vivait tous ensemble, il n'y avait aucune différence »).

C'est cette matière vivante qui est travaillée dans les études proposées ici, dévoilant avec une précision extraordinaire les territoires de cette « coexistence » réelle et/ou rêvée, et l'on va de confirmation en surprise. Oui, la musique a bien été un lieu de rencontre et parfois de fusion (Christopher Silver, Ruth Davis, Jonathan Glasser) mais le théâtre aussi (Hadj Miliani et Sami Everett), et nous pressentons que la figure inconnue pour nous jusque-là de Marie Soussan nous accompagnera désormais, comme une incarnation d'un désir de liberté artistique, d'exploration de l'écriture et de la scène ; oui, les « différentes communautés » cohabitaient dans la Casbah d'Alger, même si cette réalité s'efface dans les dessins de Slim au profit d'une uniformité arabe et musulmane fantasmée (Elizabeth Perego), et les questions politiques traversent inlassablement la création, des querelles entre peinture abstraite ou figurative à Alger ou à Tunis dans les années 30 (Fanny Gillet) jusqu'aux festivals du Maroc (Aomar Boum) et la composition de chansons de rap dans le Maroc d'aujourd'hui (Cristina Moreno Almeida) ou dans le stand-up des dernières années (Adi Bharat) ainsi que l'art de rue (Nadia Kiwan). C'est enfin dans le cinéma qu'est à l'œuvre une appropriation ou réappropriation de son histoire (voir la figure de Albert Samama, chez Morgan Corriou, ainsi que les contributions de Jamal Bahmad et Miléna Kartowski-Aïach autour du documentariste Kamal Hachkar et de sa démarche d'« orphelin de l'altérité »). C'est à travers tous ces prismes que se déploient ici passé et présent, création et contradiction, rancœurs et fiertés, analyses et découvertes, comme un geste où se rejoignent les démarches artistique et académique, dans leur tentative

Post-face 299

commune de saisir ce qui a disparu, ce qui laisse des traces, traquant le détail qui contredit la généralité, cherchant non pas à établir une « vérité » mais à offrir des portes d'entrée permettant d'arpenter à sa guise cette « mémoire » paradoxalement constituée d'oubli et de déni.

Valérie Zenatti
Août 2019

Bibliographie

Binisti, Thierry (dir.). 2012. *Une bouteille à la mer.*

Derrida, Jacques. 1998. « A voix nue ». France Culture, 14 décembre. Disponible ici: https://www.franceculture.fr/dossiers/jacques-derrida-l-integrale-en-cinq-entretiens-1998 (consulté le 27 septembre 2019).

Zenatti, Valérie. 2005. *Une bouteille dans la mer de Gaza.* Paris: L'école des loisirs.

——. 2011. *Mensonges.* Paris: Olivier.

——. 2014. *Jacob, Jacob.* Paris: Olivier.

Afterword

Translated by Samuel Sami Everett

A confession to start with: the idea of putting pen to paper following on from scholars who have chosen their research topic with such care, studied their subject with such precision, and found how to articulate a thesis around it with such flair, was extremely intimidating, not to say paralyzing for me, the writer, faced with the question: How do you justify your place here? How can you prove your legitimacy? In other words, the infamous question: Which position are you speaking from? Where is your starting point, as a writer? And suddenly the question, instead of leading to some kind of awkward justification, which in any case would have accentuated the imposture syndrome felt by this writer (incapable of proving anything and not in fact wanting to prove anything, and so deliciously guilty of having neither subject nor thesis), instead uncovers countries, a sea, two continents, a century that has somehow been swallowed up. It brings us back to a story woven together by History and forgetting, the said and the unsaid, languages that come together in an attempt to get closer to what has been lost, and the traces that remain.

For me, Le Kef, Tunis, Miliana, Algiers, and Constantine were not so much geographical nodes, dots that I could point out on a map, as the invisible decor of the memories of those who came before me and whose lives led to my own, just like many others born in France of French parents who hold within them an African history, a North African history – the echoes, at least within the context of 1970s France, resonating with folklore, stereotypes,

302 *Jewish-Muslim Interactions*

disdain for some, pride for others, and repression for others still. How to admit and transmit the unity of that which was blown apart? How not to betray that which was the site of betrayal? How to accept the blending of Jewish chant, Arabic prosody, and French song? In which port to find refuge when the dispute between North and South seems to stretch as far as the Mediterranean sea in all its blue beauty?

Only time, and the traces that it leaves in the furrows of our feelings and memories, could take charge of these contradictions and allow them to unfold.

Let us start with childhood, then, a time of acuity and alertness where bodies are sponges that gorge on the songs and dishes of the high holidays, incomprehensible sentences, and faces that express the mystery of the past. Within the intimacy of the family home, that which we call 'the past' and 'identity' are delivered in bulk and in the most absolute anarchy. Very early on in that intimate context nestles the intuition that 'life', in its most everyday banality, in its most ancestral of rites, in its most vital of preoccupations, has been turned upside down by that which we call History with a capital 'H', and has never quite recovered from the disruption.

But History, in France, and in those years specifically, resurfaced in a collective movement through 'the return of the repressed', triggered by the airing of the American mini-series *Holocaust* (directed by Marvin J. Chomsky) in the winter of 1979 on the now famous *Dossiers de l'écran* programme presented by Armand Jammot. For the first time ever on television, a fictional account of the extermination of Europe's Jews was broadcast, portrayed through the destiny of the Weiss family. It is strongly advised that the series should not be watched by those under the age of 12; the little girl writing these lines forty years later was not even nine, but what does that matter? She sensed that in this fictional account which, it seemed, the whole of France was talking about, a window had been opened onto a reality which directly concerned her. How? Why? Because the word 'Jew' seemed to be associated with something so terrible as to be almost unutterable, and she wanted to know what exactly. One episode was sufficient to engender a year of nightmares and aftershock, but also the curiosity of an entire lifetime for the sunken world of Europe's Jews, accompanied by the curious sentiment of being intimately bound to this world, more so perhaps than to her own family history, as a child of the first generation of those born in the immediate aftermath of 'repatriation' from Algeria, and despite the fact that in her family Lodz, Vilno, or Czernowitz were never pronounced.

Those 'first generation' children (though I cannot recall that we ever defined ourselves as such) grew up in France listening to another language

Afterword

303

which they were told was 'de l'arabe' ['Arabic'], which was used to express love (*ana behabak*) or to exclaim dismay, which would often be transformed into a call (*Ya rabbi Sidi!*) or an insult (*kahba*). But the meaning of these words remained opaque for the children who, at the same time, were learning the fables of La Fontaine and the poems of Maurice Carême at school, were reading the stories of the Countess of Ségur or the Famous Five, and were watching 'La Dernière Séance' and other variety television shows, worlds in which these words did not exist, where nobody ever pronounced them, whereas in the home they flowered and had real meaning, despite their opacity, because they were always accompanied by gestures, facial expressions, and intonations, which gave these words the strength of truth, inferring that there had been another place, another time, when it had been *natural* to express oneself in this way, where the language of the home and the world outside were one and the same.

Language was of course not the only 'foreign thing' that we had to come to terms with. During the holidays, 'Arabic' music put men and women into a trance; dishes that were nowhere to be found in cookery books, that were not served by any chef, provoked joy and disappointment in equal measure; acute anxieties about the children, facial features, corpulence, and different ways of dressing told the story of another psyche and another aesthetic. That brings us to the second phase of life, at the shifting borders between childhood and adolescence, and beyond.

This second phase is the time when that which the home gives you no longer suffices to constitute your world. You want to see more, beyond the border traced invisibly but firmly between 'us' and 'the others'. You open your eyes and ears wider still; diving into a black and white or sepia photo album would mean staying where you are when what you want above all is to take off, to stride towards a more desirable life, a life that appears to you full of fresh shoots fed by European earth and rain. You cut the apron strings, either brutally or softly, you disavow and deny, accepting the rituals and the holidays occasionally as they continue to give rhythm to time, but these are now more secretive meetings, dictated by a feeling of familial duty or an incommensurable culpability. You discover shame, disgrace even, and you forge a certitude: that 'culture' is absent from this history as exuberant as it is unspoken, that modernity demands other codes, other languages, other homes, with washbasins in enamel or brass. The pestles that miraculously made it across the Mediterranean during the exodus which has been given the name *rapatriement* ['repatriation'], and the peppers hung up in the corridor to protect you from the evil eye no longer have their place. The adolescent you have become discovers the French revolution and May 68, *Nuit et brouillard* and *Holocaust*, Romain

Gary and Stefan Zweig.[1] Occasionally, you decide to make a quick trip to the other side of the Mediterranean via the books of Albert Cohen who is both ashamed of and in love with his 'Valeureux',[2] Albert Camus who founded 'la condition humaine' ['The Human Condition'],[3] illiteracy and the crushing sun of literature, but the certitude is amplified – the world, life, and movement, are elsewhere than in that word that seems so obsolete and artificial: the 'Maghreb'.

It takes time to understand the territories which are designated by these two closed syllables, where the middle 'h' resembles a clue, but of what? What avenue does this word lead us down? We did not really know if, when speaking about the Jews of Algeria, we should say 'pieds-noirs' or not, given that the word provoked a sudden need to take a long cold shower; we had already noticed that for these Jews the way of stretching out the last syllable of the word 'rapatr-iés' expressed a profound sense of uprooting. We would laugh or make ironic remarks about the rivalry that opposed Oran and Tlemcen, Le Kef and Sfax, Algiers and Constantine, and in a wider circle Marrakech and Rabat; we had guessed that each of these cities had its own topography, its chic neighbourhoods and its poorer streets. We had learnt to recognize a particular way of stopping in the street, and in the middle of a conversation, wide-eyed and breathless, with that exclamation 'mais c'est pas vrai!' ['it can't be true!'] signifying an incredulous recognition: that of happening upon a former neighbour. When it became apparent that you used to live on the same street, the realization would dawn upon you that this chance visit brought you face to face with the former baker, his face reddened by the wood fire, or with the same cobbler that loved your caged Ortolans. The adolescent witness of these reunions was beginning to think of the world through the prism of History; she discovered simultaneously that 'Maghreb'[4]

[1] Translator's note: *Nuit et brouillard* is a short documentary film about the Holocaust first shown in 1956; Romain Gary is a famous French author, playwright, film director, and actor who was particularly active during the 1970s in France; and Stefan Zweig was a Vienna-born author who is particularly popular in France.

[2] Translator's note: Albert Cohen's last novel, *Les Valeureux* ['The Valliant Ones'] (1969), is a story that revolves around five cousins from the Solal family, tracing their journey from Greece to Israel via the United Kingdom. It reads like a parable of the new state of Israel.

[3] Translator's note: 'La condition humaine' ['The Human Condition'] is an ongoing literary and intellectual movement with which many of Camus's peers, including Jean-Paul Sartre, were actively engaged.

[4] As discussed in the introduction, this is a problematic term; it nevertheless prevails in France as the common term to refer to North Africa.

Afterword

meant 'Occident',[5] which seemed like a paradox before she came to understand how these cardinal points related to one another. She also discovered that the 'Occident', or the North, or France, had inserted European History into that of the Jews of Algeria first through the Crémieux decree and then through the shame of the Vichy laws. She made the words of Jacques Derrida her own, those words which evoked his exclusion from school simply because he was Jewish. Later still, she would discover Jacob, the younger brother of her grandfather, who had lived through the same experience and shame as Derrida before enlisting in the second French army to liberate the country that had rejected him and to which he would give his young life of '19 ans, sept mois et dix jours' ['19 years, seven months, and ten days'] (Zenatti, 2014):

> That trauma provoked inside of me two movements regarding the diverse communities [of Algeria]. On the one hand, the desire to be accepted once more by my non-Jewish friends and their families which was my milieu. That would mean breaking off from the gregarious Jewish movement which, legitimately, had formed out of the need to respond to the aggression of this trauma. I didn't want to belong to those who called themselves the 'Jewish community' [...] I couldn't stand the confinement of that community. On the other hand, I had become more than sensitive, indeed extremely vulnerable, to antisemitism. The insults and slurs proliferated. Insults which were [...] not just verbal, insults which would mark me forever and had made me vulnerable and hyper-sensitive to any expression of antisemitism or racism. But at the same time, [there was this desire for] a profound affective break with the Jewish community and its milieu, and anything that could remind me of my own family or community. And that, I must say, remained with me, as did the feeling, the desire for solitude, for retreat from any kind of community to a certain extent... I might even say from any 'nationality'. I felt that, deep down, I belonged to that solitude [...]. As soon as I saw the word 'community' start to form [...] as soon as I saw a sense of belonging that was a little too natural, protective, fusional, begin to form, I disappeared. (Derrida, 1998)

It was during those adolescent years that a family upheaval dealt us new cards, stretching the cartography of a personal history and its linguistic make-up. At the beginning of the 1980s, my parents chose to leave France to go and live in Israel. This meant diving into a new language – Hebrew – and the collusion between the complexity of an Israeli reality, which, after having for a long time also been in denial about the extermination of Europe's Jews, had come to give it a central expression in the public

5 Translator's note: 'Occident' is the French way of saying 'the West'.

306 *Jewish-Muslim Interactions*

sphere (museums, memorials etc.), in the sphere of education (the Shoah is an obligatory subject at secondary school), and in the artistic sphere (for example, the film *Ha Kayitz Shel Avia* by Eli Cohen, shot in 1988). At the same time, the first intifada in December 1987 put the 'Palestinian question' at the heart of political debate.

This period left several traces within me: the discovery of uprooting and exile; the sense that the Jews of Europe seemed to have more prominence in Israel at that moment in time than 'Oriental' Jews (perhaps for some there was even a certain superiority); the understanding that the Israeli-Palestinian conflict was also an internal rupture even if I did not know how to express it.

Then adulthood came. It is difficult to say when exactly, nobody really notices when the shift occurs, perhaps it is the period when, leaving adolescence, one is capable of filling the time with more magnitude. The past, the present, and the future no longer appear as distinctive, sealed, categories, but more like an experience which allows for movement. Shame, denial, anxiety have turned into curiosity. We can look back because we have looked elsewhere. To our surprise, we find ourselves scanning through the family photo album again, particular faces grab our attention, we begin to ask questions of those who are among us to find the answers, we search the archives, music comes back to us, the trances of the women, the hidden tears of the men. Upon a visit to Morocco, an unprecedented familiarity pours in from all sides, and I say yes to an invitation to go to Algeria to present a film (Binisti, 2012) adapted from a book I wrote a few years earlier: *Une bouteille dans la mer de Gaza* ['A Bottle in the Gaza Sea'] (Zenatti, 2005). Astonishingly, it is precisely that gesture of dialogue between Jerusalem and Gaza, at the heart of the rupture then, which would allow entry to the site of another rupture, to accomplish that which had never been envisageable, to return to the place where we were repeatedly told there is 'plus rien, plus personne' ['nothing and no one'], the place where 'on a laissé nos morts' ['we left our dead']. The place that was, in the family memory, a continent engulfed, an Atlantis, becomes solid land underneath our feet, the streets are animated, alive, we walk through them with the same incredulity as our parents exclaiming years before 'mais c'est pas vrai!' Yes, everything is true, the tombs covered by weeds at the cemetery, the bridge suspended above the vertiginous gorges, the 'Moorish' baths, and the people too are all 'vrais';[6] their lives went on here, gave birth to others, and the glistening mesh of conversations reveals the threads that sew together a history, distinctive and communal, between personal anecdotes ('en 1950, j'ai monté *Le Malade*

[6] Translator's note: in French, 'vrai' has the double meaning of 'true' and 'real'.

imaginaire avec des enfants du quartier, juifs, chrétiens, musulmans', the former French teacher tells us), and idealization ('on vivait tous ensemble, il n'y avait aucune différence').[7]

It is this living material that is studied in the chapters offered in this volume, unveiling with an extraordinary precision the territories of this 'coexistence' real and/or imagined, and taking us on a journey from confirmation to surprise. Of course, music was one site of encounter and fusion (Silver, Davis, Glasser) but so was theatre (Miliani and Everett), and we get the sense that the hitherto unknown figure of Marie Soussan will become a household name incarnating the desire to be artistically free to explore scenarios and the stage. Yes, the 'different communities' lived together in Algiers's Casbah even if that reality gets erased by the drawings of Slim in favour of an imagined Arab Muslim uniformity (Perego). Without fail, the political intersects with the creative presented here: from disagreements between abstract and figurative painters in Algiers and Tunis in the 1930s (Gillet) to the current Moroccan festival scene (Boum) and the composition of rap songs in today's Morocco (Moreno Almeida) to the contemporary French stand-up (Bharat) and street art scenes (Kiwan). Finally, it is through cinema that the appropriation and reappropriation of history is at work (see the figure of Albert Samama as explored by Corriou, as well as the contributions by Bahmad and Kartowski-Aïach on the documentary-maker Kamal Hachkar and his 'orphan of otherness' approach). It is through these prisms that past and present, creation and contradiction, pride and resentment, analysis and discovery unfold. Like a gesture through which artistic and academic approaches come together in a collective effort to grasp that which has disappeared, leaving behind traces, this volume tracks the details that contradict generalization, seeking not to establish a 'truth' but rather to offer points of entry that enable this 'memory', paradoxically constituted by denial and forgetting, to wander at will.

Works Cited

Binisti, Thierry (dir.). 2012. *Une bouteille à la mer.*

Derrida, Jacques. 1998. 'A voix nue'. France Culture, 14 December. Available at: https://www.franceculture.fr/dossiers/jacques-derrida-l-integrale-en-cinq-entretiens-1998 (consulted on 27 September 2019).

[7] 'in 1950, I directed *Le Malade imaginaire* ['*The Imaginary Invalid*'] with children from the neighbourhood – Jews, Christians and Muslims'; 'we all lived together and there were no differences between us'.

Zenatti, Valérie. 2005. *Une bouteille dans la mer de Gaza*. Paris: L'école des loisirs.
——. 2011. *Mensonges*. Paris: Olivier.
——. 2014. *Jacob, Jacob*. Paris: Olivier.

About the Contributors

Cristina Moreno Almeida, PhD, is a British Academy Postdoctoral Fellow in the Department of Digital Humanities at King's College London. Her research is about culture, power, and resistance at the intersection of society, politics, and digital media. Her current work analyses memes and digital cultures in Morocco, looking at the social, cultural, and political ramifications of disseminating cultural production through digital platforms. She previously worked at the LSE Middle East Centre and the Department of Media and Communications on the project 'Personalised Media and Participatory Culture' with the American University of Sharjah, researching young people's participatory culture, the internet, and creative production (2015–2017). She has published on memes, digital media, music, and resistance. Her latest book is entitled *Rap Beyond Resistance: Staging Power in Contemporary Morocco* (Palgrave Macmillan, 2017).

Jamal Bahmad is an Associate Professor of Literature and Cultural Studies in the Department of English at Mohammed V University. He earned his PhD degree from the University of Stirling (2014) with a dissertation on contemporary Moroccan urban cinema. The dissertation won the Best PhD Thesis Prize of the British Society for Middle Eastern Studies in 2015. He has held a British Academy postdoctoral fellowship at the University of Leeds and, prior to that, was a research fellow at Philipps-Universität Marburg. Bahmad was most recently a research fellow at the University of Exeter on the Arts

and Humanities Research Council (AHRC)-funded project 'Transnational Moroccan Cinema'. He specializes and has published widely in the field of North African cultural studies with a focus on cinema, youth cultures, cities, literature, and memory. He co-edited a special issue of *French Cultural Studies* (SAGE, August 2017) on trash cultures in the Francophone world, and a special issue of *The Moroccan Cultural Studies Journal* on Moroccan cinema (November 2017). In addition to working on his first monograph on Moroccan cinema and globalization, Bahmad has recently finished a book (co-authored with Will Higbee and Florence Martin) on Moroccan transnational cinema (Edinburgh University Press, 2020).

Adi Saleem Bharat is an LSA Collegiate Fellow in the Department of Romance Languages and Literatures at the University of Michigan and the coordinator of the Jewish–Muslim Research Network. He holds a PhD in French Studies from the University of Manchester. Drawing on media studies, applied linguistics, literary studies, and, more broadly, cultural studies, his interdisciplinary research revolves around the intersection of race, religion, gender, and sexuality in contemporary France, with a particular focus on Jews and Muslims. His research has appeared in *French Cultural Studies* and *Neophilologus*, among other venues.

Aomar Boum is an Associate Professor in the Department of Anthropology at the University of California, Los Angeles (UCLA). He is the author of *Memories of Absence: How Muslims Remember Jews in Morocco* (2013), and co-author of the *Historical Dictionary of Morocco* (2016), *The Holocaust and North Africa* (2019), and the *Historical Dictionary of the Arab Uprisings* (2020).

Morgan Corriou is an Assistant Professor in Media Studies at the University of Paris 8 Vincennes – Saint-Denis. She specializes in the social history of cinema in the colonial Maghreb and received a doctoral research grant from the French Institut de recherche sur le Maghreb contemporain in Tunis (Centre national de la recherche scientifique). Her current research focuses on the correlation of cinephilia and Third World struggles in Africa. Her recent publications include 'La France coloniale et le spectateur "indigène": histoire d'une incompétence cinématographique', in *MEI – Médiation et information* (2020).

Ruth F. Davis is an ethnomusicologist specializing in music cultures of North Africa, the Middle East, and the wider Mediterranean. Her publications include some fifty peer-reviewed articles, book chapters, and edited collections, and she has presented numerous radio broadcasts for the BBC and international radio

stations. Her first book *Ma'lūf: Reflections on the Arab Andalusian Music of Tunisia* (2004) is the first substantial study in English of an Arab-Andalusian musical repertory and explores its modern development in relation to nation-building. Her edition of Robert Lachmann's 'Oriental Music' broadcasts, 1936–1937 (2013) focuses on Lachmann's archive project in Mandate Palestine and includes a 2-CD set of his digitally restored metal disc recordings. She is a Life Fellow and Emeritus University Reader in Ethnomusicology at Corpus Christi College, University of Cambridge, and *chercheuse associée* of the CREM–CNRS at Université Paris Nanterre.

Vanessa Paloma Elbaz is a Research Associate at the Faculty of Music of the University of Cambridge, working on the European Research Council (ERC)-funded project 'Past and Present Musical Encounters Across the Strait of Gibraltar'. Elbaz founded KHOYA: Jewish Morocco Sound Archive in 2012 and this work has been featured internationally on BBC, PBS, France 24, *L'Express*, *The Jerusalem Post*, and TVE, among others. In 2018 she earned her PhD from the Sorbonne's Middle East and Mediterranean Research Group of the National Institute for Oriental Languages and Civilisations (INALCO) with *félicitations du jury*. A previous Senior Fulbright Research Fellow, American Institute of Maghrib Studies long-term research grant recipient, Posen Fellow, Broome and Allen Fellow, TALIM fellow, and Marie Curie H2020 laureate, Elbaz's current project is on the Jewish voice in Morocco and Spain from 1880 to 2020. She is also an internationally acclaimed performer of the repertoire she researches.

Samuel Sami Everett is a Researcher at the University of Cambridge. He holds a PhD and MPhil from SOAS, University of London and a BA in North African Language and Culture from the Institut national des langues et civilisations orientales (INALCO), Paris. He tracks the similarities and differences in migratory and post-migratory experiences between Jewish and Muslim diasporic descendants of North Africa and both their historical and present-day material and immaterial sites of encounter.

Fanny Gillet is completing a doctoral thesis at the University of Geneva on the relationship between art and politics in post-independence Algeria. She is a founding member of the AVRIMM research group on the visual arts in the Middle East and North Africa from the nineteenth to the twenty-first century (http://arvimm.hypotheses.org/) and is co-chair, since 2013, of the seminar series 'Histoires de l'art au Maghreb et au Moyen-Orient' at the Institut d'études de l'Islam et des sociétés du monde musulman (IISMM) based at the École des hautes études en sciences sociales (EHESS), Paris. Her recent

312 *Jewish-Muslim Interactions*

publications include 'Enjeux esthétiques et politiques de la mobilisation artistique durant la "guerre civile" algérienne (1992–1999)' in *Histoire@ Politique* (2019), and '"Il suffira d'ouvrir la coquille pour le récupérer": histoires développées du Monument aux Morts d'Alger de Paul Landowski' in *L'Algérie au présent, entre résistances et changements* (ed. by Dirèche, 2019).

Jonathan Glasser is Associate Professor in the Department of Anthropology at William & Mary in Williamsburg, Virginia. He is the author of *The Lost Paradise: Andalusi Music in Urban North Africa*, published in 2016 by University of Chicago Press. His writing has appeared in *Stand, American Ethnologist, Anthropological Quarterly, Anthropology and Humanism*, and the *International Journal of Middle East Studies*.

Miléna Kartowski-Aïach is a graduate scholar of Philosophy and Anthropology of Religion, as well as being a graduate of the École des arts politiques at Sciences Po Paris. She is currrently a doctoral candidate conducting ethnographic research on a new generation of young Mizrahi Israeli artists. As both director and author, over several years she has been developing an anthropological theatre workshop strongly linked to her ethnographic fieldwork. She is a singer trained in traditional Yiddish song, Jewish liturgical song, and improvisation. She has played and recorded around the world for different music projects.

Nadia Kiwan is Professor of French and Francophone Studies at the University of Aberdeen. Her research interests are focused on intersectional approaches to postcolonial migration, secularism, and citizenship in contemporary France. Her published books include *Islam, Secularism and Public Intellectuals in France* (2020); *Identities, Discourses and Experiences: Young People of North African Origin in France* (2009); and *Cultural Globalization and Music: African Artists in Transnational Networks* (2011; co-authored with Ulrike H. Meinhof). Recent articles include 'Remembering on the City's Margins: The Musée de l'histoire de l'immigration in Paris' in *Journal of Contemporary European Studies* (2017) and 'Freedom of Thought in the Aftermath of the *Charlie Hebdo* Attacks' in *French Cultural Studies* (2016).

Hadj Miliani is Professor of Cultural Anthropology at the Faculty of Arts and Letters, University of Mostaganem. He is author of *Des louangeurs au home cinéma en Algérie: Etudes de socio-anthropologie culturelle*, published in 2010 by Éditions L'Harmattan, Paris. His most recent work is the edited volume *Du patrimoine matériel et immatériel en Algérie: variations plurielles*, published in 2018 by Les Cahiers du CRASC, Oran.

About the Contributors 313

Iris Miské is an illustrator and graphic artist specializing in digital illustration. She is self-taught in illustration, graphic art, and motion design. After having edited video footage for exhibitions at the Musée du Quai Branly, she conducted research in Political History (for which she undertook fieldwork in southern Algeria and Havana, Cuba). She likes to combine digital art with paper and collage techniques with text. Something of a geek, her influences are as much taken from Beyoncé's videos as Persian miniatures from the twelfth century. Passionate and curious, she works for different media channels (France Culture, Foot Campagne), charitable organizations (Slice UP), podcasts (Takapté), and universities (University of Cambridge).

David Motzafi-Haller is an editor, translator, and doctoral candidate at the International History Department at the Graduate Institute, Geneva. He holds a BA and an MA (*summa cum laude*, 2017) from the History Department at Tel Aviv University. His PhD follows Zionist involvement in regional and international circuits of infrastructure construction and economic development through a prosopographical study of mid-range employees at Solel Boneh. A Mizrahi Israeli Jew of mixed Iraqi and Austrian heritage, his interests focus on the making of ethno-classes in Israeli Jewish society, the frontier in settler societies, and non-statist historiography. His academic work to date has seen light in *Katedra, Journal of Israeli History*, and *Middle Eastern Studies*. His translations (from English, Hebrew, and French) have appeared in numerous scholarly and popular publications, books, and periodicals.

Elizabeth Perego is a historian of contemporary Algeria and its global and regional connections. Her scholarship examines the intersection of politics, culture, and gender in the country as well as the modern Maghrib more generally. She is currently completing a book project entitled, *De-mockratiyya: Humor, History, Protest, and Conflict in Algeria, 1988 to 2005*, which explores comedy as a site of identity formation and political expression at times of heightened crisis and censorship. She received her PhD from The Ohio State University in 2017 and holds a postdoctoral fellowship in Princeton University's Department of Near Eastern Studies.

Christopher Silver is the Segal Family Assistant Professor in Jewish History and Culture in the Department of Jewish Studies at McGill University. He earned his PhD in History from UCLA. Recipient of awards from the Posen Foundation, the American Academy of Jewish Research, and the American Institute for Maghrib Studies, Silver's scholarship on Morocco, Algeria, and Tunisia has appeared in the *International Journal of Middle East Studies*,

Hespéris-Tamuda, History Today, and the United States Holocaust Memorial Museum's *Holocaust Encyclopedia*.

Rebekah Vince is Lecturer in French at Queen Mary University of London and Associate Editor of *Francosphères*. She has published articles in *Francosphères* (2018) on Jewish–Palestinian identity, *Africa and the West* (2017) on intersubjective memory in Algeria, and *Journal of History and Cultures* (2015) on French postmemory narratives, as well as a chapter in *Memory and Postcolonial Studies* (Peter Lang, 2019) on multidirectional memory in Valérie Zenatti's novel *Jacob, Jacob*. She is also involved in the collective translation of *Une enfance juive en Méditerranée musulmane* (edited by Sebbar, 2012) into English, forthcoming in the University of California Series in Jewish History and Cultures.

Valérie Zenatti was born in Nice, France, in 1970 to a family originating from Miliana and Constantine, Algeria. She spent her teenage years in Israel. Upon returning to France, she studied Hebrew in the Langues'O in Paris. She has published numerous works of young adult fiction, notably *Une bouteille dans la mer de Gaza* (2005), translated by Adriana Hunter as *A Bottle in the Gaza Sea* (2008), and adapted for the stage by Sandrine Brunner (2010) and screen by Thierry Binisti (2011). She has published several novels, including *Jacob, Jacob* (Prix Méditerranée, 2014; Prix du Livre Inter, 2015), inspired by the short life of her great uncle. She has also written screenplays for films and television series (Canal+). Her most recent novel, *Dans le faisceau des vivants* (2019, Prix France Télévisions 2019, catégorie essai) is an account of the resonances in her personal and literary relationship with novelist Aharon Appelfeld, whose novels she translates from Hebrew to French.

Index

Abadi, Jacob 183
Abassi, Hamadi 113
Abdelillah 244
Abdelkader, Emir 35
Abduh, Muhammad 167
Abergel, Reuven 249
Abiad, Georges 86
Abitbol, Michel 96
Aboullouz, Abdelhakim 167
Abrous, Mansour 128, 129
Absi, A. 128
Académie Julian 130
Addi, Lahouari 167
aesthetics 122, 133, 164, 256–58, 261, 266, 268
affiliative memory 9
Afrique 134
Agence Générale Cinématographique 32
Ageron, Charles-Robert 224
Agnello, John 135
Aharon, Meirav 193
Ahidous 242

Ahmed Reda 193
Ahwashs 242
Aïda 216, 218–20
Aidi, Hisham 168
Aïn-el-Ghezal ou La fille de Carthage 24, 37
Aïtel, Fazia 6
Al Afghani, Jamal 167
Al-Akhawayn University 207
Al-Aṣram, Muḥammad 105
Al-Fasi, Allal 73–76, 167
Al-Mustaqbal al-Masraḥi 65
Al-Rashīd Bey, Muḥammad 105
Al-Shaʿbūnī, Fārūq 109, 112–13, 115–17
Al-Taghrīr 109
Al-Ubaydi, Hedi 107
Alaoui, Assia Bensalah 211
Alaoui, Moulay Ahmad 193–94
Alapetite, Gabriel 35
Alawites 169
Alberini, Bixio 27
Algeria, construction of 142

315

316 Jewish-Muslim Interactions

Algerian War of Independence 3,
 129
Algérie-Actualité 147
Ali, Emir 35
Ali-Khodja, Ali 128
Aliyah 16, 224, 228, 232, 236, 238,
 241, 245–46, 264–65
Allagui, Abdelkrim 6, 122
Allali, Bernard 102–3
Allalou (Selali Ali) 45, 83, 86, 88,
 90–92, 146
Alliance Israélite Universelle (AIU) 6,
 224–25
Allouache, Merzak 147
Allouche, Jean-Luc 49
Allouche-Benayoun, Joëlle 48
Almeida, Cristina Moreno 2, 8–12, 15,
 98, 102, 163, 262, 307
Altglas, Véronique 274
Althusser, Louis 268
Amar, David 193
Amar, Jo 192
Amara, Noureddine 34
American Jewish Joint Distribution
 Committee (AJDC) 224
Amina, B. 91
Amzallag, Samuel *see* El Maghribi,
 Sami
Andalusi music 3, 12, 15, 47, 56, 68,
 72, 77, 81, 82, 96, 106, 112, 114,
 146, 168, 171, 184, 192, 197, 216–17,
 244
Andalusi Orchestra 54
Andalusia Festival 187
Anders, Stefansson 244
Anderson, Benedict 142
El Andoulousia 88
Anidjar, Gil 8, 281
antisemitism 7, 202, 253, 274, 280,
 284
Aouragh, Miriyam 162
Aous, Rachid 50, 55
Arab and Gezi revolts 260

Arab modes (scales) 117
Arabic Record 70
Arnauld, Daniel 101
Arslan, Savaş 27
Art et Industrie 75
Art Nouveau Gallery 124
Assidon, Sion 182, 227
Assmann, Aleida 17
Association Anou Arts pour la culture
 et les arts 196
Association Essaouira-Mogador 194
Association Marocains Pluriels 202
Association of the Sons of Abraham
 194
Atlan, Jean-Michel 131
Atlantic Andalusia Festival 194
Atoun, Maurice 116
Attali, Jacques 183
Attias, Jean-Christophe 5
Attiqa, Ch. A. 91
Avenir théâtral 65
Ayadi, Taoufik 34
Azagury, Sonia Cohen 195
El 'Azifet 108
Azimi, Negar 247
Azoulay, André 15, 172, 172, 193–95,
 207
Azoulay, Aryeh 193

Bachelard, Gaston 248
Bachtarzi, Mahieddine 77, 82, 83, 87,
 90, 93–97, 146–47
Bahloul, Joëlle 16, 48, 248
Bahmad, Jamal 9, 12, 16, 195, 223,
 228, 241, 298, 307
Baidaphon 67, 69–70
Baj, Jeannine 29
Bakhtin, Mikhail 259
Balkan Wars 114
Bambaataa, Afrika 165
Bandes dessinées 141–56
Bardin, Pierre 35
Baron, Salo 45

Barr, Alfred 122
Bataille, Maurice 38
Battle of Algiers 148
Bchiri, Gaston 106–7, 116
Bchiri, Kaliman 116
Bchiri, Mordechai 105
Bchiri, Yaakob 105–6, 110–11, 115
Bedos, Guy 278
Begin, Menachem 188, 192
Belbah, Mustapha 224
Belghazi, Taieb 166–67
Bellagha, Ali 135
Bellarabi, Ikram 218
Belle Époque 36
Bembaron et Hazan 68, 75–76
Ben, Myriam 135
Ben Ais, Maurice 116
Ben Ali, Zine El Abidine 109
Ben Aomar, Thami 68
Ben Haïm, Marylise 135
Ben Hammou, Eli 193
Ben Mahmoud, Mahmoud 36
Ben Simhon, Shaul 184, 191–92
Ben Yahia, Kaisse 207
Ben Youssef, Sultan Mohammed 68
Benais, Maurice 107
Benamira, Brahim 128
Ben-Amos, Avner 241
Benanteur, Abdallah 132, 135, 145
Benbassa, Esther 5, 11
Benchemsi, Ahmed 173
Bencheneb, Saadeddine 86, 98
Bendamèche, Abdelkader 50
Bendana, Kmar 38
Benezra, Avishai 214
Bengualid, Jan 214, 215
Ben-Gurion 188, 191
Benhassel, Abdelkrim 128
Benjelloun, Hassan 219
Ben-Layashi, Samir 6–7, 171, 206
Bennett, Ernest N. 27
Bennett, Jill 227, 229
Bensigor, François 184

Benslimane, Ahmed 128
Ben-Yehoyada, Naor 44–45
Berber Dahir 68
Berdugo, Serge 194
Bernhardt, Sarah 65
Bernstein, Deborah 186
Berthola, Agnès 25
Bey, Ahmad II 112
Bharat, Adi Saleem 3–4, 7, 12, 16, 145, 265, 298, 307
El Bidaouia, Raymonde 194
Bigini, Antonio 25
Bilakhdar, Rachid 88
Bilu, Yoram 54
Bismouth, Maurice 124
Biton, Charlie 188
Biton, Erez 190
Bitton, Simone 195
Bizz2Risk 173
Black Panthers (Israel) 186, 189, 192
Blanchard, Emmanuel 129
bled, concept of 205
Bocchieri, Emmanuel 123–24
Boniche, Élie see Boniche, Lili
Boniche, Lili 51, 81, 96
Boon, Danny 281
Borgel Cemetery 63
Borgel, Eliaou 113
Borns, Betsy 275–76
Bossier, Annabelle 134
Botbol, Haim 202, 214–16
Bouayed, Anissa 132
Boucherle, Pierre 121, 123–24, 135
Bouches-du-Rhône 32
Bouchoucha, Mustapha 37
Boudhina, Mohamed 114–15
Boudjellal, Farid 145, 287
Bouge, Auguste 32
Boughedir, Férid 110–11
Boukrouh, Makhlouf 85
Boum, Aomar 3, 48, 145, 154, 172, 182–83, 189, 193–95, 197, 204, 212, 225, 228, 265, 298, 307

Boumendil, Rosine *see* Rhaiss, Elissa
Bourget, Carine 145
Bourguiba, Habib 109
Bousbia, Safina 45, 81, 148
Boutaleb, Mahieddine 128
Bouteflika, Abdelaziz 46, 145
Bouzaglo, David 192
Bouzar-Kasbadji, Nadya 45, 51, 64, 81
Bouzid, Nouri 111–13, 151–52
Boycott, Divestment and Sanctions (BDS) 227
Boym, Svetlana 16, 244
Bozzo, Anna 127
Braïtou-Sala, Albert 124
Branche, Raphaëlle 151
Braun, Marta 24
Bretillon, Chong J. 178
Brigadier General of the Meknes region 74
Brioue, Mohammed 194
Brown, Katherine Butler (Schofield) 53
Bureau of Native Affairs (Algeria) 70, 78

Café de Paris 123
Caméras sous le soleil 38
Camus, Albert 129, 195, 304
Canal+ 254, 273, 278
Cannes International Film Festival 111
Carême, Maurice 294, 303
Carlier, Omar 63
Carthage (ocean liner) 32
Casablanca, terrorist attacks in 163–64
Casaoui 10
Castel, Robert 157
Castelli, Horace 101–2
Catalanott, M. 103
Catroux, Georges 128
Cavatorta, Francesco 167
Cenciarelli, Cecilia 25

Center for Sacred Sounds and Poetry 193
Centre de Recherche en Ethnomusicologie (CREM) 72
Cerabona, Giuliana 25
Cercle Européen de Tunis 37
Cercle francomusulman d'Algérie 127
chaâbi music 12, 15, 81–82, 176, 212
Chaqara, Abdessadeq 194
Charlie Hebdo 12
Chataigneau, Yves 128
Chaulet-Achour, Christiane 143
Cheb Mami 2
Cheikh El Afrit 106, 109–10, 112–17
Cheikh Raymond 3, 184–85
Cheikha Rimiti 2
Chekaoui, Ahmed 135
Cheniki, Ahmed 86
Chérau, Gaston 27
Cheriaa, Tahar 30, 38
Cheurfa, Hiyem 145
Cheurfi, Achour 84, 88
Cheyette, Bryan 9–10
Chikh, Slimane 151
Chomsky, Marvin J. 294, 302
Chouraqi, Eliane 84
Chreiteh, Alexandra 211, 217–18
Christian Reconquest 106
Ciné-Journal Chikli 30
Cinemato-Chikli 25
Cineteca di Bologna 27, 30
Civil Control headquarters in Rabat 69
Civil Controller of Doukkala 66, 68, 69
Cixous, Hélène 148
Ciyow, Yassin 145
Clancy-Smith, Julia 64–65
Club des Cinq 294–95
CoBrA 131
CoeXisT (street art project) 254–55, 261–63
Cohen, Albert 295, 304

Index

Cohen, Amit Hai 12, 195, 238–39, 243, 246, 248–49
Cohen, Eli 297, 306
Cohen, Jean 98
Cohen, Sarriza 81, 98
Cohen-Olivar, Jérôme 214–15
Colebrook, Claire 226
Colomb Béchar 31
Columbia Record 72
Combo Culture Kidnapper 4, 12, 16, 253–69
Combs-Schilling, M. Elaine 170
Comerio, Luca 27
Comité français de la libération nationale 127
communautarisme 280
competitive exchange 8, 14, 55, 57
Concours de l'école des Beaux-Arts de la ville de Nice 254
Constant Busson 103
Corpora, Antonio 124, 134
Corriou, Morgan 13, 25, 38, 34, 298, 307
Courrier cinématographique 35
Crémieux Decree 6, 7, 44, 72, 91, 96–97, 122, 127, 284

Da Vinci, Leonardo 255
Daadaoui, Mohamed 167
Dalel *see* Taliana, Dalila
Daninos, Abraham 85
Daoud, Sultana 44
Daumier, Sophie 278
Davidson, Naomi 277
Davis, Haleh 145
Davis, Ruth 2, 9, 14–15, 106, 108, 145, 298, 307
De Castro, Eduardo Viveiros 44, 49, 52, 53, 55–56
De Fontenay, Elisabeth 258
De Martino, Claudia 186
De Tocqueville, Alexis 127
De Tocqueville, Jean 127

Debbouze, Jamel 1, 2, 4, 273–74, 278
Deleuze, Gilles 226, 228–29
Delhaye, Blandine 130
Derbouka 82
D'Erlanger, Baron Rodolphe 104–5
Derrida, Jacques 297, 305
Deshen, Shlomo 54
Desproges, Pierre 277, 282
Destour 62–63, 65
dhimma 6–7
Dicale, Bernard 184
Die Heimat 102
diegesis (in music) 209
Dieudonné, Élie 273
Director General of the Military Cabinet (Morocco) 70
Director of Public Security (Tunisia) 62–63
Directors General of the Military Cabinet (Tunisia) 70
Disques, Raymond 185
El Djazairia 88
Don Bigg 175
Douglas, Allen 152, 154, 155
Driver, Cory Thomas Pechan 265

École d'Alger 127
École de Paris 130
École de Tunis 121, 123, 124, 125, 125, 129, 134, 136
École des Beaux-Arts d'Alger 127, 128
École des Beaux-Arts de Paris 128
École des Beaux-Arts de Tunis 124
École Nationale des Beaux-Arts 130
Egorova, Yulia 283
Egyptian national anthem 67–71
Eichmann, Adolf 213
Eid al Adha 169
Eid al Fitr 169
Elbaz, André 135
Elbaz, Simon 212
Elbaz, Vanessa Paloma 9, 12, 14, 145, 196

Eldridge, Claire 145, 148
electrical recording 67
Elkayam, Neta 12, 195–96, 236, 238, 243–44, 246–48
Elkouche, Mohamed 170
Elliott, Gregory 256
Elmaleh, Gad 2–4, 273
empathy 227–29
Eriksen, Thomas Hylland 213, 214, 216
Errihani, Mohammed 170
Ervine, Jonathan 278
Es-Saâda 70
Eustace, Nicole 145
Evans, Martin 184
Everett, Samuel Sami 2, 4, 6, 10, 17, 148, 298, 307
Exhibition of Muslim Painters of Algeria 129
exile 74, 105, 230, 235–36, 297, 306
expressionism 126
extremism 125, 261
Ezzahra, Ennejma 67

Fahmy, Ziad 183
Farhat, Ammar 112, 123, 125, 135, 133
Farmer, Henry George 105
Farrah, Abdelkader 128
El Fassia, Zohra 192, 194
Faudel 2
Faurisson, Robert 274
Favre, Lucienne 87
Ferhani, Améziane 145
Ferhat, Mohammed 128
Feros, Juan 225
Festival d'Essaouira Gnaoua Musiques du Monde 166, 172, 194
Festival of Andalusia 183
Fez Festival of World Sacred Music 167, 169
First International Congress of Arab Music 105
first intifada 297, 306

Fitoussi, Alice 81, 96
Fnaïre 164–65, 168–71, 174, 176
foundation myth 168–71
Francophone, use of the term 5
Frankel, Oz 188
French Ministry of Culture 168
French protectorate (Morocco) 238, 241
French protectorate (Tunisia) 24–25, 61, 104
French Residents General (Tunisia and Morocco) 63
French Revolution 295, 303
French Third Republic 6, 126
Front de Libération Nationale (FLN) 141, 149–50, 155, 184
Front National 274

Gale, Leanne 253
Galonnier, Juliette 277
Gary, Romain 295, 303
General Residence in the National Assembly 32
Genini, Izza 195–96
Gharnati 192
Ghazala, Z. B. 91
El Ghiwane, Nass 164, 195
Ghost Project 172
Gidley, Ben 253
Gillet, Fanny 9, 14, 30, 134, 298
Gilroy, Paul 287
Glasser 2, 8–9, 14, 45, 51–53, 63–64, 81, 147, 157, 298, 307
Gnawa 164, 169, 216
Goodman, Jane E. 50, 57
Gordon, Noah 213
Gorgi, Abdelaziz 123, 125, 133, 135
Gottreich, Emily 11, 54
Governor General of Algeria 63
Graffiti Elite Section (GES) 254
Gramophone Records 67, 72, 88
Grand Journal (Canal+) 263
Grande Chaumière 130

Index

Great Syrian Revolt 62
Green March 202
Groensteen, Thierry 141
Gros, Antoine-Jean 255
Groupe des Dix 124, 127, 134
Guattari, Félix 16, 226, 228–29
Guedira, Ahmed Reda 193
Guedj, Jérémy 45
Guemaz, Abdelkader 135
Guerroui, Brahim 153
Guetta, Mahmoud 107
Guillot, Hélène 25, 30

H-Kayne 164–66, 174–75
Hachkar, Kamal 9, 16, 183, 195, 223, 225–32, 236, 238–40, 243–44, 248, 298, 307
Hachlef, Ahmad 114–15
Halali, Salim 14, 63–64, 76–78
Halevy, Yehouda 239
Halili, Salim 3
Halimi, Sarah 258
Hall, Stuart 162
Halls, Katharine 85
halqa 82
Halter, Marek 267
Hamdaouia, Hajja 194
Hamoumou, Mohand 148
Hamrouni, Ahmed 63
Hannoum, Abdelmajid 5
Hanukkah 190
Hargreaves, Alec 259
harkis 148
Harouimi, Claire 84
Harouimi, Marcel 84
Harrison, Olivia 5, 154
Harroch, Suzanne 195
Hassan II 193–94, 204
hawzi 77, 74, 82
Hazan, Raoul 75–76
Hebrew poetry 113
Hecker, Marc 279
Hemche, Abdelhalim 128

Higbee, Will 195
Hiloula 190
Hirak Rif 162
Hirchi, Mohammed 210
Hirsch, Marianne 9, 237–38
Hirschberg, Zeev 5
Hirschkind, Charles 183
Histoire partagée 13
Hochberg, Gil 247
Holocaust 181, 245, 274, 284, 288, 294–95, 297, 302, 306
Hoofer 12, 172–74, 176
Hovanessian, Martine 241
Howe, Marvine 167
Hyper Cacher attacks 258, 261

Iberian Peninsula 3
Ibn Chebab *see* Yafil, Edmond Nathan
Idris II 170
Idris, Moulay 67, 167, 169
Iguerbouchène, Mohamed 77
Illouz, Myriam 246
Ilouz, Shalom 230
INALCO 10
Inquisition of 1492 217
Institut de Carthage 37
Institut du monde arabe (IMA) 13, 263, 266–67
'irony's edge' 259
Islam and Algerian identity 143, 207
Islamic mysticism 168
Islamophobia 7, 253, 284
Israel
 creation of 203, 225, 231–32, 241
 land of 244, 238, 224–25
 state of 225, 231–32, 236, 241, 243
Israel Prize for Hebrew Literature and Poetry 190
Israeli Andalusian Orchestra 184, 193
Israeli-Arab Wars *see* Israeli-Palestinian conflict
Israeli-Palestinian conflict 105, 183, 253, 279, 306

322 *Jewish-Muslim Interactions*

Issawa 165–66
Isserene Rozio *see* Cheikh El Afrit
Italo-Turkish War 23, 26–29, 30
Ittihad Maroc (Alliance) schools 203

Jabès, Edmond 235
Jam et Gad 2–4
Jamel Comedy Club 1, 273, 278, 284
Jammot, Armand 294, 312
Janet, Pierre 229
Jankowsky, Richard 183
Jarrassé, Dominique 132
Jay, Cleo 170
Jazouli, Adil 103
Jean-Darrouy, Lucienne 72
Jellaz 24, 32, 34–35
Jerusalem Temple 105
Jewish Agency 224–25
Jikeli, Günther 265, 274
Jilala, Jil 164
Joffé, George 167
Joris, Pierre 235
Joseph de Cabriac Désiré 82
Joyeux-Prunel, Béatrice 121
Judaken, Jonathan 253, 258, 265
Judeo-Arabic 5, 10–11, 246
Justice and Charity association 167
Justice and Development Party (PJD)
 (Morocco) 227

Kadri, Mohammed 67
kaféchantants 104, 106–7
Kali, Mohammed 86, 146
El-Kamal, Mohamed 77
Karoutchi, Maxime 202
Karsenty family 83
Kartowski-Aïach, Miléna 9, 12, 16,
 195, 236, 241, 298, 307
Katz, Ethan 48, 63, 274
Keil, Charlie 24
Kenbib, Mohammed 6, 224–25
keyboard 103–4
Khadda, Mohammed 131–32, 134–35

Khader, Youcef 154
Khan, Imran 264
Khatibi, Abdelkebir 258, 267
Khatmī, Faḍīlah 108
Khayat, Théodore 66, 68
Khayrī, Fatḥiyyah 108
Khelladi, Aïssa 143
Khlif, Omar 38
Kippur 190
Kiwan, Nadia 4, 7, 9, 16, 263, 298, 307
Kleppinger, Kathryn 1
Klug, Brian 259, 284
Knesset 11, 188
Knoll, Mireille 258
Koliphone record label 192
Kosansky, Oren 5, 145, 154, 189, 195,
 204, 212, 228
Kosher supermarket killings 12
Ksentini, Rachid 2, 14, 82–84, 87–88,
 91–97, 147
Kuipers, Giselinde 145

La Fontaine 294, 303
La Gazette des Théâtres 85
La Presse de Tunisie 121
La Zahia 86, 88
Labassi, Lili 73–75, 82, 184, 188
Labor Party 188, 192
Labor Party Secretary of the Workers'
 Committee 191
Laboratoire de Musique Marocaine
 170
Labter, Lazhari 147
Lacheraf, Mostefa 142
Lachmann, Robert 247
Ladino music 182
L'Afrique du Nord illustrée 88
Laghrari, Youness 215
Laloum, Jean 49, 77
Lamarre, Annie Stora 52
Lang, Jack 262–63
Langlois, Tony 45, 51, 169
Laskier, Michael 224–25

Index

Lasri, Yehiel 193
Lavenir, Catherine Bertho 36
Law for Preservation of the Rights to Compensation of Jewish Refugees from Arab countries and Iran 11
Le Centre de Recherches Haïm Zafrani sur l'Histoire des Relations Islam-Judaïsme 195
Le Club 77
Le Foll-Luciani, Pierre-Jean 83–84, 132, 153
Le Pen, Jean-Marie 274
Le tamtam de l'Afrique 4
Le Théâtre Algérien 88
Le Trianon 82
Le'Aliya, Mossad 224–25
Lean, Eugenia 145
Leeb, Michel 280
Lellouche, Jules 124, 133, 135
Lemchaheb 164
Lemcharfi, Mustapha 68–69
Lenk, Sabine 29
Lettrism 132
LeVine, Mark 183
Levy, André 54, 110–11, 191–92, 244, 265
Levy, Moses 123–24, 135
Levy, Nello 124
Levy, Simon 189–90
Lewinsky, Mariann 25
Leys, Ruth 226
Liberté newspaper 84
Lieutenant Colonel Margot 70
Likud Party 184, 188, 192
Lili Labassi 14, 63–64, 72, 76, 78
L'Illustration 32
Lionnet, Françoise 154
Livingston, Julie 145
Lorcin, Patricia M. E. 6
Louati, Ali 112–13, 116
Louk, Haim 187, 194
Lyazidi, Mohamed 73–74
Lycée Français de Tunis 125

ma'abarot 185, 246
Macias, Enrico 46, 181–82, 184–85
El-Madani, Ahmed Tewfik 23, 172
Maddy-Weitzman, Bruce 7, 171, 183, 206
Maghraoui, Driss 167, 172
El Maghribi, Felix 202
El Maghribi, Sami/Samy 192–94, 212, 202
El Maghribi, Victor 202
El-Mahdi, Salah 107–8
mahia 212
Maillars, D. 102–3
El Maleh, Edmond Amran 13, 190, 242
Malik, Abd Al 168
Malka, Motti 193
Malti-Douglas, Fedwa 143, 152, 154–55
ma'lūf 106, 108–9, 112, 116, 184
Mamman, Ophir 186
Mammeri, Mouloud 129
Manceron, François 61, 62
Mandel, Maud 6, 8, 253, 258–59, 274–75
Manna, Jumana 247–48
Mansour, Guillemette 25, 28, 30, 32, 35, 37
Manton, Maria 133, 136
MAPAI party 191
Marciano, Saadia 188
Markowitz, Fran 244
Marks, Essica 45, 51
Marocains Pluriels association 207
marocanité 205
Marouf, Nadir 3
Marrakchi, Laïla 210
Marrakech du Rire 4
Marrakshi, Laila 219
Martin, Florence 195
Martinez, Denis 135
Marzuqi, Mohamed 106–8
Massumi, Brian 226, 229

324 *Jewish-Muslim Interactions*

Mathieu, Georges 134
Matisse, Henri 134
Matzpen 188
M'Bala M'Bala, Dieudonné 4, 273–74, 278, 282
McClintock, Anne 142
McDougall, James 50, 57, 142, 151, 153
McGill University 196
McGonagle, Joseph 282
McKinney, Mark 143
McQueen, Fraser 266
Mdaghri, Abdelkebir Alaoui 167
Mdidech, Jouad 182
M-Doc 172
Meddeb, Abdelwahab 10, 13
Médine 168
Médioni, Maurice 81
Méditerranéisme 129
Meer, Nasar 277
Meir, Golda 188
Mejr, Ouissal 25
El Mekki, Hatem 125, 135
Memmi, Albert 11, 24, 34, 36–37, 84
Merabtène, Menouar 147
Mercer, Kobena 121
Merrill, Samuel 263
Messaoudi, Alain 123–24
Messika, Habiba 3, 12, 14, 61–62, 64–69, 71–72, 74, 77–78, 87, 112
Mestaoui, Linda 255, 259, 260, 262
Methenni, Bechir 65
Meziane, Abdelhakim 50
Meziani, Allaoua 266
Miliani, Hadj 2, 10, 45, 63, 77, 83, 202, 298, 307
Miller, Susan G. 68, 141, 183, 201
Mimouna festival 191, 193
Mimouna Foundation 207
Mimouni, Eliaou 61
Minister of Tourism (Morocco) 194
Ministry of Cultural Affairs (Tunisia) 38, 106

Ministry of Culture (France) 264
Ministry of Foreign Affairs (Israel) 11
Mizrahi, Asher 106, 113–16
Młodożeniec, Piotr 261
Mohammed VI 37, 161–62, 166–67, 170–72, 175–76, 211
Mondrian, Piet 134
Monty, Line 51
Moors, Annelies 263–64
Moosavi, Leon 277
Moreh, Shmuel 85
Morisco 5, 10
Morize, Jean 76
Moroccan Cinema Centre (CCM) 228
Moroccan Jewish Community Council 193
Moroccan National Working Group for Palestine 181
Moroccan Palestinian Campaign for Academic and Cultural Boycott of Israel 181
Morsly, Dalila 143
Moses, A. Dirk 7
El Mossilia 87, 94
Moumen, Abderahmen 8
Moussali, Bernard 104, 109–10
Moustaysir, Mokhtar 105, 107–9, 117–18
El Moutribia 72, 77, 82, 83, 87–88, 94–96, 146
Moutribia troupe 82
Moyal, Elie *see* Labassi, Lili
M'Quidech 142, 147, 153
Mrini, Driss 216–18
Müller, Jürgen 183
Murphy, Eddie 279
Musée d'Art et d'Histoire du Judaïsme 13
Muslim Press Service 70
Musrara uprisings 188

Naccache, Edgard 124, 134–35

Nadjari, David 6
nahda 2, 86
Nahum Goldman Museum of the Diaspora 240, 241
Na'ila, B. 50
Nakhli, Alia 125, 134
Nallard, Louis 133–36
Napoleon III Senatus-Consultus 6
Nass El Mellah 189, 195
Nasser, Gamal Abdel 215
Nasserism 225
National Film Festival in Tangier 223, 228
National Liberation Front *see* Front de Libération Nationale
National Museum of Fine Arts (Algeria) 128
National Theatre (Algeria) 105, 146
Neumeyer, David 209
Nieto, Miguel Angel 213
Ninio, Charlotte 265
Nizri, Yigal Shalom 186
Noguès, Charles 71, 73
Non-Aligned Movement 151

Obadia, Lionel 4
Office of Civil Control (Rabat, Morocco) 68
Olick, Jeffrey K. 244
Omi, Michael 277
Omnia Pathé 26
Organisation Armée Secrète (OAS) 184
Oslo agreement 194
O'Sullivan, Simon 226
Ottoman era 9
Ouaknine-Yekutieli, Nizri 186
Oualdi, M'hamed 34
Ouijjani, Hinda 83
Ounaina, Hamdi 125, 136
Ounnoughene, Mouloud 77
Ozar Hatorah Jewish school 258

Pacalet, Arthur 264
Palestine Broadcasting Service 247
pan-Arabism 152, 154, 203, 216, 227
Panthéon-Assas University 254
Papon, Maurice 284
Paris massacre of 1961 284
Park, Thomas 193
Parlophone Records 72
Pathé Journal 29
Pathé Records 67, 77
Péchin, Pierre 278, 280
Pépino 83
Perego, Elizabeth 8–9, 15, 298, 307
Peres, Shimon 194
Pesach 192
Petit Felix see Felix El Maghribi
Peugeot 254
Pew Research Center 171
Peyrouton laws 96
pied-noir 8
piyyut 56, 190, 192
Plamper, Jan 144
Polyphon 73–74
postmemory 237
Potie, Anne 129
Première exposition de jeunes peintres et miniaturistes musulmans d'Algérie 127
Princess Hijab (PH) 263, 264
Projet Aladin: Le pont de la Connaissance entre Juifs et Musulmans 13
Puig, Steve 168

qasida 74
Quemener, Nelly 4, 278

Rachik, Hassan 167
Racim, Mohammed 127–28
Racim, Omar 128
Racy, Ali Jihad 67, 105
Radio et Télévision Marocaine (RTM) 216

Radio Maroc 69
RadioMed 189
Rahal, Malika 146, 151
raï music 176
Raissiguier, Fernando 259
Ramadan 62
Ramzi, Rafik 154–56
Rancière, Jacques 256–57, 262, 265–69
Ranem, Mohamed 128
Rashidiyya ensemble 105–6, 108, 117
Rashidiyya Institute 14, 107, 109
Réalités Nouvelles 130
Reddy, William, M. 145
Reeck, Laura 1
Regional Bureau of Fez 74
Rehihl, Zhor 189
Reinette l'Oranaise 44
Rembrandt 255
Rémond, Georges 27
Renton James 253
République 147
Resident General of Morocco 71
Return to Morocco 228
Revue Hebdomadaire Gaumont
 Actualités 29
Reznikoff, Charles 23
Rhaiss, Elissa 91
Rhanem, Karima 228
Riad, Mohamed Slim 157
Rif Movement 162
Riggle, Nicholas 259
Robert, Claude-Maurice 127
Roessel, Jean François 82
Rosello, Mireille 275, 282
Rosen, Lawrence 15, 55, 202
Rosenwein, Barbara H. 145
Rosh ha-Shana 190
Roth, Arlette 86, 146
Rothberg, Michael 7, 9, 284
Roux, Michel 148
Rozzio, Isserine Israel *see* Cheikh El
 Afrit
Rue des Bons-Enfants 264

Ruppin, Dafna 37
Rushdī, Ḥasībah 108
Rushdi, Shāfiya 108
Rushdie, Salman 231

Saadallah, Fawzi 45–46, 51
Saber, Mourad 154
Sahara 73, 75
Said, Edward 90, 155
Salafi jihadists 167
Salafism 167
Salmon, Stéphanie 25
Salon de Mai 130
Salon de Tunis 121
Samama, Albert 23–38
Samama-Chikli *see* Samama, Albert
Sami the Moroccan *see* El Maghribi,
 Sami
Sanogo, Aboubakar 25
Sassi 96
Sater, James N. 170
Savarèse, Eric 6
Scales, Rebecca 78
Schreier, Joshua 6, 153, 269
Schroeter, Daniel 219
Secretary General (Morocco) 70–71
Seddiqi, Tayeb 194
Seddon, David 5
Seroussi, Edwin 45, 51, 53
Serres, Thomas 145
Serri, Sid Ahmed 47, 56
Shakespeare, William 267, 281
Shannon, Jonathan H. 169
Shehadi, Sebastian 227
Shih, Shu-mei 154
Shiloah, Amnon 45
Shilton, Siobhán 257–58, 261–62,
 266–68
Shoah *see* Holocaust
Shohat, Ella 90, 236, 238
Sicot, Yves 73
Siegel, Irene 13, 242
Sienkiewicz, Matt 259, 268

Index

327

Silver, Christopher 3, 10, 12, 14, 45, 62, 73, 76, 87, 183, 115, 184, 196, 298, 307
Silverstein, Paul 265
Situationist International 132
Six peintres maghrébins 135
Slim 147–55
Smadja 84
Smaïn 277–78
Smith, Mark 183
SOAS 11
SOC Simon Pinto 202–3
Société des artistes algériens et orientalistes 128
Société des orientalistes français 129
Société nationale d'édition et de diffusion 142
Solomon, Thomas 219
Sonego, Charles 47, 54, 57
Souiri, Abderrahim 169
Soussan, Marie 3, 82–90, 97
Srarfi, Amina 108
Stam, Robert 11
Stein, Sarah Abrevaya 122, 269
Stillman, Norman 5, 54, 189
Storm, Lise 167
sub-Prefect of Mostaganem (Algeria) 78
Sufism 165, 167–68, 170
Sukkot 190
Swedenburg, Ted 45, 63

ta'āyish 161
Taliana, Dalila 106
Tamazight 182, 230
Tanjazz Festival in Tangiers 182
taqlidi rap 164, 166–67, 171, 174, 176
Teboul 45, 49, 50
Tedghi, Joseph 5
TedX 254, 255
Telem 186
Tharaud brothers 88
Thénault, Sylvie 129

Théoleyre, Malcolm 51, 53, 81
Third Worldism 151
Thouroude, Thomas 289
Tikkoun Olam 245
Till, Karen 10, 240, 246
Timsit, Daniel 148
Tinghirian Jews 226–27
Todd, Emmanuel 259
Todra Gorge 205
Toledano, Jules 74, 76
Toledano, Ralph 208
Torah 239
Toufiq, Ahmed 167
Tozy, Mohamed 167
transliterating Arabic 11
trap *beldi* 176
Tripolitan 14
Troupe algéroise 94
Tsuda, 2009 244
Tunis: rues et paysages 31
Tunisian Federation of Cinema Clubs 38
Tunisian Liberal Constitutionalist Party 62
Tunisian Radio ensemble 108
Turki, Yahia 123, 125, 135
Turki, Zoubeir 135–36

ughniya wataniya 164
Umayyad Caliphate 3
Union of North African Immigrants 186
Union Sportive Musulmane 91
Universal Exposition (Paris) 103
Urian, Dan 186
urūbiyyāt 117

Valensi, Lucette 3, 6, 35, 122, 125
Van der Kolk, Bessel 229
Vazana, Noam 182
Veglia, Patrick 224
Veillot, Claude 38
Véray, Laurent 25

Verdes-Leroux, Jeannine 130
Vermeer, Johannes 255
Victor René, Alfred 88
Vidal-Bué, Marion 127
Vigouroux, Cécile B. 259, 277
Villa Arson 254
Vince, Rebekah 4, 11, 17
Vingt jeunes peintres de tradition française 130
Vinitzky-Seroussi, Vered 6
Vitali, Ilaria 287
V-Mic 173

Weil, Patrick 6
Western Wall 281
Wieviorka, Michel 279
Winant, Howard 277
Wizman, Victor 202
Woolf, Virginia 267
World War I 64, 107, 167
World War II 76, 64, 106, 121, 130–31, 284
World Zionist Organization (WZO) 224
Wyrtzen, Jonathan 68, 206

Yacoub, Taoufik 27
Yafil, Edmond Nathan 82–83, 94, 144, 147
Yehuda, Zvi 224, 226
Yellès, Bachir 128
Yelles, Mourad 145, 150
Yom Kippur War 241
Younes et Bambi 3, 4, 12, 16, 273, 275–76, 279–80, 282–84, 287, 289

Zaccaria, Massimo 24, 27
Zafrani, Haim 224, 241
Zahia theatre company see La Zahia
Zanifi, Omar 147–48, 170
Zenatti, Valérie 16–17, 294, 296, 305–6
Zerhouni, Saloua 172
Zia-Ebrahimi, Reza 7
Zionism 46, 111, 155–56, 190, 210, 224, 274
Zohar, Zion 188
Zouagha 30–31
Zulu Nation 165
zwayya 107
Zweig, Stefan 295, 304